QUEER AND BOOKISH

Before you start to read this book, take this moment to think about making a donation to punctum books, an independent non-profit press,

@ https://punctumbooks.com/support/

If you're reading the e-book, you can click on the image below to go directly to our donations site. Any amount, no matter the size, is appreciated and will help us to keep our ship of fools afloat. Contributions from dedicated readers will also help us to keep our commons open and to cultivate new work that can't find a welcoming port elsewhere. Our adventure is not possible without your support.

Vive la Open Access.

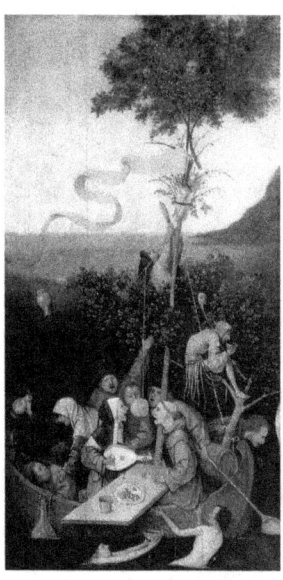

Fig. 1. Hieronymus Bosch, *Ship of Fools* (1490–1500)

QUEER AND BOOKISH: EVE KOSOFSKY SEDGWICK AS BOOK ARTIST. Copyright © 2021 by Jason Edwards. This work carries a Creative Commons BY-NC-SA 4.0 International license, which means that you are free to copy and redistribute the material in any medium or format, and you may also remix, transform and build upon the material, as long as you clearly attribute the work to the authors (but not in a way that suggests the authors or punctum books endorses you and your work), you do not use this work for commercial gain in any form whatsoever, and that for any remixing and transformation, you distribute your rebuild under the same license. http://creativecommons.org/licenses/by-nc-sa/4.0/

First published in 2022 by punctum books, Earth, Milky Way.
https://punctumbooks.com

ISBN-13: 978-1-68571-024-8 (print)
ISBN-13: 978-1-68571-025-5 (ePDF)

DOI: 10.53288/0328.1.00

LCCN: 2022932939
Library of Congress Cataloging Data is available from the Library of Congress

Book design: Vincent W.J. van Gerven Oei
Cover image: Eve Kosofsky Sedgwick, *The Last Days of Pompeii/Cavafy collage book* (c. 2007), inside back pages. Photo: Kevin Ryan, Collection H.A. Sedgwick, © H.A. Sedgwick.
Frontispiece: Hal A. Sedgwick, photograph of Eve Kosofsky Sedgwick (c. 2002), at work setting an example of Yoel Hoffmann's Japanese *Death Poems* (1986) onto a *shibori* ground. © Eve Kosofsky Sedgwick Foundation.

spontaneous acts of scholarly combustion

HIC SVNT MONSTRA

Queer and Bookish
*Eve Kosofsky Sedgwick
as Book Artist*

Jason Edwards

Contents

Introduction. Queer and Bookish?
Eve Kosofsky Sedgwick as Book Artist · 17

1. The First Three Books · 37

2. Black Queerness, White Glasses:
Tendencies, Or, *Gary in Your Pocket* · 89

3. Between Women:
Performativity and Performance,
Or, *Shame and Her Sister* · 135

4. *Fat Art, Thin Art* · 169

5. The Texture Books:
A Dialogue on Love and *Touching Feeling* · 213

6. Interlude, Pandagogic,
Or, Sedgwick's *Panda Alphabet Valentines* · 259

7. Sodomizing Edward Bulwer Lytton,
Or, *The Last Days of Pompeii* · 307

Bibliography · 401

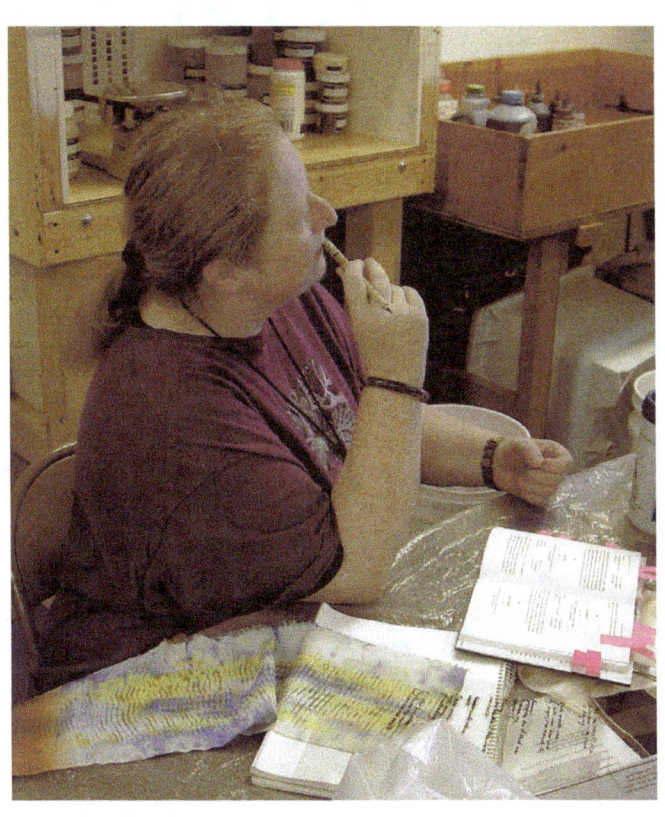

Acknowledgements

Queer and Bookish has been a long time coming, and I'd like to thank everyone for their patience during the time it's taken to get this queer little book to press. Vincent W.J. van Gerven Oei and Eileen Joy, at punctum books, made a home for the book, and Eileen a number of helpful comments on the manuscript. I'm also grateful to Lauren Berlant and Ken Wissoker at Duke, and the two anonymous readers of an earlier form of the manuscript there, for helping to shape this book in its current form. That Lauren is no longer here to see the final version is a source of deep regret to me.

At the Eve Kosofsky Sedgwick Foundation, I'd like to express my profound gratitude to Hal A. Sedgwick, Ti Meyerhoff, and Sarah McCarry, who answered numerous questions over many years, and provided me with access to an astonishing diversity of archival material, as well as commissioned the majority of photographs that illustrate this volume. For more on the Foundation, and more of Kevin Ryan's transformative photographs of Sedgwick's artwork, visit https://evekosofskysedgwick.net/.

I am thankful to Allyson Mitchell for letting me reproduce her work, which helped crystallise the final form of the introduction. For more of Mitchell's work, visit https://allysonmitchell.com. I am grateful to Simon Watney for sharing with me his photographs of Eve at Charleston, and allowing me to reproduce one here, providing the perfect conclusion to this book.

I'd like to express my gratitude to everyone who has taken part in the Sedgwick memorial conferences at the University of York; CUNY Graduate Centre, especially Josh Wilner; and the University of Manchester Sexuality Summer School, especially Monica Pearl and Jackie Stacey, for keeping Sedgwick's work alive, relevant, and in circulation. These conferences have been extraordinary, and extraordinarily moving.

At the University of York, I'd like to thank my colleagues in the History of Art department, whose doors were always open when I needed a decompressing chat over a cuppa, which was (and is) often. Jo Applin, James Boaden, and Michael White patiently shared their expertise with me. At the university's Centre for Complex Systems Analysis, I've been grateful for the mid-stretching, texturing interlocution of Susan Stepney, Elizabeth Tyler, Jeanne Nuechterlein, Richard Walsh, and Claire Westall.

To my former and current PhD students, Team Jason, I can't tell you how much I've learned from you, and how much smarter I am as a result. Thank you.

I completed this manuscript during a secondment at St Paul's Cathedral, where I've been grateful for the friendship and scholarship of Marjorie Coughlan, Adam Frost, Amy Harris, and Greg Sullivan.

To Eve's former circle, I still can't believe we get to be friends, and that means especially you Mary Baine Campbell, Jonathan Flatley, Jonathan Goldberg, Katie Kent, Michael Moon, and Carolyn Williams.

As I've said before, and as Ani Difranco said before me, we owe our lives to the people that we love. For me, vital are Charlotte Anderson, Connor Anderson, Ana Bilbao, Maddie Boden, Meg Boulton, Angus Brown, Mary Chapin Carpenter, Neko Case, Nicole Devarenne, Coen Edwards, Christine Edwards, Dylan Edwards, Michael Edwards, Paul Edwards, Tracy Edwards, Elizabeth Emens, Alison Farrell, Stephen Feeke, Adam Frost, Helen Finch, Will Gage, Betsy Galloway, Rose B. Ganim, Issy Gapp, Sarah Haessler, Emily Haines, Amy Kapczinsky, Teresa Kittler, Kate Lewis, Beth Linklater, Annifrid Lyngstad and Agnetha Faltskog, Ben Madden, Mark Madine, Sophie Mat-

thiesson, Mary McFarlane, Nicola McDonald, Ariane Mildenberg, Anaïs Mitchell, Joni Mitchell, Sarah Monks, James Nash, Diane Nelson, Ben Nichols, Melanie Patrick, Monica Pearl, Karen Peris, Jacki Piper, Sophie Raudnitz, Sara Salih, Tamsin Silver, Stuart Taberner, Stephanie Taylor, Elizabeth Tyler, Martha Wainwright, Sue Wallace, and Jessica Westwood.

For Neko, who gave me a reason to keep going.

INTRODUCTION

Queer and Bookish? Eve Kosofsky Sedgwick as Book Artist

Surface Reading Sedgwick, Sedgwick Surface Reading

In a 2010 article, 'Close But Not Deep: Literary Ethics and the Descriptive Turn', Heather Love documented the then-recent search for new critical hermeneutics in literary studies including, 'most notably', Eve Kosofsky Sedgwick's reparative reading and Sharon Marcus and Stephen Best's 'surface reading', as well as Marcus's 'just reading'.[1] Marcus had first articulated 'just reading' in the introduction to her 2007 monograph *Between*

1 Heather Love, '*Close But Not* Deep: Literary Ethics and the Descriptive Turn', *New Literary History* 41, no. 2 (2010): 371–91, at 382. For more, see Love's 'Close Reading and Thin Description', *Public Culture* 25, no. 3 (2013): 401–34, and Sharon Marcus, Heather Love, and Stephen Best, 'Building a Better Description', *Representations* 135 (Summer 2016): 1–21. For paranoid and reparative reading, see Eve Kosofsky Sedgwick, ed., *Novel Gazing: Queer Readings in Fiction* (Durham: Duke University Press, 1997), 1–40, and *Touching Feeling: Affect, Pedagogy, Performativity* (Durham: Duke University Press, 2003), 123–52. For a range of critical responses to the idea of reparative reading, see 'Reparative Reading at 21,' *Eve Kosofsky Sedgwick, 2010–2021*, http://evekosofskysedgwick.net/conferences/RR21.html. For more on Love's dialogue with Sedgwick, see Heather Love, 'Truth and Consequences: On Paranoid Reading and Reparative Reading', *Criticism: A Quarterly for Literature and the Arts* 52, no. 2 (Spring 2010): 235–42.

Women: Friendship, Desire, and Marriage in Victorian England, a sort of companion, as its title emphasized, to Sedgwick's earlier *Between Men: English Literature and Male Homosocial Desire* (1985).[2] According to Marcus, just reading attended to what texts made 'manifest on their surface' and imagined a text 'conceived as complex and ample rather than as diminished by, or reduced to, what it has to repress'.[3]

Marcus and Best developed a closely-related, although still widely contested, model of *surface* reading, in a now famous Fall 2009 special issue of *Representations* they guest-edited.[4] Their introduction argued that, in contradistinction to 'symptomatic reading', a text's 'truest meaning' did not lie in what it did not say, but in the 'complexity of [its] literary surfaces – surfaces that have been rendered invisible by symptomatic reading'.[5] Although, by this, Best and Marcus primarily meant the language

2 Sharon Marcus, *Between Women: Friendship, Desire, and Marriage in Victorian England* (Princeton: Princeton University Press, 2007); Eve Kosofsky Sedgwick, *Between Men: English Literature and Male Homosocial Desire* (New York: Columbia University Press, 1985). Sedgwick's accounts of female homosociality remain too little known. For examples, see 'Privilege of Unknowing: Diderot's *The Nun*', in *Tendencies* (Durham: Duke University Press, 1993), 23–51; her 'Review' of *No Man's Land* by Sandra M. Gilbert and Susan Gubar (New Haven: Yale University Press, 1988) in *English Language Notes* 28 (September 1990): 73–77; and 'The L Word: Novelty in Normalcy', *The Chronicle of Higher Education*, January 16 2004, B10–B11. For more, see Melissa Solomon, 'Flaming Iguanas, Dalai Pandas, and Other Lesbian Bardos', in *Regarding Sedgwick: Essays on Queer Culture and Critical Theory*, eds. Stephen M. Barber and David L. Clark (London: Routledge, 2002), 201–16. For Solomon's later reflections on Sedgwick, see 'Eighteen Things I Love About You', in *Reading Sedgwick*, ed. Lauren Berlant (Durham: Duke University Press, 2019), 236–41.

3 Marcus, *Between Women*, 3, 75. For Marcus's response to the thirtieth anniversary of *Between Men*, see http://evekosofskysedgwick.net/conferences/BM30.html.

4 Stephen Best and Sharon Marcus, 'Surface Reading: An Introduction', *Representations* 108, no. 1 (Fall 2009): 1–21.

5 Best and Marcus, 'Surface Reading', 1. See also Elizabeth McMahon, 'The Proximate Pleasure of Sedgwick: A Legacy of Intimate Reading', *Australian Humanities Review* 48 (May 2010): 17–29, http://australianhumanitiesreview.org/2010/05/01/the-proximate-pleasure-of-eve-sedgwick-a-legacy-of-intimate-reading/.

in which a text was written, rather than the font or ink in which the words were reproduced, or the paper on which they were printed — more material concerns central to the readings of Sedgwick's works that follow in this book.[6]

6 The debates on surface, and other 'new' modes of reading have been long and contentious. For a range of paradigmatic positions, see Susan J. Wolfson, 'Reading for Form', *Modern Language Quarterly* 61, no. 1 (March 2000): 1–16; Jane Gallop, 'The Ethics of Reading: Close Encounters', *Journal of Curriculum Theorising* (Fall 2000): 7–17; W.J.T. Mitchell, 'The Commitment to Form; or, Still Crazy After All These Years', *PMLA* 118, no. 2 (2003): 321–25; Bruno Latour, 'Why Has Critique Run Out of Steam?', *Critical Inquiry* 30, no. 2 (Winter 2004): 225–48; Caroline Levine, 'Strategic Formalism: Toward a New Method in Cultural Studies', *Victorian Studies* 48, no. 4 (Summer 2006): 625–57, and 'Scaled Up, Writ Small', *Victorian Studies* 49, no. 1 (Autumn 2006): 100–105; Carolyn Dever, 'Strategic Aestheticism', *Victorian Studies* 49, no. 1 (Autumn 2006): 94–99; Herbert F. Tucker, 'Tactical Formalism', *Victorian Studies* 49, no. 1 (Autumn 2006): 85–93; Marjorie Levinson, 'What is New Formalism?', *PMLA* 122, no. 2 (March 2007): 558–69; Timothy Bewes, 'Reading with the Grain: A New World in Literary Criticism', *differences* 21, no. 3 (2010): 1–33; Ellen Rooney, 'Live Free or Describe: The Reading Effect and the Persistence of Form', *differences* 21, no. 3 (2010): 112–39; Michael Hardt, 'The Militancy of Theory', *The South Atlantic Quarterly* 110, no. 1 (Winter 2011): 19–35; Crystal Bartolovich, 'Humanities of Scale: Milton, Marxism, Surface Reading, and Milton', *PMLA* 127, no. 1 (January 2012): 115–21; Elizabeth Weed, 'The Way We Read Now', *History of the Present* 2, no. 1 (Spring 2012): 95–106; Ellis Hanson, 'The Langourous Critic', *New Literary History* 43, no. 3 (Summer 2012): 547–64; Adam Frank and Elizabeth A. Wilson, 'Like Minded', *Critical Inquiry* 38, no. 4 (Summer 2012): 870–77; Cannon Schmitt, 'Tidal Conrad (Literally)', *Victorian Studies* 55, no. 1 (Autumn 2012): 7–29; Carolyn Lesjack, 'Reading Dialectically', *Criticism* 55, no. 2 (Spring 2013): 233–77; Nathan K Hensley, 'Curatorial Reading and Endless War', *Victorian Studies* 56, no. 1 (Autumn 2013): 59–83; Russ Castronova and David Glimp, 'Introduction: After Critique?', *English Language Notes* 51, no. 2 (Fall–Winter 2013): 1–5; Jackie Stacey, 'Wishing Away Ambivalence', *Feminist Theory* 15, no. 1 (2014): 39–49; Robin Wiegman, 'The Times We're In: Feminist Criticism and the Reparative 'Turn'', *Feminist Theory* 15, no. 1 (2014): 4–25; Gail Lewis, 'Not By Criticality Alone', *Feminist Theory* 15, no. 1 (2014): 31–38; Jason Potts, ed. 'Dossier: Surface Reading', *Mediations: Journal of the Marxist Literary Group* 28, no. 2 (Spring 2015): 1–108; Kathryn Bond Stockton, 'Reading as Kissing, Sex with Ideas: 'Lesbian' Barebacking', *Los Angeles Review of Books,* March 15 2015, https://lareviewofbooks.org/article/reading-kissing-sex-ideas-lesbian-barebacking/, and *Making Out* (New York: New York

For example, if the hermeneutics of depth focused on what Best and Marcus described as the meanings and motivations of the 'absences, gaps, and ellipses in texts', Marcus and Best's interest in what the text *did* say failed to pay attention to the 'absences, gaps, and ellipses in texts' in a different way: the actual (mostly white) spaces between and around individual letters and words, sentences, paragraphs, and pages, as well as chapters, and books, that contribute to the sense of any text and experience of reading and handling a book.[7] Indeed, when it came to surface reading, Best and Marcus primarily explored words, somehow freed from the materiality of ink, font, paper, binding, and typography. The metaphors they employed, however, were often highly resonant, in the context of this book, in terms of a textile culture, such as Sedgwick's later queer craft practice, even if Marcus and Best did not explore texts appearing on the surfaces of actual textiles.[8]

For example, Best and Marcus compared the way the text, in the hermeneutics of depth tradition, concealed what it did not want readers to know with the way clothing concealed the skin; a surface that insisted on 'being looked *at*' rather than 'through'. In addition, they spoke of 'surface as materiality' and the 'material supports' that are 'inseparable' from linguistic 'signs', encouraging their readers to pay attention to what Elaine Scarry had called the 'material conditions' that 'structure perception'.

University Press, 2019); and Rita Felski, *The Limits of Critique* (Chicago: University of Chicago Press, 2015), as well as Elizabeth S. Anker and Rita Felski, eds., *Critique and Postcritique* (Durham: Duke University Press, 2017); Benjamin Noys, 'Skimming the Surface: Critiquing Anti-Critique', *Journal for Cultural Research* 21, no. 4 (2017): 295–308; James Corby, 'Critical Distance', *Journal for Cultural Research* 21, no. 4 (2017): 293–94; Stefan Herbrechter, 'Critical Proximity', *Journal for Cultural Research* 21, no. 4 (2017): 323–36; Ronan McDonald, 'Critique and Anti-Critique', *Textual Practice* 32, no. 3 (2018): 365–74; and, last but not least, Benjamin Westwood, 'The Queer Art of Ardent Reading: Poems and Partiality', *Raritan* 61, no. 1 (Summer 2021): 50–71.

7 Best and Marcus, 'Surface Reading', 3.
8 For more on Sedgwick's fiber art practice, see my 'For Beauty Is a Series of Hypotheses? Sedgwick as Fiber Artist', in *Reading Sedgwick*, ed. Berlant, 72–91.

Although when they used the word 'material', they meant the Marxist economic base underpinning the semiotic superstructure, rather than the textile cultures of support necessary to reading paper, if not digital books. In addition, for Marcus and Best, 'surfaces are easier to imagine than three-dimensional objects' and so their material metaphors tend to hover around textiles, at the scale of the individual page, rather than enable accounts of complete books as complex, fully three-dimensional structures; a three-dimensionality crucial to Sedgwick's works on paper, as we shall see.[9]

More helpful to this book's concerns was Marcus and Best's alertness to the feminist and queer politics of surface reading. According to Best and Marcus, there was an obvious masculinism to Frederick Jameson's argument that 'only weak, descriptive, empirical, ideologically complicit readers attend to the surface of the text', in comparison to more 'strenuous and heroic' critics committed to 'wresting meaning from a resisting text'. As such, the practices of surface reading I practice in this book, of 'accepting texts, deferring to them instead of mastering them', and 'attending to the material life' and 'literal surface[s]' of Sedgwick's books, their 'paper, binding' and 'typography', as well as their 'narrative margins', are all, in Marcus and Best's evocative phrases, activities that require 'versions of receptiveness'. Indeed, surface reading, in Best and Marcus's terms, is a feminine, feminist, and effeminate practice, or, as I more often characterize it in this book, a queer, bottomy practice.[10]

In their afterword to Marcus and Best's special issue, Emily Apter and Elaine Freedgood emphasized a third new model of reading: a 'literal reading' more alive to the material presence of

9 Best and Marcus, 'Surface Reading', 9–11, 18. For more on books as three-dimensional art objects, see Garrett Stewart, *Bookwork: Medium to Object to Concept to Art* (Chicago: University of Chicago Press, 2011).

10 Best and Marcus, 'Surface Reading', 5–6, 8, 10–12. For more on bottoming, see Kathryn Bond Stockton, *Beautiful Bottom, Beautiful Shame: Where 'Black' Meets 'Queer'* (Durham: Duke University Press, 2006), and Nguyen Tan Hoang, *A View From the Bottom: Asian-American Masculinity and Sexual Representation* (Durham: Duke University Press, 2014).

books as 'fully physical' objects, a reading more germane to the kinds of intepretations that I subsequently pursue. Pointing to the mostly separate practices of book history and other 'material textual approaches', Freedgood and Apter encourage readers to think more about the 'lexical materialism', 'paper, binding', 'smell, crinkle, and crunch' of books, and the experience of the 'turning' and 'breaks' of pages. In addition, they ask readers to reconceptualize reading with a renewed emphasis on 'looking' as 'the default term of critical interpretation', 'at close, distant, and medium ranges', and with a refreshed attention to the 'literal parsing of "blanks" and "slots"'; indeed to all that 'hides in plain sight'.[11]

For Apter and Freedgood, Marcus and Best, Sedgwick was a crucial referent, as 'one of the great hyper-symptomatic readers' who characterized the hermeneutics of depth. But, Freedgood and Apter also recalled *Touching Feeling*'s ambition to 'explore some ways around the topos of depth or hiddenness, typically followed by a drama of exposure', and to also explore Sedgwick's desire to move from ideas of 'beneath' and 'behind' in favor of 'beside'. In addition, they cited her invocation of a 'Deleuzian interest in planar relations' as a 'useful resistance' to the hermeneutics of depth. But, having invoked Sedgwick, Freegood and Apter do not go on to consider the ways Sedgwick's own texts, as material entities, map such possibilities, which is the project of this book.[12]

Focusing primarily on Sedgwick's works on paper, *Queer and Bookish* enters these debates on surface reading at a self-consciously perverse angle. In focusing on the appearance of Sedgwick's scholarly and artist books, the latter for the first time, I follow the broader disciplinary drift, within distant reading and world-literary studies, towards books as the scale of focus.[13] In addition, in paying sustained attention to the visual appearance

11 Emily Apter and Elaine Freedgood. 'Afterword', *Representations* 108, no. 1 (Fall 2009): 139–46; 139, 141, 143.
12 Sedgwick, *Touching Feeling*, 8; Apter and Freedgood, 'Afterword', 144.
13 For more, see Franco Moretti, *Distant Reading* (London: Verso, 2013).

and often fat, haptic feel of her books, *Queer and Bookish* simultaneously chimes with, and differentiates itself from, Love's call for a more 'exhaustive but "thin" description', or 'flat reading'.[14] I say 'differentiates itself from' because Sedgwick's work was always more inclined to three-dimensionally *fat*, rather than thin, or flat aesthetics; towards the incised, thick, textured, layered and folded, rather than the straightforward two-dimensionality of the printed page. And, as a person for whom Sedgwick represents my 'only access to some vitally / transmissible truth / or radiantly heightened / mode of perception', and without whom I 'might subsist forever in some desert-like state of ontological impoverishment',[15] I am less able than Love to 'exchange the fat and the living for the thin and the dead'.[16]

An increasing resistance to 'unveiling itself as an ideology', in favor of 'redescription', is at the heart of surface reading, as we have seen.[17] Sedgwick had written on 'The Character in the

14 Love, 'Close But Not Deep', 375. For more on rhetorics of the fat and the flat, see Lucas Crawford, 'Slender Trouble: From Berlant's Cruel Figuring to Sedgwick's Fat Presence', *GLQ: A Journal of Lesbian and Gay Studies* 23, no. 4 (2017): 447–72. My sustained play on fat and thin, as well as fat and flat aesthetics, obviously draws on the title of Sedgwick's first book of poetry, *Fat Art, Thin Art* (Durham: Duke University Press, 1994).

15 Eve Kosofsky Sedgwick, *A Dialogue on Love* (Boston: Beacon, 1999), 168. For critical responses, see Katherine Hawkins, 'Woven Spaces: Eve Kosofsky Sedgwick's Dialogue on Love', *Women and Performance: A Journal of Feminist Theory* 16, no. 2 (July 2006): 251–67; Monica Pearl 'Conversation and Queer Filiation', in *AIDS Literature and Gay Identity* (London: Routledge, 2013), 143–65; and 'Queer Therapy: On the Couch with Eve Kosofsky Sedgwick', in *Bathroom Songs: Eve Kosofsky Sedgwick as a Poet*, ed. Jason Edwards (Earth: punctum, 2017), 151–68. See also Ed Cohen, 'The Courage of Curiosity, or The Heart of Truth', Michael Moon, 'Psychosomatic? Mental and Physical Pain in Eve [Kosofsky] Sedgwick's Writing', and Cindy Patton, 'Love without the Obligation to Love', all in *Criticism* 52, no. 2 (Spring 2010): 201–24. For Hawkins' further reflections on Sedgwick, see her 'Re-Creating Eve: Sedgwick's Art and the Practice of Renewal', *Criticism: A Quarterly for Literature and the Arts* 52, no. 2 (Spring 2010): 271–82. For Pearl's reflections, see 'Eve Kosofsky Sedgwick's Melancholic 'White Glasses'', *Textual Practice* 17, no. 1 (2003): 61–80.

16 Love, 'Close But Not Deep', 388.

17 Ibid., 381.

Veil' and on 'Imagery of the Surface in the Gothic Novel' as early as 1981, and much of her first book, *The Coherence of Gothic Conventions* (1980; 2nd edition 1985), from its cover inwards, is concerned with troubling the surface/depth distinction that characterized scholarship on gothic fiction at the time she was writing, and that continues to characterize close, just, and surface readings.[18] As such, Sedgwick's thoughts on surface reading not only predate current concerns, but, I would argue, represent the most sophisticated account of what's at stake, making recent models feel thin and unjust about elements of the text irreducible to the words, when compared to her earlier, fatter, thicker theorization.

For example, as Sedgwick notes in 'The Character in the Veil', and as recent accounts of surface reading have recapitulated, there has been a 'lot of intelligent writing about depth and the depths', 'inner spaces', 'inner dimensions', and 'spatial metaphors of interiority' at a structural and thematic level. This has been predicated on a 'psychological model of the self, one with an inside and an outside' derived from a 'map of psychic topography' fashioned by Sigmund Freud, as well as 'images of containers and containment' derived from Melanie Klein.[19] For Sedgwick, however, a critical 'eagerness to write about content' had led readers to feeling 'impatient with […] surfaces' — a preoccupation with the themes and psychology of depth she sought to resist by pointing the reader's 'attention back to surfaces'. Unlike recent accounts of surface reading, her earlier elaboration did not bracket the idea of the surface of the page below the text as either 'invisible' or 'empty', rethinking it in a number of registers: tactile, sexual, violent, textile, and polychromatic.[20]

For instance, in her discussion of the 'sexual function of veils', Sedgwick emphasized how important touch was to 'the attrib-

18 Eve Kosofsky Sedgwick, *The Coherence of Gothic Conventions* (1980; London: Methuen, 1986), 140–75.

19 Ibid., 140. For more on Klein, see Sedgwick, *Touching Feeling*, 123–52, and *The Weather in Proust*, ed. Jonathan Goldberg (Durham: Duke University Press, 2011), 123–43.

20 Sedgwick, *Coherence*, 140–42.

utes of the veil, and of the surface', encouraging readers to notice the texture of the printed page, as well as the words on it. She also considered the violence of printing and imprinting text, in her discussion of the ways that 'veils, like flesh' could be 'suffused or marked with blood'; a blood-red text that appears on the cover of *Coherence*, where her name and the title are printed in blood-red ink (see Figure 0.1).[21]

Indeed, much of the chapter is concerned with what she calls the 'contagious, quasi-linguistic inscription of surfaces' with blood and other blood-like substances, images resonant in the context of the AIDS pandemic then raging around her.

For example, in the 'Preface' to the second edition, written in January 1986, she expressed her horror at the then-recent call, by William F. Buckley, Jr., in his nationally syndicated column of *The New York Native* (December 16 1985), that people living with HIV should be tattooed with a 'Scarlet Letter'. With this in mind, and whilst 'no one would imagine that red ink *was* blood', the blood-red letters on the cover, including Sedgwick's name, suggest an artery-deep identification with people living with HIV and suffering from AIDS-phobia, as well as a counter-phobic insistence that handling dried blood was nothing to fear.[22]

Unlike more recent surface readers, Sedgwick was also interested in writing on surfaces other than books. She considered the ways that 'red ink spread over paper signifies, at a comfortable distance, red blood suffusing a white cheek' and a 'fantasied encroachment on a fantasy of virgin modesty' — an early sign she was interested in the flushes and blushes of desire and shame, and that the red-letter cover of her first book might be akin to a blushing face, eager for the reader's attention but anxious lest it find no loving regard there. In the essay, Sedgwick also explores writing on the earth, in the case of furrowed fields;

21 Ibid., 142–43.
22 Ibid., xii–xiii, 142, 150. A similar strategy of printing the cover of a magazine with ink containing the blood of HIV-positive men occurred with the Spring 2015 issue of *Vangardist*.

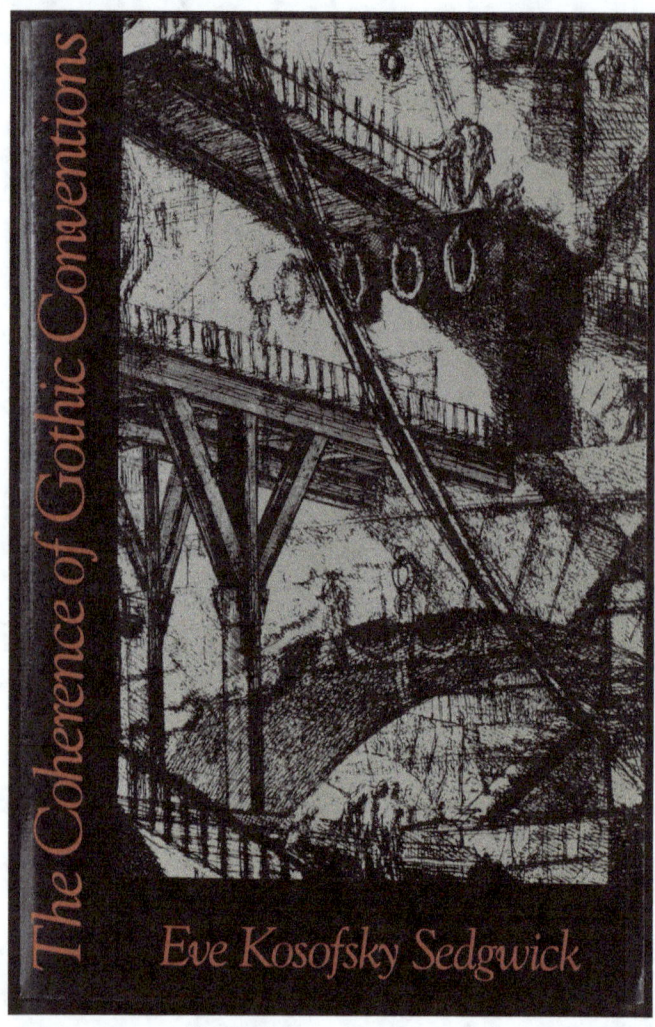

Figure 0.1. Eve Kosofsky Sedgwick, front cover of *The Coherence of Gothic Conventions* (1985, second edition).

on architectural forms, such as a turret; on the skin of animals, in vellum; and on the folds of a fabric.[23]

In addition, Sedgwick encouraged readers to think more about the specific manual and mechanical means by which ink came to be on the page, as well as ink's physical properties. She differentiated between characters 'painted on' the page, as if a codex book; 'drawn on' the page, as if a draughtsman's notebook; 'impressed upon' the page, as if wax; 'stamped' on the page, as if it were a print sheet; 'etched on' the page, as if an engraving plate; and 'branded' on the page, as if it were burned skin. She also encouraged readers to 'retrace' with their hands, as well as to 'perceive' with their eyes, the characters on the page, to understand, in a more embodied way, how each letter was formed, of what it was composed. When it came to ink, meanwhile, she asked readers to ponder the 'depth of the inscription': whether the letters were 'mark[ed] *on* the surface with a liquid', as with printing paper; 'impress[ed] *in* the surface, as with acid or a stylus' in engraving; or 'stain[ed] *through* the surface', in the case of fabric dyes, with each technology possessing a different 'dimensional status'. In so doing, she refused the idea of the page as the neutral background, insisting on it as a textured and colored 'material ground' with properties of its own.[24]

Again, unlike recent accounts of surface reading that presume a normative and neutral, easy-to-ignore, monochromatic black ink on a white ground, questions of color loom large in 'The Character in the Veil'. This actively resisted a 'bipolar color sense' that came at the 'cost of sapping any system that has three irreducible primaries'. In its place, she insisted on a minimum

23 Sedgwick, *Coherence*, 147, 150, 154. For an evocative account of graffiti-inscribed trees and furrowed fields as sexually violent, large-scale writing, see Sedgwick, *Fat Art*, 68–71. For more on shame, see Sedgwick and Adam Frank, eds., *Shame and Its Sisters: A Silvan Tomkins Reader* (Durham: Duke University Press, 1995), 1–28, 133–78; *Touching Feeling*, 35–66, 93–122. For more on Tomkins, see Adam J. Frank and Elizabeth A. Wilson, *A Silvan Tomkins Handbook: Foundations for Affect Theory* (Minneapolis: University of Minnesota Press, 2020).

24 Sedgwick, *Coherence*, 152–54, 157.

'tripolarity of color' that refused the bipolarity of 'presence/absence' or the gestalt tableau of duck/rabbit and figure/ground.[25] When it came to color, however, and if color often 'represent[ed] immediacy', Sedgwick sought to return temporality and mortality to her materialized descriptions of reading. She reminded readers that the 'color-stained' printed page was not permanent; it 'emblematize[d] the temporal' because it 'fade[d] from designs'. For example, she noted that, in their later states, when their colors faded, engravings were 'more truthful and more serene'. Citing Anne Radcliffe's description of the 'almost colorless worsted' of a tapestry, she also encouraged readers to think about the fact that 'the hands, which had wove' it had 'long since moldered into dust'.[26] As this example makes clear, Sedgwick was less interested in the 'fresh and garish' newly printed page, and more in the gradual 'deliquescence and withdrawal of color'. For example, the text she prints in her artist's books, as we shall see, frequently, flirt with the opposition 'color/outline', often resisting what she calls 'graphic legibility' in favor of the eroticized 'pole of metonymy, of spread'; whilst the material surfaces she employs repeatedly seek the 'complication' of 'two-dimensional conventions'.[27]

In what follows, then, rather than reading Sedgwick's texts 'against the grain' of an invisible page or fiber support, I want not so much to read 'with the grain', as in Love's paradigm, as to read as meaningful the actual grain of the paper and material on which Sedgwick works.[28] As such, the interpretations that follow are less a 'form of close reading that does not presume depth', as a 'fractal' or 'two-and-a-half-dimensional' reading practice that always presumes depth in the inks and fonts that form words, and in the dyed or bleached fibrous substrate that lies besides, behind, and beyond them.[29]

25 Ibid., 159–63, 168.
26 Ibid., 161–62.
27 Ibid., 162–63, 165, 167.
28 Love, 'Close But Not Deep', 383.
29 Ibid. For more on the fractal and two-and-a-half-dimensional, see Sedgwick, *The Weather in Proust*, 90, 93, where she notes that thinking fractally

In addition to intervening into ideas of surface reading, *Queer and Bookish* risks following D.A. Miller's recent dramatization of a potentially '*Too*-Close' reading or viewing.[30] Inspired by Miller's example and invitation, and believing that Sedgwick's never-thin oeuvre can never be fat enough with meaning, my methodology risks what Miller characterizes as the 'hyperannotation' of his viewing practice.[31] Indeed, inspired by his glacial, 'shot by shot', 'frame by frame' pace in *Hidden Hitchcock* (2016), *Queer and Bookish* proceeds more like an exhibition catalogue than a monograph, working painstakingly and comparatively descriptively, rather than argumentatively, through Sedgwick's monographs, edited collections, poetry books, and artist's books, one by one, at the risk of seeming 'hugely pedantic and a tiny bit mad', which is to say, queer.[32] In so doing, the book treats the images and passages I analyze as the work of a Hitchcock-like *auteur*, where every detail is potentially meaningful, or as examples of Freudian *condensation*, in which details cannot be over-read since they merge and fuse together so much manifest and latent content, combining several themes or concepts, from various spatial and affective domains and time periods, into one symbol or scene. I do this at the risk of flattening Sedgwick's

invited thinking about the 'deep, inherent relationality of touch and texture', and was 'nothing fancier than a way of talking about [...] between dimensions'.

30 D.A. Miller, *Hidden Hitchcock* (Chicago: University of Chicago Press, 2016), 4. The relation between Miller and Sedgwick cannot be easily summarized. He is frequently present in her work, in the form of his 'aegis-creating essay[s]' and as 'the first addressee and first reader' of many early chapters (*Epistemology of the Closet* [Los Angeles: University of California Press, 1990], ix, 67). In addition, Sedgwick and Michael Moon refer explicitly to Miller's earlier work on Hitchcock in *Tendencies*, 247; and, according to the later Sedgwick, Miller was the author of works that embodied, with 'remarkable force and exemplarity', paranoid and reparative positions (*Touching Feeling*, 129). I am grateful to Angus Brown for encouraging me to keep thinking about the relation between Sedgwick and Miller.

31 Miller, *Hidden Hitchcock*, 4, 6.

32 Ibid., 3. Miller's book mixes up the genres of the essay, chapter, and article, within its book-like structure. 'Against the Goliath-Book', Miller notes, he will 'take the side of the David-Essay' (ibid., 20–21).

work historically, as a body of writing consistently changing in some ways, to emphasise the less remarked upon continuity of her idiom, from her childhood to the end of her life.

In so proceeding, image by image, passage by passage, book by book, *Queer and Bookish* also seeks to respond to Sedgwick's commitment to patchwork as a methodology, and interest in the cumulative effect of multi-part assemblages, as we shall see. As such, *Queer and Bookish* emphatically represents a *reparative*, rather than a *paranoid* reading practice that is 'additive and accretive'; that, in Sedgwick's works, 'wants to assemble and confer plenitude on an object that will then have resources to offer an inchoate self'; that is chock full of 'startling, juicy displays of excess erudition' and 'often hilarious antiquarianism'; that is 'over'-attached to 'fragmentary, marginal, waste or leftover products', such as urine and feces; that has an 'irrepressible fascination with ventriloquistic experimentation'; and that loves 'disorienting juxtapositions of present with past, and popular with high culture'.[33]

Taken as a whole, then, *Queer and Bookish* represents a significant intervention into recent debates about reparative reading, surface reading, just reading, too close reading, as well as too close reading and viewing, and the descriptive turn across the humanities. It does so by embracing a not-especially-critical methodology, characteristic of surface reading, but also by not simply reducing surface reading to an anti-critical stance, instead thinking seriously about actual worldly surfaces as places to encounter texture, colour, temperature, materiality, and pattern.

The book proceeds by offering an exemplarily sustained meditation on Sedgwick's books as visual and material objects, providing a perverse monograph-length reading of the *covers* of the books she published in her lifetime, in all their iconographic and material specificity, as well as the design of those books, focusing, for example, on the queer potential difference between a footnote and an endnote; on the queer difference Modernist ty-

33 Ibid., 37, 71–72, 97; Sedgwick, *Touching Feeling*, 150–51.

pography might make in *Tendencies*; on the placement of manicules throughout *Touching Feeling* in the context of Sedgwick's thoughts about fisting in the same volume; and on the queer difference that the 'same' cover, printed in monochrome and blueprint might make, in the case of the first and second editions of *Epistemology of the Closet*, and in green and pink, in the case of the two editions of *Between Men*.

In addition, the book explores for the first time Sedgwick's sustained practice of using photographs from her own family album on the covers of her Duke books, as well as her profound meditation on the longer history of Victorian photography, and photography as a medium tout court, as well as her perverse recontextualisations of a range of canonical, long nineteenth-century artists, ranging from Giovanni Battista Piranesi through Clementina Hawarden, Julia Margaret Cameron, and Baron Adolph de Meyer to Eduard Manet, in the context of her own autobiography and the AIDS crisis unfolding around her. *Queer and Bookish* also explores the growing importance of texture and fiber metaphors across Sedgwick's work, paying particular attention to both of Sedgwick's poetry books, *Fat Art, Thin Art* and *A Dialogue on Love*, as well as providing sustained close readings of two of her little-known artist's books: her *Panda Alphabet Valentines Cards* (c. 1996) and her *The Last Days of Pompeii* (c. 2007), substantial numbers of images from both of which will be reproduced here for the first time.

Providing a perverse intellectual biography of Sedgwick, understood here primarily as an art historian and queer craft artist in her own right, *Queer and Bookish* also represents the first book-length study to deal with Sedgwick's work, across her critical writing, poetry, and, most importantly, book art, integrating the three, and making the case that her art criticism, especially her meditations on domestic and nineteenth-century photography, and 'artist's book' projects, are as formally complex and brilliant, conceptually significant and life-changing, as her literary criticism and theory.

Finally, *Queer and Bookish* suggests that, in Sedgwick's case, you might be able to judge a book by its cover if you understand

Figure 0.2. Allyson Mitchel, Eve Kosofsky Sedgwick book case (2011), with permission of the artist.

that cover through the lens of its author's, as well as its artist's, idiom. As a result, the book currently in your hands might be filed productively close, on the shelf — spine to spine, shoulder to shoulder — with a comparatively slim recent exhibition catalogue, *Queering the Bibliobject* (2016), edited by John Chaich, published to accompany the exhibition of the same name that took place at the Centre for Book Arts in New York in 2016.

Like the nineteen artists in Chaich's exhibition, *Queer and Bookish* considers Sedgwick's book arts as a kind of 'queer manifestation and materialization', with their own affecting physical presence, where the artist sometimes restricts access to the text, sometimes reclaims the book's contexts and contents in a queerly revisionary manner, sometimes uses the book itself as a medium, and very often marks the cover and pages with erotic, coded, and autobiographical material. As a result, Sedgwick's books, I will argue, represent a form of self-portraiture that both 'stand in for' and 'touch queer bodies', making us remember and celebrate beloved bodies ravaged by breast cancer and AIDS, and making Sedgwick's in particular a 'queer body present', now that it is gone.

In this context, two artists and authors stand out from Chaich's catalogue: Sedgwick's fellow queer theorist Love, whose 'passionate, almost physical identification with books', again including Sedgwick's, and understanding of herself as both 'queer [and] bookish' developed in parallel with my own; and Sedgwick's fellow fat art, maximalist artist Allyson Mitchell, whose *Eve Kosofksy Sedgwick book shelf* (2011) records Mitchell's parallel investment in Sedgwick's queer bibliObjects (see Figure 0.2).[34]

Chapter One of *Queer and Bookish*, 'The First Three Books', deals with *The Coherence of Gothic Conventions* (1980 and 1985), *Between Men: English Literature and Male Homosocial Desire* (1985 and 1993) and *Epistemology of the Closet* (1990 and 2008),

34 John Chaich, ed., *Queering the BIbliObject* (New York: The Centre for Book Arts, 2016), n.p. Mitchell's drawing first graced the cover of the Sedgwick memorial issue of GLQ 17, no. 4 (2011).

exploring further Sedgwick's queer thoughts on Piranesi and engraving, in the context of the AIDS crisis; Manet's faciality and perhaps surprisingly thalassic aesthetics; and the queer Victorian photography of Baron Adolph De Mayer, Eugene Atget, and Anna Atkins.

Chapter Two, 'Black Queerness, White Glasses', considers Sedgwick's first two Duke University Press books, *Tendencies* (1993) and *Gary in Your Pocket* (1996), and explores queer Modernist typography; questions of queer childhood and the queer rural, in relation to Ken Brown's photography; and Sedgwick and queer African-American writer Gary Fisher's closely related idioms across various genres and media, as part of the larger project of insisting on the centrality of queer brown and black subjects, across Sedgwick's work.[35]

Chapter Three, 'Between Women', considers three of Sedgwick's edited collections: *Performativity and Performance* (1995), co-edited with Andrew Parker; *Shame and Its Sisters* (1995), co-edited with Adam J. Frank; and *Novel Gazing* (1997). The chapter considers the queerness of ballet, the determining importance for Sedgwick of her relationship to her estranged sister Nina, and the centrality of shame to Sedgwick's fat art, as well as blood red aesthetics.

Chapter Four, 'Fat Art, Thin Art', considers Sedgwick's first book of poetry. It explores the intermediality of Sedgwick's meta-Victorian novella, 'The Warm Decembers' (1978–1987), especially its focus on texture, as well Sedgwick's preoccupation with a photographic canon ranging from Julia Margaret Cameron to David Hockney, and also importantly including her father — a NASA photographer — and her fictional alter-ego, Beatrix Protheroe, the latter in the context of nineteenth-century regionalist photographer P.H. Emerson. In addition, the chapter consid-

35 For a range of responses to *Tendencies at Twenty,* see http://evekosofskysedgwick.net/conferences/conferences.html.

ers further the traumatic and poignant character of Sedgwick's own family album.[36]

Chapter Five, 'The Texture Books', considers *A Dialogue on Love* (1999) and *Touching Feeling* (2003), exploring *Dialogue*'s account of the emergence of Sedgwick's fiber art practice. In addition, the chapter thinks about Sedgwick's identification with queer/crip artist Judith Scott, and examines how rethinking Sedgwick's work through touching, rather than the more widely taken up feeling, might be transformative.[37]

36 For more on the poem, see Benjamin Westwood, 'The Abject Animal Poetics of *The Warm Decembers*', in *Bathroom Songs*, ed. Edwards, 85–110.

37 For more on Scott, see John M. MacGregor, *Metamorphosis: The Fiber Art of Judith Scott* (Berkeley: Creative Growth Art Center, 1999); Catherine Morris and Matthew Higgs, eds., *Judith Scott: Bound and Unbound* (New York: Delmonico/Brooklyn Museum, 2015); and Joyce Scott, *Entwined: Sisters and Secrets in the Silent World of Artist Judith Scott* (Boston: Beacon, 2016). For influential work at the queer/crip intersection, see Robert McRuer, 'Disabling Sex: Notes for a Crip Theory of Sexuality', *GLQ* 17, no. 1 (2010): 107–17; 'As Good as it Gets: Queer Theory and Critical Disability', *GLQ* 9, nos. 1–2 (2003): 79–105; and *Crip Theory: Cultural Signs of Queerness and Disability* (New York: New York University Press, 2006); as well as Robert McRuer and Abby L. Wilkerson, 'Introduction', *GLQ* 9, nos. 1–2 (2003): 1–23, and Robert McRuer and Anna Mollow, eds., *Sex and Disability* (Durham: Duke University Press, 2012). In addition, see Carrie Sandahl, 'Queering the Crip or Cripping the Queer: Intersections of Queer and Crip Identities in Solo Autobiographical Performance', *GLQ* 9, nos. 1–2 (2003): 25–56; Alison Kafer, *Feminist, Queer, Crip* (Bloomington: Indiana University Press, 2013); and Jeffrey Jerome Cohen, 'Queer Crip Sex and Critical Mattering', *GLQ* 21, no. 1 (2015): 151–62.

To date, Sedgwick has had a central place in the formation of queer/crip studies. For McRuer, alluding to Sedgwick, 'disability refers to the open mesh of possibilities, gaps, overlaps, dissonances and resonances, lapses and excesses of meaning when the constituent elements of bodily, mental or behavioral functioning aren't made (or can't be made) to signify monolithically'. In addition, for McRuer, Sedgwick's example has been central, as a scholar working on the AIDS crisis and autism, as the author of an illness memoir — *A Dialogue on Love* — because of her interest in Down Syndrome, (Proust's) asthma, and especially her work with Fisher, because of his refusal to be 'accommodated or rehabilitated' and what McRuer characterises as their collaborative 'art of crip noncompliance' (*Crip Theory*, ix, 3–4, 8, 19, 121, 103–45, 156–57; Sedgwick, *The Weather in Proust*, 144–66). For Alison Kafer, Sedgwick similarly represents a key

Chapter Six, 'Interlude, Pandagogic', focuses on Sedgwick's until now little-known *Panda Alphabet Valentines Cards* (c. 1996), a series of twenty-six, single-side cards, which now primarily circulate in digital copies, featuring stuffed pandas in queer dioramas, collaged against the background of silk kimono swatches, to think about the queer, which is to say poignant, sexy, threatened, but resilient status of pandas in Sedgwick's life and work. The chapter considers the cards as a kind of 'spineless' book, a project central to Sedgwick's meditation upon her own spine cancer in the same period, whilst also making the case for the cybernetic character of Sedgwick's collage idiom, through an examination of her mostly, but not quite, systemic use of kimono swatches.

The final chapter, 'Sodomizing Edward Bulwer Lytton', concludes by thinking about another of Sedgwick's unique artist's books, *The Last Days of Pompeii* (c. 2007), exploring how her interventions, in her collage book, challenge Edward Bulwer-Lytton's genocidal, homophobic homosociality in his 1834 novel, through the introduction of numerous poems by early twentieth-century, queer Greek language poet Constantine P. Cavafy, a postcard of ancient Greek sculptor Polykleitos' *Doryphorus*, and queer Bloomsbury artist Duncan Grant's *Nativity* (1924), establishing a queer history to challenge Lytton's murderously straight antiquity as well as Republican characterizations of those living with HIV/AIDS then-contemporary with Sedgwick.

queer-crip scholar because of her refusal of the idea that a 'Down child', such as Scott, had 'no future' and her lifelong interest in Proust's asthma and other 'breathing difficulties' that remain 'largely unexplored by disability studies scholars', and as a person suffering from a 'spinal cord injur[y]' (*Feminist, Queer, Crip*, 3, 12, 33, 122, 153, 157).

I

The First Three Books

Queer and Bookish explores Sedgwick's works on paper in two forms. It examines the visual and material characteristics of her monographs, poetry books, and edited collections and it analyzes her unique artist's books, the *Panda Alphabet Valentines Cards* (c. 1996) and *The Last Days of Pompeii* (c. 2007). This chapter is concerned with her first three monographs: *The Coherence of Gothic Conventions* (1980, 1986), *Between Men: English Literature and Male Homosocial Desire* (1985, 1993), and *Epistemology of the Closet* (1990, 2008). In treating her published corpus as artist's books, I write self-consciously as an art historian and bring her oeuvre into loving dialogue with Keith Smith's *Structure of the Visual Book* (1984), a volume examining the semiotics of books of various stripes.

Smith was a key referent in a course Sedgwick taught at CUNY in the Spring semester of 2004 and then again in 2008: 'How to Do Things with Words and Other Materials'.[1] This represented an 'experimental seminar/studio workshop' in which participants conceptualized and practiced different ways of combining written text and other visual media that ranged across a number of genres, making unconventional use of the materiality of the

1 For more, see Keith Smith, *Structure of the Visual Book*, 3rd edn. (1984; Rochester: Keith A. Smith Books, 1996). See also Smith's *Text in the Book Format* (Rochester: Keith Smith, 2004).

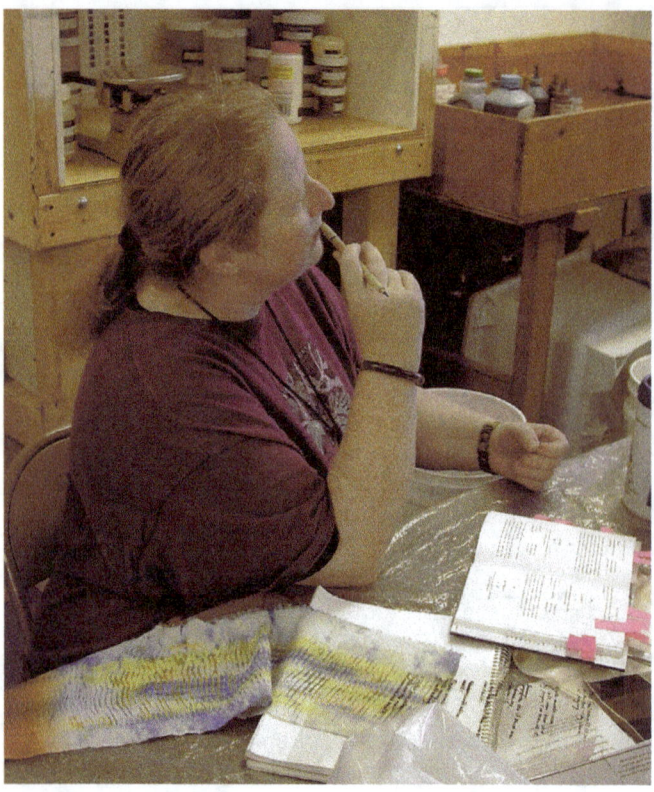

Figure 1.1. Hal A. Sedgwick, photograph of Eve Kosofsky Sedgwick (c. 2002), at work setting an example of Yoel Hoffmann's Japanese *Death Poems* (1986) onto a *shibori* ground. © Eve Kosofsky Sedgwick Foundation.

written word and its support. In parallel with historical and theoretical discussions, Sedgwick's students created a portfolio in various formats and materials, 'exploring different aspects of the complex relations among language, materiality, and visuality'. Sedgwick took this class seriously, making a number of works herself, some of which she exhibited.[2]

At first glance, Sedgwick's published works may not seem much like artist's books. They are in a standard codex form; were published, often more than once, in large, original and revised editions by mainstream university presses; and their design is comparatively conventional. There are, however, perhaps two exceptions. *Tendencies* is the first, as we shall see. Its dynamic, asymmetrical Modernist typographical experimentation; initial letters and multiple-scale and multiple-face fonts; and early-twentieth-century avant-garde, ragged, right-justified text, set on the diagonal, calls to mind Guillaume Apollinaire's famous *Eiffel Tower* calligramme (1913–1916); a genre of poems both linguistic and graphic, whose *mise-en-page* alludes to the visual image of the poem's subject.

The layout of the first pages of *Tendencies*' chapters also recalls Stéphane Mallarmé's *Un coup de dés* (1897), which similarly anticipates Sedgwick's penchant for diagonal layout; juxtaposed weighty, bold, fatface and light, roman face type; and multiple

2 For more on Sedgwick's class, see http://www.evekosofskysedgwick.net/teaching/how-to-do-things-with-words-and-other-materials.html, and Scott Herring, 'Eve Sedgwick's 'Other Materials'", *Angelaki* 21, no. 1 (2018): 5–18. For more on queer artist's books, see Scott Herring, 'Contraband Marginalia', in *Queering the BibliObject*, ed. John Chaich (New York: The Centre for Book Arts, 2016), n.p. A May 2008 dossier of the class's work, *Assembling: Memory Palace*, including work by Sedgwick herself, was produced in a limited edition of 60 copies. Sedgwick included colour prints of one of her loom books, one of her accordion books, and a hexaflexagon she made, all working with texts by Marcel Proust. *Assembling* was unlike her earlier joint dossier as part of the 1D450 collective, where each of the contributors' works remained unsigned. For more, see 1D450 Collective, 'Writing the Plural: Sexual Fantasies', *Criticism* 52, no. 2 (Spring 2010): 293–307.

scales of font on the same page.³ The second of Sedgwick's published books which will subsequently concern us in this context is *A Dialogue on Love* (1999), which again employs an extensive, Mallarméan use of white space, as well as two fonts, one each for the prose and haiku, and distinctive small capitalization for her therapist's notes.⁴

But whilst Sedgwick had less control over the typography of her earlier books, and less ambition for it, she took her cover art seriously from the outset. A careful analysis of her published books, culminating in her artist's books, suggests how significant an art historian and queer craft artist Sedgwick was, from

3 For a range of calligrammes, see Guillaume Apollinaire, *Selected Poems*, ed. and trans. Martin Sorrell (Oxford: Oxford University Press, 2015), 104–99. For *Un coup de dés*, see E.H. and A.M. Blackmore, trans., *Stéphane Mallarmé: Collected Poems and Other Verse* (Oxford: Oxford University Press, 2008), 139–81. For more on Mallarmé, see Anna Sigridur Arnar, *The Book as Instrument: Stéphane Mallarmé, The Artist's Book and the Transformation of Print Culture* (Chicago: University of Chicago Press, 2011). For more on typography, see Paul Luna, *A Very Short Introduction to Typography* (Oxford: Oxford University Press, 2018).

4 Eve Kosofksy Sedgwick, *A Dialogue on Love* (Boston: Beacon, 1999). For more on Modernist typography, see El Lissitzky, 'The Book', in *El Lissitzky: Life, Letters, Texts*, ed. Sophie Lissitzky-Küppers (1967; London: Thames and Hudson, 1992), 359–65; Herbert Spencer, *Pioneers of Modern Typography* (1969; London: Lund Humphries, 1982); Yves-Alain Bois and Christian Hubert, 'El Lissitzky: Reading Lessons', *October* 11 (Winter 1979): 113–28. I emphasise the Modernist genealogy of Sedgwick's mise-en-page in its original 1993 context, for *Tendencies*, but she would quickly grow interested in the calligramme's origins in Chinese ideograms, as part of a pronounced interest in East Asian poetic forms following *Tendencies*' publication. For example, *Dialogue* interleaves prose with haiku, whilst Sedgwick's 2002 exhibition *Bodhisattva Fractal World* reveals her interest in so-called Japanese death poetry. For more, see Yoel Hoffmann, ed., *Japanese Death Poems Written by Zen Monks and Haiku Poets on the Verge of Death* (Boston: Tuttle, 1986). As Luna notes, 'mixing characters from different typefaces', as Sedgwick does in both *Tendencies* and *Dialogue*, slow[s] down reading' and 'text set entirely in capitals', as in the case of Shannon Van Wey's notes in *Dialogue*, is 'considerably less legible than text set in lower case', since 'lower-case words have more varied shapes than all-capital words (which always form rectangles)' (*A Very Short Introduction to Typography*, 109–12).

her first published book onwards, responding, especially at the beginning of her career, to the work of art critic Michael Fried.

Sedgwick's encounter with Fried began no later than 1980, with the publication of his influential account of pictorial 'frontality', 'faciality', or flatness, *Absorption and Theatricality: Painting and Beholder in the Age of Diderot* (1980), which argued that whenever viewers became self-conscious, for example when a depicted figure returned their gaze, their absorption was compromised, resulting in a more theatrical, for him less desirable experience.[5] Sedgwick would turn to these ideas, most famously, in *Touching Feeling: Affect, Pedagogy, Performativity* (2003), noting that Fried's opposition between theatricality and absorption 'seem[ed] custom-made' for the 'paradox about 'performativity': in its deconstructive sense, performativity signals absorption; in the vicinity of the stage, however, the performative is the theatrical'.[6]

But Sedgwick was already elbow-deep in Fried's idiomatic art-history in the first half of the 1980s. In 1986, for example, Fried responded to Sedgwick's conference paper, 'Privilege of Unknowing: Diderot's *The Nun*', focused on a writer close to Fried's heart.[7] A year earlier, Sedgwick had also cited Fried in her important essay 'A Poem Is Being Written' (1985), gesturing there to the S/M possibilities of the theatricality/absorption binary in a footnote suggestively juxtaposing Fried's monograph with an 'extended reading of a sadomasochistic sexual fantasy involving theatrical tableau', with theatricality offering possibilities for voyeurism and S/M identification, focused on scenes of

5 Michael Fried, *Absorption and Theatricality: Painting and Beholder in the Age of Diderot* (Chicago: University of Chicago Press, 1980). I am grateful to Chloe Sharpe for numerous, productive conversations about Fried's categories. For more see, Chloe Sharpe, *Multiple Bodies: Looking at Spanish Cemetery Sculpture, 1875–1931* (PhD thesis, University of York, 2018).

6 Eve Kosofsky Sedgwick, *Touching Feeling: Affect, Pedagogy, Performativity* (Durham: Duke University Press, 2003), 7.

7 Eve Kosofsky Sedgwick, *Tendencies* (Durham: Duke University Press, 1993), 23–51; 51.

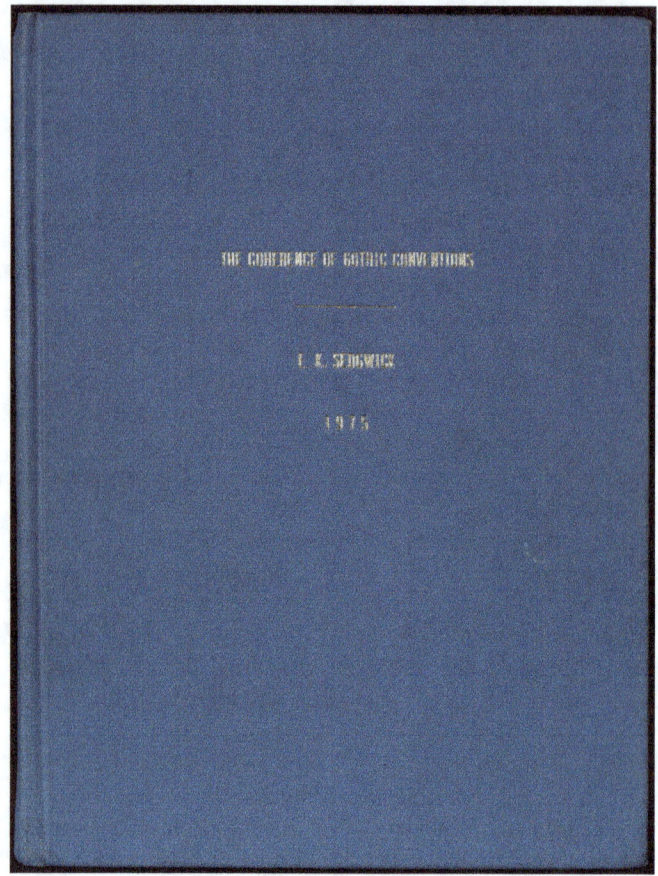

Figure 1.2. Eve Kosofsky Sedgwick, front cover of *The Coherence of Gothic Conventions* (Yale University Press, 1975).

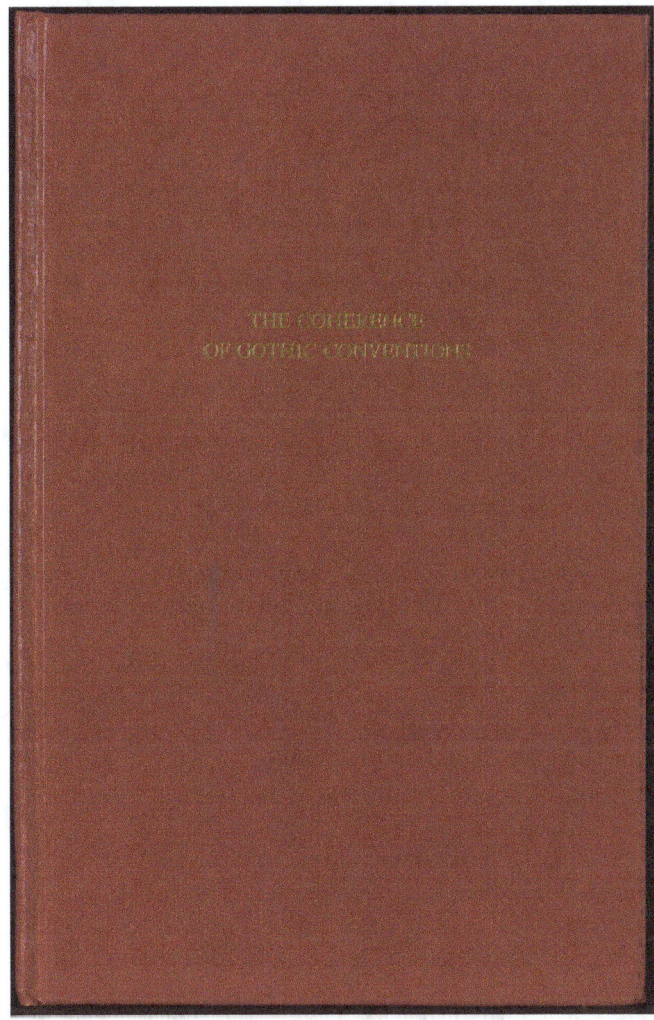

Figure 1.3. Eve Kosofsky Sedgwick, front cover of *The Coherence of Gothic Conventions* (first Arno edition, 1980).

erotic absorption, or within masturbatory reverie's absorbing frame.[8]

When she finally came to publish both of these essays in *Tendencies,* Sedgwick also cited in the bibliography, although without further discussion, Fried's less well known 1985 essay, 'Realism, Writing, and Disfiguration in Thomas Eakins's *Gross Clinic*'.[9] This offered an unusually sustained pictorial analysis focused on the American Painter's 1875 canvas depicting a difficult-to-gender surgical patient's bare buttocks, surrounded by attentive male surgeons and an audience of male students — a canvas tailor made for Sedgwick's passionate interest in homoerotic and female anality and S/M tableau. Such queer issues, combined with a Friedian idiom of absorption, frontality, and theatricality, perhaps surprisingly, also underpinned her desire to have one of Giovanni Battista Piranesi's famous prisons on the front cover of her first book.

A First Queer Essay on the Picture Plane, or, The Epistemology of the Grad School Prison: *The Coherence of Gothic Conventions*

In 1980, Arno published the first edition of *The Coherence of Gothic Conventions,* reprinting the typescript of Sedgwick's 1975 Yale doctoral thesis, originally hardbound in a royal blue cover, with capitalised gold lettering; the first of Sedgwick's blue covers as we shall see (see Figure 1.2).

The first, hardback Arno edition, with a significantly revised first chapter, again employed gold lettering against an appropriately gothic, blood-red background (see Figure 1.3).

In 1986, Methuen published an expanded second edition, following the success of Sedgwick's second book, *Between Men,* with a new final chapter we have already encountered: 'The

8 Sedgwick, *Tendencies*, 182.
9 Ibid., 269. For more, see Michael Fried, 'Realism, Writing, and Disfiguration in Thomas Eakins's Gross Clinic', *Representations* 9 (Winter 1985): 33–104, and *Realism, Writing, and Disfiguration: On Thomas Eakins and Stephen Crane* (Chicago: Chicago University Press, 1987).

Character in the Veil'. The second edition featured, on its cover, a detail from plate 7 of Piranesi's *Prisons* (1761) (see Figure 1.4).

Sedgwick selected the engraving, which she had discussed explicitly in her thesis, as we shall see, and having herself studied engraving, along with sculpture, during her time at Cornell in the early 1970s, but otherwise had little say in the book's design, later regretting the 'lack of margins or other white space — not to mention the ubiquitous typos'.[10]

In what would turn out to be a characteristic move for Sedgwick, the cover crops Piranesi's original plate, focusing on the bottom right corner, cutting most of the upper third and left side (see Figure 1.5).

As a result, she removed much of Piranesi's ceiling, making the engraving more claustrophobic and eliding the panoptical elements, such as the central tower with its crossing platform, in the top-left, from which a small, anonymous figure looks down, in the viewer's direction. Her elision makes the image more disorienting and less straightforwardly Foucauldian; perhaps the most predictable reading of the image as a whole given Sedgwick's career-long fascination with Foucault.[11]

Perhaps most difficult to read, in the cropped version, are the four rings hanging below the upper walkway, dissolving gradually into the white light, as well as the emphatic slash that seems to interrupt the plate's surface, rather than being part of its iconography, that drops from the top left to the bottom right. Looking at the original, these elements more obviously form parts of hoisting equipment, with the slash representing a swathe of rope hanging from an upper pulley, and the four empty rings echoing the one in the left corner, with rope dangling from it, hoisting equipment with s/m resonances of their own.

In Sedgwick's crop, however, the non-iconographic slash increases the plate's violent frontality, as if an impatient or hostile

10 Email from Sedgwick to the author.
11 For Foucault's paradigmatic account of the panopticon, see *Discipline and Punish: The Birth of the Prison*, trans. Alan Sheridan (London: Allen Lane, 1977).

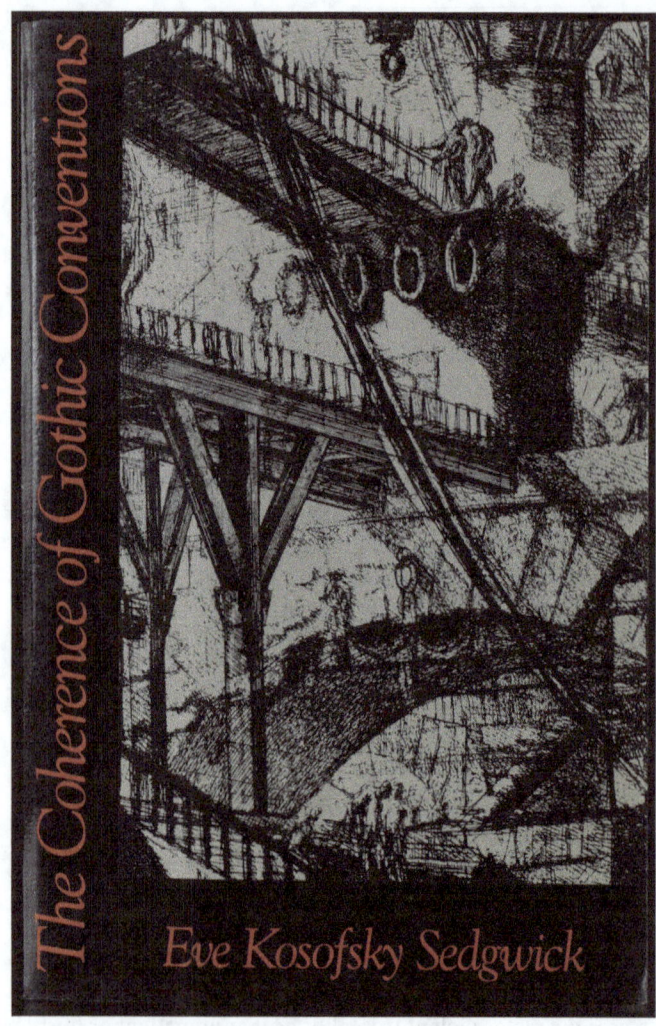

Figure 1.4. Eve Kosofsky Sedgwick, front cover of *The Coherence of Gothic Conventions* (second Methuen edition, 1985).

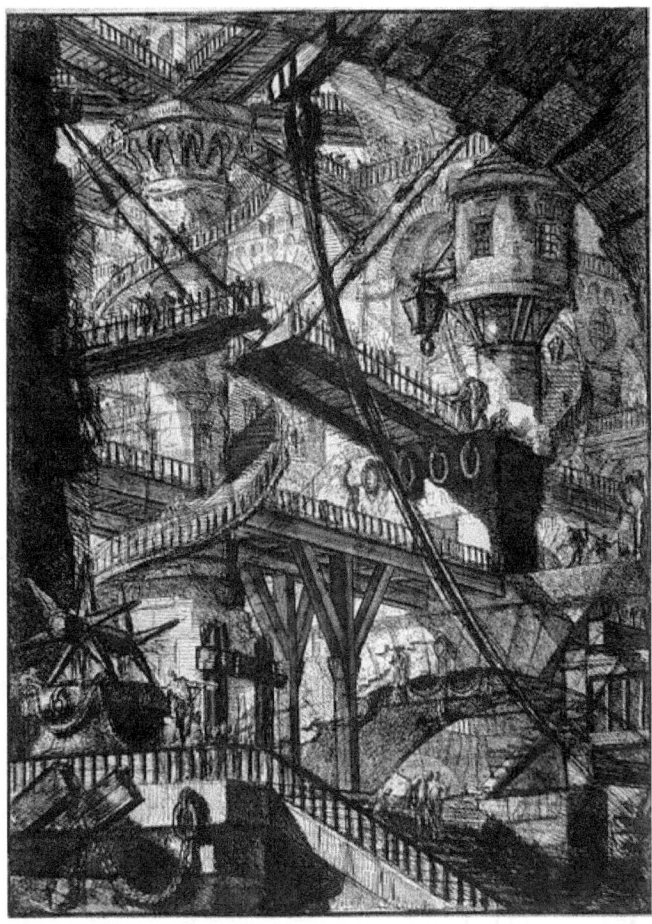

Figure 1.5. Piranesi, *The Prisons* (1761), plate 7.

engraver had gouged the plate, having grown weary of the project, or to prevent further impressions being taken — 'sloppy', slashed surfaces we will encounter Sedgwick admiring again in the cases of Victorian photographers, Julia Margaret Cameron and Clementina Hawarden.[12] The book's more carefully engraved title, meanwhile, runs up the left side, in blood-red italics against a black background, suggesting a fresh wound: text branded on, carved into, or tattooed onto sore, bleeding or burned flesh. Sedgwick's name appears in the same off-centre, blood-red italic, towards the bottom right corner, suggesting a blazon of pained, potentially pleasurable emotion.

In Chapter One of *Coherence,* Sedgwick suggested that, on a 'descriptive or phenomenological' level — and thus a reputable empirical or philosophical one — the special 'qualities of the place of live burial' were its 'vastness and extensiveness, qualities that equate it with, rather than differentiating it from, the surrounding space'. For Sedgwick, Piranesi's *Prisons* illustrated beautifully this 'apparently paradoxical relationship between the spatial idea of close architectural submergence and the Burkeian sublime based on a sense of the infinite'.[13] She also found something dreamy or nightmarish about the 'vastly expansive, obscurely defined, and repetitive interior space' of the *Prisons,* with their 'power of endless growth and self-reproduction'. She described how the 'texture of even the most distant line, especially in the later, more heavily-burred states, invite[d] and entangle[d] the eye, so that the viewer participates in the power of infinity even while being awed by it. If one could look only at the far distant ground of almost any of these prints', she noted, 'dizzy exhilaration' would be the response.[14] Her response here

12 For example, Sedgwick praised the 'excitingly amateurish surface textures generated by the great domestic photographers of the nineteenth century, such as Julia Margaret Cameron and Clementina Lady Hawarden' (*The Weather in Proust* [Durham: Duke University Press, 2011], 96.)

13 Eve Kosofsky Sedgwick, *The Coherence of Gothic Conventions* (1980; London: Methuen, 1986), 24.

14 Ibid., 25. For more on the Burkean sublime, see Edmund Burke, *A Philosophical Enquiry into the Origin of Our Ideas of the Sublime and Beautiful,*

continues apparently neutral, clearly descriptive, rather than phenomenologically idiomatic and queerly distinct, with its discussion of 'the eye', 'the viewer', and use of 'one' as its subject position.

But, for Sedgwick, it was in the foreground, or in the 'difficulty of getting from the foreground to the background', that Piranesi's compositions 'reveal[ed] themselves as prisons'. Whilst they tended to be 'dark and threatening', and framed the picture 'closely and thickly' with 'massive stone pillars' or 'tall masses of black shadows', the stairways leading from 'something like' the foreground 'already indeterminately receded from the framing masses', 'back and up'. Indeed, these stairways, which 'ought to help the eye find its way into the space of the picture', instead 'baffle' viewers' 'attempt to rationalize' the near, middle, and far distance of the 'relatively bright archways', for a number of reasons:

> because of the indeterminate depth of the point at which they reach the ground, because of the ease with which stairs become directionally ambiguous in the shiftings of optical illusion, because it is never shown how the stairways and the high balustrade galleries intersect, and because there are so many, and so long, stairways and galleries.[15]

The number of explanatory clauses here puns, perhaps, in all those 'because, because, because, because, becauses', on Dorothy's song, from *The Wizard of Oz* (1939), 'Follow the Yellow Brick Road'. As a result, and given the finally bathetic character of the Wizard, Sedgwick comically undercuts the otherwise 'awesome' and sublime phallic logic of 'endless growth and self-reproduction' found in the traditional masculinist accounts of

ed. Adam Phillips (1757; Oxford: Oxford University Press, 1990). For ideas that influenced Sedgwick's on this topic, see Neil Hertz, *The End of the Line: Essays on Psychoanalysis and the Sublime* (New York: Columbia University Press, 1985). For Hertz's recollections of Sedgwick, see 'Attention', *GLQ* 17, no. 4 (2011): 511–16.

15 Sedgwick, *Coherence*, 25.

the sublime. This would not be the last time she would employ a pop-cultural reference to undermine masculine theoretical pompousness.[16]

For Sedgwick, the 'confusion of the stairways' was 'symptomatic of the fact' that it was 'impossible to organize the spaces in any of these prints into architectural space' that would, ordinarily, 'delineate' and 'place' in 'relation to each other an inside and an outside' — an unstable epistemology of the panoptical prison, anticipating that of the closet in Sedgwick's third book, as we shall see. Indeed, she insisted, it was 'impossible to construct in imagination the shell that would delimit the inside from a surrounding outside', suggesting the viewing subject as a kind of vulnerably exposed, homeless mollusc. For example, if, in plates 2 and 4, there 'seem[ed] to be clouds in the background', Piranesi contained them within a 'monumental outside plaza' spanning the arches. In other plates, 'the density of detail' and 'complete lack of open "sky" space' made it 'impossible to imagine' the scene as 'in any sense outside'. The 'incoherent, indefinite, apparently infinite space' Piranesi depicted could not, however, 'be perceived as inside either', because 'even to locate it within a building would be to give it a stable horizon, which, while suggested by the convergences of the perspective, never literally appears and is always shifty enough to disorient the foreground from the background'. In addition, Sedgwick noted, a 'stable sense of scale' was 'lacking, the impossibly tiny human figures only rendering the problem of scale more staggering'.[17]

For Sedgwick, a prison, such as Piranesi's, that had 'neither inside nor outside', was 'self-evidently one from which there [was] no escape'; 'part of the reason' the Foucauldian prints were 'so oppressive'. But, and here is where things get more idiomatically Sedgwickian, the form of Piranesi's plates implied there was 'no access' either, emphasizing her earlier sense of frontal-

[16] Ibid., 24–25. For example, see the Carly Simon-citing 'Paranoid and Reparative Reading' essay with its subtitle 'or, You're So Paranoid, You Probably Think This Essay is About You', *Touching Feeling*, 123–53.

[17] Sedgwick, *Coherence*, 25–26.

ity. According to Sedgwick, the 'particular claustrophobia' of Piranesi's vision was that it 'rejects the viewer even as it lures her in and exerts its weight on her', a scene of implied sexual tease and assault we shall return to, and a sudden gendering of the viewer as explicitly female.[18] In addition, for Sedgwick 'the demarcation between interior and exterior' fell 'just at the dark framing edges of most of the plates, edges that form a more or less irregular proscenium arch dividing the space of the self from the space of the picture' — a theatrical architecture drawing on Fried's theatrical/absorptive paradigm and central to her later readings of the peri-performative and *The Last Days of Pompeii*, as we shall see.[19]

Unexpectedly, though, 'it is the hither side of the proscenium, the self' that Sedgwick felt 'inside', as 'confined within its relation to the 'surrounding' but unavailable picture space'. This spectatorial space 'only unfolds its unavailability as the eye is tempted into it', as 'distinct from, say, the uninviting frontal space of Manet', the artist whose 1863 *Déjeuner sur l'herbe* Sedgwick employed on the cover of *Between Men*, as we shall see.[20] In *Coherence*, Sedgwick noted that the *Déjeuner* kept viewers out because of Manet's 'uninviting', flat, 'frontal space', an image of her second book therefore refusing a missionary, male reader's penetration, or offering a confrontational, in-your-face feminist frontality perhaps. The Piranesian cover of *Coherence*, by contrast, offered a more 'fully-dimensioned weight of space', a fatter art than Manet's flat aesthetic 'that rejects the viewer and pins her down in the shallow space to her own side of the extreme foreground proscenium'. This, conversely, is an image of the canvas or her own book as a sublime presumptively male body that refuses entry as it seeks to impose its presence on an explicitly female viewer, a scene charged with masochistic eroticism for Sedgwick.[21] These two characterizations of frontality,

18 Ibid., 26.
19 For more, see Sedgwick, 'Around the Performative: Periperformative Vicinities in Nineteenth-Century Narrative', *Touching Feeling*, 67–93.
20 Sedgwick, *Coherence*, 26.
21 Ibid.

as teasingly not quite flat resistance, or as oppressively, phallically projecting into the viewer's space, continued to preoccupy Sedgwick, as we shall see, forming the verso to the recto of her more famous anal thematics of the rear and back side (of the book or canvas).

Sedgwick paused at this point, in her account of Piranesi, to refer back to her own phraseology. She noted that the phrase 'weight of space' was 'important to her argument' and was 'justified not only by the quality of Piranesi's spaces but by the palpableness of the light that fills them'. Indeed, she argued, 'especially in the deep chiaroscuro of the later states, the brightness that filters forward and down has almost an obscuring effect, heightening the already dramatic aerial perspective' and sometimes 'seeming to blank the structures over which it floods'. And 'even where the thickness of the light is not so noticeable, the air is often shown as heavy and palpable with smoke, steam, or clouds', or 'just with spots that seem to collect brightness as if it were moisture in the air' — the first evidence of Sedgwick's sustained barometric interests that would find fuller exploration in the title chapter of *The Weather in Proust* (2011).[22]

The 'heaviness of air space in Piranesi', Sedgwick argued, could be contrasted with 'its thinness and lightness' in French seventeenth-century painter Claude Lorrain and its 'elasticity' in British Romantic painter John Martin. Piranesi's was an 'aerial space' that was, paradoxically, 'like water: to be in it is already to be under it, submerged by it, stifled, gagged, and all but immobilized' — a 'space of submergence' that was 'not formally or topographically differentiated from its surroundings' and that further worked to 'undermine the sense of inside and outside, the centeredness of the "self"'.[23]

In that last complex description, there is much to notice about Sedgwick as a *queer*, as well as a Friedian art critic, even

22 For more, see Sedgwick, *The Weather in Proust*, 1–41.
23 Sedgwick, *Coherence*, 27. Sedgwick would return to exploring this sense of being partially submerged in the holding environment of water in her 1999 exhibition *Floating Columns* and 2001 exhibition *In the Bardo*.

at this early stage in her career and that proves resonant for her subsequent practice. For example, whilst the implied tableau is broadly characteristic of the erotics of the sublime, it specifically resonates with her own s/M idiom. Firstly, in the sense of a viewer-participant in a dramatic, containing institutional scene, a prison: a masturbatory tableau that much preoccupied Sedgwick's meta-pornographic poetry in the mid 1970s whilst she was at work on her thesis.[24] That smaller-scale spectator-participant is also oppressed by the palpable weight of an inelastic, inflictive object, or, more likely, a larger, male person, who 'floods' and 'blanks' any sense of the viewer's structure with a light, paint-like substance, with a 'thick' texture. But the scene could also, again more positively, recall a steamy gay bathhouse, to which we shall return, characterised by the 'heavy' atmosphere of 'moisture in the air', bathhouses being closed down across New York, in response to the AIDS crisis, around the time Sedgwick published the second, 1986 edition of *Coherence,* to which she alludes there and to which she would subsequently allude again, with even deeper pleasure, in *The Last Days of Pompeii,* as we shall see.[25]

Sedgwick's spectator-participant is also 'stifled, gagged, and all but immobilized', as if strapped to a table, ball-gag or underwear in her mouth, again familiar elements from Sedgwick's masturbatory imagination. In addition, her description of the aesthetics of water — 'to be in it', floating, but also 'to be under it, submerged' — is an aquatic 'space of submergence' Sedgwick encourages spectators to read as 'not formally or topographically differentiated from its surroundings' and that worked, like a penetrated throat or anus, to 'undermine the sense of inside

24 For example, see Sedgwick's 1974 poem 'Lost Letter', written at Yale, in *Bathroom Songs: Eve Kosofsky Sedgwick as a Poet,* ed. Jason Edwards (Earth: punctum, 2017), 225–34, and my discussion of it in the same volume (197–99).

25 For more, see Samuel R. Delaney, *Times Square Red, Times Square Blue* (New York: New York University Press, 1999), and Sarah Schulman, *The Gentrification of the Mind: Witness to a Lost Imagination* (Berkeley: University of California Press, 2012).

and outside, the centeredness of the "self"'. This is another key motif in Sedgwick's idiom, at this stage masochistic, but later suggesting the dialogic relation of airy environment and breathing, selfless self, central to her late Buddhist iconographies.[26]

Sedgwick returned, briefly, to Piranesi in Chapter 2 of *Coherence*, 'Language as Live Burial'. In a larger discussion of Jorge Luis Borges, she noted that the Argentine writer's fiction often possessed the 'flavor of Piranesian Gothic' in its 'contrast between the wretchedly confined spaces for satisfying one's human needs and the infinite spaces that cannot be domesticated'. Here, spectators might be tempted to read the cover of *Coherence* differently again, as an image expressing the seemingly 'infinite spaces' of an almost impenetrable, male-dominated literary academy that would not be 'domesticated', and, in the print's immediate foreground, the 'wretchedly confined spaces' of a young, untenured feminist scholar, at the start of her career, pinioned, masochistically, on its margins, trying to get her emotional, professional, erotic, and financial foot in the door.

Towards the end of her long narrative poem 'The Warm Decembers' (1978–1987), again written in the same period as Sedgwick's Yale thesis was revised for publication, she described this scene as 'the touring company' of her favorite show:

> *Landscape with a Frieze of Assistant Professors*
> — the one where the near-burnout women faculty
> realize for the first time that we'll never
> be loved, always be feared, by these departments,
> and, that that can be called 'fun', and 'power',
> when we decide together that it's powerful and fun,
> able to leap short colleagues at a single bound,
> to be thought in conspiracy whenever
> two or more of us lunch. ('Oh, really, nothing,
> Girltalk. You know, Lawsuits, Title IX. …')[27]

26 Sedgwick, *Coherence*, 27; *Weather*, 11–15.
27 Eve Kosofsky Sedgwick, *Fat Art, Thin Art* (Durham: Duke University Press, 1994), 152.

Title IX (1972) famously declared that 'no person in the United State shall, on the basis of sex, be excluded from participation in, be denied the benefits of, or be subjected to discrimination, under any education program or activity receiving Federal financial assistance'. As such, 'The Warm Decembers' suggests that, in Sedgwick's use of Piranesi, the prison represents both the academy as a sublime masculine space that she could not gain access to, even as she moved from a temporary, four-year post at Hamilton College to a tenure-track position at Boston University in the fall of 1981, and also, more threateningly, the prison that male faculty risked inhabiting should they be found guilty of sex discrimination under Title IX.

Finally, 'The Warm Decembers' further emphasizes Sedgwick's broader fascination, in this period, with engraving and etching as violent, s/M forms. For example, her c. 1993 afterword to the poem noted that in the period between 1978 and 1987 when she was simultaneously at work on 'The Warm Decembers' and *The Coherence of Gothic Conventions,* she developed an increasingly 'jarring alertness' to questions of the 'detailed and the blurry'. She had also been 'drawing characters' whose imagined futures 'remained sketchy'. In addition, she included a deleted passage that described the way in which Victorian novelist Anthony Trollope, who appears in in the poem as a borderline sexual harasser of the poem's heroine Beatrix Martin,

 acidly touch[ed] at the exacerbated outline
 of a heroine who has (he sees)
 some tendency to shrink both from and in the wash.

In a second excised passage, Sedgwick also implies that Trollope himself experienced the world as a mediated form of metallic engraving, when he describes how 'sour acorns' froze in 'rimy ruts where a wet month ago / withdrawing carts *embossed* them'. Finally, she also described herself as a kind of etching, documenting how, 'steeped' as she and the poem were in the 'high

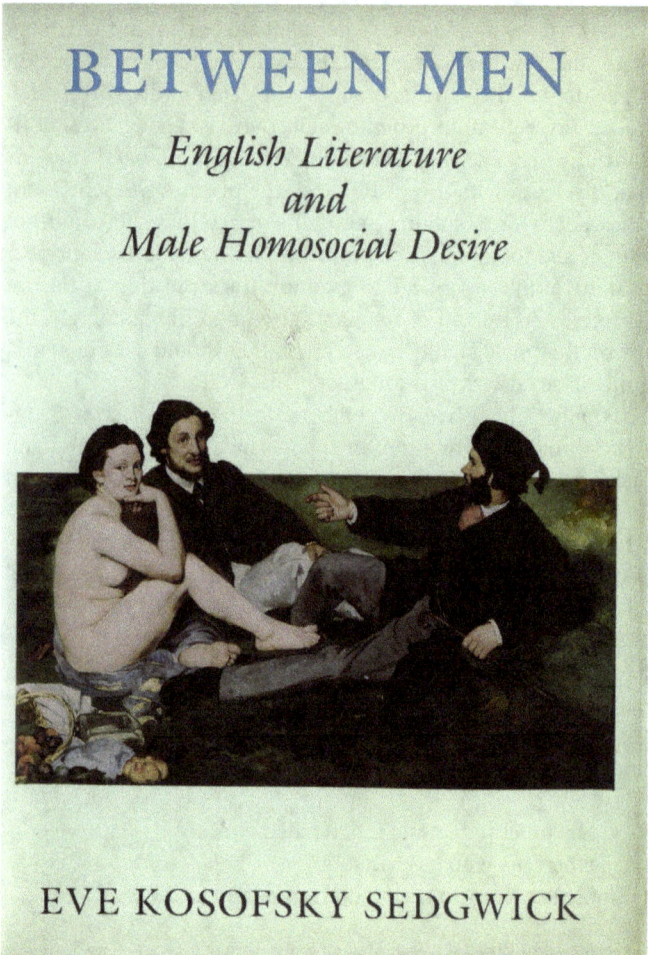

Figure 1.6. Eve Kosofsky Sedgwick, front cover of *Between Men* (1985, first edition), featuring Sedgwick's own crop of Eduard Manet's *Olympia* (1863).

realist manner', she felt 'acutely the *bite* of every lacking skill', intermedial reflections that we return to in Chapter Four.²⁸

A Twist of the Wrist, A Piss on the Grass, or, *Between Men*

In *Coherence,* as we have seen, Sedgwick discussed Manet's 'uninviting', 'frontal space', a flattening effect she emphasized by cropping the horizon from his *Déjeuner* when she employed it for the cover of *Between Men* (see Figure 1.6).

In this section, I compare the first (1985) and second (1993) editions of the book, again *bringing out* various facets of her queer idiom.²⁹ As with all of her books, her readers were invited to take seriously the queer materiality of *Between Men* in part thanks to her earlier paradigm-shifting essay 'A Poem is Being Written', first given as a talk in 1985, the year in which the first edition of *Between Men* was published, and itself published in 1993, the year the second edition of *Between Men* came out.³⁰

For example, as a codex book, *Between Men*'s spread pages recall the inviting crack of a buttock or cleavage, in the form of the curvaceous swellings of a once-poignantly-paired bosom that underwent a single mastectomy, in Sedgwick's case, just after *Epistemology of the Closet* was published in 1990.³¹ The book's intact spine, meanwhile, with Sedgwick's name upon it, was also increasingly melancholic in the context of her subsequent spinal

28 Ibid., 90, 154–55, 157–58, 160. Emphases mine.
29 For more on 'bringing out', see D.A. Miller, *Bringing Out Roland Barthes* (Los Angeles: California University Press, 1992), and Barbara Johnson 'Bringing Out D.A. Miller', *Narrative* 10, no. 1 (January 2002): 3–8.
30 Sedgwick, *Tendencies,* 177–214.
31 For more on cleavage, see Wayne Koestenbaum, *Cleavage: Essays on Sex, Stars, and Aesthetics* (New York: Ballantine, 2000). For his reflections on Sedgwick, see 'An Approach to Mourning', in *My 1980s and Other Essays* (New York: Farrar, Strauss, and Giroux, 2013), 65–70; and the 'Preface' to Eve Kosofsky Sedgwick, *Between Men: English Literature and Male Homosocial Desire* (1985; New York: Columbia University Press, 2015), ix–xvi.

Figure 1.7. Richard Ellmann, *Oscar Wilde* (Penguin Canada, 1988).

cancer — the question of backbone and the 'spineless' that we return to in Chapter Six.[32]

Given Sedgwick's S/M, anal idiom, and Friedian interest in frontality, meanwhile, readers might also think, in queer terms, about the recto and verso of each page and the book; the top and bottom of the page, and the location of headers and page numbers, in *Between Men*. Also queerly resonant in this context might be the positioning of the (rear) endnotes in *Between Men* and the remainder of her prose collections, as well as the footnotes in *Epistemology* and *Tendencies,* given her documented foot fetishism, and the various games of footsy going on in Manet's image, as we shall see.[33]

If this kind of queer reading proves suggestive for all of Sedgwick's codex books, the first thing readers might notice about the first edition of *Between Men* is its pale green cover. In employing the palette of a green carnation, Oscar Wilde's signature flower, the book was designed, Sedgwick suggested, to recall the cover of Richard Ellmann's biography of Oscar Wilde (see Figure 1.7).[34]

But since *Oscar Wilde* was not published until 1987, two years after the first edition of *Between Men*, that relationship must have occurred retrospectively to her. That, or in the queer temporality that characterized much of her autobiography, and that has been theorized in much recent queer theory, *Oscar Wilde*

32 For an astute analysis of Sedgwick's advice column for MAMM magazine as a breast cancer survivor, in relation to *Dialogue,* see chapter 3 of Lana Lin, *Freud's Jaw and Other Lost Objects: Fractured Subjectivity in the Face of Cancer* (New York: Fordham, 2017).

33 For similar puns in Gayatri Chakvavorty Spivak, see Jane Gallop, *The Deaths of the Author: Reading and Writing in Time* (Durham: Duke University Press, 2011), 129. For Gallop's recent reflections on Sedgwick, see her 'Early and Earlier Sedgwick', in *Reading Sedgwick*, ed. Lauren Berlant (Durham: Duke University Press, 2019), 13–120. Sedgwick's *A Dialogue on Love,* meanwhile, documented that she and her shrink's feet were always 'delicately poised' at the opposite corners of a 'footstool' they shared; and that she fantasized about taking his 'stockinged foot and masturbating with it' (94, 182).

34 Email to the author.

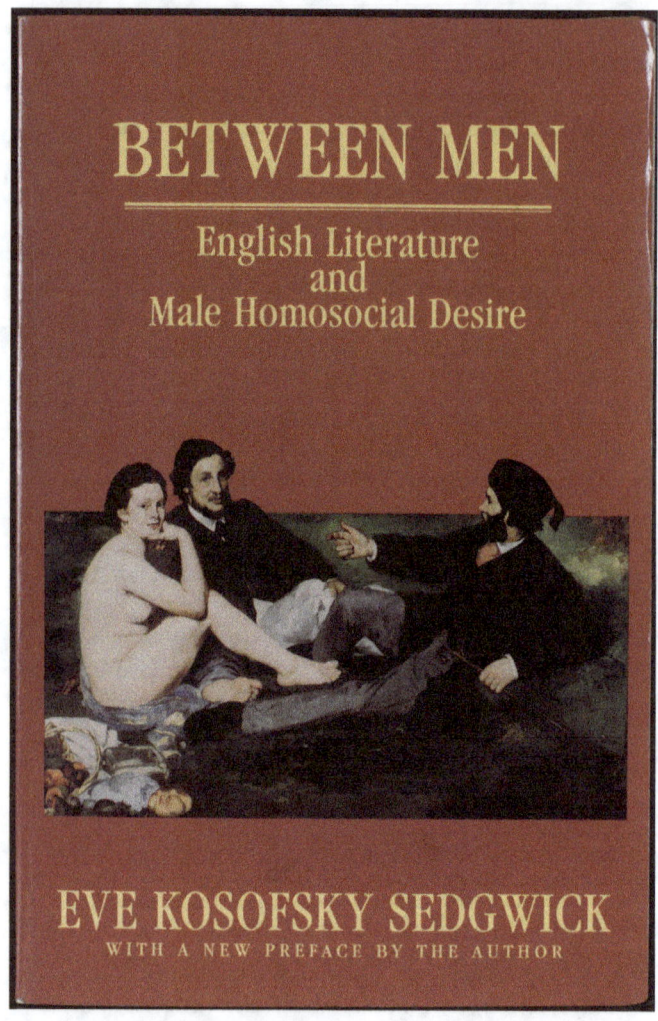

Figure 1.8. Eve Kosofsky Sedgwick, front cover of *Between Men* (1992, second edition), featuring Sedgwick's own crop of Eduard Manet's *Olympia* (1863).

must have learned a thing or two from *Between Men*.³⁵ Certainly, both share their distinctive color, representing a flirtatious, triangulated homosocial affiliation between Sedgwick, Ellmann, and Wilde — a piercing, mutually proffered, three-way bouquet of green carnations in which Sedgwick gives herself significant agency.³⁶

The palette of the second edition resonates differently, although equally queerly (see Figure 1.8).

35 Richard Ellmann, *Oscar Wilde* (London: Vintage, 1987). For more on Sedgwick's queer temporality, see Stephen M. Barber and David L. Clark, 'Queer Moments: The Performative Temporalities of Eve Kosofsky Sedgwick', in *Regarding Sedgwick*, eds. Stephen M. Barber and David L. Clark (London: Routledge, 2002), 1–56; Jane Gallop, 'Sedgwick's Twisted Temporalities, Or Even Just Reading and Writing', in *Queer Times, Queer Becomings*, eds. E.L. McCallum and Mikko Tuhkanen (Albany: State University of New York Press, 2011), 47–75; and Anna Gibbs, 'At the Time of Writing: Sedgwick's Queer Temporalities', *Australian Humanities Review* 48 (May 2010), 41–53, http://australianhumanitiesreview.org/2010/05/01/at-the-time-of-writing-sedgwicks-queer-temporalities/. For more on queer temporality more generally, see Lee Edelman, *No Future: Queer Theory and the Death Drive* (Durham: Duke University Press, 2004); Judith Halberstam, *In a Queer Time and Place* (New York: New York University Press, 2005); Heather Love, *Feeling Backward: Loss and the Politics of Queer History* (Cambridge: Harvard University Press, 2009); Carolyn Dinshaw, *Getting Medieval: Sexualities and Communities, Pre- and Post-Modern* (Durham: Duke University Press, 1999); Carla Freccero, *Queer/Early/Modern* (Durham: Duke University Press, 2006); Carolyn Dinshaw, Karma Lochrie, and Madhavi Menon, 'Queering History', *PMLA* 121, no. 3 (May 2006): 837–39; Carolyn Dinshaw et al., 'Theorising Queer Temporalities: A Roundtable Discussion', *GLQ* 13, nos. 2–3 (2007): 177–95; José Esteban Muñoz, *Cruising Utopia: The Then and There of Queer Futurity* (New York: New York University Press, 2009); Valerie Rohy, *Anachronism and Its Others* (New York: SUNY Press, 2009) and *Lost Causes: Narrative, Etiology, and Queer Theory* (Oxford: Oxford University Press, 2015); and Elizabeth Freeman, 'Introduction', *GLQ* 13, nos. 2–3 (2007): 159–76 and *Time Binds: Queer Temporalities, Queer Histories* (Durham: Duke University Press, 2010).

36 For more on green carnations, see Robert Hitchens, *The Green Carnation* (London: William Heinemann, 1894). For a further three-way, see 'This Piercing Bouquet: An Interview with Eve Kosofsky Sedgwick', in *Regarding Sedgwick*, eds. Barber and Clark, 243–62.

The cover is colored the 'penetrated dark' pinky-red of the mouth, vagina, and rectum. It looks, in the words of Sedgwick's 1975 poem 'Everything Always Distracts', '(as they say of gynecologists) in the pink, / which, to us, means the folded tissue of blood', or 'the red explanatory lapful', making the book, unlike the more frontal *Coherence* or Manet's *Déjeuner*, a bodily cavity to be laid bare, invitingly opened up.[37]

To make her cover the perfect condensation of the book's argument about the triangulation of women within male homosocial dyads, meanwhile, Sedgwick again purposefully crops Manet's second female figure, along with some of the picnic, and most of his arboreal scenery. Her elision makes impossible any relation *between women*, a subject of mourning within the text. In addition, Sedgwick's déjeuner has got significantly *less wood* than Manet's, castrating his masculine modernism as she had similarly deflated Burke's tumescent sublime.[38]

Consider also the way the Orientalized man on the right, wearing a turban, indicates, with his extended right arm and forefinger, the woman on the left of the man in the middle, in a gesture recalling Michelangelo's homosocial *Creation of Adam*, from the Sistine Chapel Ceiling, whose limply extended left hand, effetely slack at the wrist, awaits divine life from God's energetically extended right hand about to electrify his creation. I describe this scene as homosocial because the drafts of W.B. Yeats's 1939 poem 'Long Legged Fly' described the erotic appeal of 'homosexual Adam' to 'girls at puberty'; a stanza we might retitle Michelangelo and the masturbating girl, whose hands 'move to and fro' whilst looking at it.[39]

Manet's right-hand man, meanwhile, whilst extending his left leg to play footsy with the woman's left sole — an example

37 Sedgwick, *Fat Art*, 74–75.
38 For more, see Michael Fried, *Manet's Modernism, or The Face of Painting in the 1860s* (Chicago: University of Chicago Press, 1996).
39 For the history of revisions to the poem, see W.B. Yeats, *The Variorum Edition of the Poems*, eds. Peter Allt and Russell K. Alspach (New York: Macmillan, 1957). For 'Jane Austen and the Masturbating Girl', see *Tendencies*, 109–29.

dense with Sedgwickian pedo-philia—looks 'straight' at the man in the middle, with his right knee raised up, and his cane tilted up, at the angle of a growing erection, its handle framing the glands of his penis.[40] Given that the Orientalized man is also offering the central man the ticklish, tactile invitation provided by his adjacent right sole, he is seeking to be the homosocial (homo-shoe-sole!) sole-mate of the man in the middle.[41]

Spectators might also think about the way the right man's extended right arm forms part of a larger image cluster in Sedgwick's work. This is one emphasizing her corpus's diverse tactile address, in textural, balletic, spiritual, and sadomasochistic repertoires. For example, Manet's iconography has something in common with the paired manicules — or pointing fingers — that open all but the introductory chapter of *Touching Feeling,* that we return to. Manet's right hand man also anticipates, at least in the context of Sedgwick's imaginary, the Buddhist pedagogies of the ungrasping open hand pointing at the moon, and the feline-sniffed finger that preoccupied Sedgwick in the last chapter of *Touching Feeling,* as well as the extended right arms and hands of the bodhisattvas in many of Sedgwick's subsequent textiles (see Figure 1.9).[42]

40 I was inspired to think about foot fetishism as pedo-philia by Ben Nichols. For more, see his 'Queer Footing: Pedestrian Politics and the Problem of Queer Difference in *The Princess Casamassima*', *Henry James Review* 34, no. 1 (2013): 98–111.

41 The question of Sedgwick's Orientalism is a complex one. Wearing a turban, the figure on the right of Manet's picture is dressed, in the period's terms, *à la Turque*, and thus in relation to the Ottoman world, a location central to the period's so-called 'Sotadic zone', where gay male practice was supposedly more common. Within this, Sedgwick's earlier Orientalist interests tended towards the Middle East of the Old Testament's Jonathan and David and of the later Richard Burton and T.E. Lawrence. For more on the homoerotics of Orientalism, see Joseph Allen Boone's book of the same name (New York: Columbia, 2014). Sedgwick's later work, by contrast, was more inclined towards East Asian poetics, philosophies, and materialities.

42 Sedgwick, *Touching Feeling,* 153–56, 176. As James Merrill noted, in 'Prose of Departure', of the related extremities of Noh performances, 'Hands like

Figure 1.9. Eve Kosofsky Sedgwick, *Untitled [Limpid Three Bodhisattvas]* (c. 2002), quilted cyanotype, 36 × 20 cm. Photo: H.A. Sedgwick. © Eve Kosofsky Sedgwick Foundation.

Manet's turbaned man also evokes what Sedgwick described as the exquisitely masochistic and sadistic repertoire of ballet moves,[43] and what 'The Warm Decembers' had characterized as the 'grave and queenly' Dowager Jones's 'exquisite porte de bras'[44] — a related balletic gesture, of an extended right hand again depicted on the cover of *Performativity and Performance* (1995), as we shall see. In addition, spectators might think about the extended, again-right arm of the man, coming out of the closet, on the cover of *Epistemology,* and about African-American queer writer Gary Fisher's similarly queer 'graceful', 'imperious', 'inimitable', 'refined' dancing hands, as they appear in Sedgwick's c. 1993 poem 'A Vigil', that might be 'inviting a

these will never clench or cling or stupidly dangle or helplessly be wrung' (*Collected Poems* [New York: Knopf, 2002], 551).

43 Sedgwick, *Tendencies,* 186.
44 Sedgwick, *Fat Art,* 155. For more on the queer sexual politics of ballet, see Tirza True Latimer, 'Balletomania: A Sexual Disorder', *GLQ* 5, no. 2 (1999): 173–97.

hand to hold' or be 'banishing some subject (me?) eternally / from [his] countenance', published three years after the second edition of *Between Men*.⁴⁵

There's also the homoerotic, 'blindly, loftily expressive' boy's hand Cissy witnesses in Sedgwick's long narrative poem 'Trace at 46' (1980), 'making floaty gestures' above his male lover's shoulders in the back of a pick-up truck, that 'reaches back, way back, and sweeps down', 'out / past the back window of the cab', especially since Sedgwick references the poem directly at the start of Chapter Nine of *Between Men*.⁴⁶ In addition, Sedgwick's completist readers might recall Humby's 'leathery obstetric hand' extended in Chinese White's delighted direction in 'The Warm Decembers',⁴⁷ and, perhaps most persistently, the thrice returned to scene of Henry James's auto-fisted golden bowels, that she subsequently described as a 'virtually absolute symbol of imaginative value' in *Touching Feeling*,⁴⁸ but that she had already explored in *Epistemology*, three years before the second edition of *Between Men*,⁴⁹ and in *Tendencies*, published the same year as *Between Men*'s second edition.⁵⁰ Finally, and in a more painful, s/M vein, there's Catherine's 'bloody hand plunging through the broken window' in Emily Brontë's *Wuthering Heights* (1847) that Sedgwick had discussed in *Coherence*.⁵¹

Manet's man in the middle, meanwhile, seems to be suffering from strabismus. Whilst his left eye looks back at the man on our right, emphasizing their complicit relation, his right interpolates and triangulates the viewer, his spider-like right hand just emerging behind the woman's behind. Enclosed within, and trafficked between these two men, Manet's nude woman

45 Sedgwick, *Fat Art*, 13. For more, see Eve Kosofsky Sedgwick, ed., *Gary in Your Pocket: Stories and Notebooks of Gary Fisher* (Durham: Duke University Press, 1996).

46 Sedgwick, *Fat Art*, 60; *Between Men*, 161–62.

47 Sedgwick, *Fat Art*, 202.

48 Sedgwick, *Touching Feeling*, 48.

49 Eve Kosofsky Sedgwick, *Epistemology of the Closet* (Los Angeles: University of California Press, 1990), 208.

50 Sedgwick, *Tendencies*, 73–103.

51 Sedgwick, *Coherence*, 118.

also looks out at the spectator, sitting in a contemplative pose, chin in hand. Sedgwick's crop ensures the horizon line matches the woman's eye-line, and strongly encourages viewers, whether the feminists primarily addressed by the book, or the gay men whose attention *Between Men* also solicited, to identify with, rather than objectify, the woman — a horizon-line trick Sedgwick learned from her husband, Hal, a SUNY professor of Visual Perception.[52]

But Manet's triangulation is, perhaps, the least distinctively *Kosofskian* thing about the image. For example, Manet recasts Michelangelo's *Creation of Adam* to include an upright nude woman, rather than a languid man, an Eve perhaps, who has a fat crease of skin at her midriff, her right big toe raised clitorally up, and who is surrounded by a cornucopia of tempting snacks. As a result, in this Edenic, grassy, garden context, Sedgwick suggests that this is the *Creation of Eve* just as it is a creation *by* Eve. As a result, the man on the right's cane comes to anticipate Baron Adolph de Meyer's similarly caned man on the cover of *Epistemology*, indicating the sequential, historical, and conceptual relation of the two books — in particular, Sedgwick's move from the triangular, mid-nineteenth century desires of Manet's *Déjeuner*, to the turn-of-the-twentieth-century dramas of coming out and closetedness, and suggesting here the calmness of mid-century homosociality compared to *Between Men*'s bookending ages of Frankenstein and the Wilde Trials.[53]

In addition, the cane brings to mind the manifold scenes of corporal punishment throughout Sedgwick's oeuvre. Readers might again recall 'A Poem Is Being Written' and the 'nastily scenic / afternoons with the goddamned objects in the god-

[52] For more, see Hal A. Sedgwick, 'Relating Direct and Indirect Perception of Spatial Layout', in *Looking into Pictures: An Interdisciplinary Approach to Pictorial Space,* eds. Heiko Hecht, Robert Schwarz, and Margaret Atherton (Cambridge: MIT Press, 2003), 61–75.

[53] For more, see Bridget Alsdorf, *Fellow Men: Fantin-Latour and the Problem of the Group in Nineteenth-Century French Painting* (Princeton: Princeton University Press, 2013), and Andrew Parker, 'The Age of Frankenstein', in *Reading Sedgwick,* ed. Berlant, 178–88.

damned motel room' of 'Everything Always Distracts'.⁵⁴ John Vincent's contribution to Sedgwick's 1997 collection, *Novel Gazing*—'Flogging is Fundamental: Applications of Birch in Swinburne's *Lesbian Brandon*'—might also rear up into their minds,⁵⁵ as well as Trollope's conviction, in 'The Warm Decembers', that he had been 'flogged oftener than any other human being / alive', and who often boasted that it was 'just possible / to obtain five scourgings in one day' at his Winchester public school and that he 'obtained them all'. After 'half a century' of meditation, Sedgwick's Trollope also thinks back on his childhood where he was

> whipped far beyond the reach
> of 'perverse' transformation at any psychic
> exorbitance, of pleasure to
> himself, to his tormentors even.

This represents, perhaps, the most evocative passage in Trollope's 1883 *Autobiography,* and one Sedgwick again brilliantly crops for the poem.⁵⁶ In the poem, Goatey Lament also remembers, with a 'bump-bumping heart' that, soon, the bottoms of all his birchable 'pupils would be back in place', in the same way that

> in hilly countryside
> it's pleasing and notable how promptly
> that west hill rises to the mark,
> surging to meet you soon at (the obligatory)
> eye-level.

54 Sedgwick, *Fat Art*, 74.
55 Eve Kosofsky Sedgwick, ed., *Novel Gazing: Queer Readings in Fiction* (Durham: Duke University Press, 1997), 269–98.
56 Sedgwick, *Fat Art*, 150. For more, see Anthony Trollope, *An Autobiography* (1883; New York: Dodd, Mead and Co., 1905), 15.

This 'spanking frontal' landscape has much in common with both Manet's flatness and the birched-bottom palette of *Between Men*'s second edition.[57]

Finally, looking at the cover of *Between Men*, spectators should also, perhaps surprisingly, be thinking about urination. In Chapter Nine, Sedgwick encourages this reading, one making queerly resonant the flowing grey-blue fabric emerging from beneath her female figure's rear end, that runs in rivulets towards viewers. 'Homophobia, Misogyny, and Capital' is the chapter that famously upset the Dickensians, the one where Sedgwick claimed *Our Mutual Friend* (1865) was the 'only English novel that everyone *says* is about excrement' to '*forget* that it is about anality'.[58] To which the cover of *Between Men*, as well as many other moments across Sedgwick's corpus, encourage me to again suggest that her work is the queer theoretical intervention everyone says is about anality because they haven't noticed that it is also about *urethrality*.[59]

I make this claim because Sedgwick begins Chapter Nine, as I have briefly noted, by documenting the following fact: 'Eight years ago, writing a narrative about a musicologist with a writing block, I included a little literary joke: a fictional psychoanalyst in the poem was writing a fictional essay for *Thalassa: A (fictional) Journal of Genitality*, on the then-fictional topic, // "Sustained Homosexual / Panic and Literary Productiveness"

57 Sedgwick, *Fat Art*, 133.
58 Sedgwick, *Between Men*, 164.
59 For more queer readings of urination, see Lee Edelman, 'Tearooms and Sympathy or The Epistemology of the Water Closet', in *The Lesbian and Gay Studies Reader*, eds. Henry Abelove, Michele Aina Barale, and David M. Halperin (London: Routledge, 1993), 553–76; Jonathan Weinberg, 'Urination and Its Discontents', *Journal of Homosexuality* 27, no. 1 (1994): 225–44; and Kathryn Bond Stockton, 'Prophylactics and Brains: Beloved in the Cybernetic Age of AIDS', in *Novel Gazing*, ed. Sedgwick, 41–70 and, briefly, in *Making Out* (New York: New York University Press, 2019), 40–41. For Abelove's reflections on Sedgwick, see 'The Bar and the Board', *GLQ* 17, no. 4 (2011): 483–86. See also Kathryn Bond Stockton's 'Afterword', in *Reading Sedgwick*, ed. Berlant, 274–78.

(which includes / close readings from *Our Mutual Friend*')'.[60] The poem Sedgwick alludes to is 'Trace at 46', and the female character is the appropriately named Flo[w]. Her 'egalitarian', 'free-floating attention' is interested in 'lapses / of meaning and wellings-up / of excess meaning', as well as 'aggressive floodings', all taking place in the equally aqueous context of St Malo, in Brittany, with its 'regular thalassic irrigation, then deletion, of rocks, causeways, / fortifications, outline'.[61]

Sedgwick's poem alludes to Sándor Ferenczi's *Thalassa: A Theory of Genitality* (1938), which focused attention on the 'urethral individual'.[62] Prioritizing 'urethral [...] autoeroticism', he diagnosed the 'ejaculation of semen' as a 'urethral phenomenon'. He also made clear that women, too, gained 'pleasure from emptying the bladder'.[63] Many such moments characterize 'The Warm Decembers' where readers find a youthful, triangulated, Beatrix Martin forced to urinate in public, at night, where 'over the finally cool', 'never thirsty enough clay', she lets her urethral sphincter lapse, and the 'burning, banked-up piss' splits the 'uneven ground', as the sound reverberates around a surrounding 'sloppy landscape'.[64] This, in turn, brings to mind one of Sedgwick's c. 2002 textiles: *I Borrow Moonlight for This Journey of a Million Miles* (see Figure 1.10).

The hanging combines a Japanese death poem with a late J.M.W. Turner-like facture and obsession with light, recalling the moonlight of Beatrix's flit and urination, and a spreading, thalassic yellow across a child's indigo sheet that evokes another moment in 'The Warm Decembers' where readers are invited to imagine a

> child wetting its bed
> (and say the family's poor, the beds are shared,

60 Sedgwick, *Between Men*, 161.
61 Sedgwick, *Fat Art*, 60–61.
62 Sándor Ferenczi, *Thalassa: A Theory of Genitality* (1938; London: Karnac, 1989).
63 Ferenczi, *Thalassa*, 7, 11, 48, 107.
64 Sedgwick, *Fat Art*, 110–11.

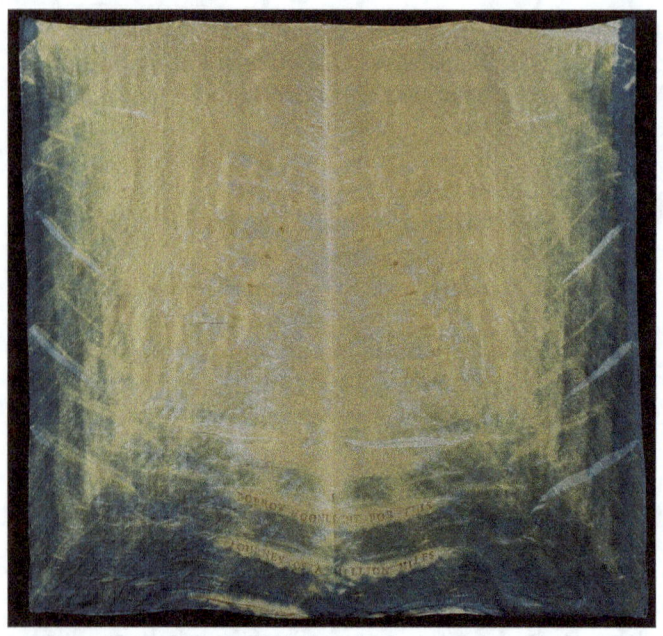

Figure 1.10. Eve Kosofsky Sedgwick, *I Borrow Moonlight for This Journey of a Million Miles* (c. 2002), ink on silk, dimensions unknown. Photo: H.A. Sedgwick, Collection H.A. Sedgwick.

> the washing's done in buckets and by hand,
> the drying sheet smothers the attic room)
> whose crazy father then decides:
> This is a child who 'must not' be given water.
> Or, that it's dangerous to let this child sleep.
> The awful logic nods only when he does –
> and then the parching child nods off
> in sleep that's only waking, waking.
> Waking to violence or the expensive wet
> that makes violence. And say the child survives
> and finds, somewhere, an art.[65]

[65] Ibid., 147.

In the poem, Beatrix's road eventually widens, and, somewhere, not quite over the rainbow, but outside the strangling triangulation of being between men, she makes a fat art like Sedgwick's, for whom a bladder-like 'vacant, distended, paper-light globe / called 'gratitude', fills up the inner space / (gratitude as it were for water and for sleep)'.[66]

But what of Manet's woman, forever trapped between men, without the comfort of another woman for company, and of Sedgwick, identified with her, at this moment in her career? Is she *pissed off,* as in angry? Does she want those men to *piss off,* to go away? Does she think the position of women is *piss poor*? Is she seeking to *piss on,* or *all over,* patriarchy, to spoil it? Certainly, Manet's nude doesn't seem to have a *pot to piss in*. Or, is Sedgwick *taking the piss* out of patriarchy? What is the emotional weather in the cropped artwork I have facetiously renamed *A Piss on the Grass*? Obviously, it is not *pissing it down,* as in raining. Equally clearly, Sedgwick is not *pissing about or around*. Even though *Between Men* is a funny book, it is deadly serious. Indeed, at moments it is so funny that it is not just women of a certain age and reproductive experience who risk *pissing themselves* laughing. Manet's female figure is also not pissed, as in drunk, or on the piss; this is a drearily bourgeois, dry *déjeuner*.

Whatever the weather, Sedgwick's task in *Between Men* was certainly not a *piece of piss,* as we know from the book's often *pissy* reception.[67] Nor was Sedgwick seeking to *piss in someone's pocket,* to borrow an Australian phrase, meaning, to ingratiate herself with anyone by writing the book, although she was, like Manet's nude and man in the middle in relation to the viewer, seeking an audience beyond homosocial triangulation: an audience of feminists, gay men, and their mutual allies. And, given how game-changing the book was, Sedgwick wasn't just *pissing in the wind* with her ambition.

66 Ibid., 147–48.

67 For example, see Sedgwick's response to David Van Leer's review, 'The Beast of the Closet: Homosociality and the Pathology of Manhood', *Critical Inquiry* 15, no. 3 (Spring 1989): 587–605, in 'Tide and Trust', *Critical Inquiry* 15, no. 4 (Summer 1989): 745 57.

Like Beatrix, Sedgwick evidently spent much time pondering the epistemology of her water closet. In *Dialogue,* she later recalled being toilet trained and documented her pleasure in the word 'we', her 'favourite pronoun': the 'dear / first personal plural', the French word for 'yes', a word that she remained 'addicted to' even in adulthood, and a bodily fluid, 'permeable we[e]' that was not so secretly a 'matter of pride' to her.[68]

The cover of *Between Men* was not Sedgwick's only bathroom song, then, as her c. 1996 poem of the same name also demonstrates, nor her only thalassic 'masterpiss'.[69] It is to the book I now cannot help but thinking of as *E-piss-temology of the Closet* that we now turn to, to conclude the chapter.

'When the Diagnosis Came', or *Epistemology of the Closet*

At first glance, the first edition of *Epistemology of the Closet* again may not seem much like an artist's book (see Figure 1.11).

But, to celebrate their centenary, California University Press chose it as one of a hundred books published between 1990 and 1995 that bore a 'special imprint' to represent an example of its 'finest publishing and bookmaking traditions'.[70] In addition, as Sedgwick documented, the book had 'come out' — in her evocative phrase — two months before she was diagnosed with breast cancer. As such, it had been published 'at the best possible time', 'if feeling ready to die' was a criterion. She had, however, been 'amazed at how satisfying its publication was', and, as 'an object' — a reparative good object — she felt the book 'looked lovely — everyone said so'. Indeed, it was 'one of those happy times when you say to yourself, "Okay, this is good, this is enough; I'm ready to go now"'. That was because, 'when the diagnosis came', she was 'feeling — as an intellectual — loved, used, appreciated' and 'would have been very, very content to quit while [she] was

68 Sedgwick, *Dialogue,* 105–6. Addition mine.
69 For more, see my *Bathroom Songs,* 31–36, 209, and Herring, 'Sedgwick's Other Materials'.
70 Sedgwick, *Epistemology,* inside leaf.

ahead'. Was she surprised to be feeling that? 'No. No', she said, in quick succession, in an idiom picked up from her mother.[71] 'To feel the wish of not living' was 'one of the oldest sensations' she could remember.[72]

Designed by Barbara Jellow, *Epistemology* remained Sedgwick's favorite design amongst her books, and one whose visual and material idiom was again distinctively Kosofskian. After all, the image of a person stepping into the light resonated closely with a woman whose wish to die had been deep rooted since childhood; with a critic who had long pondered James Merrill's séance poems;[73] and with a poet whose own 'Warm Decembers' had wondered what happened to a soul after death; the 'dispersing

> in that death-
> that-comes-after-death, when the spirit
> so far nearly intact, though fainter and
> subtly off, or subtly tendentious — struggles and gives way,
> losing its resemblance to the lost person
> but, suggestible and promiscuous, drifts apart,
> worn to the very atoms of the stuff of soul. [74]

Sedgwick's was not, however, the only mortality that preoccupied her around 1990. Two of her favorite contemporary queer authors had died, or were close to dying, in 1990–1991, and she was at work on two of her most famous obituaries: 'White Glasses', for Michael Lynch, and 'Memorial for Craig Owens'.[75] Owens had died on July 4, 1990, whilst Lynch would die just over a year later, on July 9, 1991, although 'White Glasses' was, famously,

71 Sedgwick, *Fat Art*, 122.
72 Sedgwick, *Dialogue*, 4–5.
73 For more, see James Merrill, *The Changing Light at Sandover* (New York: Athenaeum, 1984), the '1001 Seances' special issue of *GLQ* 17, no. 4 (2011), and my *Bathroom Songs*, 35–51.
74 Sedgwick, *Fat Art*, 130.
75 Sedgwick, *Tendencies*, 104–8, 252–66.

Figure 1.11. Eve Kosofsky Sedgwick, front cover of *Epistemology of the Closet* (1990, first edition), featuring an unlocated photograph by Baron de Meyer.

written as early as the summer of 1990.[76] A number of her closest friends and allies were stepping into the light.

If *Epistemology*'s cover takes on a retrospective poignancy, however, the most obvious reading of de Meyer's image is as a scene of coming out. In the first instance, a turn-of-the-century Euro-American gay man is coming out, the subject of the book's arguments. But, it would be absurdly literal, in the context of Sedgwick's oeuvre, to imagine any straightforward relationship between anyone's given sex and their promiscuous identifications across genders and sexualities. After all, in the Winter of 1990–1991, just as *Epistemology* was coming out, Sedgwick and Michael Moon published 'Divinity', in which he came out as a fat woman, and she as a gay man.[77] But de Meyer's photograph leaves open whether the man is on the verge of coming out, as Sedgwick strategically remained in the first edition, 'stubbornly fail[ing] to come out as either a lesbian or a heterosexual'; or depicts a person stepping back in, since it was only in the 'Preface' to the second edition that she explained that when she had 'had sex with another person, it ha[d] been with a man'.[78] Either way, the photograph speaks to what she might have referred to as the *peri*-closet: the space immediately adjacent to it, if one understands coming out as a stepping from darkness into a light that obscures as much as illuminates the new situation — or inside the closet, if one imagines closeting oneself as again entering a space of warm, well-lit fantasy.[79]

76 Gallop, *Deaths of the Author*, 100. For a bravura reading of 'White Glasses', see Monica Pearl, 'Eve Kosofsky Sedgwick's 'White Glasses', *Textual Practice* 17, no. 1 (2003): 61–80. Sedgwick's memorials to women are less well known. For example, see her 'Eulogy', *Women and Performance: A Journal of Feminist Theory* 25 (2002): 233–35.

77 Sedgwick, *Tendencies*, 215–51.

78 Eve Kosofsky Sedgwick, *Epistemology of the Closet*, 2nd edn. (Berkeley: University of California Press, 2008), xv, hereafter cited as *Epistemology 2*.

79 For more on the spatiality of the closet, see Eve Kosofsky Sedgwick, Michael Moon, Benjamin Gianni, and Scott Weir, 'Queers in (Single Family) Space', *Assemblage* 24 (August 1994): 30–37, reprinted in Ben Highmore, ed., *The Design Culture Reader* (New York: Routledge, 2009), 40–49. See also Henry Urbach, 'Closets, Clothes, Disclosure', in *Gender, Space,*

Epistemology was the first of two books by Sedgwick to employ the work of a famous long nineteenth-century photographer, here Baron Adolph de Meyer; the other would be *Novel Gazing*, which would employ a photograph by Clementina Hawarden, as we shall see.[80] De Meyer was a famous portrait and royal photographer, who worked as the official fashion photographer for *Vogue* from 1913 to 1921, as well as for *Vanity Fair* and *Harper's Bazaar* in Paris, from 1922 to 1938. The scion of a Scottish mother and German-Jewish father, de Meyer was educated in Dresden, joining the Royal Photographic Society in 1893, before moving to London two years later, in the year of the Wilde Trials. de Meyer was the first of a number of twentieth-century, German-Jewish photographers that preoccupied Sedgwick.[81]

Sedgwick may have identified with de Meyer for various reasons. Her own father was a German-Jewish photographer for NASA.[82] Sedgwick and de Meyer were also both respectively in-

Architecture: An Interdisciplinary Introduction, eds. Jane Rendell, Barbara Penner, and Ian Borden (London: Routledge, 2003), 342–52.

80 Inside *Epistemology,* meanwhile, Sedgwick noted that, 'like many Atget photographs', *The Picture of Dorian Gray* and *Billy Budd* (both published in 1891) framed the 'human image high up in the field of vision, a singular apparition whose power to reorganize the visibility of more conventionally grounded figures is arresting and enigmatic' (131). For example, see plate 61 of William Howard Adams, *Atget's Gardens* (New York: Doubleday, 1979).

81 For more on de Meyer, see John Szarkowski, Willais Hartshorn, and Anne Ehrenkranz, *A Singular Elegance: The Photographs of Baron Adolph de Meyer* (San Francisco: Chronicle/International Centre of Photography New York, 1995), and G. Ray Hawkins and Alexandra Anderson-Spivy, *Of Passions and Tenderness: Portraits of Olga by Baron De Meyer* (Marina Del Rey: Graystone, 1992). Sedgwick would also employ a photograph of a woman and young girl by turn-of-the-century German photographer Heinrich Traut, for one of her c. 2005 *Works in Fiber, Paper, and Proust*. I am grateful to Carol Mavor for helping me identify Traut. For more on the visuality of the closet, see Jason Edwards, ed., *Anxious Flirtations: Homoeroticism, Art, and Aestheticism in Victorian Britain,* special issue of *Visual Culture in Britain* 8, no. 1 (Spring 2007), and Dominic Janes, *Picturing the Closet: Male Secrecy and Homosexual Visibility in Britain* (Oxford: Oxford University Press, 2015).

82 For example, see L.J. Kosofksy and Farouk El-Baz, *The Moon As Viewed by Lunar Orbiter* (Washington, DC: NASA, 1970).

volved in a decades-long queer marriage, and shared a passion for Buddhist sculpture and masturbation, as we have seen — the latter signaled in Sedgwick's 'Jane Austen and the Masturbating Girl', and in de Meyer's 1912 photographs depicting Nijinsky ejaculating.[83] But if the Nijinsky jizz shot might have made a perfect, alternate cover for *Tendencies,* Sedgwick's choice for *Epistemology* is equally note perfect, given the subtle distinction, within De Meyer's own work, between being calmly inside, preparing to come out, fashionably stepping out, cruisily looking out, flamboyantly coming out, and being securely out.

Epistemology's marbled cover, meanwhile, features a second, less figurative, more abstract drama, of inside and outside, concealment and revelation.[84] This circles around the again fleshy, cutaneous pink marbled papers forming the backdrop to de Meyer's image. These were traditionally employed for interior *pages de garde,* rather than used on covers, in nineteenth-century books, with the effect that *Epistemology* is turned inside out, just as *Dialogue* reproduces, on its jacket, an image of the gutter running between its inside pages. The Japanese technique of *suminagashi,* or 'spilled ink', was, subsequently, one of Sedgwick's favorite ways to pattern paper and fiber, and a further, early indication of her sustained and sustaining engagements with Asian art and thought. In suminagashi, colored inks are not applied directly to paper, as in painting, although the pattern has been subsequently printed onto *Epistemology*'s cover. Instead, color is applied, using a small brush or hair, to the surface of a shallow water bath. This is then blown gently, or lightly brushed, with a comb or fine stick, to create a pattern. Then, a single piece of paper is laid upon the surface to receive the pattern.[85]

83 Sedgwick, *Tendencies,* 109–29; Szarkowski, *Singular Elegance,* 17, 34–36.

84 For more on queer formalisms, rather than figurations, see Jennifer Doyle and David J. Getsy, 'Queer Formalisms: Jennifer Doyle and David Getsy in Conversation', *Art Journal Open* 72, no. 4 (Winter 2013), http://artjournal.collegeart.org/?p=4468.

85 For more, see Ann Chambers, *Suminagashi: The Japanese Art of Marbling — A Practical Guide* (London: Thames and Hudson, 1991), 6.

Figure 1.12. Eve Kosofsky Sedgwick, *Untitled* (date unknown), laser print of section of brown, blue, and gray *shibori* and *suminagashi* dyed fabric, framed in white with red chop/seal overlapping one corner, 27.94 × 21.59 cm. Photo: Jason Edwards, collection of Jason Edwards.

The process depends on chance and the co-agency of artist and medium. The pattern cannot be fully controlled or repeated. In comparison with *Epistemology*'s explicitly axiomatic ambitions, especially at the beginning of the book, Sedgwick's foregrounding of *suminagashi* on the cover represents an increasingly well-developed parallel strain in her work, in which what she called the 'middle ranges of agency' were key (see Figure 1.12).[86]

For example, according to Ann Chambers, *suminagashi* responds to the 'nature of water' whose Taoist character is to be in 'constant flux, impossible to fix or hold', and 'what is transferred to paper' is a unique, 'momentary pattern'. *Suminagashi* is also an art form that is 'essentially spiritual' in which practitioners are encouraged to take a 'number of deep breaths', before commencing, 'to clear the mind and body of tensions'. As such, the technique anticipates what would soon become Sedgwick's sustained interest in Buddhist spiritual and aesthetic practice; and emphasises her interest in Orientalism and Occidentalism within the text.[87]

If Queer Asian scholars have not yet noticed Sedgwick's passion for *suminagashi,* her interests in the technique, c. 1990, may have been both spiritual and erotic. After all, to quote Gabriele Grunebaum, author of a 1984 Dover how-to guidebook that Sedgwick studied, the technique of *suminagashi* responded to the 'coming together' and 'spreading out' of waves[88] — an erotics of coming together that needs no parsing and of *spreading* central to Sedgwick's perverse accounts of enjambment in 'A Poem is Being Written'. It is also present in the S/M thematics of her

[86] Sedgwick, *Weather,* 79. For Sedgwick's reflections on the differences between suminagashi and European marbling techniques, see ibid., 83–84.

[87] Chambers, *Suminagashi,* 72, 76; Sedgwick, *Epistemology,* 175–76. For more on Sedgwick's reparative queer spirituality, see Ann Cvetkovich, 'The Utopia of Ordinary Habit: Crafting, Creativity, and Spiritual Practice', in *Depression: A Public Feeling* (Durham: Duke University Press, 2012), 154–202.

[88] Gabriele Grunebaum, *How to Marbleize Paper: Step-by-Step Instructions for 12 Traditional Patterns* (New York: Dover, 1984), 16.

c. 1993 poem, 'A Scar', in which a fellow hospital patient is instructed, in a 'far murmur that only barely / wasn't [Sedgwick's] imagination' to 'spread your legs', 'hearing which' she knew she had found a new resource for her masturbatory imagination.[89]

In addition, laying a sheet of *suminagashi* paper gently 'on the surface of the bath', to again cite Chambers, again recalls Beatrix Martin, in 'The Warm Decembers', who is similarly 'manipulated and fractured' by her father, in a 'red-gilt tub'.[90] Sedgwick's eponymous anti-hero, 'Trace', meanwhile, can be found buying a 'scarf / stained with feathery mauve-and-azure / waves ("Marbled by Hand", like endpapers)'.[91] Sedgwick does not tell us who receives this gift, but, given the *suminagashi* palette on the cover of *Epistemology*, it might be her readers, the book representing a hand-marbled, present from a transitioning man, Trace, or queer woman, Sedgwick, who is not quite or yet a gay man.

In addition to the potential s/m resonances of the marbled cover, and pedo-philia of *Epistemology*'s footnotes, readers might also meditate on the bossy s/m dynamics of being told first to look down from the main text to its footnotes, and then back up again at the author, and want to take seriously the notes' location at the *bottom* of the page, a page that, as a result, requires *rimming,* in the sense of paying attention to its lower rims, in order to be fully comprehended.

These anal thematics are perhaps especially present and pertinent in the case of the famous footnote 33 of Chapter 4, that I have already briefly alluded to, and whose aqueous holding environment suddenly takes on new importance. This footnote refers to the 'f[ass]cinating passage' in James's *Notebooks*, in which he imagined fisting himself, or his muse fisting him, rooting around inside him for long-digested inspiration; the muse's 'soft', 'cool', 'stead[ying]', 'inspir[ing]' breath on his cheek, as he plunged his hand and arm '*in,* deep and far, and up to the shoul-

89 Sedgwick, *Fat Art*, 29.
90 Chambers, *Suminagashi*, 62; Sedgwick, *Fat Art*, 101. Readers might also identify Beatrix's bath with the bath she later employs to develop her photographs.
91 Sedgwick, *Fat Art*, 53.

der', 'fish[ing] out every little figure and felicity', 'fact and fancy', previously 'packed away', 'thicker' than he could 'penetrate', 'deeper' than he could 'fathom' in the 'sacred cool darkness' (see Figure 1.13).[92]

In 2008, Sedgwick published a second edition of *Epistemology*, with a fancy, new, queer, *serifed,* rather than *straight* font,[93] especially noticeable in the musically slurring, curvaceous form of the letters 's' and 'g', on its Victorian calling-card cover (see Figure 1.14).

In the later revision, designed by Sandy Drooker, De Meyer's gentleman no longer steps into, or backs out of, bright, white light. Instead, he seems to look back into an aquarium tank or be himself immersed in one. This was a scene that preoccupied the subject of the last chapter of the book, Marcel Proust, who, in volume 3 of *In Search of Lost Time — The Guermantes Way* (1920–1921) — described seeing a fish that drifted past, 'unconscious of the press of curious gazers, behind the glass wall of an aquarium'. In volume 5, *The Captive* (1923) and *The Fugitive* (1925), Proust also recalled being stood 'in front of the luminous wall of an aquarium, watching the strange creatures moving around in the light'.[94] In addition, Proust described how the dining room of a seaside hotel, at Balbec 'became as it were an immense and wonderful aquarium against whose glass wall the working population of Balbec, the fishermen and also the tradesmen's families, clustering invisibly in the outer darkness,

92 Sedgwick, *Epistemology*, 208n33, citing Henry James, *Notebooks of Henry James*, eds. F.O. Matthiessen and Kenneth B. Murdock (New York: Oxford University Press, 1947), 318.

93 Joanna Drucker, *Figuring the Word: Essays on Books, Writing, and Visual Poetics* (New York: Granary, 1998), 56. For more, see *The Alphabetic Labyrinth: The Letters in History and Imagination* (London: Thames and Hudson, 1995) and *A Century of Artists' Books* (1994; New York: Granary, 2004).

94 Marcel Proust, *In Search of Lost Time,* Vol. 3: *The Guermantes Way,* trans. Terence Kilmartin and C.K. Scott Moncrieff, rev. D.J. Enright (1920–21; London: Vintage, 2000), 41, and Vol. 5: *The Captive and The Fugitive,* trans. Terence Kilmartin and C.K. Scott Moncrieff, rev. D.J. Enright (1923 and 1925; London: Vintage, 2000), 596.

Figure 1.13. Eve Kosofsky Sedgwick, *Tender Winds Above the Snow Melt Many Kinds of Suffering* (c. 2002), quilted cyanotype. Photo: Kevin Ryan, © Eve Kosofsky Sedgwick Foundation.

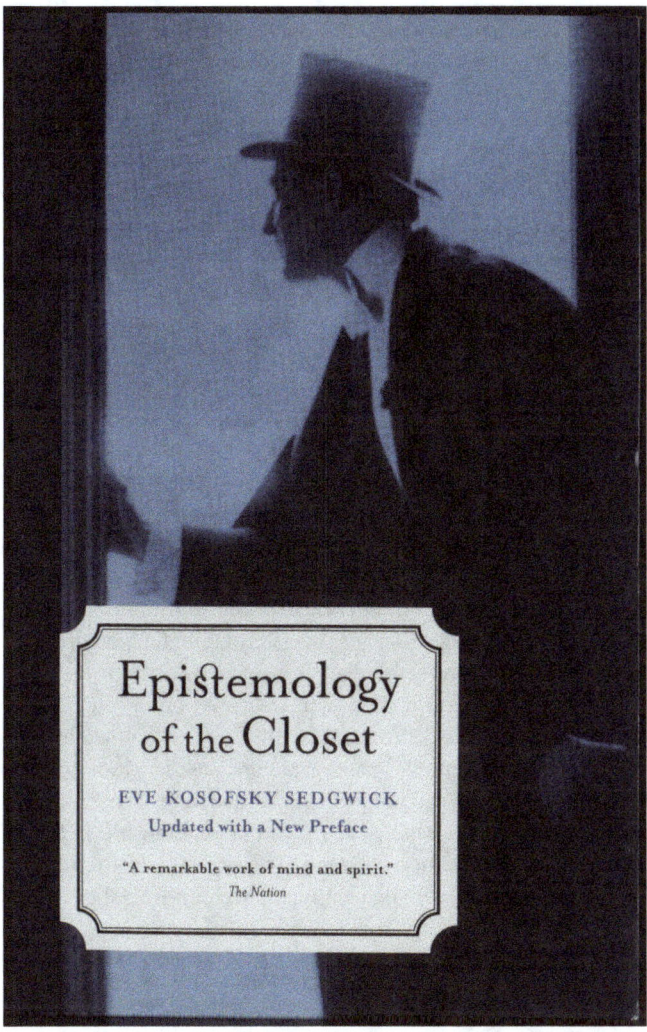

Figure 1.14. Eve Kosofsky Sedgwick, front cover of *Epistemology of the Closet* (2008, second edition), again featuring an unlocated photograph by Baron de Meyer.

pressed their faces to watch the luxurious life of its occupants gently floating upon the golden eddies within'.[95]

In addition to identifying with Proust, rather than objectifying him, as she would again in *Epistemology*'s final chapter, Sedgwick's artworks from across the subsequent period have already revealed the way in which she had become intensely preoccupied, in the period between 1990 and 2008, with the blue-printing cyanotype process. The cyanotype process had been first made famous by early Victorian botanist and pioneer photographer, Anna Atkins, through the publication of her triple-decker dossier, *Photographs of British Algae: Cyanotype Impressions* (1843), a reference guide to native seaweed, containing more than 380 sun-prints (see Figure 1.15).

Atkins made these by combining, in equal parts, a solution of potassium ferricyanide and ferric ammonium citrate. This was then pasted onto a leaf of paper and set in a dark place. Once it was dry, Atkins brought the treated paper into the sun and placed a natural object, such as a strand of seaweed, on it, before leaving it in the light. The surface exposed to the sunlight then darkened to a marine blue, appropriately enough given the subject matter, whilst the shaded areas remained white.[96]

If Sedgwick's identification with De Meyer and Proust represented an aspect of her broader identification with gay men and long nineteenth-century photographers, also including Julia Margaret Cameron, Clementina Hawarden, and P.H. Emerson, as we shall see, Sedgwick's identificatory relationship between Atkins provided further, retrospective evidence of the importance of (Victorian) female creativity and homosociality to her,

95 Marcel Proust, *In Search of Lost Time*, Vol. 2: *Within a Budding Grove*, trans. Terence Kilmartin and C.K. Scott Moncrieff, rev. D.J. Enright (1919; London: Vintage, 1996), 299–300.

96 Atkins subsequently created two more botanical surveys, with the assistance of her close friend Anne Dixon, *Cyanotypes of British and Foreign Ferns* (1853) and *Cyanotypes of British and Foreign Flowering Plants and Ferns* (1854). For more, see Larry J. Schaaf, *Sun Gardens: Victorian Photograms by Anna Atkins* (New York: Hans P. Kraus, Jr, 1985), and Barbara Hewitt, *Blueprints on Fabric: Innovative Uses for Cyanotype* (Colorado: Interweave, 1995), 14.

and of more contemporary queer feminism and women's studies to the book. After all, as she acknowledged in the 2008 Preface, her decision not to come out in the first edition was partly in response to a women's studies class she taught at Amherst in 1985. Introducing a section on lesbian issues, she 'apologized that as a non-lesbian' she felt at a 'disadvantage in understanding this material'. This led to a trio of students from the women's basketball team' showing up at her office hour, who told her 'firmly, but in this case kindly, that whatever [she] did [she] musn't do *that* again', since 'the meaning that came through to them as gay women was the clangorously phobic (in effect) disavowal of being one'.[97]

Questions of positive and negative are also central to the cyanotype process, as to all processes of 'analog' photography, where practitioners start with a negative and reverse its polarity upon developing the image. This must have resonated powerfully with the realities of being HIV positive or negative in the period of *Epistemology*'s conceptualisation and writing. As a result, the color blue resonates profoundly. In 2008, De Meyer's figure came out of the blue, suggesting the importance of surprise to Sedgwick's art and late writing. Or, with one of Sedgwick's favorite passages from Shakespeare's *The Tempest* (1610–1611) in mind, he might be imagined to be sinking into the blue, suffering a 'sea-change' into 'something rich and strange', his bones becoming coral, his eyes pearls.[98] This was an apt image of the transformations of coming out, perhaps, as well as of the somatic and ultimately mortal transformations entailed by HIV and AIDS, especially given the famously blue screen of Derek Jarman's poignant last 1993 film, *Blue,* and his 1979 version of *The Tempest,* Shakespeare's final play, the one in which Prospero's 'every third thought shall be [his] grave', and

97 Sedgwick, *Epistemology 2*, xxvi.
98 Sedgwick, *Tendencies*, 73–106; 99–100.

Figure 1.15. Anna Atkins, *Cystoseire granulata* (c. 1843, cyanotype photogram, dimensions unknown, from Photographs of British Algae: Cyanotype Impressions). Gilman Collection Purchase, the Horace W. Goldsmith Foundation Gift, through Joyce and Robert Menschel, 2005. Metropolitan Museum of Art New York: 2005.100.557 (8). Public domain.

that similarly employed found monochrome footage, and new coastal film, both filtered through a blue lens.[99]

If De Meyer's man thus seems to be 'plunging in the foaming brine' of Act I, Scene II of *The Tempest*, 'like a nymph of the sea', and if Shakespeare's Miranda, in the same scene, thought that 'There's nothing ill can dwell in such a temple', readers might still be inclined to think about the potential relationship between De Meyer's bruised black-and-blue figure and the aptly named Gary Fisher. Sedgwick had first met Fisher in 1987, three years before the publication of *Epistemology of the Closet*, and he receives an acknowledgement in the book.[100] Then, in a 1994 poem, she compared Fisher to the blue Hindu deity Ganesh, who survived his own decapitation.[101] With Fisher in mind, spectators might also consider the cover's evocative combination, of the black, blue, and colored, with 'all of their associations of racial slurs'.[102] Or, they might allow Carol Mavor to remind them, that, in French, *bleu* refers to both the color and a bruise,[103] making the cover a *punctum*, a potentially bruised and bruising image that suggests the painful uncertainty, for both parties, of any coming

99 For more, see Jim Ellis, 'Conjuring the Tempest: Derek Jarman and the Spectacle of Redemption', *GLQ* 7, no. 2 (2001): 265–84, and Tim Lawrence, 'AIDS, The Problem of Representation and Plurality in Derek Jarman's *Blue*', *Social Text* 52/53 (Autumn-Winter 1997): 241–64. It is highly likely that Sedgwick knew of the latter since her own response to C. Jacob Hale's 'Leatherdyke Boys and Their Daddies: How to Have Sex without Women or Men' was immediately adjacent, 223–36, 237–39.

100 Sedgwick, *Epistemology*, ix; *Gary*, 275.

101 Sedgwick, *Fat Art*, 13. For more on the metaphorics of black and blue, see Carol Mavor, *Black and Blue: The Bruising Passion of Camera Lucida, La Jetée, Sans soleil, and Hiroshima mon amour* (Durham: Duke University Press, 2012), and *Blue Mythologies: Reflections on a Color* (London: Reaktion, 2013), as well as Maggie Nelson, *Bluets* (London: Penguin, 2009). Mavor and Sedgwick became close at the time she was at work on *Novel Gazing*, which acknowledges her 'crucial and much-appreciated intervention' (vii).

102 Drucker, *Figuring the Word*, 62.

103 Mavor, *Blue Mythologies*, 56.

out conversation. Blue is also the color of the cornflower, the French bloom of remembrance.[104]

Alternatively, recalling Sedgwick's urethral aesthetics, viewers might think of De Meyer's blue-printed image, and the man steeped in blue within it, in relation to indigo, a color produced by steeping indigo seeds in human or animal urine,[105] especially since, as Michael Taussig documents, there was a potentially erotic component to Victorian indigo production, for anyone, like Sedgwick, who was sadomasochistically attuned to scenes of beating (off). After all, when all the ingredients were mixed together, the 'beating commence[d]' in the so-called 'beating vat', with numerous men, stripped to their waists, up to their navels in urine, thrashing the liquid 'in unison' with bamboo paddles: a painful, frothy, Melvillean scene of imperially enforced mutual masturbation and urination between men.[106]

Having now explored the queer iconography and materiality of Sedgwick's first three books, in the next chapter we turn to her first publications with Duke University Press.

104 Ibid., 91. For more on the *punctum*, see Roland Barthes, *Camera Lucida* (1981; London: Vintage, 2000). For more on blue as a colour of mourning and for the bardo of dying in South Asia, see Janet Hoskins, 'Why Do Ladies Sing the Blues? Indigo Dyeing, Cloth Production, and Gender Symbolism in Kodi', in *Cloth and Human Experience,* eds. Annette B. Weiner and Jane Schneider (Washington, DC: Smithsonian, 1989), 141–76.
105 Mavor, *Blue Mythologies*, 35.
106 Michael Taussig, 'Redeeming Indigo', *Theory, Culture, and Society* 25, no. 3 (2008): 1–15. For Sedgwick's relation to Melville, see *Epistemology*, 91–130. In thinking of Sedgwick's possible relationship to such painful imperial scenes as indigo production, her 1985 essay 'A Poem Is Being Written' reminds readers of the complex erotics that might be involved, what she there calls the 'graphic multicharacter drama of infliction and onlooking', involving the 'visibly rendered plural possibilities of sadism, voyeurism, horror, *Schadenfreude*, disgust' and 'compassion', with such scenes likely to represent a 'free switchpoint for the identities of subject, object, onlooker, desirer, looker-away', and of the 'active and passive', 'reactive' and 'impassive' (*Tendencies*, 183). Fisher's own erotics similarly gravitated towards the profoundly, performatively, racially sadomasochistic. On the terrible realities of indigo production in mid-nineteenth-century colonial South Asia, and the resistance to them, see Subhas Bhattacharya, 'The Indigo Revolt of Bengal', *Social Scientist* 5, no. 12 (July 1977): 13–23.

2

Black Queerness, White Glasses:
Tendencies, Or, *Gary in Your Pocket*

A Queer Child, Growing Sideways, or, Tales of the Avunculate[1]

First published in 1993, *Tendencies* initiated the second phase of Sedgwick's book art. As the co-editor of Series Q, with Michael Moon, Michèle Aina Barale, and Jonathan Goldberg, a queer theory list bookended by Sedgwick's *Tendencies* and posthumous last book *The Weather in Proust* (2011), Sedgwick developed a close relationship with Kenneth Wissoker, the press's editor, and team of designers, to try to ensure the appearance of her books reflected her queerest desires (see Figure 2.1).

Tendencies' cover featured a Ken Brown photograph depicting a row of pretty, candy-pink-and-white trailers in the background, with a ticket booth in the foreground, that adults, defined as anyone over twelve, as well as children under twelve and

1 I derive my subtitle from Kathryn Bond Stockton, *The Queer Child, or Growing Sideways in the Twentieth Century* (Durham: Duke University Press, 2009). For Stockton's reflections on Sedgwick, see 'Eve's Queer Child', in *Regarding Sedgwick: Essays on Queer Culture and Critical Theory*, eds. Stephen Barber and David L. Clark (London: Routledge, 2002), 181–200, and 'Afterword', in *Reading Sedgwick*, ed. Lauren Berlant (Durham: Duke University Press, 2019), 274–78.

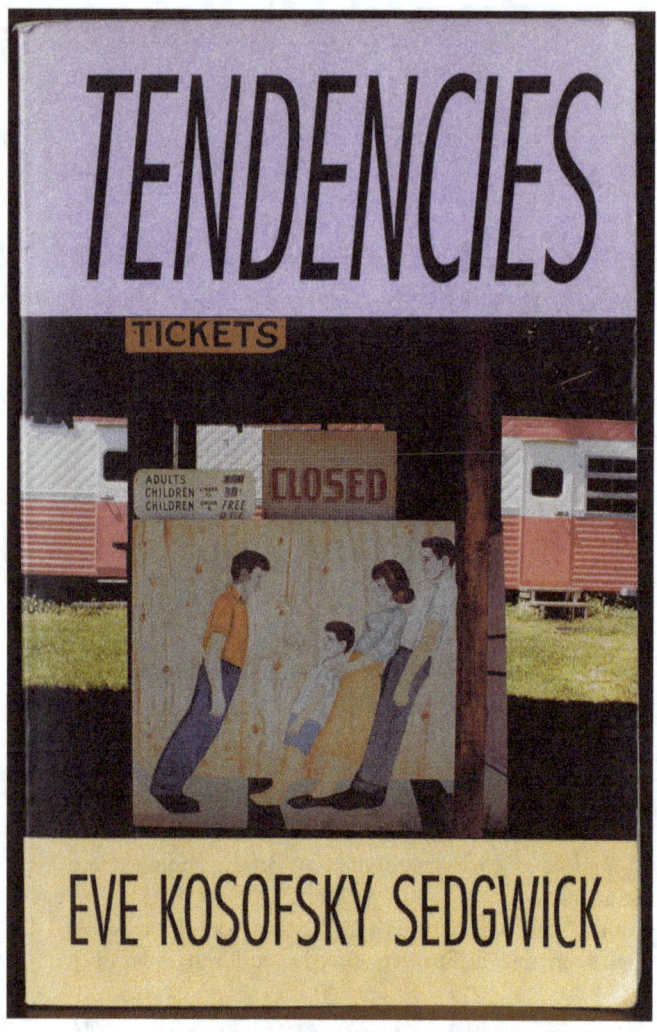

Figure 2.1. Eve Kosofsky Sedgwick, front cover of *Tendencies* (1993), featuring an unlocated photograph by Ken Brown.

six, can access at different rates, with young children going free. Whatever the amusement on offer, and in spite of the sunshine, the ticket booth is closed, because it is out of season, the wrong time of day, or because neoliberal metro-capitalism has left the location for dead.

Boarding up the ticket booth is a painted image of a nuclear family, framed against a knotted, wooden wall, standing on a stripy black-and-grey rug. The father, mother, and son lean to our right, on a forty-five-degree, bottom-left to top-right diagonal, echoing *Tendencies*' similarly slanted, italicized, capitalized title above. Sedgwick's name is unitalicised, apparently straight, below. In their slant to the right, the family embody the Reaganite shift across the US between 1981 and 1989 that *Tendencies* documents and does much to resist. As profiled, the family look alike. The father and son share their short-sleeved, white t-shirts and straightforward, short, back and sides haircuts. The father's high-waist, grey trousers harmonize with the mother's grey-blue, short-sleeved blouse, reaching to just below her elbows, emphasizing her breasts. The grey-blue palette of both parents' clothes is echoed in their son's shorts, which, in turn, harmonize with the spatially predominant grey stripe of the rug below them. The mother and father wear plain black shoes, echoing the subordinate carpet strip, whilst the son goes barefoot. The mother wears a modest, pale tangerine skirt that reaches below her knees, which echoes the lower band of color on which Sedgwick's name appears, an indication of the greater focus in the volume on women's inter-relations. This is a tight, cross-generational reproductive unit, in which the parents' handsome physiognomies, quietly fashionable dress, and conservative political and cultural leanings have been straightforwardly transmitted to their son.

A lone male figure leans towards this group. He is stood, less stably, on tiptoes, separated from the family by the left black stripe on the rug, behind which the family retreats. His quiet smile is picked up on the faces of the adults opposite, less on the boy's visage. Like the family, the man is wearing black shoes, uniform grey-blue trousers, and a short-sleeved t-shirt,

in a more saturated version of the orange palette of the mother's skirt and the place where Sedgwick's name appears below, suggesting, from the outset, the cross-gender and cross-sexuality identifications at the heart of *Tendencies*. His profile is akin to the family's. He shares their brown hair, and the contoured silhouette of the father and son's short hairstyle.

From our twenty-first-century perspective, it is, perhaps, difficult to think about the image without recalling *No Future*'s famous argument that '*queerness* names the side of those *not* "fighting for the children"'.[2] With Lee Edelman's 2004 queer polemic in mind, spectators might be tempted to read the image as an illustration, *avant la lettre*, of a queer man's pleasure in fucking with the heteronormative family and figure of the child. In this reading, the man leans in threateningly towards the personal space of the retreating family, a reading that chimes with the Reaganite/Thatcherite fantasy/reality that queer people posed a threat to family values and sought to recruit the young. This was, after all, the period of Clause 28 in the UK, which made it illegal to 'promote' homosexuality in schools, and in which the Republican government, in the US, was so phobic of queer eroticism that it shut down public sex education in schools despite the genocidal threat posed by HIV-AIDS. But I also say 'reality' because, as Lauren Berlant reminds us, the same period witnessed the Queer Nation motto 'We are Everywhere, We Want Everything', and I remember seeing queers wearing badges and t-shirts saying 'Yes, we recruit'.[3]

2 Lee Edelman, *No Future: Queer Theory and the Death Drive* (Durham: Duke University Press, 2004), 3.

3 Lauren Berlant, 'Live Sex Acts (Parental Advisory: Explicit Material)', in *Curiouser: On the Queerness of Children*, eds. Steven Bruhm and Natasha Hurley (Minneapolis: Minnesota University Press, 2004), 57–81; 77. For Berlant's relation to Sedgwick, see 'Eve Sedgwick, Once More', *Critical Inquiry* 35, no. 4 (2009): 1089–91; 'Two Girls, Fat and Thin', in *Regarding Sedgwick*, eds. Barber and Clark, 71–108; 'The Pedagogies of Pedagogy of Buddhism', *Supervalent Thought*, March 18, 2010, https://supervalentthought.com/2010/03/18/after-eve-in-honor-of-eve-kosofsky-sedgwick/; and 'Reading Sedgwick, Then and Now', in *Reading Sedgwick*, ed. Berlant, 1–5. See also Berlant and Lee Edelman's dialogue on multiple

Paying more attention to the image in the original historical and conceptual context of *Tendencies* might, however, modify that reading. Brown's family return the half-smile of the lone man, as they lean away from him, less an anxious or hostile retreat, then, as a pleasurable, synchronized performance, given the synced costumes all four wear. If so, then the family might lean less towards the Republican right than give ground to a newly powerful left. In addition, the harmonised movements emblematize what Sedgwick, a few pages later, called a continuing queer 'moment, movement' and 'motive' *across* thresholds, such as the ineffective, first black border on the carpet. If so, then the resemblance of the man to the family, and particularly the boy, suggests viewers are looking at a 'Tale of the Avunculate'. After all, in *Tendencies,* Sedgwick documented that 'uncle' was a 'common term for a male protector in a sexual relation involving economic sponsorship and, typically, class and age transitivity', as here, as well as a more general noun for the 'whole range of older men who might form a relation to a younger man (as patron, literal uncle, godfather, adoptive father, sugar daddy), offering a degree of initiation into gay cultures and identities'. Read in this queer light, viewers might reimagine Brown's image not as exemplifying the way family values stretch to incorporate the avunculate, but an example of the way the uncle's left orientation and queer idiom influences the family opposite, encouraging them to bend with him. As such, the image represents a family who has learned How To Bring Up Its Kid Gay, to borrow the title of Sedgwick's famous *Tendencies* essay.[4]

affects, *Sex, or the Unbearable* (Durham: Duke University Press, 2013) and the pair's 'What Survives', in *Reading Sedgwick,* ed. Berlant, 37–63. See also the dialogue between Sedgwick and Berlant that concludes with Sedgwick's 'Against Epistemology', in *Questions of Evidence: Proof, Practice, and Persuasion Across the Disciplines,* eds. J. Chandler, A.I. Davidson, and H. Harootunian (Chicago: University of Chicago Press, 1994), 132–36.

4 Eve Kosofsky Sedgwick, *Tendencies* (Durham: Duke University Press, 1993), xii, 52–72, 154–66. For an example of how 'scouting for girls' was 'bringing up girls to be gay', see Kathryn R. Kent, '"No Trespassing": Girl Scout Camp and the Limits of the Counterpublic Sphere', in *Curiouser,* eds. Bruhm and Hurley, 173–90; 185. For a related example of how to bring up

But, taken in its entirety, it remains uncertain whether Brown's photograph represents the right-leaning, heterosexist, and homonormative incorporation of queer energies into the project of extended family values, or the left-leaning queer project of refashioning the family in its perverse, non-familial, more-or-less friendly image that Sedgwick discusses at the end of her 'Tales of the Avunculate' essay.[5] At the centre of the image is, of course, the child, the least clearly gay, in the sense of happy, person in the image. Characterized in affectively flat terms, and leaning back towards his parents, the photograph perhaps concedes much to what James Kincaid has characterised as the 'old, melodramatic, gothic way of seeing intergenerational sex', and offers little to aid his desire to find other narratives.[6] And in this reading, the uncle, in the uncertain child's view, especially as juxtaposed with a trailer park, might bring to mind Michael Moon's recollection of queer figures being 'presented in freak shows at the local county fair in [his] childhood'.[7]

The boy's bare feet, however, could also signal what Richard D. Mohr described as the 'pedophilia of everyday life',[8] or Kevin Ohi's account of the mainstream cultural fantasy of the 'blank innocence of childhood', that is always an 'insistence on a (future and legibly incipient) heterosexuality'. Mainstream culture's widespread fantasy of the 'pleasures of seducing a child', aka het-

 girls to be tomboys, and then, tomboys to be adult bull dykes, see Judith Halberstam, 'Oh Bondage Up Yours! Female Masculinity and the Tomboy', in *Curiouser*, eds. Bruhm and Hurley, 191–214.

5 For more, see *Tendencies*, 71–72. For more on homonormativity, see Michal Warner, *The Trouble with Normal: Sex, Politics, and the Ethics of Queer Life* (Cambridge: Harvard University Press, 1999); Lisa Duggan, *The Twilight of Equality: Neoliberalism, Cultural Politics, and the Attack on Democracy* (London: Penguin, 2004); and Jasbir K. Puar, *Terrorist Assemblages: Homonationalism in Queer Times* (Durham: Duke University Press, 2007).

6 James Kincaid, 'Producing Erotic Children', in *Curiouser*, eds. Bruhm and Hurley, 3–16; 13, 15. For Kincaid's reflections on Sedgwick, see 'When Whippoorwills Call', in *Regarding Sedgwick*, eds. Barber and Clark, 229–43.

7 Sedgwick, *Tendencies*, 216.

8 Richard D. Mohr, 'The Pedophilia of Everyday Life', in *Curiouser*, eds. Bruhm and Hurley, 17–30; 17.

erosexual parenting, is thus here displaced, with an enjoyable sense of 'moralized reaction', onto the figure of the lone, queer man. Indeed, it's worth noting that this image, unlike Sedgwick's *Déjeuner,* has *got wood,* given the knotted, grainy background.[9]

Alternatively, following Ellis Hanson's claim that children are queer subjects, whose sexuality is 'subjected to an unusually intense normalizing surveillance, discipline, and repression of the sort familiar to any oppressed sexual minority', viewers might read the barefoot boy as a 'polymorphously perverse child' with a Sedgwickian inkling towards *pedo*-philia.[10] He might not be beaming, but he isn't trembling or weeping either, and Brown emphasizes the cutaneous contact of the soles of the boy's feet with the texture of the rug, a genre Julia Bryan-Wilson evokes as potentially queer, and a foot that *Tendencies* describes as the 'most universally repressed and mutilated of pleasure taking organs'.[11]

But in remaining difficult to resolve, as an image of triumphant normativity or seductive queerness, Brown's photograph skillfully intervenes in what *Tendencies* described as the 'dispiriting debates on "the seduction theory"'. It refuses the polarized positions of the 'totally volitional, unproblematically "active" child free to choose' who he is identified with, and the 'view of the child as the perfect victim, totally passive and incapable of relevant or effectual desire'. Indeed, a playful tug of war without a rope takes place, between the queer uncle and the parents, a scene acknowledging what *Tendencies* characterizes as the 'near-inevitability of any child's being "seduced" in the sense of being inducted into, and more or less implanted with, one or

9 Kevin Ohi, 'Narrating the Child's Queerness in What Maisie Knew', in *Curiouser,* eds. Bruhm and Hurley, 83–103; 83–85, 102–3.

10 Ellis Hanson, 'Knowing Children: Desire and Interpretation in The Exorcist', in *Curiouser,* eds. Bruhm and Hurley, 107–39; 110.

11 Sedgwick, *Tendencies,* 205; Julia Bryan-Wilson, 'Queerly Made: Harmony Hammond's Floorpieces', *The Journal of Modern Craft* 2, no. 1 (March 2009): 59–80. For more, see Bryan-Wilson's *Fray: Art and Textile Politics* (Chicago: University of Chicago Press, 2017).

Figure 2.2. H.A. Sedgwick, author photograph of Eve Kosofsky Sedgwick, from the back cover of *Tendencies* (1993).

more adult sexualities whose congruence with the child's felt desires will necessarily leave at least many painful gaps'.[12]

Leaning with his parents *and* sympathetically with his uncle, Brown's boy, 'objectively very disempowered', has the options to work out what he wants, and has not yet decided either way, but at least having 'intimate access to some range of adults, and hence of adult sexualities'. If this boy is lucky, his parents or uncle might buy him a copy of *Tendencies,* but even if not, when the book is spread or laid flat, he seems to be looking past his

12 Sedgwick, *Tendencies,* 64.

uncle and up at Sedgwick, on the back cover, at her most dykey and cancer butch (see Figure 2.2).[13]

Having now explored the queer valences of *Tendencies*' cover, in the next section we go under its covers, to explore further the volume's fonts and page layouts.

That Font Is So Gay

Sedgwick chose a distinctive Sabon serif for *Tendencies*' font that does much to give the book its visual character. In a recent article, 'How to Look at a Reading Font', Andrew Crompton suggests that, with the exception of typographers, 'few people could describe the font in the book they had just read', outside of the descriptions of letters as 'bundles of simple features such as horizontal, vertical or diagonal lines', and as 'combinations of black lines and white spaces'. That is because ideal reading fonts are 'self-camouflaged', such that if the letters are 'too individualistic we lose the thread of reading'. Compton also argues that because there is no standard way of describing fonts, they are open to 'personal interpretation, like Rorschach inkblots', as a result of which 'a worse subject for ekphrasis is hard to imagine'.[14] But, risking being the worst, I want to do just that, to offer a queer ekphrasis of Sedgwick's font (see Figure 2.3).

Sabon was originally designed by influential, early-twentieth-century typographer Jan Tschichold, in 1967, for linotype, monotype and letterpress equipment, providing the first indication that Sedgwick wanted *Tendencies* to resemble an artist's book. In designing the font, Tschichold's money- and space-saving brief was to ensure that slender, slanted italic and fat, heavy, bold styles took up the same space as roman, suggesting that Sedgwick remained interested, in *Tendencies,* in

13 For more, see S. Lochlann Jain, 'Cancer Butch', *Cultural Anthropology* 22, no. 4 (November 2017): 501–38.

14 Andrew Crompton, 'How to Look at a Reading Font', *Word and Image* 30, no. 2 (2014): 79–89; 79, 81–82, 86. For more, see Bob Gordon, ed., *1000 Fonts* (Lewes: Ivy, 2015), 149.

> QUEER
>
> AND
>
> NOW
>
> **A MOTIVE** I think everyone who does gay and lesbian studies is haunted by the suicides of adolescents. To us, the hard statistics come easily: that queer teenagers are two to three times likelier to attempt suicide, and to accomplish it, than others; that up to 30 percent of teen suicides are likely to be gay or lesbian; that a third of lesbian and gay teenagers say they have attempted suicide; that minority queer adolescents are at even more extreme risk.[1]
>
> The knowledge is indelible, but not astonishing, to anyone with a reason to be attuned to the profligate way this culture has of denying and despoiling queer energies and lives. I look at my adult friends and colleagues doing lesbian and gay work, and I feel that the survival of each one is a miracle. Everyone who survived has stories about how it was done
>
> > —an outgrown anguish
> > Remembered, as the Mile
> >
> > Our panting Ankle barely passed—
> > When Night devoured the Road—
> > But we—stood whispering in the House—
> > And all we said—was "Saved"!
>
> 1. Paul Gibson, "Gay Male and Lesbian Youth Suicide," U.S. Department of Health and Human Services, *Report of the Secretary's Task Force on Youth Suicide* (Washington, D.C., 1989), vol. 3, pp. 110–142.

Figure 2.3. Eve Kosofsky Sedgwick, *Tendencies* (1993), page 1.

ideas of the homo, even as the book explored the transitive.[15] Indeed, readers might read her choice of Sabon as a kind of typeface equivalent to Christopher Craft's argument, cited in *Tendencies*, regarding the 'vertiginous oscillation of "same" and "different"' when it came to the sound of words. According to Craft, punning was 'homoerotic because homophonic', and 'aurally enacting a drive toward the same, the pun's sound cunningly erases, or momentarily suspends, the semantic differences by which the hetero is both made to appear and made to appear natural, lucid, self-evident'.[16] Enacting a drive towards the same, and indifferent to the heterogeneous spatial claims of italic and roman, Sabon's appearance similarly erases or suspends the typographic differences by which the hetero is made to appear natural, lucid, and self-evident.

If this feels like over-reading, it is worth recalling Sedgwick's earlier axiomatic assertion, in *Epistemology of the Closet*, that 'an understanding of virtually any aspect of modern Western culture', presumably including its typefaces, 'must be, not merely incomplete, but damaged in its central substance to the degree that it does not incorporate a critical analysis of modern homo/heterosexual definition' and that the 'appropriate place for that critical analysis to begin from is from the relatively decentered perspective of modern gay and antihomophobic theory'.[17]

15 For more on the distinction between *Epistemology of the Closet* and *Tendencies*, see Sedgwick, *Tendencies*, xii.

16 Ibid., 53.

17 Eve Kosofsky Sedgwick, *Epistemology of the Closet* (Los Angeles: University of California Press, 1990), 1. My thinking on the homo and the hetero is indebted to Ben Nichols, who first taught me that, if Sedgwick is right, queer theory's predilection for the different might itself be homophobic. For more, see his 'Reductive: John Rechy, Queer Theory, and the Idea of Limitation', *GLQ* 22, no. 3 (2016): 409–35, and his *Same/Old: Queer Theory, Literature, and the Politics of Sameness* (Manchester: Manchester University Press, 2020). Jonathan Flatley's meditations on likeness are also vital. See his 'Unlike Eve Sedgwick', *Criticism: A Quarterly for Literature and the Arts* 52, no. 2 (Spring 2010): 225–34; 'Like: Collecting and Collectivity', *October* 132 (Spring 2010): 71–98; and *Liking Andy Warhol* (Chicago: University of Chicago Press, 2018). In a different idiom again

A second way Sabon sought to save money, by saving space, was by being 5% narrower than the existing Monotype Garamond, suggesting Sedgwick was uncharacteristically inclined towards a comparatively *thin* font, although the slender appearance of the normal font is more than offset by the *fat* heft of the capitalized font and initial letters in each chapter, as well as the weight of the book as a whole. *Tendencies* is her largest book. Its 281 pages outgrew *Epistemology*'s 258, by nearly 9%; *Between Men*'s 243 pages, by nearly 16%; and *The Coherence of Gothic Convention*'s svelte 175 pages, by nearly 61%.[18]

In addition to inventing Sabon, Tschichold was famous for another innovation: his promotion of the now-popular ragged-right margin style of book design; a ragged margin central to the poetic forms Sedgwick explored in *Fat Art,* and the appearance of Sedgwick's therapist, Shannon Van Wey's notes in *A Dialogue on Love,* as we shall see, although she does not adopt it in *Tendencies* — if anything, the opposite. With the exception of the front and back matter — the series title page, main title page, copyright information pages, contents, index, and Library of Congress pages — Sedgwick's pages are right justified, and appear rectilinear, *straight*. By contrast, and as I've already briefly suggested in Chapter One, the book's typographic innovation on all the other pages is, by contrast, more Modernist and queerly variant. On each chapter's title page, for example, the font appears in numerous different forms: fat, capitalized and bold, for the title and initial; capitalized and italic at various moments, without boldface, for emphasis; and regular Roman for the majority of the text, with scale differences marked, in superscript, for footnote numbers and the footnotes themselves.

Perhaps the single most distinctive feature of the text, however, is the certain slant of line, to echo Emily Dickinson's phrase, that characterizes each title page in which the title and subti-

is Madhavi Menon, *Indifference to Difference: On Queer Universalism* (Minnesota: University of Minnesota Press, 2015).

18 Sedgwick employs a similar device on the title page of *Fat Art,* where the words 'FAT ART' are reproduced in a fat, capitalized, bold font, whilst 'THIN ART' is in a slender, Roman upper case.

tle text descend, from the top left, at a forty-five degree angle, word by word, phrase by phrase, leading readers, after a gaping creamy space, to the start of the argumentative text. This commences usually somewhere around the middle of the page, with a fat boldface initial, juxtaposed with subsequently smaller, thinner characters, with a more modest face; text that itself, however, slowly, but surely, grows in width, getting fatter, sentence by sentence, as readers descend the page line by line, in a reverse diagonal, towards the bottom left.

One way to read this typographic innovation spread across the diagonals and horizontal lines of the page is as a queer intervention, given Sedgwick's sadomasochistic account of enjambment, as we have seen, as a pushing together and straddling apart, and the book's documentation of the etymological relation of *queer* to the word *across,* as it comes from the Indo-European root **terkw-,* that also yields the German *quer* (transverse), Latin *torquere* (to twist) and English *athwart*. In addition, as Sedgwick recalled, the 'titles and subtitles that at various times' she attached to the essays tended towards '"across" formulations: *across genders, across sexualities, across genres, across "perversions"'*. The book itself would also have had an 'across' subtitle but she 'just couldn't choose' one.[19]

Readers might also think about the book's orientation towards the diagonal, rather than the *straighter* rectilinear convention of most codex books, as being towards the fat aesthetics of being cut on the bias. They might further consider the interruptive visibility of fonts, via differences in boldface, italicization, and scale beyond the more conventional main text/footnote distinction, as an attempt to establish a queer page design if being queer famously referred to the 'open mesh of possibilities, gaps, overlaps, dissonances and resonances, lapses and excesses of meaning when the constituent elements' of any individual page 'aren't made (or *can't be made*) to signify monolithically',

19 Sedgwick, *Tendencies,* xii.

and to the 'experimental linguistic', 'representational' and typographic 'adventures' following from that.[20]

There's a Certain Slant of Line

In this context, readers might also want to recall Emily Dickinson's poem # 258, with its famous opening line 'There's a certain slant of light' that my subtitle alludes to.[21] The poet is a key figure in *Tendencies,* and across Sedgwick's oeuvre more generally, as I have argued elsewhere, even if there is no individual essay on her.[22] Part 3 of Sedgwick's 1975 poem, 'Sexual Hum', for example, employed, as a mantra, the 'unagitated syntax / and ravishing obduracy' of Dickinson's poem #822 — 'This consciousness that is aware' — as an 'excellent chant' to distract the anxious poet in the 'dentist's chair'.[23] *Between Men* employed Dickinson's poem #615 as the epigraph for its coda: 'Our journey had advanced — / Our feet were almost come / To that odd Fork in Being's Road'.[24] *Epistemology* borrowed a line from Dickinson's poem #842, 'The Fox fits the Hound', to characterize the relationship of May Bartram and John Marcher in Henry James's *The Wings of the Dove* (1902),[25] whilst *Touching Feeling* would subsequently draw on Dickinson's poem #254, '"Hope" is the thing with feathers', as part of its influential theorization of affect.[26]

20 Ibid., 9.
21 Emily Dickinson, *The Collected Poems of Emily Dickinson* (London: Faber and Faber, 1970), 118–19.
22 For Dickinson's potential importance to *A Dialogue on Love,* see my *Bathroom Songs: Eve Kosofsky Sedgwick as a Poet* (Earth: punctum books, 2017), 54–58.
23 Eve Kosofsky Sedgwick, *Fat Art, Thin Art* (Durham: Duke University Press, 1994), 77; Dickinson, *Collected Poems,* 399.
24 Eve Kosofsky Sedgwick, *Between Men: English Literature and Male Homosocial Desire* (New York: Columbia University Press, 1985), 201; Dickinson, *Collected Poems,* 303.
25 Sedgwick, *Epistemology,* 209; Dickinson, *Collected Poems,* 406.
26 Eve Kosofsky Sedgwick, *Touching Feeling: Affect, Pedagogy, Performativity* (Durham: Duke University Press, 2003), 151; Dickinson, *Collected Poems,* 116. Writing on Sedgwick, Benjamin Westwood recently noted that it was a 'truth, if not universally acknowledged then at least widely experienced,

It is, however, in *Tendencies* where Dickinson looms largest. In the volume's first essay, 'Queer and Now', Sedgwick marveled at the miraculous survival of her queer adult friends and colleagues doing LGBTQIA work, quoting, on the bias, Dickinson's poem #325:

> — an outgrown anguish
> Remembered, as the Mile
> Our panting Ankle barely passed —
> When Night devoured the Road —
> But we — stood whispering in the House —
> And all we said — was 'Saved'![27]

Dickinson's clitoral poetics, meanwhile, figured in two further *Tendencies* essays. 'Is the Rectum Straight' discussed the pleasure and danger of 'clitoral eroticism', again in *The Wings of the Dove*, through reference to Dickinson's poem #754: 'My Life Stood — a Loaded Gun'.[28] Sedgwick then fleshed out this allusion in 'Jane Austen and the Masturbating Girl', which acknowledged the centrality to Sedgwick's thinking about queer female poets of Paula Bennett's *My Life a Loaded Gun: Female Creativity and Feminist Poetics* (1986) and *Emily Dickinson: Woman Poet* (1990).[29]

Dickinson also pops up in 'White Glasses', Sedgwick's 'memorial' to queer poet and activist Michael Lynch, which revealed that Dickinson was one of the pair's 'most durable' shared lesbian reference points, leading to 'tokens, readings', 'impersonations' and pilgrimages' to her house (and grave) in Amherst, the college town where Sedgwick lived and taught between 1984 and

that even the most devoted readers of verse tend to remember parts of poems rather than the whole thing', such that 'lines, fragments, couplets, rhythms: these are all liable to be turned round in our memories like the melody from a music box' ('The Queer Art of Ardent Reading: Poems and Partiality', *Raritan* 61 [Summer 2021]: 50–71).

27 Sedgwick, *Tendencies*, 1; Dickinson, *Collected Poems*, 154.
28 Ibid., 94; Dickinson, *Collected Poems*, 369–70.
29 Ibid., 115.

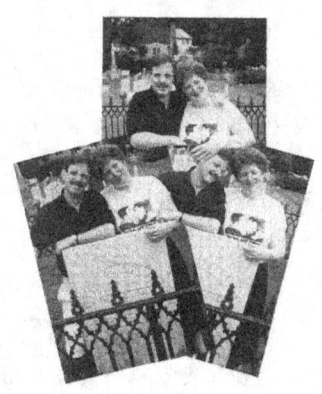

Figure 2.4. Eve Kosofsky Sedgwick, *Tendencies* (1993), page vii.

1988, and where she fought successfully to get Dickinson on the curriculum (see Figure 2.4).[30]

Tendencies' dedication page, meanwhile, 'In memory of Michael Lynch, / and with love to him', contains a two-dimensional reproduction of a two-and-a-half-dimensional photo-montage Sedgwick dated March 7, 1988, with a title deriving from Dickinson's poem #62: 'Eternity's White Flag — Before — / And God — at every Gate' (see Figure 2.5).[31]

This cropped, three-photo collage, recalling the similarly cut silhouette aesthetic Sedgwick employed on the cover of *Between Men*, depicted her with Lynch, leaning on Dickinson's grave. The pair are dressed, like an interlocking Yin and Yang, in complementary monochrome outfits. Lynch sports a black t-shirt and white shorts, and a wristwatch to suggest the inevitable progress of time, and Sedgwick a white 'Read My Lips' ACT-UP t-shirt, depicting two sailors kissing.[32] Both are wearing matching pairs of Lynch's signature white glasses, the objects giving the name to Sedgwick's notoriously premature essay.[33]

In each photo, the pair embrace, like the gay sailors on Sedgwick's t-shirt, standing shoulder to shoulder, leaning head to head, with their arms wrapped around each other, her right arm surrounding his lower back, and his left arm, at least in the top photograph, wrapped affectionately around her shoulders. The montage, as a whole, meanwhile, brings the pair only closer, with Lynch leaning his right elbow on the lower left photograph, whilst Sedgwick's left hand, in the upper, crosses down to caress

30 Sedgwick, *Tendencies*, 257, 259. For more, see Andrew Parker, 'Eve At Amherst', PMLA 125, no. 2 (May 2010): 385–86, and the 'Amherst' section of https://eveksedgwickfoundation.org/biography/biography.html. For Parker's further reflections on Sedgwick, see 'The Age of Frankenstein', in *Reading Sedgwick*, ed. Berlant, 178–88.

31 Dickinson, *Collected Poems*, 303.

32 For more on the significance of this t-shirt, see Sedgwick, *Tendencies*, xi. For more on the visual idioms of ACT-UP New York, see Gran Fury and Michael Cohen, eds., *Gran Fury: Read My Lips* (New York: 80WSE, 2011), and Jonathan David Katz, ed., *Art AIDS America* (Seattle: Tacoma Art Museum/University of Washington Press, 2016).

33 Sedgwick, *Tendencies*, 252–66.

Figure 2.5. Eve Kosofsky Sedgwick, 'Eternity's White Flag — Before — / And God — at Every Gate' (March 7, 1988, photomontage, dimensions unknown).

Lynch's right ear affectionately, in the photo below, bringing to mind the aural eroticism of her c. 1993 poem, 'One of us falls asleep on the other's shoulder', with its description of the 'artful, improbable / brand' of the 'double outside curve' of an ear in the 'fat of the shoulder'.[34] In the photo on the right, Lynch's left arm reaches across to the adjacent left photo, where it rests on, and in, the fleshy crease of Sedgwick's left inner arm. In this photo, Lynch rests his elbows on Dickinson's grave, whilst Sedgwick gently caresses its upper right-hand corner, with Lynch, in the lower right photograph, looking down at the ground where Dickinson lay, and Sedgwick, smiling eyes closed, as she thrills in the triangular proximity of both poets.[35]

Sedgwick framed the original montage against a tangerine ground, like the background color against which her name was printed on *Tendencies'* front cover, whilst the book's title is framed against the color purple, perhaps alluding to Alice Walker's 1982 queer novel of the same name, or its 1985 film adaptation, and signaling the importance of lesbian-of-colour writing to the genealogy of her queer theory. (Sedgwick employed the same purple for the book's title on its spine, and the entire back cover.)[36]

As the collage and haiku-like poem appear on the dedicatory page of *Tendencies,* however, it is framed again an expanse of

34 Sedgwick, *Fat Art*, 35.
35 For Lynch as a poet, see *These Waves of Dying Friends: Poems by Michael Lynch* (New York: Contact, 1989).
36 Sedgwick taught Walker's *Meridian* (1976) as part of her 'Asian Encounters' course at CUNY. Sedgwick further indicated the importance of intersectional, lesbian-of-color writing to her thinking through her brief memorial to Audre Lorde in *Tendencies* (xii). We shall get to *Gary in Your Pocket: Stories and Notebooks of Gary Fisher* (Durham: Duke University Press, 1996) shortly — a book whose title perhaps alludes to queer, African-American sci-fi writer Samuel Delaney's 1964 novel *Stars in My Pocket Like Grains of Sand*. Sedgwick later wrote a short introduction to Delaney — 'Flying with Samuel Delaney' — that remains uncollected. For more on Delaney, see Robert F. Reid-Pharr, 'Clean: Death and Desire in Samuel Delaney's *Stars in My Pocket Like Grains of Sand*', *American Literature* 83, no. 2 (2011): 289–411. I am grateful to Nicole Devarenne for discussions about Sedgwick's possible relations with Delaney.

white space, anticipating the look of Dialogue, and suggesting its formal debt to the spare visuality of Dickinson's verse.[37] In addition, that expanse of white space anticipates Sedgwick's 'Interlude, Pedagogic', in *Touching Feeling*, which recalled a 'ravishing Dickensonian winter afternoon' at Amherst, when a 'beautiful, thick, and silencing snow began to fall', where she 'almost burst with exaltation at the spare and indicate Americanness of the scene'; the snow 'profuse, gratuitous, equalizing, theatrically transformative', and guaranteeing the 'totality and symbolic evenness' of the 'pure, signifying space' where she was trying to perform civil disobedience, reminding us here of Lynch's key status as an AIDS activist as well as poet, and Sedgwick's own affiliations with ACT-UP during her time in Durham, North Carolina.[38]

In its *Tendencies* context, Sedgwick's collage, in conjunction with the simple, memorial text, also recalls a gravestone and the 'obituary frame' of 'White Glasses', Dickinson's sparse poem reminding us that Lynch and Sedgwick had nowhere to go, retreat from their illnesses being hopeless, the white page of eternity's white flag behind them, making impossible any escape into the past:[39]

37 For more on the white space of *A Dialogue on Love* (Boston: Beacon, 1999), see Carolyn Williams, 'The Gutter Effect in Eve Kosofsky Sedgwick's *A Dialogue on Love*', in *Graphic Subjects: Critical Essays on Autobiography and Graphic Novels*, ed. Michael A. Chaney (Madison: University of Wisconsin Press, 2011), 195–99, and Tyler Bradway, "Permeable We!': Affect and the Ethics of Intersubjectivity in Eve Kosofsky Sedgwick's *A Dialogue on Love*', *GLQ* 19, no. 1 (2013): 79–110. For Williams's recollections of Sedgwick, see 'The Boston Years: Eve's Humor and Her Anger', *Criticism* 52, no. 2 (Spring 2010): 179–84.
38 Sedgwick, *Touching Feeling*, 28–29.
39 For Lynch's extraordinary, hardly known response to 'White Glasses', see his 'Terrors of Resurrection "By Eve Kosofsky Sedgwick"', in *Confronting AIDS through Literature*, ed. Judith Laurence Pastore (Urbana: University of Chicago Press, 1993), 79–83. I am grateful to Monica Pearl for alerting me to this essay.

Our journey had advanced
Our feet were almost come
To that odd fork in Being's road
Eternity by term.

Our pace took sudden awe
Our feet reluctant led.
Before were cities, but between
The forest of the dead.

Retreat was out of hope
Behind, a sealed route,
Eternity's white flag before
And God at every gate.[40]

And it is in this bleak, funeral context that I want, finally, to turn to Dickinson's poem #258:

There's a certain Slant of light,
Winter Afternoons —
That oppresses, like the Heft
Of Cathedral Tunes —

Heavenly Hurt, it gives us —
We can find no scar,
But internal difference —
Where the Meanings, are —

None may teach it — Any —
'Tis the seal Despair —
An imperial affliction
Sent us of the Air —

[40] Dickinson, *Collected Poems*, 303.

> When it comes, the Landscape listens —
> Shadows — hold their breath —
> When it goes, 'tis like the Distance
> On the look of Death —[41]

With its themes of the differences left by Death, even in the absence of a visible scar, and thinking about the ragged scar that lay across the place where Sedgwick's right breast had been, the poem suggests *Tendencies*' slanted lines are not just queerly athwart, but also mournful. As such, the distinctive page format employed, in *Tendencies,* encapsulates the way the volume volleys between two poles. Firstly, the claim that queer is 'cumulatively, stubbornly' 'inextinguishable', a 'continuing moment, movement, motive, — recurrent, eddying, *troublant*'.[42] This should make readers think of Sedgwick's diagonally-slanting text as being emphatically, queerly, alive and in motion, falling, eddying, perhaps, like snow or light on a winter afternoon. But the queer slant of lines also emphasizes the unusual, oppressive surrounding white space where something — text — or someone — the words or images of Lynch, Audre Lorde, Craig Owens, Melvin Dixon, Tom Yingling, or Divine — had been, but are no longer. White is also, as Sedgwick was soon to discover, the colour of mourning across the Buddhist and Shinto world.[43]

The internal difference of the layout from regular codex formats, then, represents a kind of diagonal scar, or the air where such despairing, afflicting, mournful meanings and losses emphatically are. If so, we might read Sedgwick's diagonal text, at the top of each title page, as descending down to earth, like settling ashes, or rising up like crematorium smoke, dissolving away to a breathless nothing in the distance. Or, in a quite different idiom, we might imagine the overall curve made by her text, curving up towards the top left, as marking the silhouette

41 Ibid., 118–19.
42 Sedgwick, *Tendencies,* xii.
43 For more, see Louise Allison Court, 'The Changing Fortunes of Three Archaic Japanese Textiles', in *Cloth and Human Experience,* eds. Annette B. Weiner and Jane Schneider (Washington, DC: Smithsonian, 1989), 377–415.

of a kneeling figure, whose head is leaning in and looking up to something or someone white above, which brings us, a little circuitously, to Gary Fisher.[44]

Through White Glasses? *Gary in Your Pocket*

Published in 1996, *Gary in Your Pocket* selects and collects various stories, notebooks, and poems by queer-of-colour, African American writer Gary Fisher (see Figure 2.6).[45]

44 There is a similar anthropomorphic character to the full title page of *Touching Feeling*, as well as its Library of Congress page, as we shall see in Chapter Five, which are both laid out to echo the image of Judith Scott on the cover, embracing one of her fiber works.

45 The critical reception of *Gary in Your Pocket* has been bumpy to say the least, with Sedgwick herself noting, in her 'Afterword' to the book, that 'as one of the manuscript's readers put it', the book's title 'risk[ed] sounding "in some ways trivializing"', making Fisher seem 'small, appropriable'. This was a move 'all too resonant in the context of the posthumous publication of an African American writer, mediated by an older, Euro-American editor and friend, from the press of a mostly white Southern University', although the title was Fisher's, and both he and Sedgwick were 'both very conscious of a history of white patronage and patronization of African American writers, the tonalities of which neither of [them] had any wish to reproduce'. 'Sexuality was a place where Gary was interested in dramatizing the historical violences and expropriations of racism', Sedgwick documented, whereas 'friendship, authorship, and publication, by contrast, were not' (*Gary*, 285-86). Particularly controversial was Fisher's repeated articulation of highly racialized s/M scenes, which, Sedgwick argued, demonstrated a highly self-conscious, performative, fantasmatic, and real-world idiom for Fisher, offering him and his readers a 'detailed, phenomenologically rich reconstruction of the fragments of traumatic memory', a 'claiming and exercise of the power to re-experience and transform that memory, and to take control of the time and rhythm of entering, exploring, and leaving the space of it; and having its power, and one's experiences of it, acknowledged and witnessed by others'. This 'richness of experimental and experiential meaning', Sedgwick also suggested, was 'neither simply continuous with, nor simply dislinked from the [racist] relations and histories that surround[ed] and embed[ed]' it (*Gary*, 283). For other positions, see Chistian Haye and Eve Kosofsky Sedgwick, 'All About Eve', *Frieze* (May 6 1997), esp. 1, 3–4; Arthur W. Frank, 'Bodies, Sex and Death', *Theory, Culture, and Society* 15, nos. 3/4 (1998): 417–25; Robert F. Reid-Pharr, 'The Shock of Gary Fisher', in *Black*

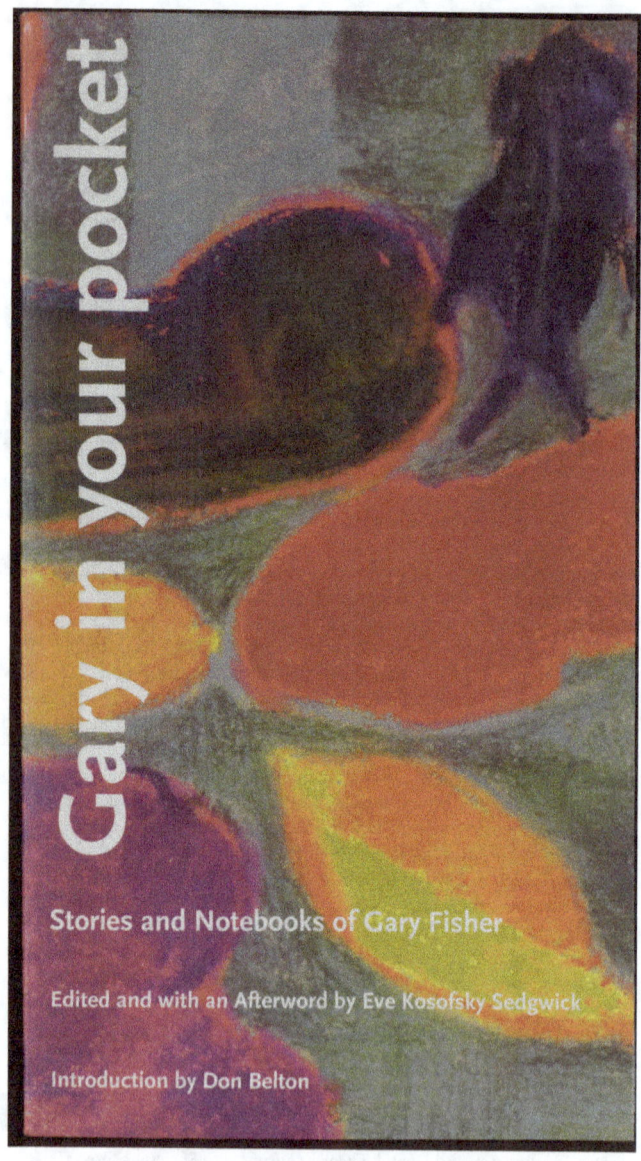

Figure 2.6. Eve Kosofsky Sedgwick, *Gary in Your Pocket* (1996).

Edited by Sedgwick, and with an afterword by her, the book's front cover features a colorful, by-turns floaty, phallic, fishy, cellular, wax-crayon work by Fisher, in Sedgwick's own collection, chosen jointly by the artist and Sedgwick, when it became clear she would see the book through its posthumous publication, after his death from AIDS-related illness in 1994 (see Figure 2.7).

Sedgwick described her relation to Fisher, both in her 'Afterword' and in *A Dialogue on Love,* which provided a 'live' account of her response to his death. There, 'getting back from somebody's dinner party', she found a phone message from a 'very weak'- and 'sick'-sounding Fisher, revealing he had been in a hospital in Berkeley for a week, suffering from CMV, or cytomegalovirus, in his gut. Initially thrown, Sedgwick couldn't remember much about the illness except it frequently led, as in Derek Jarman's case, to blindness. She had not imagined it could affect someone's intestines.

Fisher's diagnosis brings into focus the cover of the book, whose forms resemble the orange, pink, and purple forms of CMV isolated under a microscope. Sedgwick was understandably disoriented by the message. She couldn't tell what was happening because of the way that, at some moments, Fisher seemed to be planning to find a new apartment, but, simultaneously, to be facing death. He also told her he loved her, something she knew, and wished that 'things had been different so there would have been more chance to show it'. She felt like she had been 'caught in a high wind', perhaps making sense of the yellow and gold leaf on the cover's bottom right, wanting both 'to go straight / to him' and to 'run to / the opposite ends

of the earth rather
than feel even closer to him

Gay Men: Essays (New York: New York University Press, 2001), 135–49; Ellis Hanson, 'The Future's Eve: Reparative Readings After Sedgwick', *South Atlantic Quarterly* 110, no. 1 (2011): 101–19; and José Esteban Muñoz, 'Race, Sex and the Incommensurate: Gary Fisher with Eve Kosofsky Sedgwick', in *Reading Sedgwick*, ed. Berlant, 152–66.

Figure 2.7. Gary Fisher, untitled, mixed media, dimensions unknown. Collection of Eve Kosofsky Sedgwick. Photo: Kevin Ryan, © H.A. Sedgwick.

before [she lost] him.[46]

Sedgwick's haibun form here is poignant, recalling the form and theme of James Merrill's *Prose of Departure* (1987), similarly concerned at a painful, but helpful distance — in Merrill's case, in Japan — from the deaths of many of his American friends from AIDS-related illnesses, and, although the poem does not say so, his own recent HIV-positive diagnosis.[47] The gap between Sedgwick's poetry and prose here similarly works to signal the distance dividing her from Fisher. The need to cover the ground between them is also poignantly emphasized by the effort required to turn the page before the quoted haiku.

Later, there is 'some better news of Gary', but Sedgwick acknowledged how, compared to the illness of her newly-returned brother-in-law, Fisher's predicament seemed 'so much more real and terrifying', even if she and Fisher were 'related by no blood and not much of a past'. Indeed, she 'could probably — with some work — make a list of every time and place' she had 'ever been with Gary', and could certainly give a 'summary of the, say, four conversations' that represented 'turning points' in their relationship.[48] It was strange, though, she noted, 'to be plunged again into that set of feelings —

not quite terror — but
fright, intense fright; for someone
else, at a distance.

46 Sedgwick, *Dialogue*, 127-28.
47 For more on Sedgwick's relation to Merrill, see her 'The 1001 Seances', *GLQ* 17, no. 4 (2011): 457-83, and the surrounding essays in the Sedgwick memorial issue by H.A. Sedgwick, 'A Note on "The 1001 Seances"' (451-56); Henry Abelove, 'The Bar and the Board' (483-86), Michael Moon, 'The Black Swan: Poetry, Punishment, and the Sadomasochism of Everyday Life; or Tradition and the Individual Talent' (487-97); Kathryn R. Kent, '"Surprising Recognition": Genre, Poetic Form, and Erotics From Sedgwick's "1001 Seances" to *A Dialogue on Love*' (497-510); and Neil Hertz, 'Attention' (511-16); as well as my *Bathroom Songs*, 35-51.
48 Sedgwick, *Dialogue*, 128.

Indeed, she found herself 'dizzy', 'not paralysed but very constrained — yes, like being physically constrained'. Her imagery here, of physical constraint, resonates both with the compressed form of her haiku and, as we have seen, with many of her s/m fantasies, whose broad idiom she shared with Fisher, often feeling herself whiplashed by the end of his sentences.[49] But readers should also note the liquid character of the feelings Sedgwick is 'plunged' into since *Gary*'s cover evokes a similarly liquid, *suminagashi*-like form, with the yellow-and-orange leaf perhaps floating on algae-filled green water, and what looks to be the silhouette of a purple bubble-eye fish, seen from above, swimming out of the shot, top right. This liquid imagery is characteristic of the way Sedgwick repeatedly described being immersed in Fisher's fishy idiom.[50]

Fisher's writing and death, as Sedgwick revealed, both coincided with, and, in part, prompted her return to poetry; a fact commentators have failed to emphasize, preoccupied, as they have perhaps understandably been, with the problems of Sedgwick's patronage of Fisher, at the expense of understanding how inspired she was by him. After all, as she noted, with an increasingly characteristic sense that good and bad were inseparable, 'Gary is dying. But then my poetry has returned'. What that felt like for Sedgwick, employing another aqueous image, and a phrase echoing the title of Merrill's AIDS memoir, *A Different Person* (1993), was a 'great, upwelling flux of mutability

> as if, falling in,
> you'd emerge young — old — dead —
> a different person — [.][51]

49 For example, Sedgwick earlier documented how she was 'identified with' and 'envious of' the 'excitement of realizing one could put a sting like that in a paragraph's tail — which didn't, either, soothe the hurt of being at the other end of it' (*Gary*, 277).
50 Sedgwick, *Dialogue*, 129.
51 Ibid., 136; James Merrill, *A Different Person: A Memoir* (1993), in *James Merrill: The Collected Prose*, eds. J.D. McClatchy and Stephen Yenser (New York: Alfred A. Knopf, 2004), 457–685.

The next time Fisher appears in *Dialogue*, we learn, in Van Wey's capitalised idiom, that 'GARY DIED LAST NIGHT', and Sedgwick and her shrink 'SPEND MUCH OF THE HOUR TALKING ABOUT THE DEATH, GARY HIMSELF, AND E'S REACTION TO IT, WHICH IS MOSTLY SLOW REALISATION SO FAR'. Sedgwick also reports to Van Wey a 'vivid and frightening dream' she had the night after Gary's death in which she found herself driving on a highway with cars threatening in all directions, when 'the bus-truck behind ours bumped (fairly gently) into the back of ours — but no one took any notice'; an image of potentially mortal anal vulnerability, of being penetrated, bum[m]ed from the rear, that is being ignored, and that resonated strongly in the context of the US government's murderously indifferent response to the AIDS crisis. Then, in the dream, Sedgwick's father's 'red pickup truck' — one recalling, as we have seen, the similarly dreamy 'light-blue pickup truck', with two queer boys, arms around each other's shoulders, that Cissy sees in 'Trace at 46' — makes a U-turn and 'jokily' is launched straight at Sedgwick and her unnamed passenger.[52] She continues:

"Us" = ??
Narrow arteries, swarming with

madly-driven trucks
branching at unexpected
dangerous junctures ...

Bloodstream?[53]

As if in panic, Sedgwick's haiku form breaks down. It's hard to work out how the first line of the first stanza could represent

52 Sedgwick, *Fat Art*, 57.
53 Sedgwick, *Dialogue*, 158–59. There may again have been anal resonances for Sedgwick in choosing an afterword, at the rear end of the book, rather than a foreword, since Fisher wanted Sedgwick to write an introduction, and since she had suggestively noted she 'couldn't tender teacherly observations on the bottoms of [Fisher's] stories forever' (*Gary*, 278, 285).

five syllables, the second line has an additional eighth, and the third line is missing altogether. In addition, the image of 'narrow arteries, swarming with' potentially fatal, 'madly-driven trucks' suggests that *Gary*'s cover does not just represent the CMV blossoming in his bowels, but the HIV carried in his bloodstream, recalling *Coherence*'s differently blood-marked cover.

Following Fisher's death, Sedgwick immersed herself in his papers; an experience she described as a 'two-hundred-proof taste of what the coming months' would hold, as she would 'plunge into the vat of his unmakings'.[54] The phrase resonates with a number of moments in Sedgwick's poems written around the time of her closest involvement with Fisher, suggesting his powerful influence on her later poetry. For example, in 'Who Fed This Muse?' she described the return of her poetic inspiration, by noting how she 'fell into it all / the vat of her [sister's] unmakings, her returns'.[55] In the immediately adjacent 'Joy. He's himself today! He knows me!', almost certainly describing Fisher, she documented the way in which, 'From under the shadow', he wielded a

> power to
> be (or some days not to be) yourself,
> to recognise and treat me as
> (or some days not to) as *my*self.
>
> Thus, to make me myself
> by being recognisable to me;
> not to unmake us both,
> turning away,
> joining your sullen new friends.[56]

In the context of Fisher's potentially mortal illness and simultaneous 'identification with death and the dead', and with what

54 Sedgwick, *Dialogue*, 160.
55 Sedgwick, *Fat Art*, 8.
56 Ibid., 9.

Sedgwick described as his 'extraordinarily aggressive fight against the deterioration of his health', and the 'heroic measures' he demanded 'from his doctors and himself through several crises',[57] the poem alludes to Hamlet's famous soliloquy, in Act 3 Scene 1, 'to be or not to be', and its images of whether it was better to suffer quietly the 'slings and arrows of outrageous fortune', to take a perversely masochistic delight in the 'whips and scorns of time', 'to take arms against a sea of troubles', or 'to die' more peacefully, and so end the 'heartache and the thousand natural shocks / That flesh is heir to'. In addition, the poem meditates on the effect of dying and death on those who bore loving witness to it, and provided companionship within it, as Sedgwick finds her possibilities for her italicised self confirmed and unpicked, as well as nearly endlessly delayed by the interruptive syntax of the bracketed phrases, as Fisher risked unmaking them both, in remaining unrecognisably out of reach or whilst focused on others.[58]

Swimming in the vat of his idiom was a painful experience, Sedgwick documented, including 'intensely: abyssal, glazed-over boredom', not in the sense of ennui, or because his writing failed 'to astonish', but, rather, in the sense of 'the kind of boring that's a penetration', as well as an 'overstimulation' or 'stimulation of wrong or dangerous kinds'. This is an image of burning oral stimulation already suggested by the 'two-hundred-proof taste' of Fisher's white-spirit, pure-alcohol idiom, and of phallic boring signalled, on the cover of *Gary,* by the way the red, green, and orange phallic shapes, often partially outlined in different colors, as if wearing condoms, bore into the green liquid. They

57 Sedgwick, *Gary*, 275.
58 A similar scene occurs in 'The Use of Being Fat' where Sedgwick finds challenged her 'superstition that / there was this use to being fat'; that no one she 'loved could come to harm / enfolded in [her] touch'; that a lot of her would be able to 'blot it up, / the rattling chill, night sweat or terror', the phrase recalling Thom Gunn's AIDS-crisis poems in *The Man with Night Sweats* (London: Faber, 1992). In her poem, Sedgwick realizes she was wrong, that, even when held by her, her ill friends would 'withdraw to the secret / scenes of their unmaking' (*Fat Art*, 15).

also rub up against each other at their edges and tips, suggesting that Sedgwick's images of forced oral and phallic penetration were not without their pleasurable payoffs at the level of the recipient and giver's nerve endings.[59]

Later, Sedgwick again described her 'daily', 'uncanny', 'unswerving immersion' in Fisher's idiom, this time emphasizing not the oral/phallic way he bored into her poetry and prose, but through the register of the olfactory, encouraging readers to imagine the funky, musty, salty, and fishy smells of *Gary*'s cover; of penises rubbing against each other, latex rubbing against itself; of bubble-eyed goldfish; of autumnal leaves; and of the dank green water in, or on, which they find themselves. Indeed, Sedgwick pointed expressly to the 'archaic fragrance of profanation around the project'.[60] It, perhaps, also goes without saying that the iconography and smell of fish evoke Fisher's surname, and may further explain the presence of a koi carp, held protectively inside a bodhisattva that we have already encountered in Sedgwick's c. 2002 wall-hanging *Tender Winds Above the Snow Melt Many Kinds of Suffering* (see Figure 2.8), especially since a traditional poem associated with Kuanyin strongly recalls the cover of *Gary*.

This described how

The fish swims in muddied jade green water
Surrounded on all sides by a trawler net;
He thinks that if he wriggles, he can escape –
And fate says yes, OK; and equally, no: no way.[61]

[59] Sedgwick, *Dialogue*, 160–61, 174, 198. Viewers might also recognize as testicular the pink patch of colour at the bottom left of the cover image.

[60] Ibid., 198. Sedgwick acknowledged frankly, in her 'Afterword', that she did not think hers was 'the perfect aegis for his stories to appear under'. Indeed, she didn't think Fisher's stories 'needed any aegis but their own' (*Gary*, 285).

[61] Martin Palmer, Jam Ramsey, and Man-Ho Kwok, *The Kuan Yin Chronicles: The Myths and Prophecies of the Chinese Goddess of Compassion* (1995; Charlottesville: Hampton Roads, 2009), 170.

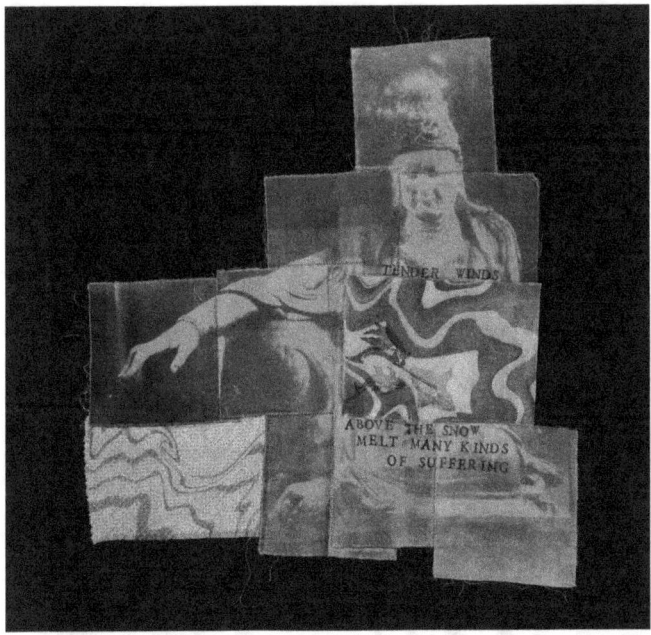

Figure 2.8. Eve Kosofsky Sedgwick, *Above the Snow Melt Many Kinds of Suffering* (c. 2002, cyanotype and *suminagashi* ink on cotton, with rubber stamps, dimensions unknown). Photo: Kevin Ryan, Collection H.A. Sedgwick, © H.A. Sedgwick.

Sedgwick had already dealt with some of these issues, in her August 1994 'Afterword' to *Gary*. There, she documented she and Fisher had first met, in Berkeley, in Spring 1987, when he was the only African American student to take her 'Across Genders, Across Sexualities' course, suggesting his centrality to the project that became *Tendencies*.[62] At first, she had not known what to make of his 'light and sweet, but oddly formidable presence', except that, 'habitually sitting on the floor, almost always silent,

62 Sedgwick would employ the phrase for the third section of *Tendencies* (167–267).

Figure 2.9. Eve Kosofsky Sedgwick, photographic portrait of Gary Fisher, reproduced on the back cover of *Gary in Your Pocket* (before 1993).

just by the door', he registered as an 'allegory for the liminal'. It was only later, when she encountered him through the more revealing medium of his writing that she became enamored, coming to see the relationship between a 'reserve whose specific gravity might not have been as palpable to himself as it was to those around him' and his 'beautiful smile, infrequently used' in class, and depicted in a Sedgwick photograph of Fisher that graces the book's back cover, where he appears in a related grey-green palette to that of the front (see Figure 2.9).[63]

But as she started to read him, Sedgwick realized how much their idioms productively, if not always painlessly, overlapped. She noticed that they were both shy around each other and had in common a strategy for dealing with rage, which they would put 'naked on paper, then half-shield [...] the paper from sight with the smoke screen of a deprecating or even puppyishly ingratiating persona'. This was a disarmingly 'luminous sweetness' and 'beatific manner' strategically captured in Sedgwick's jacket photo that offers readers a similar jolt as they encountered his more stringent words on the inner pages.[64] It is also in the 'Afterword' that the close relationship between Sedgwick's poetry and Fisher's writing comes into sharpest focus, with little sense indicated of which direction of flow the influenced occurred, given that the Sedgwick poems in question, those written in the late 1980s and early to mid-1990s, may postdate her encounter with Fisher.

For example, noticing the way his oeuvre seemed motivated by the 'formal question' — 'What if I could just-?' — Sedgwick's readers might have recalled the final two lines of the first section of the then-recently-published *Fat Art*, that asserted that 'In every language the loveliest question / is, You can say that?'[65] Fisher's speculation that his straight housemates probably wouldn't 'recognize human anatomy' if they saw 'two men fucking' echoes the moment, towards the end of 'The Warm

63 Sedgwick, *Gary*, 276.
64 Ibid., 277–78.
65 Ibid., 278; *Fat Art*, 39.

Decembers', where we find 'somebody / somewhere (Upstate?) […] busy wracking brains / to figure out what on earth it is that men / *can* Do Together'.[66] Earlier in the same poem, Sedgwick described 'Waking in the morning', to 'remember first' she'd grown up, 'had some money and a car' and anything she wanted 'to cook and eat', and 'in the horrid, doggerel blank verse' in which she not quite thought, 'some vapid version of a Shakespearean phrase', remembering that she 'was beloved'.[67] This parallels Fisher's description of how, 'Waking up, it's funny', he felt like he had 'left that world of [his] dreams still going on, like a movie I'd felt uncomfortable with and left', as well as Sedgwick's description of how, during her 'time of immersion' in Fisher's notebooks, she would often dream 'not *of* Gary, but *as* him', 'inhabited' by his idiom, and dreaming her own 'mental semantics' in his 'sentence structure'.[68]

Viewers might also ponder further the extent to which Fisher's example was 'thrillingly instructive' when it came to Sedgwick's then-fast-developing fiber art, although this never involved spinning even as it did include weaving. For example, in spite of the shaky start to their friendship, Sedgwick always felt that 'the thread of contact, however finely spun, was never irredeemably distant from [their] fingers'. She documented the perseveration of Fisher's voice even when it was 'worn to the very warp and woof of its syntax', and she retrieved from his archive a phrase she found particularly resonant: 'A loose weave / An ancient Indian breeze / blowing off the desert'.[69] Her most elaborate comparison of Fisher and fiber art, however, occurs in her c. 1993 poem describing him, 'The Navajo Rug':

> I wouldn't say that, delirious,
> he's 'not himself'. Eye-dazzler
> left to ruin on a loom

66 Sedgwick, *Gary*, 279; *Fat Art*, 149.
67 Sedgwick, *Fat Art*, 147.
68 Sedgwick, *Gary*, 289, 291.
69 Sedgwick, *Gary*, 278, 280, 288, 290.

the weaver was forced to abandon,
he is here in the unfielded, blinding
patches of what's been himself,
and if you knew him, you can see it all.
The bolt of his graciousness
like lightning with no sky;
his fury, his very own fury — it is nonsense;
the dry, thrown storm of his ravishing sentence.

Rug that's still on the loom:
a writer, just turned 32.[70]

In the poem, Fisher remains beautiful, even as his body failed him, an 'Eye-dazzler' of a rug 'left to ruin on a loom / the weaver was forced to abandon'. Indeed, even delirious, and in the 'unfielded, blinding / patches of what's been himself', he maintained his idiom, and, 'if you knew him', you could make out what the entire pattern had once been, or might one day have been. For Sedgwick, his graciousness, fury, and ravishing syntax were a 'bolt' in two senses: 'like lightning with no sky', and a roll or swathe of fabric.

As well as revealing Sedgwick's increasing textile orientation, to which we shall return, *Gary in Your Pocket* represents a further development in the sequence of books she was publishing in the mid-1990s in which questions of the materiality of the object were becoming increasingly important. For example, she documented that she and Fisher agreed on the book's cover art as well as its title. Nevertheless, she had a 'lot of second thoughts' about the latter, flirting with an alternate title, *Soul Releasing*, from one of his poems, anxious lest the book risked 'trivializing' Fisher, and making him seem 'small' and 'appropriable'.[71] On balance, however, she came to like what she characterized as the title's 'Whitmanian intimacy', and how, given the 'indignity' and 'promiscuity of book production', the title captured the way

70 Sedgwick, *Fat Art*, 12.
71 Sedgwick, *Gary*, 285.

Fisher's spirit could be 'held often mute in a closed box', perhaps like a miniature closet or coffin, that anyone could 'buy and put in their pocket', since this answered 'eerily' to the 'indignity of death' and to 'survivors' yearning for a potent condensed, sometimes cryptic form of access to the person who would otherwise be lost'.

Sedgwick also evidently relished the way that, in reading, books were always 'touching you', as you turned the pages, recalling, in the case of Gary, the hours she spent in 'fragmentary fellowship, holding and being held' by Fisher, bathed in his 'beatific smile' and with 'no fever or confusion' able to 'burn out the princeliness' of his sentence structures. In addition, and with Whitman in mind, readers might think about the coronary, genital, or anal intimacy of having Gary's book thrust beneath their clothing, in a shirt, front or back trouser pocket, where they might 'feel the throbs of [their] heart[s]'. But, Sedgwick noted, and again as in Whitman, it was also publication and the book form that allowed the dead to 'continue to resist, differ, and turn away from the living'. Indeed, Whitman was insistent that his grassy leaves would certainly 'elude' his readers 'at first and still more', even if they thought they had 'unquestionably caught' him. As such his leaves of grass might resemble the turf separating grieving mourners from their lost beloved. Indeed, with this in mind, viewers might interpret a less aqueous, more grassy reading of the leaf-strewn, green base layer of Fisher's waxy crayon artwork gracing the equally waxy paper cover, across which your fingers elusively *slide*.[72]

Sedgwick's photograph of Fisher's 'beatific smile' on the back of the book was one of many that she took of him. Before finishing this chapter, I want to consider one of the photo-collages she made of him in April 1992, a genre inspired by the work of queer

[72] Sedgwick, quoting Whitman, *Gary*, 286, 290. For Sedgwick's account of turn-of-the-twentieth-century English attempts at reading Whitman, see *Between Men*, 201–18. See also Eve Kosofsky Sedgwick and Michael Moon, 'Confusion of Tongues', in *Breaking Bounds: Whitman and American Cultural Studies*, eds. Betsy Erkkila and Jay Grossman (New York: Oxford University Press, 1996), 23–29.

British artist David Hockney she also employed to memorialize her friend, the AIDS activist Michael Lynch, as we have already seen in the case of *Tendencies*.[73] She described her photo-collage period in an untitled poem about Fisher:

> Grave, never offering back the face of my dear,
> abey: let me take some more pictures
> from this dramatic low angle by the footstool,
> pictures I won't be in,
> his face homing toward mine.
> Catch him mugging with his pretty sisters
> (one cuts her eyes drolly away,
> clearing a place to be sad)
>
> — and wait, please,
> for the 1-HR. Prints, then let me assemble
> a big pseudo-David Hockney photo collage;
> also hold on till I'm old enough to go instead,
> even just tag along.[74]

[73] In Sedgwick's February 1988 photo-collage, *Terrible Scrabble*, Lynch appears with his son, Stephen, and Sedgwick's husband, at her Lincoln Avenue house in Amherst [https://eveksedgwickfoundation.org/art/objooo129-01.html]. For more on Hockney's c. 1982-83 'joiners', see Arts Council, *Hockney's Photographs* (London: Balding and Mansell, 1983). For Hockney' account of his photographic practice in phenomenological and cubist terms, see Alain Sayag, ed., *David Hockney Photographs* (London: Petersburg, 1982), 8–27.

[74] Sedgwick, *Fat Art*, 10. *Hockney's Photographs* draws readers' attention to O.G. Rejlander and Henry Peach Robinson's Victorian photomontages. Particularly resonant is the pair's *Fading Away* death-bed scene (1858). For more on Rejlander, see Edgar Yoxall Jones, *Father of Art Photography: O.G. Rejlander, 1813-1875* (Newton Abbot: David and Charles, 1973), and Stephanie Spencer, *O.G. Rejlander: Photography as Art* (Ann Arbor: UMI Research Press, 1985). For more on the relationships between Cameron, Hawarden, Rejlander, and Lewis Carroll, see Philip Prodger, *Victorian Giants: The Birth of Art Photography* (London: National Portrait Gallery, 2018).

In the poem, looking at Fisher is a 'grave' business, in the sense of being serious, solemn, and potentially alarming, and akin, in some ways, to looking at a hole in the ground, and in relation to which Sedgwick desperately requires a pause, to take 'some more pictures' from a 'dramatic low angle by the footstool'; an angle resonant, in the context of Fisher's s/M idiom, of fellatio, and, in Sedgwick's, of her foot fetishism.[75] These will be pictures of Fisher that Sedgwick won't appear in, but in which his face will home towards hers, and in which, rather than the excluding scene of Fisher's 'sullen new friends', she finds a joy in him 'mugging with his pretty sisters', one of whom 'cuts her eyes drolly away, / clearing a place to be sad', just as, on the back cover of the book, Fisher's eyes and head are down, clearing a place for him to beam with happiness. Sedgwick wants to stop time to take the photographs, to rush them to the '1-HR. Prints', and to cut and assemble them into a 'big pseudo-David Hockney photo collage', as well, more poignantly, so she can die before or alongside Fisher.

The closely-related collage I want to discuss is *Listening to Dionne (1)* (see Figure 2.10).

This collage features Fisher and his friend Eric Patterson at Sedgwick's house in Durham, North Carolina.[76] According to

[75] A later poem sequence suggests an additional, more peaceful reading of the adjective 'grave', when Sedgwick, in describing her beloved therapist Shannon Van Wey, documents that she wanted to write how he listened: 'Grave, / never offering back the face of my emotion, / only, the face of you listening, / it sinking in, / the violet in your thick cheeks' (*Fat Art*, 20).

[76] Sedgwick's montage featured in Hilton Als's 2016 exhibition, 'James Baldwin/Jim Brown and the Children', at the Artist's Institute in New York. For installation shots, see http://www.theartistsinstitute.org/hilton-als/. For a white gay male lineage for the collage, note the close tonal and formal similarity to Hockney's *Christopher Isherwood Talking to Bob Holman, Santa Monica (14 March 1983)* (*Hockney's Photographs*, 22). In addition, Hockney shared Sedgwick's vocabulary of snapshots, referring to himself as a 'snapper' (*David Hockney Photographs*, 15), and they also shared a love of Proust, with Hockney snapping Promenade Marcel Proust whilst visiting Cabourg in Normandy, and Mark Haworth-Booth arguing that Proust perhaps provided the 'programme' for Hockney's collages' (*Hockney's Photographs*, 8, 12).

Figure 2.10. Eve Kosofsky Sedgwick, *Listening to Dionne (I)*, photomontage on carboard, date and dimensions unknown. Photo: Kevin Ryan, Collection H.A. Sedgwick, © H.A. Sedgwick.

Don Belton's foreword to *Gary in Your Pocket*, Dionne Warwick, who Fisher is listening to in the photographs, represented the 'essence of intergenerational cool' for him, and, in the collage, he looked as Belton imagined him from their earlier phone conversations, as 'a beautiful brown man with startled eyes and a flowerlike mouth, indrawn, quizzical', and 'seated, with a satisfied look, in Eve's living room, his head inclined in an attitude of listening'; a receptive attitude central to Sedgwick, in a number of contexts.[77]

The collage features twelve thinly-overlapping, patchwork photographs glued together, five containing Fisher, five Paterson, with the snapshots at scales suggesting the idea of carrying Gary in your pocket. Sedgwick arrayed the photographs in a combination of portrait and landscape orientations, employing a single diagonal shot to capture and echo Paterson's extended, crossed legs towards the middle of the montage. Paterson, who seems to be reading an art book, is dressed in black boots, blue jeans, and an indigo 'Know Your Assholes' t-shirt made by

77 Don Belton, 'Gary at the Table: An Introduction', in Sedgwick, *Gary*, ix, xii.

Sedgwick, and now part of her archive; another early sign of her growing interest in Craftivist textile production.[78]

Paterson is seated, absorbed in the book on his lap, in two differently-oriented lost-profile shots; the one closer to the middle revealing his left profile, and playing with his body at different scales.[79] His head represents the largest image, which then descend down in scale through his torso to the more distant photograph of his legs, as if the act of reading were phenomenologically concentrating and expanding his mind, at the expense of his body. The second portrait towards the right is more frontally posed, with the image of his legs immediately below him taken not from the side, but from immediately in front of him, with his knees more emphatically crossed. This suggests Sedgwick's interest in multi-perspectival Cubist faceting and a sequential, time-lapse logic to the collage — time-lapse photography originally identified with Victorian photographer Eadward Muybridge that we shall return to.[80] Behind Paterson is a stack of books, including Jonathan Dollimore's then recently published *Sexual Dissidence* (1991), to anchor the photograph's queer tone.

Fisher, by contrast, has put his two books to one side, and is looking up, to devote his full attention to the music, in real life, or, in the context of the collage, to focus on the puzzling view of his own image towards the top-left. In the three conjoined images towards the middle, he is seen, in a thoughtful pose, with his elbows resting on his knees, his chin on his hands. Unlike Paterson's body, which extends across numerous photographs,

78 For more on Craftivism, see Anthea Black and Nicole Burisch, 'Craft Hard, Die Free: Radical Curatorial Strategies for Craftivism in Unruly Contexts', in *The Craft Reader*, ed. Glenn Adamson (Oxford: Berg, 2010), 609–19, and the Craftivism section of Maria Elena Buszek, ed., *Extra/Ordinary: Craft and Contemporary Art* (Durham: Duke University Press, 2011); and Bryan-Wilson, *Fray*.

79 A lost profile represents a view of a person who has turned slightly towards, or away from, a strict left or right profile view of their face.

80 For more on cubist collage, see Christine Poggi, *In Defense of Painting: Cubism, Futurism, and the Invention of Collage* (New Haven: Yale University Press, 1993).

Fisher's is cropped at the ankles and down his right side, as if he were transported by the music, and floating in its aural space. Again, Sedgwick suggests the passing of time, and the centrality of light to the experience of color because of the way the sofa on which Fisher is seated subtly modulates from a darker pink towards a peach tone, in hues resembling the palette of *Epistemology* and *Between Men,* depending on the moment at which, and the angle from which, Sedgwick took the photograph. This suggestion of the variability and performativity of color is evocative in the context of Fisher's queer-of-color status, as well as a reminder that Sedgwick had a particular, consistent palette. At Fisher's feet is a yawningly open medicine bag, suggesting his HIV status. There are also the icy remains of a glass of water, indicating the ways Fisher's and Sedgwick's bodily states were prone to shifting and, in the case of Sedgwick's spine, dissolving away, as we shall see. Perhaps most poignantly, a Navajo rug is at Fisher's feet, the title of Sedgwick's poetic portrait of him, as we have seen.

To the left are four further portraits of Fisher in different poses, at different moments, from various angles, and in two different orientations, The two on the left are in portrait format, the two on the right in landscape, with the portrait images in both cases topping the landscape images, following the art-historical hierarchy. Top-right is the image Fisher seems to have been looking up at in the previous group of photographs. Taken from closer in, and offering a greater intimacy, his chin still rests on his hands, and he still looks up to his right, to just above the head of the immediately adjacent portrait, a smile creasing his lovely face. In that juxtaposed portrait to the left, he looks more serious, gazing into the distance, his chin resting on his left palm and knee, his right having fallen down, cropped out of the picture. His sleeves are buttoned up to his wrists, perhaps to keep hidden the KS lesions that increasingly marked his arms. For example, Sedgwick documented that whilst 'nobody else ever saw them', since he 'always wore long-sleeved shirts', alone in his apartment he spent 'hours, sometimes whole days […], para-

lyzed in front of his mirror, incredulous, unable — also unable to stop trying to constitute there a recognizable self'.[81]

'Impaled by the stigma', Fisher himself, meanwhile, in September 1993, in the final diary entry Sedgwick included in *Gary*, tried to write about how he looked with his 'new skin' and 'new identity', as his lesions increasingly 'converge[d]' and 'eclipse[d] one another'. Culturally understood as 'the telltale sign, the first indication, the marker, the scarlet letter', Fisher tried to make aesthetic sense and beauty out of what he called his 'spots', 'lesions' and, most evocatively in this collage context, his 'patches'. I say 'evocative' because Sedgwick's collage suggests a patchwork idiom sympathetic to Fisher's HIV symptomatology, just as the book's cover represented his triumphant ability to turn viral imagery into something beautiful; a lesson she carried with her in her subsequent art practice and experience of living with metastatic cancer.[82]

And just as Fisher noticed the way his lesions seemed, initially, 'so random', it is hard to make sense of the way Sedgwick decided which of her photographs should eclipse any other, and, if so, how and where, with some 'clustered', others more 'island-like', as in Fisher's description of his lesions. Unlike Fisher's KS marks, however, Sedgwick's photographs share, rather than 'refuse a common shape or texture or size'. But, looked at for longer, and as Fisher found in relation to his lesions, there was a 'geometry' and 'interesting, attractive' poetry to the arrangement, although he was careful not to move too quickly or finally away from the fact that the marks represented 'cancer and AIDS'.[83]

In addition, like the palette of the two top photographs of Fisher, with his grey checked shirt juxtaposed with the plum-colored couch, he described his lesions as an appetizing combination of the 'grayish, purplish', 'mauve', and 'a light eggplant'; the colors of patches on the cover of Gary. Fisher also described the way his hope, again like Sedgwick's horizontal collage,

81 Sedgwick, *Gary*, 281.
82 Ibid., 271, 281.
83 Ibid., 271.

seemed 'so long and so broad', and resembled a 'great big room full of possibilities', but with death a 'broken bulb there in the centre of it'. 'Are there windows and is it daylight?' Fisher asked. 'Can a room full of this light rejuvenate the bulb, fix it, change it?' Sedgwick's photo answers with a quiet, if temporary, yes, to the extent that, in the image containing his complete body, the one where he has extended his right leg out into the surrounding space, and is laughing as he reaches for something in the medicine bag with his right hand, viewers can see a thin slither of daylight coming in through a mostly shuttered window.[84]

By the end of the 1990s, Fisher speculated, some 40 million people across the planet would be HIV positive, but he felt like he was in plentiful 'good company' and 'less afraid', as a result, in a 'big room […] full of everybody's hope', and, in Sedgwick's collage, certainly in the company of his friends.[85] The final image we have of Fisher is found at bottom left, wearing a green cap, sitting facing Sedgwick directly, his smiling face resting on his left fist, his right hand holding a pencil, looking at one of the many 'spiral notebooks' she would subsequently edit. He was as evidently inspired as Sedgwick by what he called, in the closest published diary entry to the photomontage, the 'excitement in the smallness of things, the fraction of things'.[86]

84 Ibid., 271–72.
85 Ibid., 272.
86 Ibid., 247.

3

Between Women: *Performativity and Performance*, Or, Shame and Her Sister

Performativity and Performance, Or, Further Queer Footnotes

In 1995, Sedgwick published two co-edited collections: *Performativity and Performance,* with Andrew Parker, and *Shame and Its Sisters: A Silvan Tomkins Reader,* with Adam J. Frank. Two years later, she published a third edited collection, *Novel Gazing: Queer Readings in Fiction* (1997), part of a sustained experiment in multi-voiced books that culminated with *A Dialogue on Love* in 1999. In this chapter, I consider the three edited collections in the broader context of Sedgwick's relation to her sister and mother, and her parallel, in some ways related, interest in affect theory and queer and peri-performativity.

Sedgwick first made her (and Frank's) interest in affect theory apparent in the Winter 1995 edition of *Critical Inquiry,* in the form of an article entitled 'Shame in the Cybernetic Fold: Reading Silvan Tomkins', later reproduced as the introduction to *Shame and Its Sisters*.[1] Her interest in queer performativity,

1 Eve Kosofsky Sedgwick and Adam Frank, 'Shame in the Cybernetic Fold: Reading Silvan Tomkins', *Critical Inquiry* 21, no. 2 (Winter 1995): 496–522, and Eve Kosofsky Sedgwick and Adam Frank, eds., *Shame and Its Sisters:*

meanwhile, was realized in her contribution to the inaugural edition of GLQ (1993), in an article entitled 'Queer Performativity: Henry James's *The Art of the Novel*', then extended through three further essays: 'Shame, Theatricality, and Queer Performativity: Henry James's *The Art of the Novel*', 'Around the Peri-Performative: Peri-Performative Vicinities in Nineteenth-Century Narrative', both later collected in *Touching Feeling: Affect, Pedagogy, Performativity* (2003), and 'Proust, Cavafy, and the Queer Little Gods', posthumously collected in *The Weather in Proust* (2011).[2]

The covers of *Shame and Performativity* fit neatly into two trends in Sedgwick's book designs that we have already encountered. Like *The Coherence of Gothic Conventions* (1986), *Performativity* has a monochrome cover, with blood-red text, here with the image also bled to the edge, with the text perhaps a nod, given the ballet-themed photograph, to *The Red Shoes*, Hans Christian Anderson's sadistic 1845 fairytale, which told the story of a young woman enamored of a pair of colored pumps, and who finds, on putting them on, that she can't take them off, and is nearly danced to death; a sadism central to Sedgwick's accounts of ballet, as we shall see. The mostly monochromatic single photograph cover of *Performativity* also recalls *Epistemology*

A Silvan Tomkins Reader (Duke: Duke University Press, 1995), 1–28. See also ibid., 133–78, and Eve Kosofsky Sedgwick, 'Shame and Performativity: Henry James's New York Edition Prefaces', in *Henry James's New York Edition: The Construction of Authorship*, ed. David McWhirter (Stanford: Stanford University Press, 1995), 206–39. For Frank's later reappraisal of Tomkins, see Adam J. Frank and Elizabeth A. Wilson, *A Silvan Tomkins Handbook: Foundations for Affect Theory* (Minneapolis: University of Minnesota Press, 2020).

2 Eve Kosofsky Sedgwick, *Touching Feeling: Affect, Pedagogy, Performativity* (Durham: Duke University Press, 2003), 35–66, 67–92, and *The Weather in Proust* (Durham: Duke University Press, 2011), 42–68. For more, see Eve Kosofsky Sedgwick and Michael D. Snediker, 'Queer Little Gods: A Conversation with Michael D. Snediker', *Massachusetts Review* 49, nos. 1–2 (2008): 194–218. For Snediker's further reflections on Sedgwick, see his 'Weaver's Handshake: The Aesthetics of Chronic Objects (Sedgwick, Emerson, James)', in *Reading Sedgwick*, ed. Lauren Berlant (Durham: Duke University Press, 2019), 203–35.

of the Closet, and anticipates those of *Novel Gazing* and *Touching Feeling. Shame and Its Sisters,* meanwhile, follows the precedent of *Fat Art, Thin Art* to which we turn in the next chapter, in employing a tinted photograph from Sedgwick's own family archive: rose-colored, in the case of *Fat Art,* aqua for *Shame and Its Sisters,* and then, as we have seen, indigo for the second edition of *Epistemology of the Closet.*

The cover of *Performativity and Performance* features a 1972 photograph, Spring Festival, by photographer Margaretta K. Mitchell (see Figure 3.1).

The image depicts a group of ballerinas likely taken at the Temple of Wings, in Berkeley. The cover represents a single print from a sustained, multi-photo Mitchell project that spanned more than twenty years. This explored the Californian legacy of bisexual, turn-of-the-twentieth-century dancer and choreographer Isadora Duncan. Born in San Francisco, Duncan developed her reputation across Europe in the first quarter of the twentieth century. She drew inspiration not from the classical repertoire of European ballet, but from Greek vases and sculptures, and the simple, spontaneous movements of children, such as skipping. From these, Duncan sought to choreograph more natural patterns of movement. Committed to teaching the young, and to learning from them, Duncan opened a number of schools, in Paris, Moscow, and New York, articulating the idea that each movement should arise, organically, from the one that preceded it, and from the bodily core of the solar plexus. She would characteristically dress herself and her students in Greek-inspired tunics, and preferred bare-feet to the pointe shoes associated with romantic ballet — both characteristics of the dancers on the cover of *Performativity and Performance.*[3]

Mitchell's photograph documented Duncan's continuing pedagogic legacy in California, in a scene of a Spring Festival performance, at the Temple of the Wings, where a Duncan-inspired school of dance ran from the mid-1960s into the mid-

3 For more, see Ann Daly, *Done into Dance: Isadora Duncan in America* (Middleton: Wesleyan University Press, 2002).

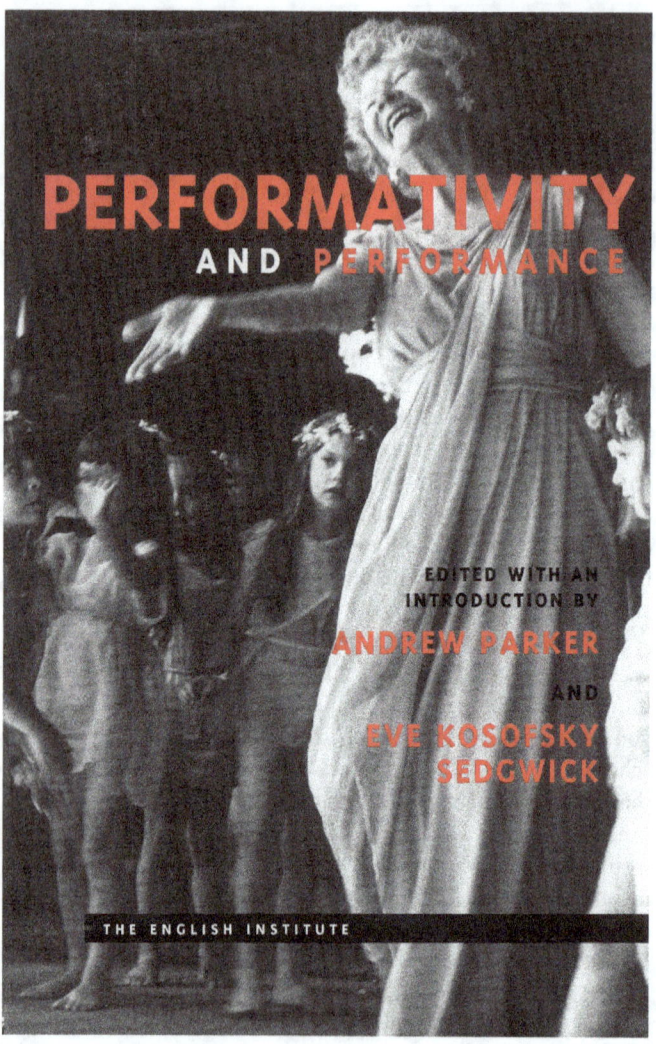

Figure 3.1. Front cover of Eve Kosofsky Sedgwick and Andrew Parker, eds., *Performativity and Performance* (1995), featuring a photograph, Spring Festival (1973), by Margaretta K. Mitchell. Cover design by Leslie Sharpe.

1980s. Mitchell's photographs of these performances were first exhibited ten years before the publication of *Performativity and Performance,* at Oakland Museum, in 1985, in a show entitled *Dance for Life: Isadora Duncan and her California Dance Legacy,* accompanied by a limited edition photogravure portfolio. The photographs were exhibited again in Winter 2001, six years after the publication of *Performativity and Performance,* first in Berkeley, then in Oakland, where the show coincided with the performance of an orchestral work, *Berkeley Images,* inspired by Mitchell's photographs, by French composer Jean-Pascal Beintus, commissioned for the Berkeley Symphony Orchestra.

Mitchell's image, meanwhile, of an ageing ballerina with six of her protégés, also formed part of a wider strand of the photographer's work concerned with depictions of, and representations by, all-female groups. These included the 1979 exhibition, *Recollections: Ten Women of Photography,* and her November 1996 group portrait of thirty contemporary women photographers.[4]

In the photograph, Mitchell depicts, against a matte black background, rather than against the well-lit neoclassical architectural Temple she employed in other photographs from this series, a beaming, extroverted, ageing ballerina, confident of the quality of her performance and its reception. Her right hand, as we have already briefly noted, is characteristically extended, palm upwards, in the direction of the audience, her eyes squinted with pleasure. Her Greek-inspired, floor-length, sleeveless robes reveal, unselfconsciously, her ageing arms, and form a cross just below her breasts to accent the solar plexus, so crucial to Duncan's pedagogy, as she positions her right knee backwards, in the act of curtseying to the audience.

Joining her on the narrow stage, and spread across the front of the book, its spine, and onto its back cover, are eight female pupils and fellow performers. They are barefoot and wear short, white, semi-transparent, Greek-inspired tunics, crowns of spring flowers on most of their heads. The only exception may

4 For more about Mitchell, see http://www.margarettamitchell.com.

be the almost invisible girl, three from the right, and right at the back of the photograph, nearly fading into the darkness, whose garland, rather than having fallen off in the performance, might have been absorbed into the blackness.

The girls are mostly formed into a line running backwards from the most audience-oriented, and confident, foot-lit, slightly solarized girl, on the extreme left, who finds herself singled out, and starring, on the back cover, with her blurry hands in motion, but, perhaps frustratingly, denied centre stage, whilst her less successful, spot-lit peers appear on the front. On the extreme right is another, more self-absorbed, pot-bellied girl, in profile, apparently walking, rather than dancing, into the shot, in front of the ageing ballerina. The girl has a passing resemblance to the youthful Sedgwick gracing the cover of *Shame and Its Sisters*, as well as to the slightly older Sedgwick, in the same left profile, on the cover of *Fat Art, Thin Art*, as we shall see.

The girls represent a spectrum of degrees of skill and of theatricality and absorption, to return to Michael Fried's terms that we explored in Chapter One. They might thus be aligned on a line depending on whether they are more concerned with audience response, as in the overtly theatrical girl at the extreme left and the girl to the immediate left of the ballerina; with their teacher, as in the girl who just appears on the left, on the front cover; or with each other, as in the case of the two girls immediately behind her. The deeply absorbed girl, apparently indifferent to the audience, walking onto stage right, completes the spectrum.

My reading of the image, and Sedgwick and Parker's choice of it, brings to mind all three terms of the subtitle to her 2003 monograph, *Touching Feeling: Affect, Pedagogy, Performativity*, which reprints portions of her and Parker's introduction. That is because Mitchell's photograph either documents an actual performance, or, more likely, a pedagogic rehearsal for one, given the absence of the temple in the shot. In addition, the photograph, as we have seen, is rife with different feelings, ranging from the prima ballerina's joy to the girl on the right's self-absorption. The photograph is also flooded with feelings not just

on the part of the performers, but, presumably, on the part of Mitchell, the subsequent audience for the show, and the spectators of the picture, both when it was exhibited and when it was reproduced on the cover of Sedgwick and Parker's book.

After all, am I the only one feeling excruciated? At least for me, there's something embarrassing about the picture, about the way that, with the exception of the prima ballerina, all the girls are either trying too hard or not hard enough. For example, on the back cover, the little girl on the extreme left has evidently precociously aced a performance mode at her young age, making me wonder how and why. Behind her, by contrast, is a girl who looks remarkably and contagiously unhappy on stage. The girl to the extreme left of the front cover, meanwhile, seems to have entirely forgotten the audience, and her required frontal orientation, as she looks up, unselfconsciously, at the prima ballerina, less to mimic her moves, than because the older dancer is so charismatic.

The next girl in line, second from our left, appears to be waving at an audience member, or playing patty-cake. As such, she engages in a spontaneous, childhood physicality Duncan found inspiring. In this case, however, the girl seems to be playing a game of patty-cake with no-one opposite her to meet her gaze or hands. This gives the impression that her raised left hand might, instead, push or slap the girl immediately in front of her.

The next two girls in line seem also to have spotted a parent or admirer in the audience, and, unprofessionally, break the fourth wall; the one on our left, delighted at the audience members she has found there; the one on our right less certain that she has found a familiar face in the dark. Then there is the girl on the extreme right who seems to have forgotten she is part of a performance altogether, but unselfconsciously so; and, finally, the figure I find most haunting, the girl with the surprisingly, precociously adult face fading into the darkness, but making eye contact with the viewer, barely discernible, unless you're looking hard, right at the back of Mitchell's image.

When it comes to questions of performance and performativity, then, as well as to female homosociality, the photograph

seems more Sedgwickian than Butlerian, more interested in shameful affect and performance, than keen to 'expose residual forms of essentialism lurking behind' this performance of femininity, or 'to uncover' the 'violent or oppressive historical forces' that go into making it.[5] Indeed, to follow Sedgwick's account, in the introduction to *Touching Feeling*, Mitchell's picture does not explore the 'drama' of ideological, so much as affective, 'exposure', and, following Sedgwick's sustained interest in surface reading, as we saw in the introduction, there is no 'behind' here, only the matte-black darkness, and precious little 'beneath' the shallow stage, framed closely as to exclude the footlights, but tellingly framing three of the girls' six feet just below the added banner reading 'THE ENGLISH INSTITUTE'.[6]

What the again frontal, shallow recessional depth of the picture of imperfect practice offers instead is a poignant meditation on what Sedgwick characterised as the 'irreducibly spatial positionality of *beside*'. Indeed, because of the absence of boys, and the contagiously affecting presence of the girls, there is 'nothing very dualistic' about the image, except in the structural contrast it foregrounds of the young girls with the older prima. Instead, we find a 'number of elements' that 'lie alongside one another, though not an infinity of them', in a picture of a performance where the idea of 'subject versus object' is firmly suspended, since the girls are simultaneously the objects of our attention, but the subjects of their practice. More than that, they are somewhere on a spectrum of more or less self-consciousness, of the

5 Sedgwick, *Touching Feeling*, 4. For the *locus classicus* on Butlerian performativity, see Judith Butler, *Gender Trouble: Feminism and the Subversion of Identity* (New York: Routledge, 1990). My subsequent thinking on female homosociality in this chapter is indebted to Kathryn R. Kent. For example, see her *Making Girls into Women: American Women's Writing and the Rise of Lesbian Identity* (Durham: Duke University Press, 2003), and 'Eve's Muse', in *Bathroom Songs: Eve Kosofsky Sedgwick as a Poet*, ed. Jason Edwards (Earth: punctum books, 2017), 111–38. I am also indebted to Mary Baine Campbell's '"Shyly / as a big sister I would yearn / to trace its avocations", or Who's the Muse?', also in *Bathroom Songs*, 139–51.
6 Sedgwick, *Touching Feeling*, 8.

'*extroversion*' of the successful performer, confident they will win the audience's love, and the '*introversion*' of the ambitious, but not very good dancer, who hopes against hope they might.[7]

Characterized in this way, the cover evokes a number of other moments in Sedgwick's oeuvre. Perhaps most relevant, as I have already briefly indicated, is her account of the 'beyond, beneath, and beside' in *Touching Feeling*, with the 'scattered or clustered', 'multisided interactions of people "beside" each other' on this stage offering a 'wide range of desiring' and 'identifying', in the case of the girl on the left of the front cover; 'repelling', in the case of that girl's relation to the one behind her, to whom she seems indifferent, but who seems to want to either play with her, or, in a mode of 'aggressing', to slap her silly; as well as 'attracting' and 'rivaling', in the case of the prima ballerina and girl on the extreme left of the back cover, both determined to shine. There is also 'leaning', in the case of the girl to the immediate left of the prima, who has angled her body to echo her teacher's pose, and 'withdrawing', in the case of the girl on the extreme right, into herself, although prominently at the front of the stage, and, when it comes to the girls one from the left and right at the back, disappearing into the darkness.[8]

If the photograph knows as well, then, 'as any child […] who's shared a bed with siblings', that 'metonymically egalitarian or even pacific relations' are a 'fantasy', and 'teas[es] out' what follows, a particular sibling of Sedgwick's may haunt the image: her big sister, Nina.[9] For example, with so many barefoot girls in shot, it is worth recalling that, during her sister's long family exile, Sedgwick would often recall Nina, in a 'low-vamped flat pump like she wore in her teens', whenever she saw 'somebody's

7 Ibid., 5, 7–9.
8 Ibid., 5, 8–9.
9 Ibid., 5, 8. For more on Sedgwick's relation to Nina Kosofsky, see Sedgwick's *Fat Art, Thin Art* (Durham: Duke University Press, 1994), 3–8, 31–32, 112–14, 122–23, and *A Dialogue on Love* (Boston: Beacon, 1999), 13–14, 125–26, 128, 132–37.

brown, dry', and apparently edible 'round little muffin of a foot, with the toe divisions sexily shadowed at the top'.[10]

The cover might also bring to mind Sedgwick's earlier, c. 1993 sororal poem 'Little kid at the airport practicing'. Focused on two youthful dancing sisters, the poem describes the elder sister's 'tap-dance steps', as she 'gaz[es] through her bangs' and, obviously managing her disappointment, 'visibly tr[ies] not to be seen to think / There's no proper audience for me here'. Although disappointed that her performance could not create around her an ideal audience, the girl is evidently more confident of her star quality than, say, De Meyer's man nervously stepping into the spotlight on the cover of *Epistemology of the Closet*. Indeed, the girl's felt confidence is such that the narrator joins in with her, noting, sadly, that 'No one will marvel at her, pick her out / and 'discover' her, etc.' before, briefly, in that 'etc.', losing interest in the girl. But then, after an anxious half-line break in which there is nothing to be seen, the girl's potential audience revives, as Sedgwick asks: 'But, who knows? / Anyone really might, despite appearances'. Newly confident that discovery might be around the corner, the poem advises the reader and girl, now newly identified together: 'So don't look gauche or (worst) self-conscious'. Following another line-break, Sedgwick turns the spotlight on herself, acknowledging that

> Of course I identify with her. Also with
> the 3-year-old sister who (embarrassing)
> clumsy from servitude
> mimes every move she makes.[11]

A second child herself, with a sister three years older, the reader quickly sees why the tableau of the two sisters caught Sedgwick's attention, and why she turned the spotlight first on the older girl, the one who Sedgwick was never tired of providing an audience for, and who she wanted to be like — an identifica-

10 Sedgwick, *Dialogue*, 20–21.
11 Sedgwick, *Fat Art*, 31.

tion that continues through the description of the little sister that gets interrupted by the big sister's 'embarrassing' bracketed aside. But at the end of the poem, the big sister's judgmental voice disappears and readers are left with a scene in which it is the more talented big sister who is emotionally excruciated, by being copied, whilst the clumsy little sister, so full of love and identification, has 'no trace of self-consciousness, no audience consciousness'.[12]

The poem's clear instruction not to 'look gauche or (worst) self-conscious' brings to mind a second 'performative' poem from the first act of *Fat Art, Thin Art*: 'How Not to Be There', with its self-help instruction to 'remember to palliate all blame; / also, if you have a grave disease, / to be preoccupied about your health'. Perhaps the first thing to notice again about these two poems together, as well as the earlier poems about HIV-infected men in the last stages of their lives, is the Hamletian proliferation of the verb 'to be', whose problematics, in many ways, defines the ambitions of Sedgwick's mid-1990s lyrics. These express a range of queer performativities, in some anxious relationship to an audience, in which the first person, as she put it in *Tendencies*, never represented a 'simple, settled congratulatory "I"'.[13]

'How Not to Be There' perhaps speaks most to the 'tiny, feminine' shadowy figures at the back on the cover of *Performativity and Performance*, seeking to find a 'way to go AWOL', and especially the disappearing ghostly girl who may well 'wish I were dead'. Her 'body of depletion', however, provides only the opposite way of hiding, perhaps, to the most 'silvery', successful girl at the front of the stage, whose body of 'repletion', all spot-lit, superficial, performative exteriority and no vulnerable interiority, perhaps suddenly appears, with the poem in mind, not so confident after all that the audience is 'full of love and interest'.[14]

12 Ibid.
13 Eve Kosofsky Sedgwick, *Tendencies* (Durham: Duke University Press, 1993), xiv.
14 Sedgwick, *Fat Art*, 27.

By far the most difficult poem to read, however, in this context of dancing sisters, is an untitled lyric I will quote in full.

In dreams they're interchangeable — my husband,
my big sister; I'm with someone to make us
and waking, can't remember which.
 As if
the furrows of my path to her
wore almost to the quick,
as the eye's ear from syllable to line
staggers its numb, repeated drag
of the foot, mauled and mauling, that still though numb
feels pain
across the never again to be resistances
to meter — in that rereading where the 'by heart'
dull impulse of memory first speaks its part.

The only touch today, it seems,
the breath of my desire can make on Nina's, is
through her shy windows now licked from within,
the joining of their gaze toward some other form of life.[15]

The poem begins with a perverse, dreamy comparison between Sedgwick's husband, Hal, and sister, Nina, the two blended together in the strength of Sedgwick's unconscious wish 'to make' an 'us'. The poem ends with a scene in which she desperately wants her newly returned sister's attention, touch, desire, and kiss, as if she were a hungry, newly-wed lover, but one separated from her beloved by a more-or-less invisible window, in which she is only likely to be registered in the abstract, as one of a series of 'other form[s] of life'.

The middle of the poem offers up a difficult series of parallels between reading a poem, for the first time, hearing it read aloud, and a perhaps barefoot dance performance, like the one depicted in Mitchell's photograph. The predictable rhyme at the end of the stanza, of heart and part, in conjunction with the

15 Ibid., 32.

lines they frame, suggests how comparatively straightforward later readings of difficult poetry might be, once their semantic and grammatical sense and metric patterning have been established. But the predictable rhyme's bathos also signals the excitement that is lost, and the duller impulse that remains once a persuasive interpretation and way to perform lines successfully are established.[16] That leaves us with the most difficult, relevant, part of the poem.

The stanza begins with Sedgwick imagining that, by force of sheer, repetitive linear persistence, she can come close to her sister, or can write, engrave herself, or plough herself into, her surfaces. The lines of the poem, the lines of her desire, like 'furrows' on her path to Nina, 'wore', in the sense of both worn down and of wearing a costume, 'almost to the quick', as if such a performance were potentially speedy, and might result in their mutual nakedness. Sedgwick then compares this already-difficult-to-grasp range of images to the way in which

> the eye's ear from syllable to line
> staggers its numb, repeated drag
> of the foot, mauled and mauling, that still though numb
> feels pain
> across the never again to be resistances
> to meter —

Here, the ear and eye, in the first reading of a poem, proceed slowly, 'from syllable to line', recognizing and making sense, first, of parts of words, and then the larger syntactical unit of the line — an experience of slow, difficult reading Sedgwick returns

16 The poem's part/heart rhyme recalls Shakespeare's thematically relevant Sonnet 23, the epigraph to this book, with its focus on an 'unperfect actor on the stage, who with his fear is put besides his part, / Or some fierce thing replete with too much rage, / Whose strength's abundance weakens his own heart' (Katherine Duncan-Jones, ed., *Shakespeare's Sonnets* [London: Bloomsbury, 2010], 165–66). For more on the sonnets, see Eve Kosofsky Sedgwick, *Between Men: English Literature and Male Homosocial Desire* (New York: Columbia University Press, 1985), 28–48.

to in much of her textile art. The eye reads the words and sounds them within so the ear can hear, perhaps, possible punning homophones. But as Sedgwick's line unfolds, it is not potential puns she emphasizes, but the verse's meter. Here, rather than the painfully delicious spanking regularity she described in 'A Poem Is Being Written', in the case of Louis Untermeyer's trained, efficient, perhaps tap-shoe-like 'two-beat line', which she came to know as well as her pulse,[17] the meter is 'mauled and mauling', in its irregular footing, just as the poem describes how the eye and ear 'stagger', rather than dance, through the poem, with a 'repeated drag / of the foot' that, 'though numb', as a ballerina's *en pointe* foot must be, still 'feels pain' as it moves across the resistant ground. And the ballerina or tap-dancing sister readers have in mind here might be either very young, involved in the painfully difficult project of first learning to dance/read/relate, or older than the prima on the cover of *Performativity*, limping her way alone across the stage, long after her final acclaimed performance.

If we might, then, be inclined to read Nina Kosofksy as somehow present in the uber-confident and successful performance of the girl on the extreme left, on the back cover of *Performativity and Performance*, flirting with 'what seem the thousand tendrils, all / responsiveness' of her 'knowing, solicitous' audience,[18] we might also think about the prima as evoking Sedgwick's mother, Rita. After all, with her emphatically performed smile, closed eyes, and strained neck tendons, the aged ballerina recalls a photo of Sedgwick's mother in which it was 'hard to see [her] eyes', and in which she was performing her 'photo face', with its

> painful, dissociated clamp-eyed rictus
> tugging at the cords

17 Sedgwick, *Tendencies*, 181. For a range of legal-theoretical responses to the essay, see Janet Halley, ed., 'A Tribute from Legal Studies to Eve Kosofsky Sedgwick', special issue of *Harvard Journal of Law and Gender* 33, no. 1 (Winter 2010): 309–56.
18 Sedgwick, *Fat Art*, 39.

of her neck to make her look
like Nancy Reagan.[19]

In addition, we might recall that 'foot pain' represented, for Sedgwick, in the early to mid-1990s, 'another scare about a possible cancer symptom', and that her diagnosis with metastatic cancer was followed by long periods of painful pins and needles in her feet.[20] These facts bring into newly reparative focus another key aspect of Duncan's preferred performance practice, documented in Mitchell's photo: her preference for bare feet, rather than *pointe* pumps, and the comparative kindness of Duncan's method to the feet of little girls, almost all of whom, in the image, have their pudgy-muffin-soft soles placed comfortably on the ground, with the even happier exception of the girl to the immediate left of the prima who appears, because of the shadowing effect below her of the freeze-framed image, to be floating effortlessly above it. All those girlish, soft, responsive, comparatively well-trained, happy feet also return us to those series of moments across Sedgwick's oeuvre concerned with that 'most universally repressed and mutilated of pleasure taking organs', the foot.[21]

Finally, spectators might also think about the way in which, having been trained in ballet as a child, finding or not finding a firm footing continued to resonate with Sedgwick in her midforties, the period in which *Performativity and Performance* was published. For instance, when it came to her then-emerging arts and crafts practice, Sedgwick was delighted to report that her 'conscience ha[d] no foothold'. The very opposite of being *en pointe*, Sedgwick told Van Wey that she saw herself as a 'big, loose footprint / like a messy hurricane' that 'churn[ed] up the space' and maybe kept 'things aerated and fertile'.[22]

19 Sedgwick, *Dialogue*, 19.
20 Ibid., 89.
21 Sedgwick, *Tendencies*, 205.
22 Sedgwick, *Dialogue*, 140, 199.

This brings us to a key footnote to 'A Poem is Being Written' that meditated on a similar scene of the 'girl culture' of ballet that I'll again quote in full. In many ways, Sedgwick began,

> ballet itself functioned for many girls, including me, very much as poetry did for me, as another arch-mediator of one's relation to half-ritualized violence: like poetry, it was a rhythmic, prestigious, exhibitionistic, and highly theatricalized way of choosing the compelled and displayed body—here, for an intensively though impossibly gendered one. (The egalitarian bliss of girls undressing together, my nicest memory of 'ballet', somehow turned through this culture into the rapt recital and celebration of a rigorously meritocratic hierarchy—corps de ballet, ballerina, prima ballerina, prima ballerina *assoluta*—that was the only plot, aside from heterosexual love, of the ballet books we gobbled up in series). I can't remember any more the name of the particular kind of *battement* that's being performed by the prone figure in my tableau of enjambment, I can still remember the founding moment in a ballet class of my articulable sense of the transfigurative (i.e., misrecognition-creating) potential of any art, a dictum only the more received for being directed, not to my own, but to my big sister's class, which I was visiting at age five or so: 'The ballerina's limbs must look vulnerable, but to do this they must be strong as iron'. I learned early, also, that ballerinas are nearly always in pain and musn't ever show it. The potential for sustained and productive, if costly, play between power and impotence, through the medium of sanctioned spectacle, was not lost on me or on many other girls.[23]

The passage repays a little parsing. In it, Sedgwick moves into, and fades in and out of, the group of girls she describes, just as the girls move towards each other and into the limelight or away from each other and into the darkness offstage, on the cover of *Performativity and Performance*. Sometimes she is amongst

23 Sedgwick, *Tendencies*, 186.

'many girls, including me'; sometimes the things she says sound idiomatically unique; sometimes there is one other girl in the comparative, competitive frame: sister Nina; sometimes, a range of anonymous girls come into and out of focus: 'ballerina, prima ballerina, prima ballerina *assoluta*'.

Perhaps most idiomatic is Sedgwick's comparison of ballet to poetry, in the specific context of 'A Poem is Being Written', in which she scandalously compared meter and enjambment to spanking, here putting the ass back into the 'prima ballerina *assoluta*'. For Sedgwick, ballet represented an only 'half-ritualized violence'. Like spanking and poetry, it was a 'rhythmic, prestigious, exhibitionistic, and highly theatricalized way of choosing' a 'compelled and displayed', 'intensively though impossibly gendered' body; and here viewers might appropriately think of the way in which, in Butlerian performativity, all gender performativity is a failure.

But the ballet nevertheless offered, to Sedgwick, a range of perverse, nutritive pleasures. There was the potential power-bottom, masochistic joy of a sustained, productive, disciplined, sadistic, highly power-differentiated practice that required being able to bear considerable pain. There was the proto-lesbian 'egalitarian bliss of girls undressing together', Sedgwick's 'nicest memory of "ballet"', even if this was inevitably turned into the 'rapt recital and celebration of a rigorously meritocratic', but painfully divisive 'hierarchy'. And the ballet books she 'gobbled up in series' suggest a way of feeding a hungry muse, even if the 'heterosexual love' plot does not sound very delicious or (ful-)filling.[24]

Indeed, viewers might want to think about the self-absorbed girl, with the serious expression, in left profile and with convex belly, on the extreme right in Mitchell's photograph, walking, rather than dancing into the shot, as Sedgwick's disguised self-portrait. Firstly, as we have seen, because of her close resemblance to the image of Sedgwick on the cover of *Shame and Its*

24 For more, see Tirza True Latimer, 'Balletomania: A Sexual Disorder?', GLQ 5, no. 2 (1999). 173–97.

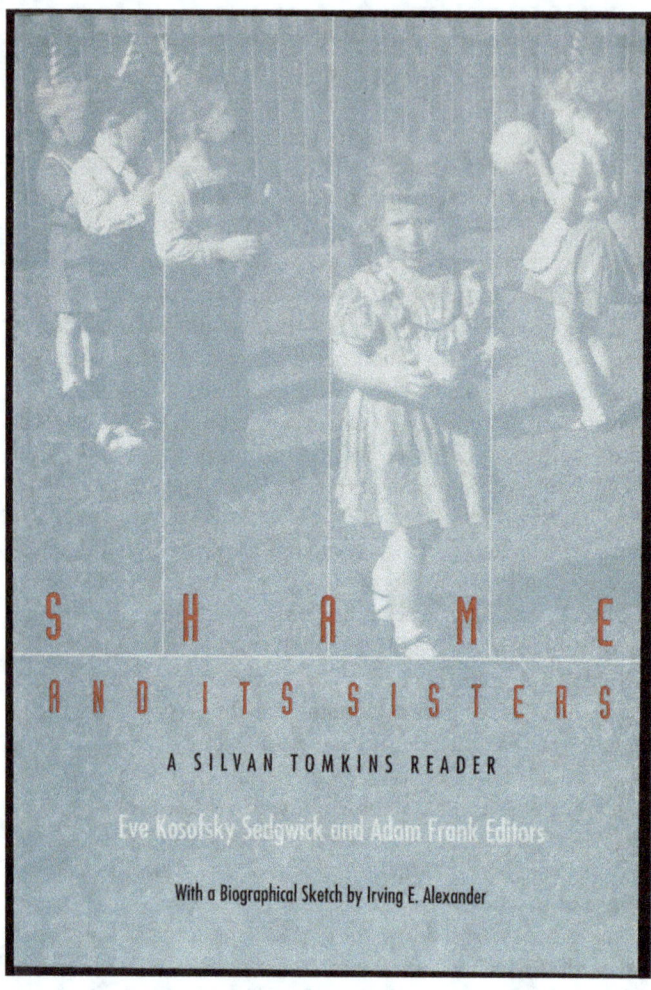

Figure 3.2. Front cover of Eve Kosofsky Sedgwick and Adam Franks, eds., *Shame and Its Sisters: A Silvan Tomkins Reader* (1995), featuring a photograph of Sedgwick probably taken by Leon Kosofsky (c. early 1950s).

Sisters, sporting a similar bob and probable profile, and, apparently generating a similar shaming 'stain that's spreading too fast for the blotter', given the aquatinting of the photograph. In addition, the girl's pedestrian thoughtfulness brings to mind Sedgwick's recollection of how, when she and her sister were in the same high school, Nina 'bitterly accused [her] of embarrassing her by walking around looking as if I was *thinking*'.[25]

Walking into shot, at this flower-crowned Spring Festival, just in front of a figure resembling her performing mother, meanwhile, is a girl who might recall another painful scene from the Kosofsky's family life. In this one, Sedgwick's mother Rita used to recite a poem Sedgwick 'ALWAYS FELT' was 'POINTED AT HER AND IMPLIED THAT SHE WOULD BE LIKE THIS, UNLOVED AS SHE MATURED INTO A WOMAN'. The poem was Frances Cornford's 'To a Fat Lady Seen From the Train' (1910), a poem that takes us, helpfully, to shame's backyard:[26]

> O why do you walk through the fields in gloves,
> Missing so much and so much?
> O fat white woman whom nobody loves,
> Why do you walk through the fields in gloves,
> When the grass is soft as the breast of doves
> And shivering-sweet to the touch?
> O why do you walk through the fields in gloves,
> Missing so much and so much?

It's My Party and I'll Cry If I Want To, or, *Shame and Its Sisters*

The cover of *Shame and Its Sisters* features a blueprint from the Kosofsky family album (see Figure 3.2). It depicts a youthful Sedgwick at a birthday party, indicated by the striped coronets worn by the four other children. As would happen with the second edition of *Epistemology of the Closet,* and with so much of

25 Sedgwick, *Fat Art,* 14; *Dialogue,* 219.
26 Sedgwick, *Dialogue,* 193.

her textile production around the time of her 2002 exhibition *Bodhisattva Fractal World,* Sedgwick put a black-and-white photograph through a blue filter, here less Anna Atkins' cyanotype or Derek Jarman's indigo, and more of an aqua, continuing Sedgwick's interest in images or patterns floated on, or immersed in, water.

In the photo, Sedgwick wears a pretty dress, and carries, perhaps, her hat in her hand, her outfit completed by white bobby socks and Minnie-Mouse open, round-toed shoes. Looking at the viewer, and probably up at her distant, lunar-photographer father, she stands apart from the girl in the top-right, not sister Nina, but perhaps standing in for her, and the line of three boys descending towards her, from the top-left, like the titles of the chapters in *Tendencies*.[27] Separate from her age-mates, like the girl on the right of *Performativity and Performance,* Sedgwick's *contrapposto* pose, with her right leg straight, carrying her weight, and her left trailing behind, mirrors and reverses that of the prima, suggesting Sedgwick's identification with her mother's comparatively svelte body and shaming point of view. In addition, Sedgwick is a girl rather than a woman, and may not be wearing gloves in the image, unlike the fat woman seen from Cornford's train. And she is walking through a back garden, rather than a field, but her father's camera is pointed at her and her slightly furrowed brow suggests she is not fully confident of performing the role her parents wanted her to play.

There is also a considerable foreground divide between Sedgwick and the viewer, suggesting a difficult-to-broach distance, although one again flattened and made frontal by the abstracting aqua-tinting, and the way the cover's text encourages readers to interpret the image again frontally, as a flat ground to its figuration. This was a *gestalt* effect of interest to Frank and Sedgwick, formed 'by the decision to digitalize a specific difference,

27 For more, see L.J. Kosofsky and Farouk El-Baz, eds., *The Moon as Viewed by Lunar Orbiter* (Washington, DC: NASA, 1970). I am grateful to Hal Sedgwick for letting me know that whoever the other girl in the photograph is, it is not Nina Kosofsky.

so as to form a *distinction* between figure and ground'. Such a gestalt can also result from the decision to 'introduce a particular boundary or frame into an analog continuum'.[28]

Following this logic, the experiential flatness of the photograph is further encouraged by the way the image is divided into four vertical, thin, white-framed, portrait-oriented, rectangular columns. These again separate Sedgwick from her playmates, with Sedgwick and her 'sister' getting a column more or less to themselves, along with the front boy, whilst the two smaller and recessed boys fit into a single column. The columns are not, however, entirely containing. The other girl's ball just breaks her frame, although her svelte form is neatly contained within. The back of the front boy's right arm and party hat similarly exceed his frame, although he is perhaps the most columnar of all the figures, given his left profile, solid-block verticality, and the way his corporeal and territorial expansion beyond the frame sit straightforwardly with him. Sedgwick, by contrast, self-consciously and fatly exceeds her frame in numerous places: the edge of her left sleeve; the bottom half of her right foot; her right arm and hand. In addition, the way the four white columns break up the image into neatly transparent, geometrical portrait-oriented sections suggests the viewer is looking from afar, perhaps through a window, thus aligned with the shaming speaker of 'To A Fat Lady Seen From the Train'.

In addition, the context of Cornford's poem suggests that Sedgwick's walking in the image is restless, that she is unable to sit down and be herself on grass that is 'soft as the breast of doves' and 'shivering sweet to the touch', just as she is unable either to be with herself, unlike the other girl's happy, solitary ball game, or part of a team, like the lined-up boys. '[M]issing so much' of her childhood world, Sedgwick looks up for the approval of the parental world, whose shaming attitude about her supposed weight was, doubtless, one of the causes of her self-consciousness in the first place. Like the cover of the second edition of *Epistemology of the Closet*, this is another bruising,

28 Sedgwick and Frank, 'Shame in the Cybernetic Fold', 22.

bruised, black, white, and blue image, suggesting a Sedgwick, like many of the African-American singers she admired, singing the blues.[29]

The titular red font of the title, meanwhile, as we have seen in the cases of both *The Coherence of Gothic Conventions* and *Performativity and Performance,* can also connote blood, thus the flush of shame, and, taken together with the aqua, recall what Sedgwick and Frank describe as a 'repertoire of risk', indeed 'a color wheel of different risks'. The geometricizing trellis that runs across the surface similarly evokes their 'periodic table' of 'infinitely recombinable elements of the affect system'. If the image speaks a single affect, however, it must surely be shame, which spectators might sense in the photograph's blue mood, the slight 'lowering of [Sedgwick's] eyelids' and the 'lowering of [her] eyes', as she tips her forehead slightly down — 'the hanging of the head in the attitude of shame', as Frank and Sedgwick suggest.[30]

What has caused the discomfort in this 'vignette' featuring, as 'our hero[ine]', a 'child who is destined to have every affect totally bound by shame', is what Tomkins described as the 'production of a total affect-shame bind by apparently innocuous and well-intentioned parental action', following a 'set of excruciating scenes in which a child is shamed out of expressing [her] excitement, distress, anger, fear, disgust, and even shame', as well as her desires and appetites. This leaves our heroine, her head tilted down, nevertheless looking up, scanning 'all incoming information for its relevance' to 'shame and contempt', her body transformed into the 'cognitive antenna of shame', one 'activated by the drawing of a boundary line or barrier, the introduction of a 'particular boundary or frame into an analog continuum', literally in the case of the columnar white lines, between her and her peers, or her, the foreground lawn, and the parental view-

29 For more on the metaphorics of black and blue, see Carol Mavor, *Black and Blue: The Bruising Passion of Camera Lucida, La Jetee, Sans soleil, and Hiroshima mon amour* (Durham: Duke University Press, 2012), and *Blue Mythologies: Reflections on a Color* (London: Reaktion, 2013).
30 Sedgwick and Frank, 'Shame in the Cybernetic Fold', 20.

ers. As a result, the photograph both registers the punctum of a shamed Sedgwick, 'punctuat[ed]' and 'distinct from [her] environment', and is shaming, its flatness keeping viewers out and at a distance, an experience exacerbated by the paradoxically deep foreground. As Tomkins puts it, 'any barrier to further exploration' will 'activate the lowering of the head and eyes in shame'.[31]

Indeed, emblematising Sedgwick's 'failure ever to renounce' her desired loving relation with her parents and readers, and with Frank and Sedgwick reminding us that the only scene that can be shaming is one that 'offers you enjoyment or engages your interest', such as a birthday party, the cover makes this particular shame-prone viewer 'blush', with shame registered as a 'precarious hyperreflexivity on the surface of the body'. Or, in this case, on the cover of the book, whose red text evokes the capillary expansion of the shamed flush. As such, *Shame*'s cover registers both as Sedgwick's shamed face and the spectator's, signifying that

> moment when the circuit of mirroring expressions between the child's face and the caregiver's recognised face [...] is broken: the moment when the adult face fails or refuses to play its part in the continuation of the mutual gaze; when, for any one of many reasons, it fails to be recognisable to, or recognising of, the infant who has been, so to speak, 'giving face' based on a faith in the continuity of the circuit.

This is a circuit signalled by the circuit-board-like white lines, joined at right angles across the cover.[32] The cover, then, includes numerous 'blazons of shame': Sedgwick's 'fallen face' and the blushing font are both 'semaphores of trouble and at the same time of a desire to reconstitute the impersonal bridge'.[33] Or, as Sedgwick put it elsewhere, the cover emblematises beautifully

31 Tomkins quoted in ibid., 5, 20–22.
32 Sedgwick and Frank, 'Shame in the Cybernetic Fold', 21–23.
33 Sedgwick, *Touching Feeling*, 36.

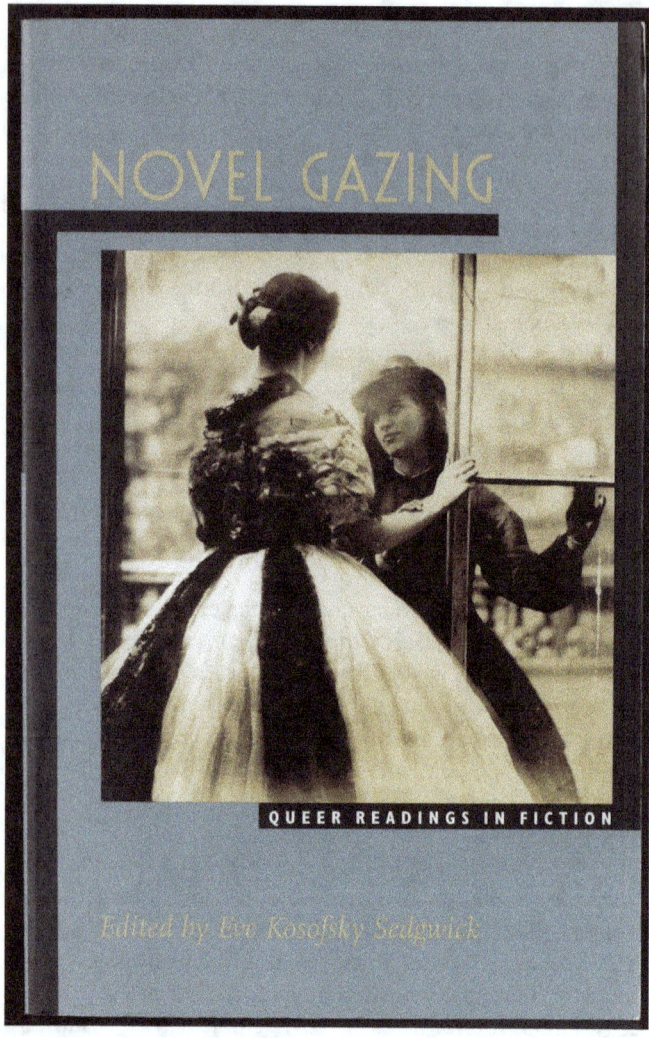

Figure 3.3. Front cover of Eve Kosofsky Sedgwick, ed., *Novel Gazing: Queer Readings in Fiction* (1997), featuring a photograph by Clementina Hawarden.

the uncertain, excited, shame-prone experience, for writers and readers, of

> starting a book,
> the way your fate and preoccupations,
> hundreds of things, the allergenic roses
> in the garden where you've thrown yourself
> to read, flirt with what seem the thousand tendrils, all responsiveness, of those
> knowing solicitous first paragraphs[.][34]

Novel Gazing, or, The Two Girls with Buttons

The cover of *Novel Gazing: Queer Readings in Fiction* focuses on a single, sepia photograph: an albumen print from a wet-collodion on glass negative, taken in the summer of 1864 by Clementina Hawarden, and cropped from her family album (see Figure 3.3).[35]

It depicts two young women, almost certainly Isabella and Clementina Hawarden, the photographer's daughters, on either side of a French door, and on the cusp of the public and private world of mid-Victorian South Kensington, in West London.[36] Hawarden shot the photograph, poignantly taken in the bardo of the last summer of her life, from an unspecified internal room, necessarily flooded with light, that recalls De Meyer's

34 Sedgwick, *Fat Art*, 39.
35 The photograph is currently housed within the collections of the Victoria and Albert Museum: PH 267–1947/D738. My dating of the image derives from Virginia Dodier, *Clementina, Lady Hawarden: Studies from Life, 1857–1864* (Denville: Aperture, 1999), 54, which reproduces the image on p. 85.
36 A related Hawarden image, of the two sisters, on the balcony, arms wrapped around one another's bodices, had earlier graced the cover of the Virago Press edition of Lillian Faderman's *Surpassing the Love of Women* (1981; London: Virago, 1991). Hawarden's centrality to the emergence of especially lesbian queer theory remains a thorn in the side of more conventional photographic history.

gentleman, in a similar bardo, on the cover of *Epistemology of the Closet*.

The smaller, darker figure of Clementina junior is seen from the front, stood on the balcony, dressed in a riding habit. A moment before the photograph was taken, she reached out and rested her bare right hand on her sister Isabella's naked right wrist, and looks up longingly into her eyes; an assured mutual gaze lacking in the case of *Shame and Its Sisters*. Hawarden shoots Isabella from the back, dressed in a two-part, white-and pale, off-the-shoulder silk and muslin dress, cinched at the waist, with a dark, lace sash, her hair tied neatly into a bun, her face and response hidden from view.

From first glance, the picture seems emphatically framed. Isabella and Clementina's gazes meet in the central third of the picture, a vertical trisection emphasized by the placement of the descending window frame two-thirds of the way across to the picture to the right, recalling *Shame and Its Sisters*' similar circuitry. The encounter of the girls' faces takes place just into the top half of the picture, a horizontal bisection similarly marked by the window's cross bar. In addition, Sedgwick has again neatly cropped the picture into a square, excising the torn, outer edges of the scrappier original, lifted, carelessly, from an album — a sloppiness representing one of the things she nevertheless liked most about Hawarden and Cameron, as we have seen.

But, everything is not as straight as it seems, or as conservative Hawardians would have us believe.[37] To date, Carol Mavor's *Becoming: The Photographs of Clementina, Viscountess Hawarden* (1999) represents the queerest reading of the im-

[37] For example, Dodier describes how Hawarden's 'two eldest daughters reaffirm their bond with each other and with their mother'. Isabella, 'in evening dress with her hair elaborately arranged, stands at the French windows to the terrace', with 'her back to the camera', so as to exhibit the 'intricacies of her dress and hair to full advantage'. Clementina, 'poised like a mirror before her sister whose expression she perhaps reflects, incongruously wears a riding habit and appears disheveled'. According to Dodier, the daughters' 'rapport is strengthened visually by the lines of the window, which directs our eyes to their linked arms' (Clementina, *Lady Hawarden*, 54).

age. Published two years after *Novel Gazing*, it seems likely that Sedgwick and Mavor discussed the picture during the genesis of the book since Sedgwick thanks Mavor in the acknowledgements to *Novel Gazing*.[38] Mavor reads the photograph of Clementina and Isabella as offering 'mirroring images of dark and light', 'masculine and feminine', and of 'the object of desire and her pursuer'. Mavor also notes that 'prim and proper' Isabella 'keeps her body protected and out of our view', whilst Clementina, 'with her hair loose, opens her body for Isabella and toward us'. Clementina's desiring gaze was, apparently, enough to make Mavor 'blush', and she also 'swoon[ed]' over Clementina's 'bare right', 'lovely ungloved' hand, 'stripped of the dark glove that her left hand so openly displays'. Indeed, Mavor could 'feel the pressure' of Clementina's touch, as it 'so softly but firmly clenche[d]' her sister's arm.[39]

Mavor compared Isabella and Clementina to Lizzie and Laura in Christina Rossetti's 1862 poem 'Goblin Market', published around the time the picture was taken, with Isabella echoing Rossetti's Lizzie, 'white and golden [...] / Like a lily in a flood', and Clementina recalling Rossetti's Laura who 'sucked and sucked and sucked the more / Fruits which that unknown orchard bore; / She sucked until her lips were sore'.[40]

For Mavor, then, Hawarden's image is about striptease, the fetish of the undressed hand, pleasures of eye contact, and delights of going down, to gobble at the market.[41] But Hawarden's image probably resonated differently for Sedgwick: the sisters' relationship more perverse, but also scratchier. For example, consider the picture's drift towards the bottom right, with a fo-

38 Sedgwick, *Novel Gazing*, vii.
39 Carol Mavor, *Becoming: The Photographs of Clementina, Viscountess Hawarden* (Durham: Duke University Press, 1999), 49–50. The image is also reproduced, in an un-torn, octagonal format, without commentary, in Graham Ovendon, ed., *Clementina Lady Howarden* (London: Academy, 1974), 91.
40 Rossetti, quoted in Mavor, *Becoming*, 49–50.
41 For a bravura reading of Rossetti's poem, see Victoria Coulson, 'Redemption and Representation in Goblin Market: Christina Rossetti and the Salvific Signifier', *Victorian Poetry* 55, no. 4 (Winter 2018): 423–50.

cus on the posterior, and on women's anal eroticism, encouraged by the framing of Isabella from the back, her crack suggested by the vertical crinkles of her muslin dress, emphasized by the descending bow-lines of the lace cinch. Her asshole, meanwhile, might be implied by the way the silk dress puckers darkly through the constraint of the lace cinch just above her coccyx. Indeed, the 1860s were the golden age of the caged crinoline, which became increasingly flat in the front and more voluminous behind, a back view often emphasized by a flowing train.

In spite of the ocular excitement of Clementina's gaze, and the imagined oral pleasures of the possible kiss that might provide the subsequent money shot, the pleasures of the hand, gloved and ungloved, and of fiber more generally, are at the heart of Hawardan's photographic eroticism. And, for Sedgwick, herself increasingly a fiber artist in this period, whose first exhibition, *Floating Columns,* debuted at Rhode Island School of Design in 1999, the differentiated cutaneous sensation of the textures and temperatures of silk, muslin, and lace, the first smooth, the second scratchier, as well as of light and dark fabrics, must have been central to her vicarious experience of the image — an image that suggests tactile pleasures might not just be interpersonal, but also between hands and fibres.[42]

For example, spectators might imagine the sensations of cutaneous constraint suggested by Isabella's cinched, and possibly corseted, waist, a moment of thin couture counteracting the fatter fashionable cage crinoline extending amply behind her. In addition, Isabella's fingers are pressed against the glass and metal bars of the window and its frame, with her thumb and pinkie separated out from her middle three fingers, to suggest digital extension, contraction, and sensation, rather than implying the thumbing, tapping, or rapping pleasures of the closed fist. Clementina's gloved left hand, meanwhile, similarly fondles the

42 For more on queer posthumanism, see Noreen Giffney and Myra J. Hird, eds., *Queering the Non/Human* (Aldershot: Ashgate, 2008); Mel Y. Chen, *Animacies: Biopolitics, Racial Mattering, and Queer Effect* (Durham: Duke University Press, 2012); and Mel Y. Chen and Dana Luciano, eds., *Queer Inhumanisms*, special issue of GLQ 21, nos. 2–3 (June 2015).

same frame, through a leather second skin, and providing the two sisters with the sturdy, predictable connection of the grid, with her thumb and pinky again sympathetically separated from her exploratory middle three fingers, both women exploring the pleasures of pressing their fingertips against a hard, resistant, registering surface.[43]

The picture does not just, however, 'invite [...] overall fingering' as Mavor suggests. To the upper right, as well as immediately below, Clementina's left glove can be found descending left to right diagonal and vertical scratches, which at first seem to be in the glass, within the picture, but are on the glass plate, and akin to those found in Piranesi's plate on the cover of *The Coherence of Gothic Conventions,* as we have seen. More conservative, less imaginative scholars have tended to read such scratches as a sign of Hawarden's 'sloppy' craft.[44] But we might be inclined to interpret them differently, along with the torn edges of the original print, as a sign of the pleasures, not just of touching and caressing, but scratching and marking, tearing and removing, possessing and destroying, and of nails on glass and skin. Indeed, the vertical scratch that runs down immediately below and from Clementina's left pinkie looks like a kind of snail trail upon the glass, a line of desire akin, perhaps, to the line or urine we detected on the grass on the cover of *Between Men*.

Indeed, if *Novel Gazing*'s characteristic crop seems to work uncharacteristically hard, in some ways, to straighten out Hawarden's image at the edges, it fails to reign in the perversity of the image seen with a queerer eye. After all, Sedgwick's viewers might wonder how Clementina came to be in the position in which Isabella now finds her. Her outfit suggests she has ridden here, an equine practice, often in pursuit of a quarry, involving 'horn[s]' and 'mounts', with sustained sexual connotations in "The Warm Decembers' (1978–1987), Sedgwick's meta-Victorian

[43] For more on the erotics of leather, see Mark Thomson, ed., *Leatherfolk: Radical Sex, People, and Practice* (1991; Los Angeles: Daedalus, 2004).

[44] For more on sloppy craft, see Elaine Cheasley Paterson and Susan Surette, eds., *Sloppy Craft: Postdisciplinarity and the Crafts* (London: Bloomsbury, 2015).

novella, in the form of a long narrative poem with eight chapters, whose events take place around 1880 in England and across its empire. The poem involves both real life protagonists from British nineteenth-century literary history, including Anthony Trollope, and an extended fictional family, the Martins, whose lives intersect with his, and reflect, in some complex ways, the experience of Sedgwick herself, who also appears, from the vantage point of "circa 1980" as she is writing the poem. [45]

In the poem, readers certainly find the poem's characters Tim Oughton, as he tries to flirt with Beatrix Martin, described as 'fresh-faced and eager of throat / as a plump hound in training'. Beatrix is later sat at the piano accompanying her cousin Ivy, who is singing 'batti, batti': Merlina's spanking first aria from Mozart's *Don Giovanni* (1787), where we discover that, 'since marriage', Beatrix has learned the piano as a 'late accomplishment', just as she learned how to be on 'horseback', activities 'learned in private out of duty' to her violent husband Gene Protheroe's 'ordinary, delusional ambitions', scenes causing Trollope to picture her 'in the marriage bed'. Trollope himself, meanwhile, envies profoundly his male companion's ongoing pleasure in riding, himself 'too heavy and weak-sighted to ride, finally, / after years of hunting', and dreaming, whilst adjacent to Beatrix at dinner, of his character Uncle Miles 'pulled across / a scrubble field on someone else's / mare, one he'd been warned about, that slanted off / rightward when it jumped'.[46]

In the poem, Sedgwick's language becomes even more erotic when it comes to the fledgling relationship between Chinese White and Lord Twytton's more or less factotum, Humby. At the end of Chapter Seven, White writes to Humby inviting him to a secret, late-night rendezvous in a graveyard in St. John's, in London, that White had spotted whilst riding through it. 'I am more

45 Eve Kosofsky Sedgwick, 'The Warm Decembers', in *Fat Art, Thin Art* (Durham: Duke University Press, 1994), 87–160. For more, see Jason Edwards, 'Bathroom Songs? Ferenczi and the Urethral Eroticism of "The Warm Decembers"', and Benjamin Westwood, 'The Abject Animal Poetics of *The Warm Decembers*', in *Bathroom Songs*, ed. Edwards, 29–35, 85–110.
46 Sedgwick, *Fat Art*, 95, 98, 100, 117, 132, 141, 149.

than ready', he informs Humby: 'Here is my whip'. In Chapter Eight, as we have briefly seen, we get to eavesdrop (Evesdrop?) on that delicious assignation and 'game' between

> The tough old whipper-in, catamite and familiar
> to tough, ancient Lord Twytten [who]
> lends to the drugged, imperious boy his seamed
> voice, his leathery obstetric hand,
> at…
> Oh, at what?
> At 'sex'.
> At a game of *horses*?[47]

Immediately before that, meanwhile, Sedgwick introduces her readers to a character with more than a passing resemblance to Chinese White, as well as one of her other poetic favorites, T.E. Lawrence.[48] This is Sir Richard Burton who

> wondered why
> whole boys commanded almost twice the rental
> of young castrati. — 'The reason proved to be
> that the scrotum of the unmutilated boy
> could be used as a kind of bridle for directing
> the movements of the animal'.[49]

Like the male protagonists in 'The Warm Decembers', then, Hawarden's Clementina seems to like riding and to possess a Humby-like 'leathery obstetric hand'. In addition, Clementina and Isabella function as a perverse, butch-femme, consensual lesbian-incestual Romeo and Juliet as they stand on the thresh-

47 Ibid., 149.
48 For more on Sedgwick's relation to Lawrence, see Edwards, 'Introduction', in *Bathroom Songs,* ed. Edwards, 193–97.
49 Sedgwick, *Fat Art,* 148. For more, see Joseph Allan Boone, *The Homoerotics of Orientalism* (New York: Columbia University Press, 2014). I am also grateful to Maddie Boden for numerous stimulating conversations about Burton, and the queer Victorian Middle East.

old of whatever will happen next. Indeed, the image represents a kind of sororal version of *Epistemology of the Closet*'s erotic threshold coming out into the light, with spunky Clementina having succeeded, unlike the comparatively wussy Romeo, in leaping from her horse, climbing up the balcony, even though the walls were 'hard and high', for 'stony limits cannot hold love out', and opening Isabella's French doors. Clementina is also apparently trying, now, either to invite herself into Isabella's comparatively shadowy apartment, or to persuade Isabella to join her on the warmer, lighter balcony, as the ideal location for their Sapphic, sisterly embrace.

As I have just indicated, the language of Act 2, Scene 2 of Shakespeare's *Romeo and Juliet* (1597), the famous Balcony Scene, seems tailor-made for Hawarden's image, or a possible source for it. What is that 'soft ... light' that 'through yonder window breaks', that we can see just 'o'er' Clementina, the pantomime principal-boy Romeo's head that represents a 'mask of light' on Isabella's face? Given the orientation of the picture, in relation to Hawarden's apartment, the light must come from the east, and represent the dawn sunlight of our lovers' aubade, signifying the hot golden glow of desire glistening between them. Like Juliet, Isabella, dressed in white, has also arisen, and threatens to eclipse the more shadowy Clementina, but, if anything, the silver light that shines on, and picks out, Isabella's bottom, coupled with the roughly hemispherical shape of her crinoline makes her seem more like the moon, the lunar orb that so fascinated Sedgwick's NASA-photographer father, as we have seen.

In addition, like Clementina, Romeo has a thing for gloves, wishing that he 'were a glove upon' Juliette's 'hand, / That [he] might touch [her] cheek': either one of the ones on her face, or below her coccyx. Clementina's 'white-upturned wondering eyes', meanwhile, focus on 'the bosom of the air'—the love of the incestuous pair of sisters, unlike Romeo and Juliet, not here going against the wishes of their mother. Like the flirtatious, cautious Juliet, however, Isabella is not to be 'too quickly won', seems to 'frown, and be perverse, and say thee nay'; the nay of negativity, though, homophonically doubling as the encourag-

ing neigh of a horse for Clementina to ride, the 'bud' of her love no doubt 'ripening' by 'summer's ... breath', sure that she will not, ultimately, be left 'unsatisfied'. In short, this is a scene to 'make a maiden blush'. 'Ay me!' and 'Oy Vey'!

As a result, the scene replays in a less paranoid and heterosexual, more reparative and lesbian mode the threshold crossing Sedgwick earlier discussed in *The Coherence of Gothic Conventions*, in which Emily Brontë's Lockwood, in *Wuthering Heights* (1847), after reading Catherine's 'fragmentary diary', dreams a particularly painful dream in which, whilst 'lying in the oak closet', 'knocking his knuckles against the glass', he stretched out his arm 'to seize' an 'importunate branch' that had been beating against the window, only to find in his hand 'the fingers of a little ice-cold hand'. Unlike Clementina's evident pleasure at the feel of her sister's arm within her palm and fingers, an 'intense horror' comes over Lockwood who tries to withdraw his touch, even as a 'melancholy voice sobbed, "Let me in — let me in!"' Terror makes Lockwood cruel, and 'finding it useless to attempt shaking the creature off', he 'pulled its wrist on to the broken pane, and rubbed to and fro till the blood ran down and soaked the bedclothes', refusing entry to the waif outside, who had been homeless for 'twenty years'.[50]

As Sedgwick observes, if 'the hands battling through the smashed window are a figure for many of the kinds of violated separation we have been calling Gothic', our novel gazing at Hawarden's photograph might memorialize one last context: the temporary, reparative return of Nina Kosofsky.[51] Sedgwick's sister had absented herself from the Kosofsky family for decades before returning home in the mid-1990s, at the time Sedgwick was working on *Novel Gazing*. The book's cover suggests the momentary rapprochement between the Kosofsky sisters, no longer trapped on either side of a painful divide.

50 Eve Kosofsky Sedgwick, *The Coherence of Gothic Conventions* (New York: Methuen, 1986), 98–99.
51 Ibid.

4

Fat Art, Thin Art

Many Arts That Feed as One, Or, 'The Warm Decembers' as Texture Book

In this chapter I consider the visual and material characteristics of Sedgwick's first book of poetry, *Fat Art, Thin Art* (1994), focusing on the intermediality of her long narrative poem 'The Warm Decembers' (1978–1987), whilst also developing further on our understanding of Sedgwick's relation to both nineteenth-century photography and her own familial photographic archive. The poem takes the form of a meta-Victorian novella, in eight chapters, whose events take place around 1880 in England and across its empire, involving both real-life protagonists from British nineteenth-century literary history, including Anthony Trollope, and an extended fictional family, the Martins, whose life intersect with his, and whose experiences also engage, in complex ways, with those of Sedgwick herself, who also appears, as she is writing the poem 'circa 1880'.[1]

1 Eve Kosofsky Sedgwick, 'The Warm Decembers', in *Fat Art, Thin Art* (Durham: Duke University Press, 1994), 87–160; 88. For more, see Jason Edwards, 'Bathroom Songs? Ferenczi and the Urethral Eroticism of "The Warm Decembers"', and Benjamin Westwood, 'The Abject Animal Poetics of The Warm Decembers', in *Bathroom Songs: Eve Kosofsky Sedgwick as a Poet*, ed. Jason Edwards (Earth: punctum books, 2017), 29–35, 85–110.

In her afterword to the poem, Sedgwick noted that, during the decade she was at work on it, the 'ecology of genres was changing', and whilst the poem represented a sustained attempt to demonstrate that the 'most writerly writing' she could do as a poet, and the 'most thinkerly thinking' she did as a critic, were not 'generically alien to each other', other scholars were 'experimenting with increasingly elastic understandings of what kinds of writings the genre of criticism might accommodate'.[2]

In what follows, I make a related argument, suggesting that Sedgwick's poetry, as well as her criticism, was not generically alien to the kinds of photographic and painterly interventions she made on her book jackets, and the kinds of textile practice she would go on to explore shortly after *Fat Art* was published; which is to say, that her ecology of genres was not limited to the verbal. Indeed, Sedgwick encouraged her readers to think about 'The Warm Decembers' as a gathering together of 'just such ontological thresholds' and the 'perverse, desiring energies that alone can move across them'.[3]

In her afterword to 'The Warm Decembers', Sedgwick also tells a comic story in which one of her fictional characters, Humby, received a copy of George Eliot's 1860 novel *The Mill on the Floss* bound together with her 1859 novella *The Lifted Veil* and failed to notice the difference between the end of the *Mill* and the beginning of the *Veil*. The anecdote happened to a friend of hers who was a Kant scholar, and she praised the 'intense creativity [...] passionate readers' were 'willing to invest in preserving, and if necessary inventing, the continuity of the nexus of individual identity'.[4]

2 Sedgwick, *Fat Art*, 160. For more, see Annamarie Jagose, 'Thinkiest', *Australian Humanities Review* 48 (May 2010): 11–15, http://australianhumanitiesreview.org/2010/05/01/thinkiest/.

3 Sedgwick, *Fat Art*, 157.

4 Ibid., 139–41, 156. For an account of Sedgwick reading *Daniel Deronda* (1876), see *Fat Art*, 34; of Sedgwick teaching *Middlemarch* (1871–72), *A Dialogue on Love* (Boston: Beacon, 1999), 175; and of *Adam Bede* (1859), *Between Men: English Literature and Male Homosocial Desire* (New York: Columbia, 1985), 134–60. Sedgwick's friend may have been Kant scholar

In the final section of 'The Warm Decembers', Sedgwick also drew attention to the way she composed the poem, her 'penning' and 'penciling' of the words on paper, and the 'mechanical' typing and reproducing the text that occurred in its editing and publication. In addition, she reminded her readers of the inevitable collapse of subject-object dichotomies involved in the touch of a hand on a pen, pencil, or keyboard, or the brush of the skin against a writer's notebook, in her description of the indivisible, although not necessary simply pleasurable or pain-free mutuality of a 'finger / however loving that sets the harmonic glass / to vibrate — and that stays it' as well as a ' finger however loving on the string' and a 'string's however swollen bite of the finger'.[5]

Actual textiles, as well as broader questions of texture, also play a conspicuous part in the poem. Indeed, one might read it as every bit a 'TEXTURE BOOK', as Sedgwick's second poetry book, *A Dialogue on Love,* and as an exemplary text for the Fall 2001 course she taught at CUNY on Victorian textures. This course sought to analyze textures in British Victorian material and literary culture, and to explore 'some working definitions' of texture, including its relation to sight and touch, scale and sound; ornamentation, structure, and organization; changing means and materials of production; colonial relations, affects and sexualities; and changing perceptual technologies. As a result, Sedgwick hoped her students would gain a rich sense of the textures of the Victorian material world, develop a vocabulary for the formal and phenomenological analysis of that texture, and understand how authors and practitioners employed texture as a tool for gaining theoretical leverage on history, class, imperial relations, spirituality, science and technology, gender and sexuality, labor, pleasure, and representation.

Alongside theoretical work by Carol Mavor and Renu Bora, to which we shall return, the course proceeded through a series

David L. Clark, co-editor with Michael Snediker, of *Regarding Sedgwick: Essays on Queer Culture and Critical Theory* (London: Routledge, 2002).
5 Sedgwick, *Fat Art*, 151, 153.

of readings of canonical literary texts.⁶ These included Eliot's *Lifted Veil*, *Silas Marner* (1861), and *Middlemarch* (1871–1872), which Sedgwick characterised as 'one of the definitive novels of texture'.⁷ John Ruskin's *Unto This Last* (1860) joined Charles Dickens's *Our Mutual Friend* (1864–1865) and William Morris's *News from Nowhere* (1890), with its 'characteristic Morris pattern of equidistant, unforegrounded, unbroken, and perspectiveless ornamentation drawn "from nature"' spreading 'from landscape to architecture to interior design to male and female raiment to the body and back again'.⁸ The syllabus also included Edith Somerville and Violet Florence Martin's less well-known *The Real Charlotte* (1894) and Henry James's *The Spoils of Poynton* (1896).

As if exemplifying the course, numerous textiles appear in 'The Warm Decembers', most predictably, in the form of clothes and other fabrics. Readers find Ellen Hatched dressed in a funeral 'crepe' that would 'wear out at last'. Runaway Beatrix Martin wears a 'sturdy dress in gray' and an 'oatmeal shawl', later with a 'rolled-up hem'. Her father, Cosmo Monkhouse, sports a 'spotted, felt-shod shoe'. 'Miles of damask' are found at the first dinner at Bluefields. 'Pursy muslin' is hanging 'at the black dormer', and 'the curtains' in baby Henry's nursery are compared to 'tapeworm swags / of indigestible lines, all thrown up / at bedfoot'. That candlelit nursery also 'unfolds' as Beatrix enters it one night with a candle, 'like gauze consumed by moon / or moths, or simpler darkness', revealing 'one small swathed-up bed / visible only in patches'. Another baby, Ivy Martin, is conceived on

6 The bibliography specified Mavor's *Pleasures Taken: The Performance of Sexuality and Loss in Victorian Photography* (Durham: Duke University Press, 1995). For Bora's article, see Renu Bora, 'Outing Texture', in *Novel Gazing: Queer Readings in Fiction*, ed. Eve Kosofsky Sedgwick (Durham: Duke University Press, 1997), 94–127. For more on the course, see https://eveksedgwickfoundation.org/teaching/victorian-textures.html.

7 Eve Kosofsky Sedgwick, *Touching Feeling: Affect, Pedagogy, Performativity* (Durham: Duke University Press, 2003), 15.

8 Ibid., 17.

a 'damson coverlet', whose father 'threaded' his mother 'like a needle carved out of a wishbone'.

Elsewhere in the poem, meanwhile, and anticipating Sedgwick's subsequent weaving practice, she described the 'very coarseness' of the extended Martin-Lucas 'family's social weave' within the 'net / of masculine filiations'. Sedgwick also picks out the 'Martin strands' within the Lucas 'weave', and the 'bright Lucas wool' on the Martin 'canvas', the latter image deriving from embroidery. In addition, Sedgwick compares the relations of the Lucases and Martins to 'visual warp and woof';[9] and describes Lucinda's voice as 'low, voile'. Beatrix offers to Trollope a 'silk-topped finger of / puffy cake'. The 'Lucas features of her early life', meanwhile, are 'touched into one anamorphic wipe / in putty silk'; while Cosmo and Lucinda are characterised, in the idiom of the period's Arctic sublime, as

> Two icy chaoses,
> boneless like chopped water throwing up on shore
> vast canted floors of ice brown
> in silk rags, mile after mile.[10]

In her 'Afterword', Sedgwick again employs a range of textile metaphors. If the Martin family has partly made its fortune from India rubber, used for 'elastic', Sedgwick, as we have seen, points to the 'increasingly elastic understandings of what kinds of writing the genre of criticism might accommodate'. She describes a scene of Beatrix in the bath as the last line of the poem 'destined to have been written out of a relatively *seamless* sense

9 Sedgwick, *Fat Art*, 91, 98, 100, 103, 109, 111, 116–17, 125. For a bravura reading of tapeworms, moths, and other creatures in the poem, see Benjamin Westwood, 'The Abject Animal Poetics of The Warm Decembers', in *Bathroom Songs*, ed. Edwards, 85–110.

10 Sedgwick, *Fat Art*, 90, 92, 96, 100. For more, see Chauncey Loomis, 'The Arctic Sublime', in *Nature and the Victorian Imagination,* eds. U.C. Knoepflmacher and G.B. Tennyson (Berkeley: University of California Press, 1977), 95–112.

of the integrity and momentum of this writing process' [emphasis mine].[11]

But 'The Warm Decembers' does not just riff on embroidery, weaving, tailoring, and soft furnishings. It provides a constant reminder of the huge variety of the haptic and visual textures of the Victorian world. These cluster into a number of kinds. For example, Sedgwick is frequently preoccupied, in the poem, with the 'behaviors of water', just as she was on the cover of *Epistemology of the Closet* and in her fiber practice. This image cluster includes the 'absorptive' Beatrix who 'leak[s] expressiveness'. Goatey Lament is 'very pervious to / any idea of failure', and Cosmo wears 'blotted slippers of felt'. There is a 'diffusion of daylight' and a sky 'streaming, / watery, awful, bright'. 'Long thin darkness' is 'spilt / over ground, flowing at this moment', and the sun 'leak[s] from its outlines'. We also encounter a 'raw mist'; a 'swollen' hose; and Maria Outon's 'remote / swimmy diffusion'. With Sedgwick's later interest in the water cycle in mind, readers might also note, in addition to Lucinda and Cosmo's 'icy chaoses', the presence of 'moist snow', the 'thin ice of pleasure in breathing and seeing', and we should note that other qualities, in the poem, 'melted away' over time. There is also Chinese White, a character whose name alludes both to his drug use and the popular Winsor and Newton watercolor paint invented in 1834.[12]

Fibrous and granular textures are also a key feature of the poem. Sedgwick describes Beatrix's voice as a 'reedy fasces' and her Urinary Tract Infection as a series of 'twining, nosy pains', twines that are central to Sedgwick's subsequent *shibori* tie-dye practice and the fiber art of Judith Scott that she so much admired, as we shall see in Chapter Five.[13] Beatrix's 'fretted poten-

11 Emphasis mine.
12 Sedgwick, *Fat Art*, 89, 93–95, 97, 100, 102–3, 105, 107, 110, 115, 118.
13 For more on shibori, see Yoshiko Iwamoto Wada, Mary Kellogg Rice, and Jane Barton, *Shibori: The Inventive Art of Japanese Shaped Resist Dyeing* (1983; Tokyo: Kodansha, 1999), and Yoshiko Iwamoto Wada, *Memory on Cloth: Shibori Now* (Tokyo: Kodansha, 2002). For more on Scott, see John M. MacGregor, *Metamorphosis: The Fiber Art of Judith Scott* (Berkeley: Creative Growth Art Center, 1999), and Catherine Morris and Matthew

tially female nudity', meanwhile, is revealed in the tub whilst more flexibly and softly striated is the 'plumy, toppling / head' of a messenger boy in the room as she bathes. More granular textures include various 'swarmed forms' and 'columns of bees and dust'. A Great Yarmouth boarding house is in an 'airy, dry, / salted place near the sea', presumably containing sedimented, white crystals across its surfaces. But the poem's granular focus resolves down beyond the salty grains of the microscopic to 'mercury, dissembled / to winking atoms'.[14]

In the poem, varnished, stained, painted, and layered textures also prove important, the latter again central in Sedgwick's subsequent patchwork, as we shall see in our discussions of her artist's book projects in Chapters Six and Seven. Readers hear of 'glazed' pastry and plates, and the 'rainy glaze' of 'paternal / words', as well as of 'greasy' mutton and 'muddy' and 'ruddy' children. Henry's ideas are 'spread thin' across his journalism. Trollope's whiskers are 'milky'. The bathing Beatrix is 'whorled like the painter's day's-end palette'; 'a kind of stucco / of raised beauty fingerpainted her, ungainly, / florid' at another moment; whilst, at her father's funeral, she is 'painted across the face / with pollen and tears'. On her moonlit flit to London, her 'greenish hands in the mantled pool' are 'lifting curtains of water up, the walnut / membrane of exposure tugging at her face', whilst her mother is 'stained dark with fatigue' and 'brittle' with responsibility. Twentieth-century American poet James Merrill and his lover David Jackson, meanwhile, appear, by contrast, in all their 'full memorious narrative polish'.[15]

Questions of temperature and light also come to the fore. Sedgwick describes the Lucas-Martins as a 'chill, ill-assorted family'. Bricks are, by contrast, 'bewarmed' and clay is 'finally cool' although 'never thirsty enough'. 'Shrimp light' bathes Beat-

Higgs, eds., *Judith Scott: Bound and Unbound* (New York: Delmonico Books/Brooklyn Museum, 2015).

14 Sedgwick, *Fat Art*, 89, 93, 102, 104, 107–8, 112, 114, 130.
15 Ibid., 95, 98, 102, 108, 110, 114, 130, 133 34, 137, 139, 151.

Figure 4.1. Eve Kosofsky Sedgwick, *Untitled*, c. 2002, cyanotype on cotton, dimensions unknown. Photo: H.A. Sedgwick, Collection H.A. Sedgwick, © H.A. Sedgwick.

rix in her tub, a shellfish illumination central to Sedgwick's later patchworks (see Figure 4.1).

At the same time, 'the pinking of the coal-light brims away', with a first 'blearing', then 'blinded' effect, leaving the 'thickest shadow'. Miles the dog is also 'beautifully glossy' with a 'lemony tinge — unless that's just / this odd solstitial light?'[16]

Surface textures also move between the transparent, reflective, and opaque. The narrator describes the 'seamless glassy inaudible hating flow' of Henry's *idée reçue*. Trollope, equally smooth and glassy, but more opaque, like a clear mirror, 'reflects'. A 'wheatfield' is similarly 'hoofed to silver' during the hunt. Offal, in the poem, meanwhile, drops 'glistening'. Readers are also frequently in the range of the blurry, scratchy, scrubby, and audibly frictive — the textures of the print culture that so preoccupied Sedgwick at the start of her career, as we saw in

16 Ibid., 100–101, 104, 110, 127, 134.

Chapter One. There is a blurrily motile 'shruggy edge' to Ivy and the sun is 'jiggled' and, suggestively, 'rimmed / around'. Cosmo has been 'scouring his horizons'. He and Ivy are also, at one key moment, 'at the table's end rustling'; and there are the 'static confusions' of Beatrix's life and heart.[17]

Sedgwick's poetic surfaces, in the poem, can also be hard or soft, and more or less densely grained or textured, depending on what has happened to them. Lucy Lucas is 'unified and hard', whilst Beatrix is soft with her 'puffing feet'. Nevertheless, she has a 'wooden' body under her father's intoxicated, and insensate 'hard rhetorical hand' as he 'raged on and on'; whilst the phallic Cosmo is 'stiffly ashamed' and 'growing stiffer / by the year'. We find a minimally textured and patterned 'bare, / nested fledgling' and dinner guests 'sparsely disposed'. But Tim Oughton's writing has a 'delicacy / whose grain his charismatic prose may swell'; whilst, at other moments, things move 'opposite to the grain of nature'.[18]

Surfaces can also be flat rather than folded, but potentially pliable, as when we hear of an 'alert but still ungathered silence'. Textures, in the poem, additionally move across a spectrum ranging from the fuzzy to the hairy and prickly, or from the viscous to the more durably structural. Beatrix's lap is 'creased and fussy', and Goatey's chins 'stubble onto' his breast. The description of a dreamy Trollope, meanwhile, begins by comparing him to an 'architectural mayonnaise, / rounded, and swaggy with arabesques' that later descends into a viscous mess: 'the sucking rift / of pudding pulling pudding', leaving it with the texture of 'broken meat, burst dimpled milk' when the protein 'girdle ruptured, / or almost', as it increasingly becomes a 'spreading turbid' sauce, with the ruptured girdle signaling Sedgwick's ongoing interest in fat art.[19]

Textures are also more or less as their manufacturers intended them, or show signs of weathering, wear and tear, as well as of

17 Ibid., 94–96, 99–100, 105, 110.

18 Ibid., 96, 98, 101, 105, 110, 114, 117, 129–30.

19 Ibid., 98, 102, 129–31, 134.

human bodily presence and more-or-less continent liquid and solid process, the latter important for Sedgwick's *thalassic* aesthetics, as we have seen. The Cosmo brothers' college walls are 'frayed' — a characteristic of the edges of almost all of Sedgwick's textiles. There is a 'nick' in the 'tin of robin's egg / enamel' in Beatrix's tub. Baby Henry's lips are 'drying'. His 'small mauve chin' is 'roughened with saliva'. His spectacles are 'swimming upward' on his 'winnowing hair'. An imaginary fox's tail is 'heavy' and 'matted with dung / and leaves' — a 'matte black' akin to that of Clare Lucas's mourning clothes. 'Mud silt in a slow river', meanwhile, similarly 'aliment[s] some passage of countryside', whilst 'the sky is silted up / with low, retarding marks of lava'.[20]

Having now offered a sustained surface reading of 'The Warm Decembers', one alert to its many textural idioms and that pointedly challenges the textural flatness and thinness of literary accounts of surface reading thus far, in the next section we go on to think about the significant place of drawing, engraving, and photography in the poem, developing the sense we have already of Sedgwick as an idiomatically sharp critic of the cultures of both photography and print.

Beatrix Martin, John Ruskin, and P.H. Emerson, or, Drawing, Engraving and Photography in 'The Warm Decembers'

In addition to being a texture book, 'The Warm Decembers' explores three Victorian visual reproductive technologies: drawing, engraving, and photography. In the poem, Sedgwick cites John Ruskin's *The Elements of Drawing* (1857) which argued that 'in general, everything that you think very / ugly will be good for you to draw'.[21] And Beatrix, after having a terrible encounter with a swan, with a 'white back / mounded like the chalky downs

20 Ibid., 89, 91, 94–95, 100, 123.
21 Ibid., 97; John Ruskin, *The Elements of Drawing* (1857; New York: Dover, 1971), 108. Ruskin's account of drawing had already figured in Sedgwick's *The Coherence of Gothic Conventions* (1980; London: Methuen, 1986) as a source for her thinking on 'nonce taxonomies' (160, citing Ruskin, *Elements*, 117).

of the south', is later inspired to take up drawing in chalk, again emphasizing the potential sexual violence of different media, as Sedgwick had done in *The Coherence of Gothic Conventions* in the case of engraving. Readers learn that, 'on the whited walls' of the Great Yarmouth boarding house, following her foiled escape, are pinned self-referential

> textured little landscapes scratched in chalk
> by the invalid's fingers. The English field
> her imaginary subject: fields
> with sausages of flab; or foliage like eyebrows;
> or grass the fur of an animal
> too sick to tend itself — possibly one
> even whose old distracted claws
> hoed at its own numb sides;
> like the Beatrix Beatrix perceived,
> extents of vital texture, slabs of it
> only at the last extremity nipped in
> to make an animal form.[22]

Whilst Sedgwick does not footnote her Ruskin reference, returning to *The Elements of Drawing*, with 'The Warm Decembers' in mind proves informative, since both describe drawing and photography through the language of digestion, and thus of fat and thin arts. For example, he documents the way 'the chemical action of the light in a photograph extends much within the edges of the leaves, and, as it were, eats them away', whilst she describes the 'photographic light that eats the plate'. In addition, *The Elements of Drawing* and 'The Warm Decembers' employ an epistolary format, and, like the Sedgwick of *Tendencies* and *A Dialogue on Love*, Ruskin is preoccupied with the 'white interstices' between graphic marks, encouraging readers to look at them 'with as much scrupulousness as if they were little estates on which you had to survey, and draw maps' — his monarch-of-

22 Sedgwick, *Fat Art*, 97, 111, 114–15.

all-you-survey imperialism in a markedly different mode, however, to Sedgwick's melancholic queerness.[23]

Ruskin also repeatedly advocates the use of 'Chinese White', the name of a key queer character in Sedgwick's poem, as we have seen, in what he suggestively calls the 'gay world' of color, describing it as 'strangely delicious' when 'well managed', like 'white roses washed in milk'. This was a color, according to Ruskin, to which the eye can seek for 'rest, brilliant though it may be', since it represented a 'space of strange, heavenly paleness in the midst of the flashing of the colors'. In addition, when thinking of whiteness, and in advocating how 'more delicate gradations are got in an instant by a chance touch of the India-rubber', Ruskin would have improved the finances of the Martin family, in the parallel factional world of the poem, who made a 'killing in India-rubber', as we have seen.[24]

Ruskin's sexually repressed pedagogy, meanwhile, coming from an author apparently ignorant about female sexual anatomy, if rumours surrounding his unconsummated marriage provide reliable evidence, might also partly explain why Beatrix is so clueless about the location of her 'uterus and clitoris'. That said, *The Elements of Drawing* is intimately concerned with the 'habit[s] of the hand'. Indeed, readers might interpret Ruskin's treatise as a cautionary tale for the nineteenth-century masturbating girl. For example, he noted how, in drawing foliage, there was something compulsively pleasurable, a moment at which 'leaf No. 1 necessitates leaf No. 2' and so on until 'you cannot stop' drawing. And, in the characteristically erotic idiom of riding that recurs through 'The Warm Decembers', as we have seen, 'your hand is as a horse with the bit in its teeth'. But it is at just such tempting, potentially out-of-control moments that 'you must stop that hand of yours, however painfully; and make it understand that it is not to have its own way any more, that it

23 Ruskin, *Elements*, 40, 73; Sedgwick, *Fat Art*, 100.
24 Ruskin, *Elements*, 37, 137, 150, 154–55; Sedgwick, *Fat Art*, 89.

shall never more slip from one touch to another without orders; otherwise it is not you who are the master, but your fingers'.[25]

If Sedgwick expresses her interest, meanwhile, in 'the finger's-breadth by finger's-breadth / dearly bought knowledge / of the body's lived humiliations' and 'dependencies', Ruskin focuses on 'hair's-breadth' differentiations, and his prose is similarly not without its s/M undercurrents. There is a violent delight in what he calls 'the power of rightly striking the edge' of a drawing that 'comes only by time and practice', as well as in being able 'finally to strike the color up to the limit with perfect accuracy'. More masochistic at other moments, Ruskin suggests that 'Nature will show you nothing if you set yourself up for her master. But forget yourself, and try to obey her, and you will find obedience easier and happier than you think'.[26]

If drawing and watercolor painting, often aligned for Ruskin, represent a key intermedial component of 'The Warm Decembers', then engraving and photography, particularly in its silver nitrate and sepia phases, play a still greater part. The introduction of these two novel reproductive forms within the Victorian media ecology presumably explains the peculiarly metallic character of much of the poem's imagery. For example, a speculative article in one of Cosmo's journals asks 'Is Painting Dead?', whilst 'Acid / and Quill' is the name of another of his presumably illustrated journals. Readers learn, elsewhere, of baby Henry's 'etchy lids' and 'ugly-duckling smile' that 'flashes itself most graphically', descriptions combining engraving with flash photography. Sedgwick also compares Beatrix to the 'gilded, scored' metallic Horses on San Marco, engraved with the 'dull traces of the harness', her 'haunches' 'brushed with mercury'. In addition, Sedgwick describe an autumn day's 'curdy bronze' palette; the 'mercury / that dilates on puddles' as 'the sun drops', and

25 Ruskin, *Elements*, 119-20.
26 Ibid., 33, 42, 51; Sedgwick, *Fat Art*, 149.

the effects of an opiate's 'dull brush of nacre' on Henry Martin's vision.[27]

Photography, however, looms largest in the poem, and *Fat Art, Thin Art* more generally as a book. It takes the forms of the David Hockney-like photomontages we discussed in Chapter Three referred to in one of the poems, and the snapshot of the youthful Sedgwick on the front cover, that we shall come to.[28] Victorian photography also plays a key role in 'The Warm Decembers', as it had already done on the covers of *Epistemology of the Closet* and of *Novel Gazing*, which employed and referenced the works of Anna Atkins, Baron Adolph De Meyer, and Clementina Hawarden, as we saw in earlier chapters.[29]

In 'The Warm Decembers', Beatrix is an amateur photographer, and the poem, Sedgwick revealed, had Victorian photographer Julia Margaret Cameron as a muse, who died a year before the poem largely takes place. As Sedgwick documented, 'Sticking the housemaid or neighbor into idyll, like sticking friends into WarmDecs. Lot's about this'.[30] Sedgwick's abbreviated note here refers to Cameron's *Idylls of the King* (1874), a deluxe two-volume edition of twenty-four photographs, selected from 245 exposures, commissioned by Alfred Lord Tennyson, and inspired by his 1859 poem of the same name, which Cameron self-published, having felt unhappy with how her photo-

[27] Sedgwick, *Fat Art*, 94, 101, 104–7, 109, 116. The repeated presence of mercury in the poem reminds readers of its use as a treatment for syphilis in the period. For a related, queer-theoretical reading of the environmental spread of poisons and their ingestion into unwitting, non-consenting bodies, see Mel Y. Chen, *Animacies: Biopolitics, Racial Mattering, and Queer Effect* (Durham: Duke University Press, 2012), 159–223.

[28] The poem is 'Grave', *Fat Art*, 10.

[29] With the cover of *Novel Gazing* in mind, it may be important to note that, in 'The Warm Decembers', Sedgwick first introduces Trollope, considering Beatrix, to whom he is attracted, 'outside the French window'. It is also 'at the French window' that we see the two first talking (*Fat Art*, 94–95).

[30] Sedgwick, *Fat Art*, 88, 158. For more on Cameron, see Carol Mavor, *Pleasures Taken: The Performance of Sexuality and Loss in Victorian Photography* (Durham: Duke University Press, 1995).

graphs appeared in the reduced-scale wood engravings in the official, illustrated edition.³¹

In the poem's Norfolk sections and when it came to the visual character of Beatrix's photographs, Sedgwick may also have been inspired by a second set of photographic *Idylls,* this time made by Naturalist and Pictorialist photographer P.H. Emerson, a famous Victorian practitioner the poem does not mention. He was famed, in his lifetime, for his eight volumes of East Anglian images. These ranged from *Life and Landscape of the Norfolk Broads* (1886), through *Idylls of the Norfolk Broads and Pictures from Life in Field and Fen* (1887), to *Pictures of East Anglian Life* (1888, 1890), *Wild Life on a Tidal Water* (1890), *On English Lagoons* (1893), and *Marsh Leaves* (1895). His 1889 manifesto, *Naturalistic Photography for Students of the Art,* meanwhile, argued against the practice of composite photography, of the kind advocated by Oscar Rejlander, that Sedgwick was so enamoured with, in favor of his own Naturalistic, single-shot, untouched images of real people in their native environments.³² The potential parallels with the immediately historically and geographically proximate Beatrix are numerous.

31 For more on Cameron's *Idylls,* see Brian Hilton, ed., *Illustrations by Julia Margaret Cameron of Alfred Lord Tennyson's 'Idylls of the King and Other Poems'* (Freshwater Bay: Julia Margaret Cameron Trust, 2004); J.P. Yamashiro, 'Idylls in Conflict: Victorian Representations of Gender in Julia Margaret Cameron's Illustrations of Tennyson's *Idylls of the King', The Library Chronicle of the University of Texas at Austin* 26, no. 4 (1996): 89–116; and M. Hill, 'Shadowing Sense at War with Soul: Julia Margaret Cameron's Photographic Illustrations of Tennyson's *Idylls of the King', Victorian Poetry* 40, no. 4 (2002): 445–62.

32 For more on Emerson, see Peter Turner and Richard Wood, *P.H. Emerson: Photographer of Norfolk* (London: Gordon Fraser, 1974); Nancy Newhall, *P.H. Emerson: The Fight for Photography as a Fine Art* (New York: Aperture, 1975); Neil McWilliam and Veronica Sekules, eds., *Life and Landscape: P.H. Emerson — Art and Photography in East Anglia 1885–1900* (Norwich: Sainsbury Centre, 1986); and John Taylor, *The Old Order and the New: P.H. Emerson and Photography 1885–1895* (Munich: Prestel 2006). For more on Victorian composite photography, see Elizabeth Siegel et al., *Playing with Pictures: The Art of Victorian Photocollage* (New Haven: Yale University Press, 2009).

Beatrix is eleven years Emerson's senior, and active around 1880, and so, in Sedgwick's parallel late-Victorian universe, technically his predecessor and, indeed, his potential unacknowledged source. Anticipating Emerson, Beatrix is, primarily, a landscape photographer, and can be found repeatedly in the poem 'pig-faced' with 'absorption' — that key Friedian concept again — 'tilting photographically / outward toward' the horizon with her 'landscape camera', creating the 'curdy bronze' and 'mercury' landscapes we have already had cause to notice. Like Sedgwick, 'absorptive' Beatrix is an exponent of fat art, as readers learn when Trollope asks her 'how many plates' she has 'consumed' with her 'light and camera', and when she replies that she may be 'slow' but is 'omnivorous'.[33]

Whilst Trollope jealously does not believe Beatrix is 'suited / to ocular domination', which is to say, to photography or his desire to consume her visually, the poem takes her art seriously. Readers learn that she first takes to photography when she finds a camera amongst the abandoned 'rubble' of one of her violent husband's now abandoned, repeated earlier enthusiasms 'about expensive things, / for short terrorizing periods'. And, in an uncompleted later scene, readers were to discover that Beatrix leapt at the 'thought of a move toward financial autonomy' from her husband, who she is desperate to leave, when Chinese White 'suggests to her in private that he knows how she may be able to sell some of her photographs professionally'. Sedgwick also makes clear that Beatrix's photos were key to the evidence she would offer readers to 'sow the suggestion of Ivy's having been molested over a fairly long period by Gene' — a family album providing documentary evidence of non-consensual abuse, to which we shall return.[34]

Admittedly, the photographs readers see Beatrix taking do not, unlike Emerson's images, represent Norfolk; they depict Sussex. But the kinds of plates she takes repeatedly anticipate Emerson's, indicating the way her Norfolk youth impacted how

33 Sedgwick, *Fat Art*, 94, 96, 99, 103.
34 Ibid., 115, 119, 154, 156.

Figure 4.2. P.H. Emerson, *Idylls of the Norfolk Broads,* 1887, photogravure, 14.3 × 25.1 cm, Victoria and Albert Museum, London: E.142–2015 (open access).

she subsequently experienced the Sussex landscape. The scenes including Beatrix in Norfolk can, for example, repeatedly be illustrated with Emerson's roughly contemporaneous photographs (see Figure 4.2).

Like much of Emerson's Norfolk work, the first 'view that Beatrix's eye and […] camera / concoct and share' is 'like the mud silt in a slow river / alimenting some passage of countryside' in the way it captures the 'sky, reflective and bounded, / nevertheless, though broadly passive', that 'trains […] across the fields stubbled and fouled, towards dung, / toward the flat, the blueless / aerated tones of earth — and glazed, like pastry'.[35]

Emerson's *The Fringe of the Marsh* (1886), meanwhile, recalls the second landscape we see forming, deforming, and reforming, in Beatrix's mind (see Figure 4.3).

35 Ibid., 95.

Figure 4.3. P.H. Emerson, *The Fringe of the Marsh,* 1886, platinum print, 17.5 × 28.7 cm, Getty Collections: 84.XO.1268.40 (open access).

Figure 4.4. P.H. Emerson, *Great Yarmouth from the Breydon Water,* 1890, photogravure, 17.8 × 21.9 cm, Getty Collections 84.XO.1373.1 (open access).

Figure 4.5. P.H. Emerson, *A Yarmouth Row, from Wild Life on a Tidal Water* (1890), plate 48 of Peter Turner and Richard Wood, *P.H. Emerson: Photographer of Norfolk* (London: Gordon Fraser, 1974).

This evokes the precarious fortunes of her immediate family and describes a kind of time-lapse scene in which

> a puddle of night in a hollow
> of bright lawn, [is] all day anxiously deforming,
> eccentric toward the grassy lip at dawn,
> then shrinking southward and into the roots,
> and then, at noon, like mercury, dissembled
> to winking atoms, bridling in the afternoon
> one little knob, brimming from that
> up every grass to where the golden shield
> of the evening crushed it level — this plot
> of striving shadow, daily rolled around
> the grassy mouth, never could it reach over
> those shallow hummock lips; not, not by the breadth
> of one fine blade; never, until
> there leapt across the spread of grass and air
> writ large, the earth's shadow, darkness, that had
> no shadow, but washing downward embraced
> the pool that leapt up into it.[36]

Vividly capturing the family's changing economic status, the passage suggests the multi-level iconographic and affective complexity of Beatrix's photographs, to viewers and readers attuned to her personal history and to Sedgwick's idiom. For example, there is something evocatively, erotically urethral, labial, and vaginal about that little puddle in a hollow of bright lawn, filling up with liquid and floating up to the grassy lip at dawn, before shrinking southwards into the roots and evaporating away. There is also something clitoral about the remaining little knob, passionately and indignantly bridling through the afternoon, but finding, out there in the world, first in the form of Beatrix's abusive father, and then her abusive husband, a crushing golden shield determined to keep it down between those shallow hummock lips. But, in spite of all of this violent sup-

36 Ibid., 104.

FAT ART, THIN ART

Figure 4.6. P.H. Emerson, *Rockland Broad* (date unknown), plate 149 of Nancy Newhall, P.H. Emerson (New York: Aperture, 1975).

pression, there remains a bleak kind of hope. If Beatrix's marshy liquid could not, thus far, reach over her shallow lips, finally, perhaps only in death, there will be a liquid release, when the earth's complete shadowless dark washes downward to embrace the pool that leaps up to meet it.

The poem's Norfolk scenes further echo Emerson's work. Beatrix and her aunts live in a Great Yarmouth boarding house, perhaps of the kind seen behind the boats in Emerson's *Great Yarmouth Harbor* or the bleaker scene of *A Yarmouth Row* (both 1890) (see Figures 4.4 & 4.5).

On the course of her moonlit flit from the coast, meanwhile, Beatrix encounters cows in a 'sloppy landscape'. This is a scene, like Figure 2, in which similarly condensed above Beatrix's eyes

Not only the land

and the water, or the sea water and the fresh water,
but the water and the air, over and over the same places,
sometimes invisible and sometimes visible.

Later, she falls asleep under what she takes to be a 'windmill / she thought she'd glimmered onto in the dark', perhaps like that in Emerson's *Rockland Broad* (see Figure 4.6).

She wakes up, however, under a 'continent violet sky', with 'no mill there', to find herself under 'inexpressive, overprecise clouds / that could not change in shape' — a photographic truth-to-nature central to Emerson's practice, but actively resisted by Sedgwick's condensing, always multiply suggestive imagination and imagery.[37] In the poem, therefore, the scene resonates deeply with Beatrix's personal history, encouraging readers to interpret her photographs in autobiographical terms. The continent sky contrasts painfully with the increasingly unwell Beatrix, suffering from a urinary tract infection, and unable to pass urine, with her delirious, Don-Quixote-like mistaking of the windmill as a sign of how unwell she is. Ultimately, she is able to crouch 'waist-deep / in the near-opaque channel of the Broads / in the dark' to allow the 'rush of strangled liquid through', though it brings her little ultimate relief or pleasure, unlike the thalassic world of Sedgwick's *Déjeuner* that we considered in Chapter One, since, when she comes to, a page and 'fortnight later', she is back 'at home (in Yarmouth), undelirious'.[38]

The image of Beatrix, as a lone woman, trying to piss, before passing out, in the broads also brings to mind Emerson's most famous photograph, *Water Babies* (1887), a parallel revealing her painful female isolation in contrast to its subject's youthful male homosocial pleasure (see Figure 4.7).

After all, where desperate, lonely, poorly Beatrix is seen from the front, stripped below the waist and submerged to her na-

[37] Ibid., 111. Whilst Emerson does not depict swans in his photographs, he bought his first camera in 1881–1882 to use on bird-watching trips with his friend, ornithologist A.T. Evans.
[38] Ibid., 111–13.

FAT ART, THIN ART

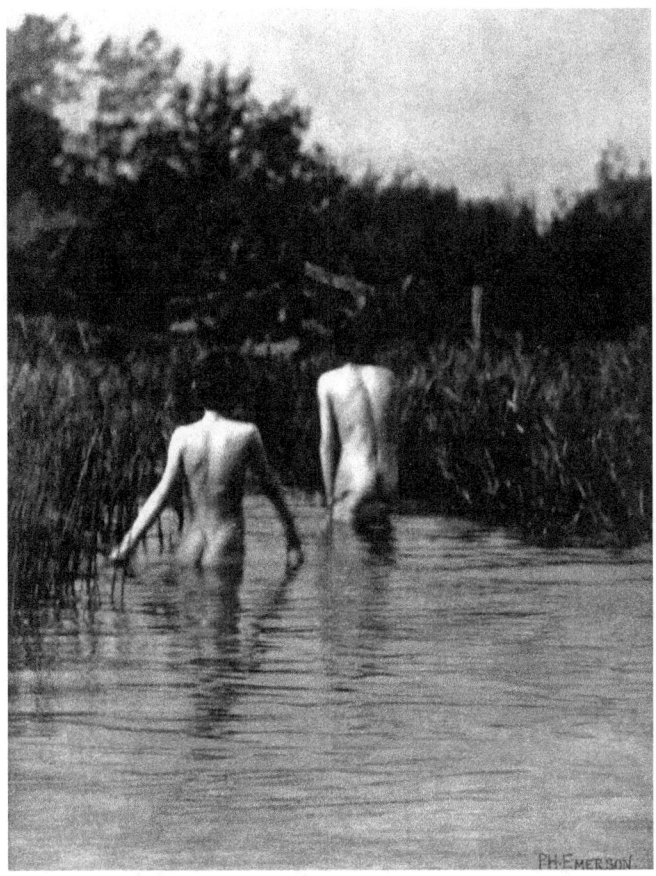

Figure 4.7. P.H. Emerson, *Water Babies*, 1887, photogravure, plate 6 from *Idylls of the Norfolk Broads*, 15.9 × 12.2 cm, Getty Collections: 84.XB.696.1.6 (open access).

Figure 4.8. P.H. Emerson, *A Spring Idyll,* plate from *Pictures from Life in Field and Fen* (1887), plate 40 of Peter Turner and Richard Wood, *P.H. Emerson: Photographer of Norfolk* (London: Gordon Fraser, 1974).

vel, in order to piss in relative privacy, Emerson's naked boys wade happily together, are seen from the back and emerge, unselfconsciously, into the 'steamily beautiful / wetland view'— an avuncular pedophilia that, perhaps, takes us back to the cover of *Tendencies*.[39]

During her subsequent recovery, Sedgwick depicts Beatrix in bed, at her aunts' boarding house, peeling potatoes. The scene anticipates Emerson's *A Spring Idyll* (1887), with its young woman preparing root vegetables in the garden (see Figure 4.8).

The final time we encounter Beatrix, with camera in hand, she is 'taking a whole day to shoot / the Priory ruins', having assumed it would be a good place, 'away from the hunters'. The ever-stalky Trollope, like Emerson's poacher with *A Hare in View* (1888), is not to be deterred, however, tracking her down, accompanied by his canine sidekick, Miles (see Figure 4.9).

But Trollope gets more than what he bargained for, when an irritated Beatrix's 'gray, Athenan camera gaze fell / toward her fingers' as she strategically recalls her unflattering dream of him as a 'kind of pudding, like blancmange'.[40]

Sedgwick includes one last set of Beatrix's photographs in the poem, this time depicting her family. Readers encounter this album in the hands of Chinese White, whilst Beatrix and Ivy are singing their masochistic duet, causing Beatrix to keep gazing anxiously in White's direction, hoping 'to penetrate invisibly to every page' he sees, fearful what he will discover there, and longing to see her two dead daughters, whose images the album preserves. White works backwards through the volume, discovering recent shots of 'Gene and Baby Henry', and then 'of –' and the sentence ends and the line breaks before readers find out who, suggesting this is the first time White realizes Henry was not Beatrix's first child.[41] White then realizes it was Gene who took the early shots of Beatrix. A particular image catches his attention. This is of Beatrix

39 Ibid., 111–13.
40 Ibid., 114, 127–31.
41 Ibid., 136.

Figure 4.9. P.H. Emerson, *The Poacher — The Hare in View, Suffolk*, plate from *Pictures of East Anglian Life* (1888), plate 61 of Peter Turner and Richard Wood, *P.H. Emerson: Photographer of Norfolk* (London: Gordon Fraser, 1974).

herself, badly, grimly, holding on behind
the neck of an exquisite girl child:
the cheek of velvet underneath the cheek of rumpled
silk, three puffy hands that can't let go,
four light-colored hating eyes cemented
on the camera, the tiny face speaking for the huge face
a closure as of eyes that fit like little nuts
into their unfinished sockets, and the mother's face
speaking for the daughter's face an amplitude
of light-catching small impressions, dints of pity
as it learns slowly to withhold itself, of fear of violence,
dints of patience, patience, floated on blubbering tears,
bright dimples of visceral connectedness with the child
who's dying — also the hammered glare of the new shy
art winking with pink Gadarene
defiance to the utmost.[42]

Sedgwick's description again reveals a characteristic violence in photography as a medium, a sadomasochistic tableau we have already encountered on the cover of *Shame and Its Sisters,* and that lies at the heart of her queer accounts of the medium specificity of engraving as well. Here, the violence belongs to Beatrix's husband and the father to whichever of her never-named, short-lived toddlers is on her lap. After all, Beatrix does not just hold the baby in her arms, and hold its neck, presumably to keep it up if it is newly born, or from moving and blurring the slow exposure, but also 'hold[s] on' behind it, for dear life. Beatrix, however, resists Gene's violent visual objectification in two ways. Firstly, by emphasizing the intimate tactile dialectic she and her daughter share compared with the distance at which her husband stands. Here Sedgwick sympathetically invites readers to imagine the baby's 'cheek of velvet' underneath her mother's 'cheek of rumpled / silk', the 'bright dimples of visceral connectedness' signaling the rich, soft, warm textures of the pair's more

[42] Ibid.

or less pre-Oedipal bond.[43] Mother and daughter also share three soft 'puffy hands that can't let go', and 'four light-colored hating eyes' seeking to resist Eugene's objectifying gaze. The baby's 'tiny face speak[s] for' Beatrix's 'huge face', in its 'closure as of eyes that fit like little nuts into their unfinished sockets', signaling the baby is sleeping or, more likely, resisting reciprocating its father's penetrating gaze with all the power of well-designed, tightly-fitting, industrial metal. Beatrix's face, meanwhile, protects her daughter by monitoring the environment and absorbing its blows, her contrasting soft puffiness acting as a cushioning fabric to sponge up most of the violence, anticipating the belief of Sedgwick's c. 1993 poem 'The Use of Being Fat', that no one that she loved 'could come to harm / enfolded' in her fat touch, which would 'blot it up, / the rattling chill, night sweat or terror' — there enfolding Sedgwick's friends suffering from HIV and AIDS-related illness, here keeping Beatrix's daughter from her family's ingrained domestic and sexual violence.[44]

Like a camera, Beatrix's face, in this context, offers an 'amplitude / of light catching small impressions' of the world around it. The prints it makes, however, are more like a subsequent piece of Sedgwick cyanotype fabric than a two-dimensional photograph, whose textile-soft, three-dimensional surface can be dinted by pity, for herself, and, generously, for her husband, as she learns to withhold herself, and hold her daughter, against the violence he projects at them. For example, this occurs when he hammers away at them with the 'new shy / art' of photography, with its shaming objectification and

43 Sedgwick's description of the tactile softness and intimacy of 'rumpled / silk' anticipates the description of her therapist Shannon van Wey 'spinning straw into gold' in *Dialogue,* who is thus akin to fiber artist Rumpelstiltskin. For more on the latter, see Jane Schneider, 'Rumpelstiltskin's Bargain: Folklore and the Merchant Capitalist Intensification of Linen Manufacture in Early Modern Europe', in *Cloth and Human Experience,* eds. Annette B. Weiner and Jane Schneider (Washington, DC: Smithsonian, 1989), 177–214.
44 Sedgwick, *Fat Art,* 15.

FAT ART, THIN ART

photographer hidden coyly underneath fabric and behind his camera's 'glar[ing]' flashlight.[45]

This experience of photography as a kind of violent exposure, of women and children, by men, brings us, finally, to the cover of *Fat Art, Thin Art*.

The Child in the Photo, with One Breast Missing, or the Kosofsky Family Album

The cover of *Fat Art, Thin Art* reproduces a photograph of Sedgwick, aged around seven, taken by her father, in the family back yard in Dayton, Ohio (see Figure 4.10).

In *A Dialogue on Love*, a discussion of the image leads to a stumbling block in Sedgwick's relationship with her therapist, Shannon Van Wey. In his characteristic SMALL CAPS, he documents a dream she reported in which she looked in the mirror and saw herself 'REFLECTED AS THE CHILD IN THE PHOTO FOR THE POETRY BOOK COVER, BUT WITH ONE BREAST MISSING AND THAT LONG HAIR'. In characterizing the snapshot, Sedgwick described her body as looking and feeling 'SLENDER, DISCRETE, RESOLUTE' and 'SELF-CONTAINED'. The image was taken 'JUST BEFORE ALL OF THE TURMOIL OF BECOMING GENDERED' came down on her, causing her to have mixed feelings about it. On the one hand, as the rose tinting indicates, she saw 'HERSELF AS VALUABLE', as a resourceful child relatively untainted by the demands of pubescent gender. Viewers might, however, read the rose tinting more poignantly, recalling that, in a 'Mediterranean' family with 'fine brown frames' and 'sparkling or / soulful, extravagant-lashed / eyes of chocolate', Sedgwick was a 'dorkily fat, pink, boneless middle child', who resembled a 'Marshmallow',

45 In looking at Beatrix's family album, White, orphaned as a boy, misreads the photographs, thinking it was she who would slip away, 'as mothers do', leaving 'the child' with the 'awful heroism' of trying to survive without her, and here locking his mother 'like a glacier in its arms, / tugging her back toward it and making gravel of her' — the product of 'either the pages growing more peculiar' or, more likely, 'his own edginess' and family history (Sedgwick, *Fat Art*, 136–37).

197

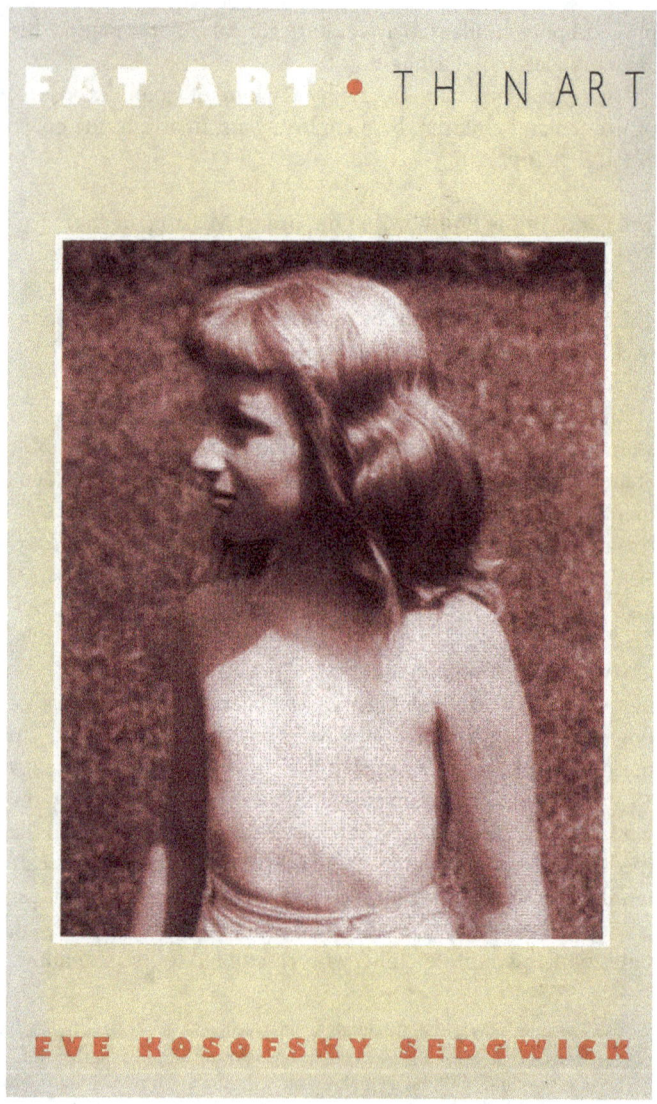

Figure 4.10. Eve Kosofsky Sedgwick, front cover of *Fat Art, Thin Art* (1994), featuring a c. late 1950s photograph of the author by Leon Kosofsky.

one of her 'worst nicknames'; a confection pink that also recalls the palette of *Epistemology of the Closet*'s *suminagashi*.[46]

With this painful reading in mind, it is perhaps unsurprising that Sedgwick recognised herself in the photograph as already 'SPOILED', her right breast by then missing, although, in the snapshot, her left nipple solarised out. And this in spite of her assertion, elsewhere in *A Dialogue on Love,* that the loss of her breast 'was *nothing*' compared to the shock and interest of losing her hair, abundantly long in the image. Sedgwick registered a similar sentiment in her earlier, c. 1993 poem 'Mobility, Speech, Sight', which expressed her view that 'a breast; a breast' was 'nothing / comparatively' to the loss of 'mobility, speech, sight, / a bowel, a genital, a hand to grasp, / a feature of a face'. She had 'said this so much', however, that sometimes she needed reminding that her right breast was *'something'*. Maybe she'd be 'lying waiting for some other, little surgery', and it would come back to her, its painful loss 'smothering [her] in lymph and tears'.[47]

The front cover photograph of *Fat Art, Thin Art* represented one of a number of images Sedgwick arrived with in therapy 'for show-and-tell' and that she used on her book jackets in this period, as we have seen.[48] But before she opens her family album, another painful photograph punctuates the prose, from Sedgwick's early teens. If her heart 'held an image then', she told Van Wey, 'perhaps it came from the *Scientific American*', although she wasn't sure if she had remembered or imagined it. This again 'painfully flash-bulbed black-and-white photo' depicted sadistic mid-twentieth-century behaviourist scientist 'Harry Harlow's baby monkey studies'. It showed specifically some

> hairy infants cowering in avoidance of their wire experimental 'mother', rigged though she is to yield milk if only they'd give her spiky frame a nuzzle. They won't. Where they cling instead is to the milkless, white puffy breast of her sister, also

46 Sedgwick, *Dialogue*, 19, 64.
47 Ibid., 64, 193; *Fat Art*, 28.
48 Sedgwick, *Dialogue*, 10.

wire, but padded with cathectible terrycloth that dimples with their embrace.

Who would dare to break back from the terrycloth bosom, one by one, those scrawny, holding, ravenous, loving toes?[49]

The difficult-to-read description is characteristic of Sedgwick's relation to photography in a number of ways. Firstly, in the painful sensations she ascribes to the flashbulb. The retinal pain of the cowering monkeys recalls Beatrix and her daughter pinioned by Eugene in the family album and the solarised cover of *Fat Art, Thin Art*. Also familiar from 'The Warm Decembers' and from across Sedgwick's oeuvre is the comforting, endlessly-cathectable, apparently pre-Oedipal world of textiles, of puffy and padded, dimpling, embracing fibres and fabrics. Readers of the passage also find themselves in a world of fat and thin art: the puffy, padded breast of the mother contrasts with the wiry, scrawny, ravenous toes of the infant. Also characteristic is the way that pre-Oedipal scene was, in Sedgwick's imaginary, split between a spiky but yielding mother, and a milk-less but softer sister.

Having primed Van Wey with what to expect, Sedgwick acknowledged a mix of 'pride and peevishness' when it came to her family album. Partly, she wanted to use the photographs to turn the 'old twining pains into grownup, full-throated grievances'; a twining central to Sedgwick and Judith Scott's fiber art, as we shall seen, and a phrase quietly alluding to the idea of twins central to Scott, herself an identical twin, as well as the Kosofsky sisters frequently dressed, in the period, in 'identical-sister' dresses.[50] But Sedgwick also wanted to give Van Wey the 'taste' of her 'handsome, provincial / Jewish family' that the pho-

49 Sedgwick, *Dialogue*, 12. I self-consciously choose not to depict an example of this image, finding them too painful to look at, and believing, strongly, that all testing and experimentation on animals is indefensible.

50 Sedgwick, *Dialogue*, 15, 18–19. For more on the Scott sisters, see Joyce Scott, *Entwined: Sisters and Secrets in the Silent World of Artist Judith Scott* (Boston: Beacon, 2016).

Figure 4.11. Leon Kosofksky, c. late 1950s monochrome photograph of the Kosofsky siblings: Nina, David, and Eve.

tographs were meant to depict, including she and her siblings 'doing blunt-scissored arts and crafts around a table' — a fiber art parallel to the 'testimonials to literacy' other photographs documented (see Figure 4.11).[51]

A certain 'loveseat' was where her father assembled 'many of these tableau'; a word mixing pleasure and pain whenever Sedgwick used it (see Figure 4.12).

Above the bourgeois crafting family, meanwhile, could be found an 'anxious succession of rabbinic, existentially miserable faces' in brushwork that ranged from 'like-Cezanne to like-Roualt', loaned from the Dayton Art Institute's circulating collection, suggesting the impact of 'degenerate' Jewish art on Sedgwick's queer embodiment, art practice, and criticism.[52] She had earlier given a hint of this in *Epistemology of the Closet,* in her first set piece of family album ekphrasis. This described a

51 Sedgwick, *Dialogue*, 18–19.
52 Ibid.

Figure 4.12. Rita Kosofsky (?), c. mid-1950s monochrome photograph of the Kosofsky siblings Nina and David.

'snapshot' of herself 'at about five, barefoot in the pretty "Queen Esther" dress' her grandmother made for her, from white satin and gold spangles, designed to educate this little Jewish girl in her appropriate gender role, with its 'fondness for being looked at', 'fearlessness in defence of "their people"', and 'non-solidarity with [her] sex'. In the photograph, she was 'making a careful eyes-down toe-pointed curtsey', a pose combining theatricality and shame and anticipating the prima ballerina on the cover of *Performativity and Performance*. Sedgwick's 'Esther performance was choreographed by her father, who was again violently present in the photo in the form of the 'flashgun that hurl[ed] her shadow, pillaring up tall and black, over the dwarfed sofa onto the wall behind [her]'. Indeed, in her description it is as if he were a nuclear bomb, and she the subsequent mushroom cloud; or, in a queer reading, as if she were Lot's wife, transformed into a pillar of salt, looking back, regretfully, at the destruction of So-

dom, already sympathetic to apparently doomed, queer populations, a motif we shall return to in the final chapter.[53]

With this earlier photograph in mind, it is telling that, in the *Fat Art, Thin Art* cover photograph, Sedgwick, in lost profile, again does not make eye contact, having learned to avoid proffering her mother's 'photo face'. The result is that, unlike Beatrix's daughter, held straight up and looking directly at her father, the Kosofsky children tend to have been 'transfixed by the flashbulb at some precarious angle' to their bodies, or 'seem to pop' from their mother's arms 'as toast from a toaster', another suggestion Sedgwick experienced her father's flash as burning.[54]

Seeing her family photos made Van Wey wonder at whom Sedgwick's photo face was *aimed,* an again violent description recalling Beatrix's confrontational marital gaze and the metaphorics of shooting that frequently accompany photography's long history. Sedgwick's answer is layered. At her father, who was mostly 'behind the flash', her being flashed at suggesting further scenes of unwilled sexual exposure. Behind him, however, was also the idea of Sedgwick's four grandparents, and, especially, her maternal grandmother, Nanny. She sewed the dresses and wanted to see, or at least was 'supposed to want to see', how 'family-like' they made the Kosofsky sisters. As such, Sedgwick always felt herself in the shadow of her sister, frequently dressed identically to her, but unable to display herself in a 'platonically ideal form' (see Figure 4.13).

Indeed, Sedgwick acknowledged, it was 'uncanny how frontal, as toddler and child', Nina was, 'whether in the mode of cute or seductive' — a Friedian frontality that frequently captured Sedgwick's interest, as we have seen, if only because there was

53 Sedgwick, *Epistemology,* 82. For a bravura reading of this scene, and of the three Biblical figures of Esther, Eve, and Lot's Wife in *Epistemology,* see Lee Edelman, 'Unnamed: Eve's Epistemology', *Criticism* 52, no. 2 (Spring 2010): 185–90. For the potential racial politics of the scene, see Siobhan B. Somerville, 'Feminism, Queer, Theory, and the Racial Closet', *Criticism* 52, no. 2 (Spring 2010): 191–200.
54 Sedgwick, *Dialogue,* 19.

Figure 4.13. Unknown photographer, c. late 1950s photograph of the Kosofsky family: Leon, Rita, Nina, Eve, and David.

always 'something perfect' about Nina, 'something that [gave] / a snap to snapshots'.⁵⁵

What was also clear to Sedgwick from the photographs was how much her sister loved her, 'if awkwardly'. Nina's eyes may have been 'glued to the camera', but, like Beatrix and her daughter, Nina always held on 'as if for life to [Sedgwick's] waist or leg'. Sedgwick herself, meanwhile, sought to escape her father's violent flashing and sister's always winning, competitive visual charms, explaining why she was 'never quite there' in the pictures from Dayton. That was because she sought to will her 'whole being into [her] fingertips'. From there, she could will herself 'into something else through touch — a stuffed panda, my other hand, a book or cat, the fabric of a skirt'. Such things represented a comforting, tactile corporeality and immediacy, as against the scene of photography's visual objectification and distance. This tactile appeal was at the heart of many of her subsequent art works, as we have already noted - her soft, quilted cyanotypes re-fashioning old images, in soft new forms, rather than violently shooting new ones (see Figure 4.14).⁵⁶ Sedgwick's complex, lifelong affinity with pandas, meanwhile, will receive a subsequent chapter of its own.

That Sedgwick chose, for the covers of *Fat Art* and *Shame*, images from Dayton, when she was under seven, comes into further focus later in *A Dialogue on Love*. There, she attempts to skip on from the photographic show-and-tell images of her teenage years, with the exception of 'one, stylised shot' when she was nineteen, her eyes 'crinkled with laughter and embarrassment' at her husband 'pushing a morsel of [...] wedding cake' into her mouth.⁵⁷ Readers also learn here that her mother was highly enamoured of photographers. Having married a man who became a NASA photographer, Sedgwick's father, she 'gravitated helplessly', in space-age language, towards a certain 'W', a 'new cherished', female 'intimate', and another 'slightly older,

55 Ibid., 20.
56 Ibid.
57 Ibid., 21.

Figure 4.14. Leon Kosofsky, c. mid-1950's photography of the Kosofsky siblings: Eve, David, and Nina.

German-Jewish photographer', who recalls Sedgwick's fondness for Baron Adolph De Meyer and anticipates her interest in Heinrich Traut, as we have seen.[58]

Pressed by Van Wey to bring more teenage photographs, Sedgwick finds 'half a dozen', and hopes they 'don't show much'. These are absent from the covers of her books, and Van Wey describes them as 'matronly' and 'masklike'. Briefly, the cache brings the two closer. Van Wey particularly connects with a snapshot of Sedgwick under a tree with her paternal grandfather, in which she thought she looked 'sweet' and a bit 'out-of-it', her again balletic feet in a 'sort of third position, chin and eyes down to the right, hands clasped in a twist behind the back', as if a more modest or shameful version of Degas's *Little Dancer of Fourteen Years* (1881), and making denser still the cover of *Performativity and Performance*. Taking off his glasses, Van Wey examined the photo and tried to 'pretzel into just the same

58 Ibid., 21–22.

posture', discovering how 'sweet' it felt across his shoulders and down his back.[59]

Encouraged by Van Wey's cross-generational, transgender identification, Sedgwick finds more beauty in subsequent images. In one, she felt 'lovely', sat on the edge of a chair, but 'sort of flying toward the camera', her arms spread wide, 'looking nubile, mouth ecstatically open, eyes almost closed — quite radiant'. But her enjoyment in, and of, the photograph proved quickly precarious: the snapshot revealed an 'awfully depressed person, momentarily exalted, who is about crash in some disastrous way'. And Van Wey and Sedgwick both, in a telling phrase, 'get arrested at this picture', like Monsieur O, a teacher of Sedgwick's arrested for queer soliciting. Indeed, the more Van Wey wants her to talk about what she finds 'so scary' about the image, the more mistrustful she feels about 'why *he* finds it strange for me to find it so' and why, she presumes, he finds it 'so attractive'. Finally, she 'accuse[s] him of finding it attractive *because* the young woman in it looks so off-balance and exploitable — "Like Marilyn Monroe", who people could not resist, Sedgwick thought, because of the 'incandescence of being so unstable'.[60]

The photograph had a catastrophic effect on the therapy. Sedgwick could not believe how, 'with *one single* step over the line from kid pictures into puberty', she did not trust nor 'even *like*' Van Wey, and how 'stunned and frightened' she felt. Tipped from a reparative into a paranoid-schizoid mode, she noticed how the angle of the photograph emphasised her 'breasts quite a lot', causing her to picture Van Wey, accurately, appreciating the 'new, soft, alien' curves from her father's point of view.[61] Sedgwick and her therapist's different responses to the photograph reveals how over-determined the cover of *Fat Art* was. Not only does it picture Sedgwick before puberty sets in, but, because of its solarisation, her left nipple is missing, whilst her right nipple is difficult to detect, alluding to her mastectomy, making her

59 Ibid., 74.
60 Ibid., 76–77.
61 Ibid., 77–78.

youthful body difficult to gender, even if when she 'had the two breasts', she 'kept forgetting them'.[62]

In addition, *Dialogue* reveals that Sedgwick's mastectomy acted as a switch point in the diminishing of her fantasy life, making it difficult for her to identify with herself as a person with two breasts or one.[63] Reparative spectators might still be inclined to see the cover image positively, representing a prosthesis-free image of post-mastectomy pride, given her instruction, in the late poem 'Death', '*Don't* grab that prosthesis', 'come-as-you-are'.[64] This was a position inspired by Audre Lorde, with the youthful Sedgwick representing what queer/crip theorist Robert McCruer recently described as one of Lorde's 'imagined army of one-breasted women'.[65]

In an email, however, Sedgwick reminded me that her 'post-mastectomy chest' did not 'look a bit like a prepubescent one'. Her youthful self did not have its other adult breast and lacked the 'long wandering scar' and 'disrupted clumps of sewn-together but not evened-out flesh', which was 'not gross' but nor was it 'neat or boyish', and in which the 'real aesthetic shock' was not 'the absence of one breast but the presence of the other', raising the question of 'how to deal with the scandal of one's body being radically asymmetrical'. Indeed, she recalled, when her husband took a 'nudie' photo of her bathed in a 'lovely

[62] Ibid., 78.
[63] Ibid., 64.
[64] Sedgwick, *The Weather in Proust*, xiv.
[65] Sedgwick briefly discusses Lorde in *Tendencies*, xii, 13. For more, see Audre Lorde, *The Cancer Journals* (San Francisco: Spinsters Ink, 1988) and *A Burst of Light: Essays* (Ithaca: Firebrand, 1988). For discussion, see Robert McCruer, 'Disabling Sex: Notes for a Crip Theory of Sexuality', GLQ 17, no. 1 (2010): 107–17; 109; Robert McCruer, 'As Good As It Gets: Queer Theory and Critical Disability', GLQ 9, nos. 1–2 (2003): 79–105; Robert McCruer, *Crip Theory: Cultural Signs of Queerness and Disability* (New York: New York University Press, 2006); and Abby L. Wilkerson. 'Introduction', GLQ 9, nos. 1–2 (2003): 1–23, as well as '*Richard III*: Fuck The Disabled: The Prequel', in *Shakesqueer: A Queer Companion to the Complete Works of Shakespeare*, ed. Madhavi Menon (Durham: Duke University Press, 2011), 294–301, and Anna Mollow, ed., *Sex and Disability* (Durham: Duke University Press, 2012).

creamy, Venetian-blind light' where she was 'ambiguously, or do I mean ambivalently, using [her] forearm to cover the scar and/or remaining breast', she was interested to discover whether she '*would* feel moved to cover' the breast or the scar.[66]

Sedgwick also encouraged me to think about the photograph in relation to classic Freudian and Lacanian questions of the phallus, as part of her call to 'Forget the Name of the Father' and 'long, in fact never quite concluded, process of pondering whether genitality in general, and the phallic signifier in particular', really was 'all that'.[67] For instance, she suggested, viewers might be inclined to read the 'breastless child's self-possession as a matter of "Ha ha, you can't castrate me, I'm already castrated"', with the problem that, whilst resisting the logic of the phallus, spectators risked reducing the breasts to a metaphor for the penis. Or, she suggested, spectators might ponder the way her nude 'upper body' stood in for, and referred to, her clothed lower body, and, if so, did her torso refer to her 'absence of (a male) genital' or 'presence of (a female) one', or something like a 'display of nothing to display', not even a scar, let alone a phallic cigar. For Sedgwick, however, the 'main force' of the picture 'attached less to the contrast between top and bottom halves of the figure's torso' and more to her 'open, prepubescent trunk and private, very formed, almost fully adult face', making the 'pedophilic' an inadequate 'marker of what's troubling about the picture'.[68]

66 Email to the author. This recalls an orphaned line from 'The Warm Decembers', describing Mrs. Hatchet, in relation to whom, someone wondered, 'How many men were there who, dreaming of the scar, / thought it was the cheek they were in love with' (*Fat Art*, 158).

67 Eve Kosofsky Sedgwick, *Tendencies* (Durham: Duke University Press, 1993), 58; email to the author.

68 Email to the author. Sedgwick further discussed the issues surrounding the picture in her May 6, 1997 interview with Christian Haye, where she noted that, for her, 'a lot of the action around the issue of the body' was less about male versus female, masculine versus feminine, and more around 'size, acceptability, beauty, ugliness, frontality, shyness, exhibitionism, shame, grotesqueness, abjection', issues that had been 'very productive' intellectually, emotionally, and politically for Sedgwick ('All About Eve',

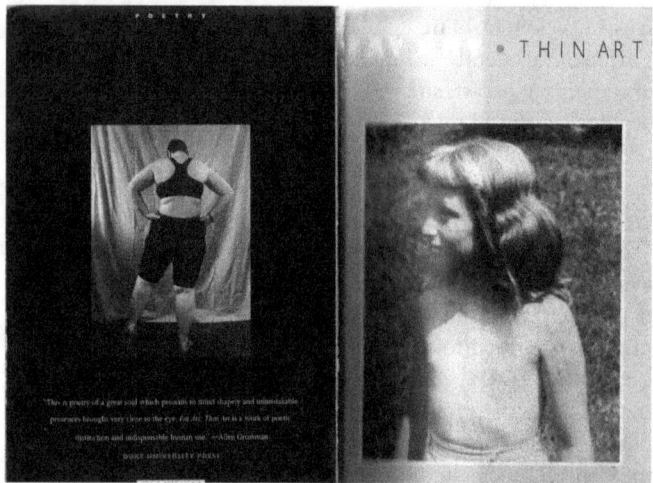

Figure 4.15. Eve Kosofsky Sedgwick, cover of *Fat Art, Thin Art* (1994), front cover photograph of the author (c. late 1950s) by Leon Koskofsky, back cover photograph of the author (c. early 1990s) by H.A. Sedgwick.

Finally, if one lays *Fat Art, Thin Art* flat, the youthful Sedgwick looks across the spine to an equally difficult-to-gender image of an adult Sedgwick on the back cover (see Figure 4.15).

This was one of a series she had taken, doing tai chi, for a calendar she made, as she did in many years following her recurrence diagnosis, to which we shall return (see Figure 4.16).

Frieze, May 6, 1997, 5, https://www.frieze.com/article/all-about-eve). She there directed her readers to *Shame and Its Sisters: A Silvan Tomkins Reader* (Durham: Duke University Press, 1995), which she had co-edited with Adam J. Frank, and her essay, 'Shame and Performativity: Henry James's New York Edition Prefaces', in *Henry James's New York Edition: The Construction of Authorship*, ed. David McWhirter (Stanford: Stanford University Press, 1995), 206–39. For a discussion of the Terry Richardson photograph accompanying the interview, see Paul Clinton, 'A Queer Image: Eve Kosofsky Sedgwick Photographed by Terry Richardson', *Frieze*, September 21, 2016, https://www.frieze.com/article/queer-image.

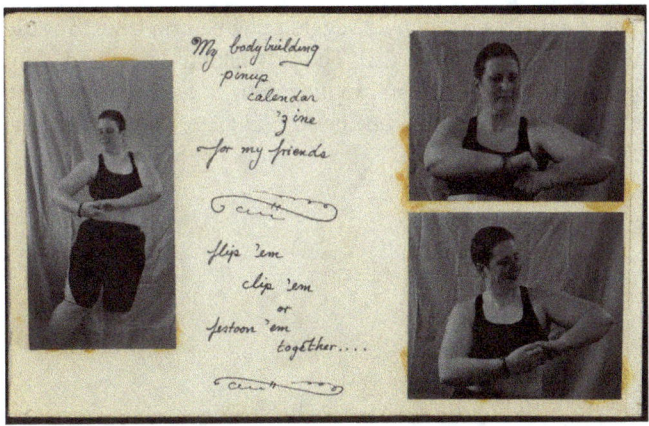

Figure 4.16. Eve Kosofsky Sedgwick, bodybuilding pin-up/calendar/zine (c. early 1990s).

In the photograph, she appears in a sports bra and cycling shorts, facing away. Her head is down in what appears less a physiognomy of shame, and more a meditative turning into the space of the self, or a person preparing to reveal themselves to her audience once the grey curtain-like fabric, that echoes the folds of her flesh, is raised. As such, the photograph recalls again De Meyer's man on the cover of *Epistemology of the Closet*, about to come out. Viewers might also spot the parallel between Sedgwick and the women at Manet's *Déjeuner*, both baring their left soles for the spectator's delight, and, given the balletic, tip-toe pose, recall also the cover of *Performativity and Performance*.

In her c. 1993 poem, 'Who Fed This Muse?', Sedgwick pondered what had happened to the person who was 'born / to be elastic, even graceful'. What 'spell' had bound her 'bad' feet so that she 'never learned to dance / through years and years of the lessons she liked', 'for the sociability, for all the pain'? Whatever the cause, Sedgwick found that, as an adult, she inhabited a body that fluctuated between a 'strange deadness' and 'strange propulsions', causing her to 'jerk' and knock things over all the

time.⁶⁹ *Fat Art*'s back cover suggests she had no time to waste finding out what happened. She was taking dance and singing lessons. It was time to live differently in her body. After all, when faced with a knot, one has two choices. One can unravel it or just cut the rope.⁷⁰

69 Sedgwick, *Fat Art*, 6–7.
70 There is a final photograph in *Fat Art* I have not discussed. This depicts 'The Girls with Buttons' (*Fat Art*, 113, 123). For a sustained reading, see my *Bathroom Songs*, 58–61. I am grateful to Betsy Galloway for this formulation around knots, as well as an infinite amount else.

5

The Texture Books: *A Dialogue on Love* and *Touching Feeling*

In this chapter, we return to the idea of surface reading with which the book began. As we saw in the previous chapter, Sedgwick had a pronounced interest in texture and textiles that reached its first crescendo in the period she was at work on 'The Warm Decembers', between 1978, when she began thinking about the poem, and 1987 when she was finally forced to abandon it. In this chapter, we explore the re-emergence of Sedgwick's interest in texture a decade or so later, around 1996, in the period when her breast cancer metastasized to her spine, and in which she was in the most productive relationship to therapist Shannon Van Wey, the subject of her 1999 memoir *A Dialogue in Love*.

This chapter also explores a second re-emergence: the renewal of Sedgwick's interest in the poetics of white space, that we examined first in the Modernist design of *Tendencies* in Chapter Two, but that returns in different forms and with different valences in *A Dialogue on Love*. Having pondered the re-emergence of Sedgwick's interest in texture, I then go on to discuss its theorization and presentation in her 2003 collection of essays *Touching Feeling: Affect, Pedagogy, Performativity,* particularly in relation to Sedgwick's profound identification with fiber art-

ist Judith Scott, whose monochrome portrait graces the book's waxed cover.

The Fiber Arts of *A Dialogue on Love*

Sedgwick's most sustained account of the re-emergence of her interest in textiles occurs in *A Dialogue on Love*. At the start of the book, her sense of the world of fiber is intermittent but present, when she registers, in Chapter One, that her unpromising new shrink's office is a 'large, rugless space', a room without the queerly evocative floor covering that we briefly discussed in the context of *Tendencies* in Chapter Two. Van Wey's empty, fabric-free office anticipates her later recollection of the photographs of sadistic, mid-twentieth century behaviourist scientist, Henry Harlow's pointlessly tortured baby monkeys, who we have already encountered, primates drawn instinctively towards puffy, responsively dimpled, cathectible terrycloth. Her subsequent patchwork aesthetic is also apparent in her early hope that if she could 'fit the pieces' of herself 'back together', it would not be 'the way they were' before.[1]

Surgical yarns appear in Chapter Two, when, alluding to Theseus and the minotaur, Sedgwick describes how she would need to 'thread the viscera of the labyrinth' of herself to establish what she did and didn't know, and how that felt. In addition, she characterizes her husband's sweetness as an 'aegis', a favourite word for Sedgwick as we have seen in the case of her editing of Gary Fisher, a goatskin shield identifying Hal Sedgwick with her beloved (Proustian) grandmother, 'nanny'.[2] Sedgwick also compares husband Hal's reassuring demeanour to the fat art comfort she acquired from holding on to the 'crease' of her father's 'baggy trousers', with baggy trousers suggesting his svelte legs and the fabric's folds' own fatness. In addition, Sedgwick

1 Eve Kosofsky Sedgwick, *A Dialogue on Love* (Boston: Beacon, 1999), 3, 12.
2 I describe Sedgwick's grandmother as 'Proustian' because of the centrality of the narrator's grandmother to *In Search of Lost Time* and the passages Sedgwick excerpts for her textile work.

describes a further photo in which her blue eyes chime with the color of her 'electric blue' shirt; blue eyes that 'blot [...] up as if passively' her parents and sister; a cyanotype-like blueprint central to Sedgwick's book art, as we have seen, and further attested to by Sedgwick's student Maggie Nelson's account of the 'varying shades of indigo blue' dominating Sedgwick's 2001 *In the Bardo* show, as well as its sequel show *Bodhisattva Fractal World* (2002).[3]

Towards the end of the chapter, readers learn that Sedgwick's mother experienced Nanny's 'demon' sewing as the 'worst' because she didn't take to the project of having to make Halloween costumes for her children, precipitating an ulcer. This anecdote suggests both the potential Oedipal aggressions and grandparental reparations inherent in Sedgwick's fiber art, although this rarely included embroidery, or other forms of sewing, since Sedgwick preferred a kind of Whitmanian *adhesion* by gluing in her own practice, having historical reservations about the gender and imperial connotations of embroidery.[4]

For example, *Epistemology of the Closet* argued that whilst Victorian embroidery might answer to the 'hungrily inventive raptness of the curious or subtle perceiving eye or brain', the 'intricacy' of such 'wrought' fabrics was manufactured or hand-crafted by poorly-paid working-class women or imported

3 Sedgwick, *Dialogue*, 21–32; Maggie Nelson, 'In the Bardo with Eve Sedgwick: A Buddhist "Art of Dyeing"', *CUNY Matters*, Summer 2000, 9. For more on Nelson's dialogue with Sedgwick, see *The Argonauts* (New York: Melville House, 2016), 35–37, 77–78, 92, 116, 138–42, 153. For more on the colour blue in Nelson's idiom, see Maggie Nelson, *Bluets* (London: Jonathan Cape, 2009).

4 Sedgwick, *Dialogue*, 34, 49. For more on Whitman's queer adhesiveness, see Michael Moon, *Disseminating Whitman: Revision and Corporeality in 'Leaves of Grass'* (Cambridge: Harvard University Press, 1991), 12–13, 50, 156. For Moon's reflections on Sedgwick, see 'Psychosomatic? Mental and Physical Pain in Eve Sedgwick's Writing', *Criticism: A Quarterly for Literature and the Arts* 52, no. 2 (Spring 2010): 209–14; 'The Black Swan: Poetry, Punishment, and the Sadomasochism of Everyday Life; or, Tradition and the Individual Talent', *GLQ* 17, no. 4 (2011): 487–96; and 'On the Eve of the Future', in *Reading Sedgwick*, ed. Lauren Berlant (Durham: Duke University Press, 2019), 141–51.

> How they're intertwined—
> his permanence in me—my
> permanence in him—
>
> How, when I suppose
> him to be forgetting or
> dropping me—somehow—
>
> from his mind—I lose
> the Daedalian thread of
> Shannon in *my* mind—

Figure 5.1. Eve Kosofsky Sedgwick, *A Dialogue on Love*, p. 122.

from South Asia, where laborers earned even less. This was a 'monstrous', 'strange', and 'terrible' industry, involving 'tedious labor, and sheer wastage of (typically female) eyesight', levied on women by men, by the upper classes on the lower, and by 'the Orient by the nations of Europe'.[5] Nevertheless, there is a clear resemblance between running stitches, binding everything together, and her sustained use of dashes in her haiku, in *A Dialogue on Love,* and the longer horizontal lines she employs to separate her sub-sections (see Figure 5.1).

Textile metaphors, both in terms of continuous textured surface and taut connecting thread, proliferate with increasing intensity through Chapter Three. There, Sedgwick describes the 'wider canvas for action' that her junior high school life represented, and notes how striking it was 'how much the thread' of herself was 'tied up with' masturbating. The scene of the dye bath, with its requirements for acid as well as dyestuffs, provides

5 Eve Kosofsky Sedgwick, *Epistemology of the Closet* (Los Angeles: University of California Press, 1990), 174–75.

the foundational image when she describes how her main high school experience was being 'submerged over and over, in the most corrosive acid of anxiety'. 'Ragged edges' also characterize her broader 'family and group dynamics' at the time, suggesting the pain inherent in the form of both her poems, with their ragged right margins, and the title pages of the chapters of *Tendencies*, with their ragged left margins.

Towards the end of Chapter Four, fabrics dyed, unwillingly, with blood, add a new, menstrual dimension to the covers of *The Coherence of Gothic Conventions*, *Performativity and Performance*, and *Shame and Its Sisters*, as well as anticipate a number of her fiber artworks. These blood-soaked textiles appear when Sedgwick describes waking up from a 'DREAM OF TRYING ON CLOTHES AND NOTICING BY THE BLOOD RUNNING DOWN HER LEG AND ON THE CLOTHES THAT SHE IS MENSTRUATING'. This 'bloody discharge' returns, in Chapter Five, when she sees an airplane being sluiced with pink anti-icing fluid and recalls the contents of medical tubes in the weeks after her mastectomy — a discontinuous, mobile pink fluid that recalls the *suminagashi* ground of the cover of *Epistemology of the Closet*, the book published just before Sedgwick's diagnosis with breast cancer, and again adding a new, retrospective dimension to its understanding.[6]

Chapter Five reveals more about the potential metaphoric resonance of Sedgwick's textured, two-and-a-half dimensional fabric collages. There, she described how, having grown anxious around the therapy, she felt she had 'lost [her] third dimension' and had the 'sensation that the front and back of [her] chest cavity' were 'glued together with fear', with 'no place' left for her 'hammering heart, no interiority'. Indeed, her 'whole materiality ha[d] flattened' (see Figure 1.9). Perhaps inspired by their furry three-dimensionality, she also discusses the comforting touch of pets in the chapter, telling Van Wey about the 'long, irresistibly soft black fur' of her cat Harpo. In an acutely painful scene, however, she describes nearly abandoning the cat in a wintry

6 Sedgwick, *Dialogue*, 75–76, 82–83, 88.

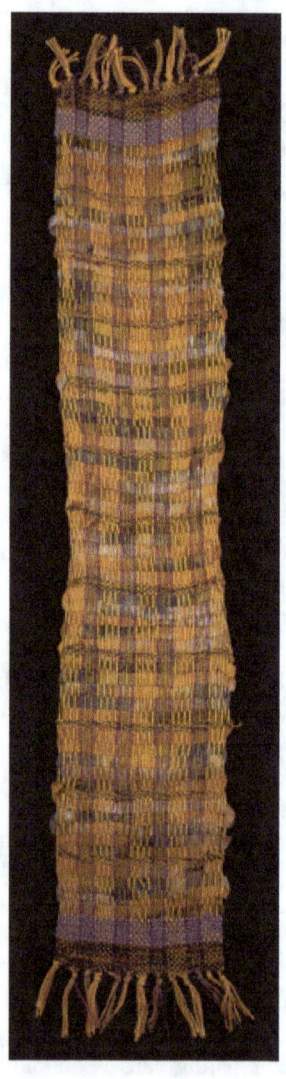

Figure 5.2. Eve Kosofsky Sedgwick (after 1996), fabric hanging, long, narrow, fringed weaving in orange, lavender and green, using hand-painted ribbons for weft. Photo: Kevin Ryan, © Eve Kosofsky Sedgwick Foundation.

graveyard, having been unable to find a way of successfully cohabiting with him, where the wind was cold enough to 'gnaw through' her 'own coat'. Harpo, meanwhile, unfolds his 'inky skeins'; the inclement weather 'ravelling', which is to say fraying, his 'black rags'.[7] The idea of fibre as an umbilical connection, meanwhile, recurs in the conclusion to the Chapter, when Sedgwick describes 'TRYING TO INJECT SOME LIFE INTO THE CORD' of her relationship with Van Wey, as well as the returning image of the 'bliss of moving within a beloved aegis'.[8]

Chapter Six again abounds with textile metaphors, at various scales. Van Wey, having caught the fiber bug, reassures Sedgwick he doesn't think conflict is 'looming too large' in her relationships. This is the first, foreshadowing reference to a weaving that represents one of Sedgwick's earliest craft practices. Indeed, her soon to be burgeoning woven-scarf, self-adornment project might underlie her description of Van Wey as a 'Barbie doll to dress and undress', and to factor into their description of the way their experience of people is less in terms of 'A SENSE OF CHANGE' and more 'ADDITIVE', as if they've gained a new accessory (see Figure 5.2).

Sedgwick also describes a dream in which 'HER CLOTHES ARE ON HER BODY IN SOMETHING OF A STUCK-ON MANNER', with her bra 'BAKED INTO A LAYER' of a pie she is carrying, which she tries to pass off as 'SOME SCARF'.[9]

And in a context in which the NAMES Project AIDS Quilt represented, perhaps, the paradigmatic form of queer craftivism and textile practice, memorial patches unsurprisingly form a key part of Sedgwick's idiom. As a kid, she remembered a 'patch of dirt' in her elementary school yard that, 'wandering around the periphery one recess […] instead of playing ball with my

7 Ibid., 92, 98. Sedgwick later describes her similarly 'Ravelled mother for / whom three [children] might as easily / have been 300' (ibid., 208). Sedgwick's more famous, compassionate account of human-feline relations occurs in the 'Pedagogy of Buddhism' essay, in *Touching Feeling: Affect, Pedagogy, Performativity* (Durham: Duke University Press, 2003), 153–83.

8 Sedgwick, *Dialogue*, 99, 105.

9 Ibid., 107–10.

agemates' — and the periphery was as close as spectators got to the patches when the quilt was laid out — she stood staring at and intensely willing herself 'yes, *this*, I will remember, *this* I will project forward into the future so that it's there as much as it here, just *this*, not because it's exceptional but because it's ordinary, it's nothing, it's dirt; I will remember it'. She also described the way her mother, again like the quilt, was 'PIECED TOGETHER WITH PIECES OF THE CARETAKING OF OTHERS'.[10] In addition, the insistent capitalisation of the NAMES Project AIDS Quilt perhaps partly explains Sedgwick's new interest in capitalisation and quotation in *Dialogue,* in which her voice frequently appears quoted, with and without quotation marks, in Van Wey's SMALL CAPITALS passages which appear within Sedgwick's edited, ordered narrative.[11]

In spite of Sedgwick's mixed feelings about the quilt, as a space of mourning rather than activism, fibres continue to form the fabric of the text.[12] She depicts herself, again like Theseus, 'trying to follow back the thread', within an inter-relational con-

10 Ibid., 116, 124.
11 For more on the quilt, see Peter S. Hawkins, 'Naming Names: The Art of Memory and the NAMES Project AIDS Quilt', in *Thinking About Exhibitions*, eds. Reesa Greenberg, Bruce W. Ferguson, and Sandy Nairne (London: Routledge, 1995), 133–56; Michael Moon, 'Memorial Rags', in *Professions of Desire*, eds. George E. Haggerty and Bonnie Zimmerman (New York: MLA, 1995), 233–40; Monica Pearl, 'American Grief: The AIDS Quilt and Texts of Witness', *Gramma* 16 (2008): 251–72; and Julia Bryan-Wilson, 'Remains of the AIDS Quilt', in *Fray: Art and Textile Politics* (Chicago: University of Chicago Press, 2018), 181–250.
12 As a member, in the early 1990s, of the North Carolina branch of ACT-UP, Sedgwick worried that the quilt risked 'monopolizing, for no purpose more liberatory than memorializing and consolation, the energies and money of a lot of the A-list of North Carolina gays' for which they 'could find considerably more telling uses'. She was also critical of its 'nostalgic ideology and no politics', and its 'big, ever-growing, and sometimes obstructive niche in the ecology of gay organizing and self-formation', which is not to say that it did not wring her out on every viewing (Sedgwick, *Tendencies,* 264–65). For a related view, see Douglas Crimp, 'Mourning and Militancy', *October* 51 (Winter 1989): 3–18; and *Melancholia and Moralism: Essays on AIDS and Queer Politics* (Cambridge: MIT Press, 2002). For Crimp's reflections on Sedgwick, see 'Mario Montez, For

text in which she and Van Wey are increasingly 'all knotted together' and 'intertwined', and in which she worries over losing 'the Daedalian thread' of her therapist in her mind, whilst she and the dead also 'seem like a braid'. Here Sedgwick, with a practitioner's mind increasingly attuned to the differences, carefully differentiates groups of threads in twos and threes, in the form of twines and braids, and between fibres twined, which is to say twisted, and knotted together.[13] Towards the end of the chapter, meanwhile, the overdetermined scene of sewing returns with a vengeance, in the context of the overall rough, fibrous texture of hessian or jute, when Sedgwick described how much she hated the idea

> that you're born sewn up
> in a burlap bag with a
> few other creatures,
>
> and you have to claw
> and fight inside that burlap
> bag for your whole life.[14]

Chapter Seven begins with the return, after a long self-imposed exile, of Sedgwick's sister, Nina, and the 'fraying' experience of hope this engenders that we discussed in some detail in Chapter Three, underpinning, as it does, the cover imagery of *Performativity and Performance*, *Shame and Its Sisters*, and *Novel Gazing*. Scenes of the family's disciplinary structures, meanwhile, strike Shannon as unusual, at least in the way they affected Sedgwick — the more usual experience being that spanking is 'cut from the same / fabric as other kinds / of care'.

The metaphorics of braiding return in Chapter Eight, when Sedgwick describes a paranoid fantasy that 'seemed like such a

Shame', in *Regarding Sedgwick*, eds. Stephen M. Barber and David L. Clark (London: Routledge, 2002), 57–70.

13 Sedgwick, *Dialogue*, 119, 121–22.

14 Ibid., 130.

seamless and inexorable braid of fatal inferences'. This misleadingly monologic seamlessness associated with non-patchwork fabrics and too-tightly-twined yarns is worth noticing, as it again helps explain the emphatic seams of her cyanotype works and loose weave of her wall hangings and scarves (see Figures 1.9 and 5.2).

Finally, a baffled Van Wey wonders how certain elements of Sedgwick's idiom became 'woven into' her S/M fantasies. The comfort-blanket like quality of being 'swaddled up in enough narrative stuff', meanwhile, enables her to talk about these private scenes. There is also something temporarily comforting and unusual about the way in which, at the end of her S/M fantasies involving characters from the TV show *The Man from U.N.C.L.E*, they are 'seamlessly married' back to their work and the organisation, but only so as to enable the return of a new homoerotic and fantasmatic episode in which the homosocial couple are again isolated and tested.[15]

Suddenly Lots of Arts and Crafts Fascination, or A Portrait of the Artist as a Terminally Ill Queer Crafter

It is in Chapter Nine, however, that textiles and texture come to the centre of the narrative thematically, rather than embroidering it metaphorically, as Sedgwick moves from a sitting position, facing Van Wey, the traditional set-up in object-relations therapy, to lying on the couch, the *locus classicus* of Freudian analysis. Initially, she experiences her new lumber position as a loss in visual possibility, since she can no longer see Van Wey's prints or photos. Quickly, however, she finds renewed interest and growing pleasure in the more fibrous, tactile, and cutaneous possibilities that lying on his couch offers. For example, it is at this moment that Sedgwick first confesses her fantasy of masturbating with Van Wey's stockinged foot, as she experiences herself 'surfacing', in other, increasingly cutaneous ways: 'ALL ON THE SURFACE LIKE A SOAP BUBBLE, NOT CENTRED'; soap

15 Ibid., 133, 158, 169, 173, 177–78.

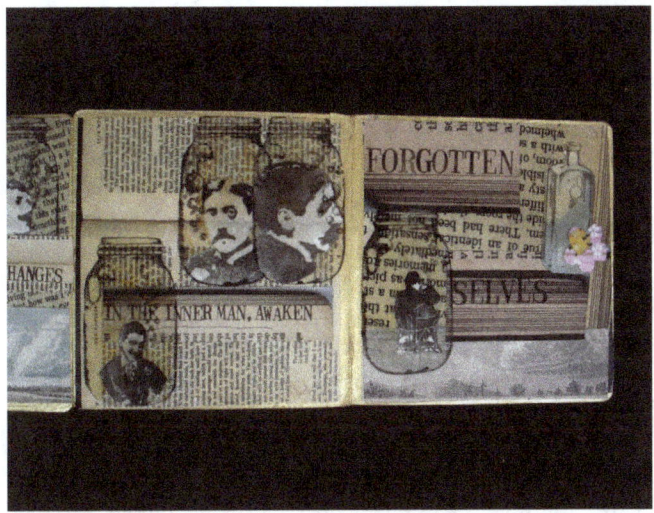

Figure 5.3. Eve Kososfky Sedgwick, The Weather in Proust (c. 2005), board, mixed media, collaged text, accordion book structure, 15.24 × 15.24cm closed, 15.24 × 63.5cm open. Photo: Kevin Ryan, © Eve Kosofsky Sedgwick Foundation.

bubbles central to Sedgwick's visual idiom in her 2005 exhibition, *The Weather in Proust* (see Figure 5.3).

Van Wey quickly notices the change in her sensory hierarchy, documenting 'THE AMOUNT OF SKIN AND TEXTURE AND TACTILE CONTENTS SHE HAS PRODUCED SINCE GETTING ON THE COUCH'. This is the product of having 'HER EYES CLOSED' and decreasing the 'TYRANNY OF THE VISUAL'. As a result, he documents one of Sedgwick's cutaneous S/M dreams in which she was 'LYING HAVING BEEN COVERED WITH A PLASTER MIXTURE, NAKED, WITH HER LEGS SLIGHTLY SPREAD, AND HAS TO REMAIN MOTIONLESS UNTIL THE PLASTER DRIES'; 'THE SMOOTHNESS OR CRACKING OF THE PLASTER' indicating if 'SHE HAS MOVED'.[16]

16 Ibid., 182, 186–88.

When American poet James Merrill, one of their favourite mutual writers, dies, meanwhile, Van Wey reads out Merrill's 'The Kimono' (1976), a Japanese costume whose silk was central to Sedgwick's weavings and collages, as we shall see.[17] The poem describes the transition from life to death and, from there, to after-life, as akin to putting on a kimono, in 'The pattern of a stream / Bordered with rushes white on blue' — a dominant East Asian blue-and-white palette we already recognise as characteristically Sedgwickian.[18] Her *thalassic* aesthetics also return to centre stage, when we learn she associated being partially dressed with the experience of being 'CLOTHED ON TOP AND UNCLOTHED ON BOTTOM' during 'TOILET TRAINING', in which having her 'BOTTOM EXPOSED' was a pride-filled 'PLUS' in comparison to the shame-emphases of spanking and the cover of *Fat Art, Thin Art* where she was naked above the waist and clothed below. The imagery of an identity patched scrappily together also returns, when she acknowledges the 'incoherent // way' she 'pieced together a sense of / [her] own sexual // desire', along with an increasingly recurrent image of herself, at the spinning wheel, 'TRYING TO HOLD ON TO SEXUAL SENSATIONS AND SPIN A COHERENT THREAD OUT OF THEM'. This is a 'thread' Sedgwick will again need, with a switch to the tale of Daedalus and the Minotaur, for 'the labyrinth', but this was a practice of spinning that remained of metaphorical, not practical interest to her.[19]

It is at this point that there is 'SUDDENLY LOTS OF ARTS AND CRAFTS FASCINATION', and Sedgwick ponders where this new fat art practice emerged from: 'Where have they come from, the luscious materials that have suddenly been wooing, feeding my fingers with such solicitous immediacy? And how long has this been going on?' 'Sure', she used to make clothes, 'incompetent-

17 Ibid., 188–89. For more, see Terry Satsuki Milhout, *Kimono: A Modern History* (London: Reaktion, 2014) and Rebecca A.T. Stevens and Yoshiko Iwamoto Wada, *The Kimono Inspiration* (San Francisco: Pomegranate, 1996).

18 James Merrill, *Collected Poems*, eds. J.D. McLatchy and Stephen Yenser (New York: Alfred A. Knopf, 2002), 361.

19 Sedgwick, *Dialogue*, 182–90, 195, 197.

ly—back when [she] had time and no money', and, although she doesn't say so here, 'sure' she would soon be weaving scarves designed for self-adornment, as we have seen. In addition, 'sure,' the 'phrase "arts and crafts"' had long made her 'drool', like an infant, 'at auctions, as it used to at Girl Scout camp', but, whilst she taught William Morris in her Victorian textures course, as we documented in Chapter Four, she rarely described textiles in his Marxist terms, with the exception of the passage on Oriental embroidery from *Epistemology of the Closet* I cited earlier in this chapter.

But where Sedgwick found herself now felt 'so different' and was 'so out of the blue' that she and Shannon joked, with gallows humour, about the possibility of a 'new tumour pressing on the Sculpey nodes' in her brain. 'Polymer clay in every color', paint, and 'silk kimono scraps' suddenly preoccupied her mind, and she had 'started to elope' from her 'school and writing, flying toward this stuff with the stealth, joy, almost the guilt of adultery', thrilled with the way textiles were 'so not writing', although her textiles and texts significantly overlapped, as this book is hopefully making abundantly clear (see Figure 5.4).

In this first account, however, Sedgwick argued that, in writing, perfectionism was a problem, so that she had to 'wrestle and contort to keep it at bay long enough for words to get onto the screen'. In this, she was more like a sculptor, a metaphor she rarely used with approbation. In fact, she acknowledged, with a nod to her grandiosity, she felt like queer Renaissance superman, Michelangelo, 'knowing what's supposed to emerge from the marble block', her task to 'excise everything that isn't that'. But this fantasy of 'knowing what you're doing', she discovered, felt 'less and less good'. In her craft studio, by contrast, that 'other, indiscriminating realm', 'conscience ha[d] no foothold'. What was she doing? 'Messing with "stuff"'.[20]

In addition, Sedgwick found a new pleasure in the feel of fabric against her skin, enjoying 'WEARING SKIRTS' in a different way, her own textiles now akin to Van Wey's 'MAGIC CARPET'

20 Ibid., 199.

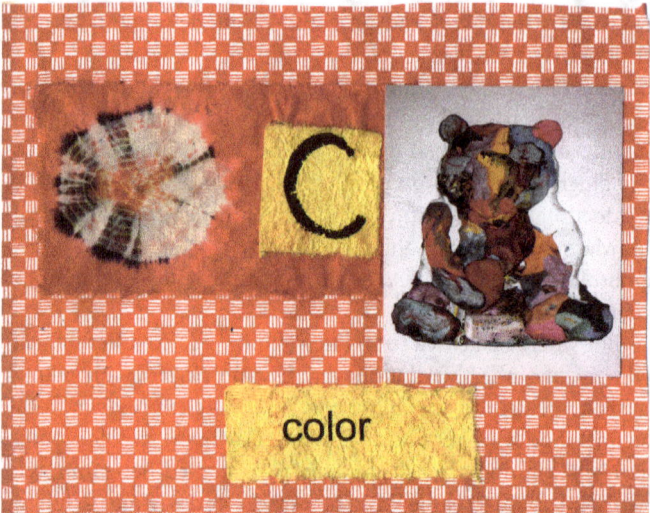

Figure 5.4. Eve Kosofsky Sedgwick, 'C: Color' in *Panda Alphabet Cards* (c. 1996), © Eve Kosofsky Sedgwick Foundation.

in keeping her sense of self buoyant.[21] Crucial to this new sense of self was what she described as a 'MORE REALISTIC SENSE AND UNDERSTANDING OF HER POWER'. Indeed, she acknowledged she felt 'LESS AND LESS' that her 'INTELLECTUAL, SPIRITUAL' and

21 Ibid., 201–2. Sedgwick here implicitly identifies Van Wey with Prince Husain from *One Thousand and One Nights,* the eldest son of the Sultan of the Indies, who travels to Vijayanagara in India to purchase his flying carpet. Earlier in her career, she had been preoccupied with the queer Middle East of Richard Burton and T.E. Lawrence, as well as with Javanese folk cultures, inspired by Benedict Anderson's Mythology and the Tolerance of the Javanese (1965; Jakarta: Equinox, 2009), which she had read with great interest as an undergraduate. Increasingly, however, her attention would turn, in the mid-1990s, to South and East Asia. For more on Sedgwick's relation to Lawrence and Burton, see *Between Men,* 106, 173, 182–83, 189, 192–96, 198, and Jason Edwards, *Bathroom Songs: Eve Kosofsky Sedgwick as a Poet* (Earth: punctum books, 2017), 193–97, 272–73, 275–76, 281–84, 287–90. For more on Vijayanagara, see George Mitchell, ed., *Vijayanagara: Splendour in Ruins* (New York: Alkazi, 2008).

'ARTISTIC' power was 'EITHER BOUNDLESS OR NOTHING, EITHER THE OVERBLOWN' or the 'SUDDENLY DEFLATED BALLOON'. It was 'MORE LIKE' a textile, 'A SLEEPING BAG WITH MANY SEPARATE COMPARTMENTS — A SINGLE PUNCTURE WON'T FLATTEN IT'. In short, her textile experience brought her into the middle ranges of agency, that 'POSSIBLE SENSE OF AGENCY THAT MAY NOT LIE IN EXTREMES OF GRANDIOSITY OR ABJECTION'.[22]

Perhaps appropriately, the final chapter of *A Dialogue on Love* opens with an affirmation, in the form of a first line of a haiku, in Van Wey's shouty script: 'HAIKU AND CRAFTS YES', haiku being a key form in both the memoir and her subsequent exhibition *Bodhisattva Fractal World*. Sedgwick acknowledged that she felt embarrassed but 'not enough to stop' at the 'hours and hours' she wasted with Van Wey trying to account for her 'crafts mania'. But, in spite of her auto-pathologizing, case-study language of waste and mania, she found herself 'trying to believe' she was 'allowed this vast pleasure'. Like a guilty Lady Macbeth, afraid she had killed her former writer self, Sedgwick asked: 'Who knew the old superego had so much blood in her?' before allowing herself the novel 'strangeness' of 'floating downstream with a current that's so resolutely wordless'.[23]

At this point in the narrative, and in an oft-quoted passage, Van Wey became the first critic to comment in print, allusively and associatively, on Sedgwick's works in fiber. He documented:

SILK WORK — TURNING FABRIC INTO OTHER FABRIC / CHILDHOOD BLANKET WITH THE SATIN BINDING / SKIN HUNGER / THE FASCINATION EVERYONE HAD WITH HOW SILKY MY SKIN WAS / BRO'S PILLOW PIFFO, HIS DROOLING, 'MAKING FISHES' ON IT / MAY SAY SOMETHING ABOUT HOW HUNGRY OUR SKIN WAS FOR TOUCH, BUT ALSO ABOUT OUR HAVING THE PERMISSION TO DEVELOP AUTONOMOUS RESOURCES — THE DOWNSIDE OF BEING SILKY WAS THAT SOMEHOW I WAS AN

22 Sedgwick, *Dialogue*, 200–203. For more, see *The Weather in Proust*, ed. Jonathan Goldberg (Durham: Duke University Press, 2011), 79–80.

23 Sedgwick, *Dialogue*, 205.

Figure 5.5. Eve Kosofsky Sedgwick, *Untitled* (c. 1996?), assemblage of quilted kimono scraps, decoratively sewn with gold thread, dimensions unknown. © Eve Kosofsky Sedgwick Foundation.

OBJECT FOR OTHERS TO SATISFY THEIR TOUCH NEEDS, NOT MINE / TREASURE SCRAPS OF SILK / SOMEHOW THE SILK AND SHIT GO TOGETHER — THE WASTE PRODUCTS, FANTASIES OF SELF-SUFFICIENCY, NOT DEPENDENT, SPINNING STRAW INTO GOLD.[24]

Given the density of this passage, it is worth pausing to parse it. At the start, Van Wey gave readers the indication of the kinds of works viewers would subsequently find in Sedgwick's exhibitions. Works made from silk and cotton. Works in which extant pieces of fabric, and especially kimono swatches, are cut up and fashioned into new images and objects (see Figure 5.5).

We are already familiar with Sedgwick's unembarrassed acknowledgement of her fiber works as adult equivalents of queer

24 Ibid., 206.

childhood comfort blankets for a skin ego in pain and anxiety, as it moved through a mastectomy, chemotherapy, and recurrence; as well as of the importance, in queer childhood and supposed adulthood, of fabrics able to absorb bodily fluids, salty or golden-brown, like urine, menses, sweat, and shit. In addition, Van Wey points to an epidermal reading of Sedgwick's layered fabric collages, with his nod to her 'skin hunger' and her family's, and subsequent viewers', 'FASCINATION' with her silky-skin-like pieces. Eroticism also looms up, quietly, in Van Wey's description of Sedgwick's masturbatory permission to develop autonomous, cutaneous resources. But Van Wey additionally gives us a characteristically Sedgwickian caution, not to simply objectify the works, or their artist, without risking ourselves in the process, if 'THE DOWNSIDE OF BEING SILKY' was that Sedgwick was an 'OBJECT FOR OTHERS TO SATISFY THEIR TOUCH NEEDS' on. In relation to which, let me say that I 'TREASURE' Sedgwick's 'SCRAPS OF SILK', not as part of some 'FANTAS[Y] OF SELF-SUFFICIENCY', or because I want to 'SPIN' her 'STRAW INTO' academic 'GOLD', but, rather, 'DEPENDENT[ly]' as a vital life-line, as I find my way through my own maze, and especially now that she herself has gone.[25]

In spite of a 'STIFF NECK FOR A COUPLE MONTHS —MAYBE FROM THE COUCH, OR THE STRESS FROM CRAFT ACTIVITIES', which turns out to be the first indication of the recurrence of Sedgwick's breast cancer, which had metastasised to her spine, Sedgwick turned first to weaving, Van Wey reveals, and in particular to 'AN ATTRACTIVE WOVEN SCARF, THE PRODUCT OF [A] WEEKEND'S LEARNING HOW TO WORK WITH [A] TABLE LOOM' (see Figure 5.6).

This project, Sedgwick informs Van Wey, was 'TACTILE, NON-VERBAL, REGRESSIVE', and hugely 'ENJOYABLE', since it lacked the 'CONSTANT ALERTNESS' she needed for writing. As a result, and as the increasing prevalence of Van Wey's voice testifies, Sedgwick finds her own verbal idiom less pressing, as her book art and fiber work increasingly gave space not just to the words of

25 Ibid.

Figure 5.6. Eve Kosofsky Sedgwick, untitled fabric/hanging (c. 1996?), comprising long, narrow, fringed weaving in deep reds and yellows, with green and blue accents, using hand-painted ribbons for weft, dimensions unknown, © Eve Kosofsky Sedgwick Foundation.

Van Wey, but, as we shall see, to early twentieth-century queer Greek-language poet Constanin Cavafy and Georgian novelist Edward Bulwer-Lytton.[26]

For example, Van Wey documents Sedgwick twice 'IN THE MIDDLE OF PARSING THE THREADS OF INFLUENCE AND MEANINGS' when 'THE THREAD OF THE REASONING GETS LOST', and, whilst she is 'NOT SURE WHAT THIS IS', she is right that this verbal difficulty represents her being 'MORE THAN JUST PREOCCUPIED WITH WEAVING'. Indeed, her symptom is such that she feels increasing resistance to finishing the *Dialogue*. That is because, for the first time in a career famous for its autobiographical dimension, she finds the 'PRODUCTION OF THE FIRST PERSON' both 'LABOUR INTENSIVE' and 'CONSTRAINING', in 'THAT THERE WERE EMOTIONAL REGISTERS THAT WEREN'T AVAILABLE WHILE GENERATING THE FIRST PERSON'. As a result, she starts to have fantasies about 'A TEXTURE BOOK' that 'WOULDN'T NEED A FIRST PERSON AT ALL, ANY MORE THAN WEAVING [...] DOES'. 'THAT RHYME[D] WITH A LOT OF STUFF FOR [HER]', Van Wey notes, 'THE BUDDHIST STUFF' and the 'MANIA FOR MAKING UNSPEAKABLE OBJECTS', which is to say, objects that are comparatively silent and that many early viewers took to be too queer, in the sense of too excruciatingly embarrassing to express in words.[27]

Finally, the cover of *Dialogue* may also be queer in a couple of other senses (see Figure 5.7).

In depicting the gutter between two blank pages, it again resembles the cleavage of breasts and buttocks, a symmetrical

26 Ibid., 206–7.
27 Ibid., 207. For example, when Sedgwick came to the University of York at my invitation in November 2007 to give the lecture 'Making Things, Practicing Emptiness', which described her work as a fiber artist and was a well-received paper she first gave earlier that summer at Goldsmith's College to an audience comprising interested artists and cultural theorists, a significant proportion of the York audience, a large, interdisciplinary group with few practicing artists — since the university does not possess a fine art department — were restless and dissatisfied that she did not present a more straightforwardly queer talk, and embarrassed she focused on her Buddhist craft practice. For the lecture, see Sedgwick, *The Weather in Proust*, 69–122.

Figure 5.7. Eve Kosofsky Sedgwick, front cover of *A Dialogue on Love* (1999).

Figure 5.8. Eve Kosofsky Sedgwick, spine of *A Dialogue on Love* (1999).

breast cleavage Sedgwick by this point pointedly lacked, as we have seen. In placing the internal gutter of the book on its cover and on its spine, she again reversed the polarities of inside and outside, as she had done with *Epistemology of the Closet,* and characteristically exposed what was beneath the covers (see Figure 5.8).

She also poignantly played on the notion of the spine of the book in relation to her dissolving spine, with the gutter representing the inside of the book's spine, the part most visible when the book is stacked on a shelf, as in Allyson Mitchell's *Eve Kosofsky Sedgwick Book Case* (see Figure 0.2) but a spine here transformed into a gutter, a narrow trough or duct rather than a solid structure.[28]

Covering and Cripping *Touching Feeling*: Sedgwick, Bora, Scott

The cover of *Touching Feeling* focuses on a single, monochrome photograph of fiber artist Judith Scott by Leon Borensztein[29]

28 For more on gutters, see Carolyn Williams, 'The Gutter Effect in Eve Kosofsky Sedgwick's *A Dialogue On Love*', in *Graphic Subjects: Critical Essays on Autobiography and Graphic Novels* (Madison: University of Wisconsin Press, 2011), 195–99. For Williams's further reflections on Sedgwick, see her contributions to *Between Men at Thirty,* https://www.centerforthehumanities.org/programming/eve-kosofsky-sedgwicks-between-men-at-thirty-queer-studies-then-and-now.

29 For a reading of Scott's career within the 'broad context of the culture of feminism', see Catherine Morris and Matthew Higgs, eds., *Judith Scott: Bound and Unbound* (New York: Delmonico Books/Brooklyn Museum, 2015). For interpretations of Scott within the context of the identity politics of 'queer and LGBTI artists', see 12, 15. Morris and Higgs also note that the cover of *Touching Feeling* represents 'perhaps the most widely known photograph of Scott', 'hugging one of her large sculptural works, which

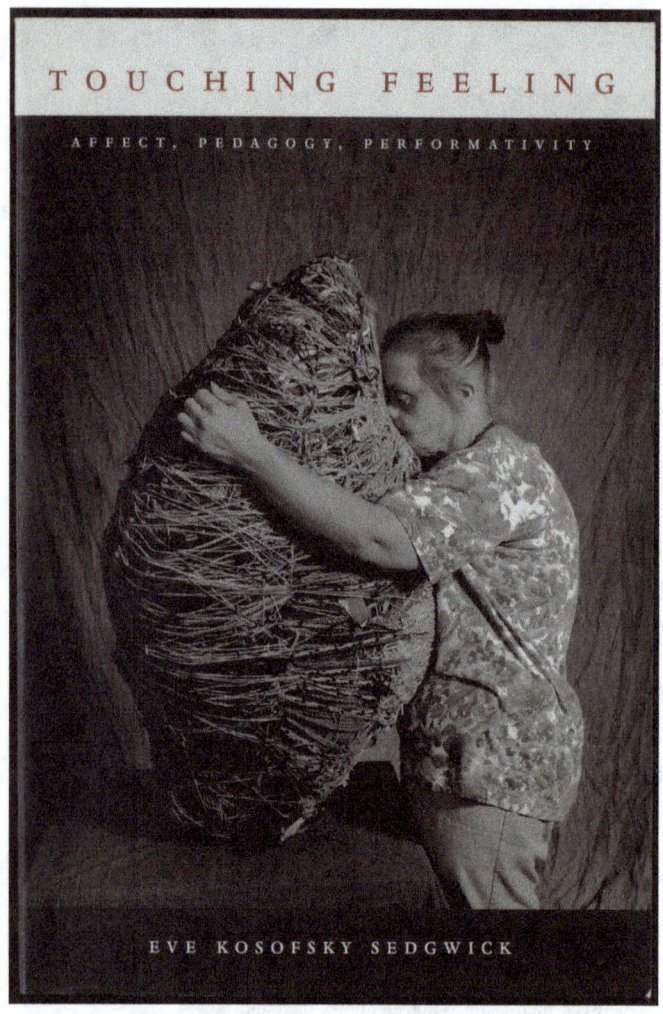

Figure 5.9. Eve Kosofsky Sedgwick, front cover of *Touching Feeling* (2003).

(see Figure 5.9). He pictures her in a floral shirt, encountering one of her textured, seed pod-like, mixed-media works, stood on a table in what may be his studio, against a background of anally-puckered fabric recalling the more creased, lustrous, and satiny sheet hanging behind Sedgwick on the back of *Fat Art, Thin Art*.[30] The creases in Scott's top, like the rolls of skin below Sedgwick's sports bra, suggest fat aesthetics, as well as the emerging importance of folds, of various kinds, to Sedgwick's thinking.[31] The monochrome character of Borensztein's photograph, meanwhile, recalls the scratchy black-and-white Piranesi engraving on the cover of *The Coherence of Gothic Conventions*, the grey palette emphasizing Scott's twiggy textures rather than her vibrant palette.[32]

appears to function almost as a surrogate, an anthropomorphic object that seemingly mirrors her own body' (33).

30 Joyce Scott described the scene of her sister re-encountering her work later at exhibition, noting how she 'went to each one in turn and greeted it, a hug here, a kiss there, sometimes a gentle caress. Some seemed only to receive a token recognition, just a simple wave of the hand. It brought to my mind a mother meeting her lost children' (*Entwined: Sisters and Secrets in the Silent World of Artist Judith Scott* [Boston: Beacon, 2016], 155).

31 Chapter Three is concerned with 'Shame in the Cybernetic Fold' (93–122) and with Gilles Deleuze, formalist of the fold, who had last appeared as a comic figure in the introduction to *Novel Gazing: Queer Readings in Fiction* (Durham: Duke University Press, 1997). There, in an unlikely utopian future, 'You'll never want to tell Deleuze and Guattari, 'Not tonight, dears, I have a headache" (24). In *Touching Feeling*, by contrast, he returns as a go-to figure for thinking about Buddhist 'thusness' and an inspirational philosopher of 'planar relations' (8, 171). For more, see Gilles Deleuze, *The Fold: Leibniz and the Baroque*, trans. Tom Conley (London: Athlone, 1993). Sedgwick was also engaging with David Bohm's thinking about the implicate and explicate orders. For more, see Sedgwick, *The Weather in Proust*, 100–101, and David Bohm, *Wholeness and the Implicate Order* (London: Routledge, 1980).

32 Even though there have been claims that Scott 'cared little for color and was much more interested in texture', Joyce Scott couldn't 'think of anyone who loved color more' than her sister (*Judith Scott*, 43). More recent critics of Scott's work repeatedly emphasise her skill as a colorist. Faye Hirsch described Scott's palette as 'endlessly fascinating' ('Judith Scott', *Art in America*, February 3, 2015, https://www.artnews.com/art-in-america/aia-reviews/judith-scott-2-61864/); whilst Holland Cotter

Thinking about texture had been long central to Sedgwick's criticism and poetry, as we have seen, and newly so in the mid-1990s, in the wake of her own turn to fiber arts, a new saliency that also affected her conception of *Touching Feeling*, although affect has dominated the critical reception of the book at the expense of its interest in tactility.[33] For example, as Angus Brown has argued, scholars have extended Sedgwick's treatment of feeling, in texts such as Sianne Ngai's *Ugly Feelings* (2005) and Heather Love's *Feeling Backward* (2009), at the expense of the 'physical connotations of Sedgwick's *Feeling*'.[34]

But the tactile connotations of feeling had long been at the heart of Sedgwick's thought in *Novel Gazing*, which, whilst most famous for the 'Paranoid and Reparative Reading' essay, also included Renu Bora's 'Outing Texture', a chapter whose importance she acknowledged in the introduction to *Touching Feeling*.[35] This acknowledged that Bora's conceptualisation of texture had 'influenced [her] a lot', especially his idea that

> to perceive texture is always, immediately, and de facto, to be immersed in a field of active narrative hypothesising, testing, and re-understanding of how physical properties act and are acted upon over time. To perceive texture is never only to ask or know What is it like? nor even just How does it impinge on me? Textural perception always explores two other ques-

commended Scott's 'subtle and acute' sense of color ('Silence Wrapped in Eloquent Cocoons', *The New York Times*, December 5, 2014, https://www.nytimes.com/2014/12/05/arts/design/judith-scotts-enigmatic-sculptures-at-the-brooklyn-museum.html). Indeed, as Hirsch documented, only 'occasionally' did Scott 'go monochromatic', and only when more colorful materials were not available ('Judith Scott').

33 Sedgwick, *Touching Feeling*, 17.
34 Heather Love, *Feeling Backward: Loss and the Politics of Queer History* (Cambridge: Harvard University Press, 2009); Sianne Ngai, *Ugly Feelings* (Boston: Harvard, 2005); and Angus Brown, 'Look with Your Hands', in *Bathroom Songs*, ed. Edwards, 71–75. This may prove less true in a Spanish context in which the title of Maria José Belbel Bullejos's translation is *Tocar la fibra* (Madrid: Estudios de Género, 2018).
35 Renu Bora, 'Outing Texture', in, *Novel Gazing: Queer Readings in Fiction*, Eve Kosofsky Sedgwick (Durham: Duke University Press, 1999), 94–127.

tions as well: How did it get that way? And What could I do with it?³⁶

In addition, according to Sedgwick's gloss, we have not perceived a texture until we have 'instantaneously hypothesised whether the object' was 'sedimented, extruded, laminated, granulated, polished, distressed, felted, or fluffed up', and to perceive texture was also to 'know or hypothesise whether a thing will be easy or hard, safe or dangerous to grasp', 'stack', 'fold', 'shred', 'climb on', 'stretch', 'slide', or 'soak'. And, 'even more immediately than other perceptual systems', the sense of touch makes

> nonsense out of any dualistic understanding of agency and passivity; to touch is always already to reach out, to fondle, to heft, to tap, or to enfold, and always also to understand other people or natural forces as having effectually done so before oneself, if only in the making of the textured object.³⁷

Much here is as we might expect. To perceive texture is to make 'nonce hypotheses' about it, whilst Sedgwick characteristically refashions the supposed binary of active and passive as an interactive spectrum or constellation of different qualities and possibilities. In addition, there is clear, as well as queer corporeality to these discussions, especially in the suggestions of polishing, tapping, and fluffing, verbs with a slang sexual resonance. For example, tap that ass is a euphemism for anal sex; knob polishing for male masturbation, and fluffing as a euphemism for oral sex. There are also queer resonances in the imagined possibilities of grasping or fondling something hard and dangerous, touching something soft and soaking wet, of climbing on and stretching out, as well as the more enveloping relationalities of the fold, and of knowing that one is not alone in any sexual history one forms a part of.

36 Sedgwick, *Touching Feeling*, 13.
37 Ibid., 13–14

Questions of mortality and bodily vulnerability also, perhaps unsurprisingly, come to the fore, when Sedgwick cites Walter Benjamin's famous account of how even if the second-empire bourgeoisie were unable to give their 'earthly being permanence', it was a 'matter of honour' to 'preserve the traces' of their 'articles and requisites of daily use in perpetuity', in the form of velvet and plush covers and cases that 'preserve[d] the impression of every touch'.[38] If Benjamin encourages us to read Sedgwick's textiles as memorials to her handiwork, it is telling that, in discussing the different ways touch and vision had been 'amplified by technology', the tactile example she employed was the use, in a breast self-examination, of a 'film of liquid soap, a square of satiny cloth, or even a pad of thin plastic filled with a layer of water to make the contours of the breast more salient' to the fingers.[39] And, with scenes of mastectomy in mind, one of the things Sedgwick finds most interesting about texture is the way 'there is no such thing as textural lack', since whether a textured surface 'bears the scars and uneven sheen of its making' or 'defiantly or even invisibly blocks or refuses such information', there is always texture, whether rough or smooth.[40]

Sedgwick's remarks on Scott, meanwhile, come in the introduction's concluding section, which provides a three-page account of her relation to a fiber artist whose work she had seen at first hand.[41] Sedgwick noted that Borensztein's photograph was

38 Ibid., 14.
39 Ibid., 15.
40 Ibid., 14.
41 For the *locus classicus* of what might be at stake in engaging with disability images, such as those of Scott and her work, see Rosemarie Garland-Thomson, 'Seeing the Disabled: Visual Rhetorics of Disability in Popular Photography', in *The New Disabilities History: American Perspectives* (New York: New York University Press, 2001), 335–75. In Garland-Thomson's terms, whilst Sedgwick's choice of cover photograph for *Touching Feeling* might resist the 'genre of medical photography' — the 'primary lens used to interpret disability' — her image of Scott risks the 'stereotype of the "supercrip"' with the cover acting as a 'kind of visual resumé documenting [her] accomplishments'. Seeing Scott in lost profile, meanwhile, 'normalizes and [...] minimizes the visual mark of [her] disability', in ways that could be read as universalizing, rather than minoritizing, but risks

the 'catalyst that impelled' her to 'assemble the book in its present form'; a verb suggesting *Touching Feeling* itself was a kind of patchwork or dossier that could be added to, subtracted from, or rearranged, with Sedgwick also acknowledging, from the outset, 'the project's resistance to taking the form of a book-length, linear argument on a single topic'. It is also important that the cover image was one of many the photographer took of Scott. As Sedgwick notes, the sculpture Borensztein depicts is

> fairly characteristic of Scott's work in its construction: a core assembled from large, heterogeneous materials has been hidden under many wrapped or darned layers of multi-colored yarn, cord, ribbon, rope, and other fiber, producing a durable three-dimensional shape, usually oriented along a single axis of length, whose curves and planes are biomorphically resonant and whose scale bears comparison to Scott's own body.[42]

In her subsequent discussion, Sedgwick praises Scott's 'inventive technique for securing the giant bundles, her subtle building and modulation of complex three-dimensional lines and curves', and her 'startlingly original use of color, whether bright or muted, which can stretch across a plane, simmer deeply through the multi-layered wrapping, or drizzle geographically along an emphatic suture'.[43] These chromatic effects are difficult to imagine from Borensztein's melancholically monochrome photograph, but Sedgwick quietly eroticises Scott's work through employing her characteristic language of stretching, especially given that Scott's bound work rests on a table — the scene of so many of Sedgwick's s/m tableaux, as we have seen — and that Scott

complicity with 'the social mandate to hide disability'. Garland-Thomson is also mindful that 'disability sells', and not just to a 'disability market', especially when it comes to 'the 'cute'', with the 'sentimental cuteness' of Down's at the cuter end of the spectrum (336, 340, 344, 351, 354, 356, 360, 365–66).

42 Sedgwick, *Touching Feeling*, 1, 22.
43 Ibid., 22.

presses herself, at groin height, against it.⁴⁴ In addition, viewers might think about the structure of Scott's works, in which a found object was largely hidden within a mass of fiber, as akin to the kind of closet-like, x-within-a-y form that had preoccupied Sedgwick in *Epistemology of the Closet* and *The Coherence of Gothic Conventions,* with its focus on live burial, and that she would return to in her thinking on fractals as an 'X within an X' in *The Weather in Proust,* although her c. 2003 preference was for more surface models of reading as she made clear in the introduction to *Touching Feeling*.⁴⁵ This emphasised, as we saw in this book's introduction, *Touching Feeling*'s cumulative project to explore some ways around the 'topos of depth or hiddenness', of 'beneath', 'behind' and 'beyond', to concentrate on a 'Deleuzian interest in planar relations', and the adjacent 'spatial positionality' of the 'beside'.⁴⁶

For Sedgwick, such adjacencies offered, as we saw in the case of *Performativity and Performance,* a 'wide range of desiring, identifying, representing, repelling, paralleling, differentiating, rivalling, leaning, twisting, mimicking, withdrawing, attracting, aggressing' and 'warping' possibilities.⁴⁷ Sedgwick's account of Scott, for example, points to the pain of separation and reconnection inherent in her work, through her language of suturing,

44 Morris and Higgs also employ a queerly evocative language in describing Scott's 'bent and trussed forms' (*Bound and Unbound,* 57). For related scenes of being tied and trussed up, see Eve Kosofsky Sedgwick, 'Tide and Trust', *Critical Inquiry* 15, no. 4 (Summer 1989), 745–57.
45 Sedgwick, *The Weather in Proust,* 13. Sedgwick may have become less concerned with the hermeneutics of depth, but Scott's family, critics, and curators were not. Kevin Killian described how Down Syndrome was 'very much something in the closet' as she was growing up (Morris and Higgs, *Bound and Unbound,* 41). Some of the works have been x-rayed to find out what is inside them, whilst Lucienne Peiry noted Scott's works frequently 'conceal a secret that their author always took great care to hide' ('Judith Scott', *Notes d'Art Brut,* May 29, 2013, https://www.notesartbrut.ch/judith-scott/). Hirsch also documented how all of Scott's works 'convey a sense of inner life' ('Judith Scott').
46 Eve Kosofsky Sedgwick, *The Coherence of Gothic Conventions* (1980; London: Methuen, 1985), 37–96; *Touching Feeling,* 8.
47 Ibid.

a language of sisterly distance and closeness hugely resonant for Sedgwick, as we have seen in Chapter Three. After all, like Scott, Sedgwick was one of a pair of sisters who underwent a painful, near complete separation for many decades.[48] And, with that in mind, viewers might think about the cover of *Touching Feeling* as the sequel to *Novel Gazing,* with the latter evoking Nina's brief return to Sedgwick's life, the former the renewed sense of loss Sedgwick felt after her sister disappeared again afterwards. Sedgwick's culinary language of simmering and drizzling, meanwhile, might also bring *Fat Art, Thin Art* to mind.

After this, her account of Borenzstein's photograph develops in an equally characteristic, triangular way, with Sedgwick noting that the image focuses on Scott's 'relation to her completed work' and the viewer's to the 'sight of that dyad'. Sedgwick, of course, puts herself into the picture, refusing Scott's objectification and commodification. 'For me', Sedgwick insisted,

> to experience a subject-object distance from this image is no more plausible than to envision such a relation between Scott and her work. She and her creation here present themselves to one another with equally expansive welcome. Through their closeness, the sense of sight is seen to dissolve in favour of that of touch. Not only the artist's hands and bare forearms but her face are busy with the transaction of texture. Parents and babies, twins (Scott is a twin), or lovers might commune through such haptic absorption. There is no single way to understand the 'besideness' of these two forms, even though one of them was made by the other.[49]

Sedgwick's language here catches beautifully the inter-relation of the two forms, the way Scott's arms open onto the sculpture which leans back into her, its round belly pushed against hers,

48 For a poignant account of what it was like to 'a sister without her twin', see Scott, *Entwined,* 71.

49 Sedgwick, *Touching Feeling,* 22–23

as if the two are seeking to reconnect, umbilically, at the navel.[50] Indeed, the two are so close that Scott's eyes presumably cannot see the pattern she has made. Instead, she experiences the texture, sensing its striation, feeling its temperature, inhaling its scent, and hearing, as well as feeling, the brush of yarns against her skin. Indeed, citing Bora, Sedgwick had earlier reminded readers that the sense of texture was not 'coextensive with any single sense', and that other senses beyond the visual and haptic were involved in the 'perception of texture'.[51] As such, Sedgwick might explicitly allude to lovers, twins, and parent-baby dyads, as well as recalling her sisterly relations, but the image and its description also recalls Chapter Five of *A Dialogue on Love*, published four years earlier. There, she and Van Wey surprisingly get up and push against one another, turning out to be the 'same height and pretty evenly matched' before stepping back, 'panting ostentatiously, though clearly [they]'ve been pulling their punches'. The post-coital pair then settle back down into their respective couch and chair, their 'feet delicately poised' at the opposite corners of the footstool they loved to share, as we have seen.[52]

In spite of the probable pressure of Scott's groin, it is, perhaps, difficult for some viewers to read the photograph as eroticised, since her erotic life is absent from her sister and critics' accounts of her work. Nevertheless, Sedgwickian spectators might want to think about the possible, reciprocal pressure of Scott's clitoris

50 In March 2015, Jessica Holmes described a number of Scott's forms as 'womblike with a pregnant belly' ('Boundless: Judith Scott at the Brooklyn Museum', *Art Critical*, March 20, 2015, https://artcritical.com/2015/03/20/jessica-holmes-on-judith-scott/). Holland Carter described how 'densely swaddled' Scott's forms were ('Silence Wrapped in Eloquent Cocoons'). Lawrence Downes noted that some were 'large enough to cradle in both arms' ('An Artist Who Wrapped and Bound Her Work, and Then Broke Free', *The New York Times*, December 1, 2014, https://www.nytimes.com/2014/12/02/opinion/an-artist-who-wrapped-and-bound-her-work-and-then-broke-free.html). Cheetham expressed his 'child-like urge to feel the softness of the fibers' (Whitworth Work of the Week).

51 Sedgwick, *Touching Feeling*, 15.

52 Sedgwick, *Dialogue*, 93–94.

against the table, and to write an article entitled 'Judith Scott as a Masturbating Woman'.

Scott's erotic life was not, though, Sedgwick's primary concern, however abashed she felt that *Touching Feeling* included 'so little sex'.[53] That was because affect had increasingly replaced desire as her chosen mode for touching and feeling the world, and

> the affect that saturates the photo is mysterious, or at least multiple, in quality: besides the obvious tenderness with which Scott embraces the sculpture, her relaxed musculature and bowed head suggest sadness, for example, as perhaps does the abandon with which she allows her features to be squashed against it. The height and breadth of her embrace could suggest either that she is consoling herself or seeks consolation from the sculpture, which is slightly canted toward here while she stands on her own feet: the loose-jointed breadth of her embrace can also be read as a sign of her Down Syndrome. Yet the jaunty top and bottom points of the rounded shape are only the most visible of the suggestions that this soberly toned black-and-white photograph is at the same time ablaze with triumph, and relief.[54]

Again, a scene from *A Dialogue on Love* comes to mind, especially in the mixture of sadness, consolation, relief, and triumph, and in the context of a complicatedly impersonal, as much as interpersonal, embrace. After all, Scott's sculpture does not, in any conventional sense, possess a subjectivity, even if it might have agency, from the perspective of Bruno Latour's actor-network theory.[55] In the scene I have in mind, Sedgwick praised 'being *impersonally* held' by Van Wey, comparing it to taking a 'tepid bath', in which she could / slowly lower [her] great bulk, / to be supported / in some medium less human than 'holding'

53 Sedgwick, *Touching Feeling*, 13.
54 Ibid., 22.
55 For more, see Bruno Latour, *Reassembling the Social: An Introduction to Actor-Network-Theory* (Oxford: Clarendon, 2005).

(in Winnicott's famous image of the therapeutic relation) would suggest'.⁵⁶ And I talk about the photograph's mixture of sadness, consolation, relief, and triumph because the scene is twined together, in *A Dialogue on Love,* with the text's conclusion. Here Van Wey skilfully replaces a patch of dirt he did not know Sedgwick had earlier dislodged, before giving her permission to die, reminding her that the world will go on being repaired without her — a passage impersonally re-enacting Sedgwick's earlier active remembering of a piece of childhood dirt, as we saw earlier in this chapter.⁵⁷

The depth of Sedgwick's engagement with Scott, an artist earlier recognized within the frame of 'outsider' art, and who had been 'repeatedly diagnosed in terms of lack', might give readers cause for concern, as well as feelings of melancholy. After all, as Sedgwick acknowledged, critics often pointed to Scott's color blindness, long-undiagnosed deafness, apparent indifference to the art world, and experience in a 'crushingly negligent Ohio asylum system' in Cincinnati, close to Dayton, where the Kosofsky children spent part of their nearly historically parallel childhood. Sedgwick acknowledged frankly:

> I don't suppose it's necessarily innocuous when a fully fluent, well-rewarded language user, who has never lacked any educational opportunity, fastens with such a strong sense of identification on a photograph, an oeuvre, and a narrative like these of Judith Scott's. Yet oddly, I think my identification with Scott is less as the subject of some kind of privation, than as the holder of an obscure treasure, or as a person receptively held by it. The drama of Scott's talent is surely heightened by her awful history, her isolation from language, and what I assume must be her frequent cognitive frustrations. But the obvious fullness of her aesthetic consciousness,

56 Sedgwick, *Dialogue,* 66–67. The description also recalls a moment from James's *The Ambassadors* (1903, cited in Bora's chapter of *Novel Gazing*), where Lambert Strether describes 'the essential freshness of a relation so simple' as 'a cool bath to the soreness produced by other relations' (122).

57 Sedgwick, *Dialogue,* 219–20.

her stubbornly confident access to autotelic production, her artist's ability to continue asking new, troubling questions of her materials that will be difficult and satisfying for them to answer — these privileges seem to radiate at some angle that is orthogonal to the axis of disability.[58]

Sedgwick's identification with Scott, then, is important from a number of angles: firstly, as a female artist similarly taken with the cross-pollination of sculpture and fiber, as Sedgwick already was in her own practice, as we have seen.[59] Secondly, as a fellow, post-war, queer fiber artist from Ohio, whose talent emerged in her mid-forties. And I emphasise queer here because if Sedgwick was often hostile, in her writing, to monolithic sculptural forms, before she became enamoured of Chinese statues of the Buddha and bodhisattva Kuanyin, she was frequently interested in craft forms that involved the intersection of many fibers — forms that became the definition of queer for her. Indeed, returning to *Tendencies,* with Scott in mind, it is hard to imagine a better description of Scott's work than as the 'open mesh of possibilities, gaps, overlaps, dissonances and resonances, lapses, and excesses of meaning' when something isn't made 'or can't be made' to 'signify monolithically', and as 'organised around multiple crossings of definitional lines'; 'constituting' and 'fracturing' lines that 'crisscross' and 'can be at loose ends with each other'.[60]

Although Sedgwick was too determined to challenge the language of lack in Scott's case to acknowledge it, Sedgwick's identification with Scott was also as a person facing serious physical, linguistic, and cognitive challenges, who might nevertheless remain able to engage in a passionate, impressive, tactile fiber practice, and who might have retained, until close to the end of her life, a 'sensibility in which fibers and textures have particular

58 Sedgwick, *Touching Feeling,* 23–24.
59 For more, see Jenelle Porter, *Fiber: Sculpture 1960–Present* (Munich: Prestel/Del Monico, n.d.).
60 Sedgwick, *Tendencies,* 8.

value, relationally and somehow also ontologically', even as her own mnemonic, hermeneutic, and linguistic facilities deteriorated, partly as a result of her 'chemobrain'.[61] Indeed, Sedgwick concluded the introduction with a discussion of fellow literary critic Barbara Herrnstein Smith's notion of the 'senile sublime'. This referred to the

> various more or less intelligible performances by old brilliant people, whether artists, scientists, or intellectuals, when the bare outlines of a creative idiom seem finally to emerge from what had been the obscuring puppy fat of personableness, timeliness, or sometimes even of coherent sense.

This was something Sedgwick had already, perhaps, begun to encounter, with an expression of her own 'sadness and fatigue', as well as 'affective and aesthetic fullness', as she repeatedly came up against the experience of 'cognitive frustration', as well as the plenitude of fibers, as she tried to write her essays and patch them into a coherent whole.[62]

At the end of her life, then, Sedgwick seemed to have hoped that there might remain a fat art of 'affective and aesthetic fullness', with a 'belly like a wineskin: / round, sometimes, as a kittenful of milk', as well as the thin art of a persona no longer obscured by 'puppy fat' — either way, a life full of comfortingly soft, furry, folded, and enfolding texture.[63] With that in mind,

61 Eve Kosofsky Sedgwick, 'Come as You Are', in *Come As You Are, After Eve Kosofsky Sedgwick*, ed. Jonathan Goldberg (Earth: punctum books, 2021), 85–111; 92.

62 Sedgwick, *Touching Feeling*, 24. For an, in some ways, parallel identification with autistic figures, see *The Weather in Proust*, 144–65. For a related account of outsider artist Henry Darger, against the idea of an 'isolating and pathologising version', see Michael Moon, *Darger's Resources* (Durham: Duke University Press, 2012), 11. For a poignant account of trying to do literary theory in the midst of severe linguistic impairment, see Barbara Johnson, 'Speech Therapy', in *Shakesqueer: A Queer Companion to the Complete Works of William Shakespeare*, ed. Madhavi Menon (Durham: Duke University Press, 2011), 328–32.

63 Sedgwick, *Fat Art*, 4.

the final section of this chapter ponders what it might mean to experience *Touching Feeling* with your fingers as well as your eyes; with touch rather than vision, as the 'perceptual gold standard'; to look at the book, as well to read it: the project of *Queer and Bookish* as a whole.[64]

Look with Your Hands, or Touching *Touching Feeling*

What does it mean to 'think about texture across different scales' and *Touching Feeling* in the 'filthy workshop of its creation'? After all, if 'texture has everything to do with scale', as Sedgwick noted, what do readers make of the numerous, miniscule, recurrent paired manicules pointing inwardly to each other at the start of each chapter, and the individual left-pointing manicules at the start of each subsection, which, in their diminutive scale, compared to the size of actual hands, act as a reminder that 'there is no one physical scale that is intrinsically the scale of texture' (see Figures 5.10 & 5.11)?[65]

And what happens when readers are encouraged to see, through a magnifying glass, the 'underlying texture of paper or fabric'?[66] Which is to say, what might it mean to encounter *Touching Feeling* as a small-scale Scott sculpture, a 'woven thing with just a woven depth', to borrow a line from Sedgwick's early, c. 1973 poem 'Essay on the Picture Plane',[67] especially since the egg-like shape of the first full-title page of the book and the final Library of Congress page both resemble, as we have already briefly noticed, the silhouette of Scott's untitled sculpture on the

64 Sedgwick, *Touching Feeling*, 15.
65 According to Sedgwick, the manicules were the brainchild of Ruth Ann Buchanan, a student of Mavor's and 'v. talented designer', who had them 'searching for sufficiently plump pointing fingers' (email to the author). For more on manicules, see William H. Sherman, 'Toward A History of the Manicule', http.www.livesandletters.ac.uk/papers/FOR_2005_04_001.pdf.
66 Sedgwick, *Touching Feeling*, 15–17.
67 Sedgwick, *Fat Art*, 72.

Chapter 5

PEDAGOGY OF BUDDHISM

What does it mean when our cats bring small, wounded animals into the house? Most people interpret these deposits as offerings or gifts, however inaptly chosen, meant to please or propitiate us, the cats' humans. But according to the anthropologist Elizabeth Marshall Thomas, "Cats may be assuming the role of educator when they bring prey indoors to their human owners.... A mother cat starts teaching her kittens from the moment they start following her.... Later she gives them hands-on practice by flipping victims in their direction, exactly as a cat does in play. Mother cats even bring [wounded] prey back to their nests or dens so that their homebound kittens can practice, especially if the prey is of manageable size. So perhaps cats who release living prey in our houses are trying to give us some practice, to hone our hunting skills" (105).

For persons involved with cats or pedagogy, Thomas's supposition here may be unsettling in several ways. First there is the narcissistic wound. Where we had thought to be powerful or admired, quasi-parental figures to our cats, we are cast instead in the role of clumsy newborns requiring special education. Worse, we have not even learned from this education. With all the cat's careful stage management, we seem especially stupid in having failed to so much as recognize the scene as one of pedagogy. Is it true that we can learn only when we are aware we are being taught? How have

Figure 5.10. Eve Kosofsky Sedgwick, p. 153 of *Touching Feeling: Affect, Pedagogy, Performativity* (2003).

Figure 5.11. Eve Kosofsky Sedgwick, title page of *Touching Feeling: Affect, Pedagogy, Performativity* (2003).

Figure 5.12. Eve Kosofsky Sedgwick, pp. 154–55 of *Touching Feeling: Affect, Pedagogy, Performativity* (2003).

cover and reproduced again before the title page (see Figures 5.12 & 5.13)?[68]

And what might a model of surface reading, close-but-not-deep reading, or too-close-*for*-reading reading look like that was focussed more on *Touching Feeling*'s texture, appearance, and materiality, than on its text?

Viewers might contemplate the quiet, dull, unreflective, matt, unpolished texture of the book's cream paper; smooth, but not shiny, sparkling, or gleamingly so, especially in light of what Bora says about the how 'smoothness is a both a type of texture and texture's other'. After all, the pages do not bear the 'scars and uneven sheen' of their pulpy making, at least not without the aid of a microscope — a metaphor of scarring reassuringly absent,

68 I am grateful to Meg Boulton and Becky Sanchez for first drawing these parallels to my attention. For Boulton's reflections on Sedgwick, see 'Waiting in the Dark: Musing on Sedgwick's Performative(s)', in *Bathroom Songs*, ed. Edwards, 169–77.

Eve Kosofsky Sedgwick is Distinguished Professor of
English at the CUNY Graduate Center. She is the author of books
including *Fat Art, Thin Art* (Duke University Press, 1994), *Tendencies*
(Duke University Press, 1993), and *Epistemology of the Closet*
(University of California Press, 1991).

Library of Congress Cataloging-in-Publication Data
Sedgwick, Eve Kosofsky.
Touching feeling : affect, pedagogy,
performativity / Eve Kosofsky Sedgwick.
p. cm. — (Series Q)
Includes bibliographical references and index.
ISBN 0-8223-3028-8 (cloth : alk. paper)
ISBN 0-8223-3015-6 (pbk. : alk. paper)
I. Frank, Adam. II. Title. III. Series.
PS3569.E316 T68 2002
814'.54 — dc21 2002007919

Figure 5.13. Eve Kosofsky Sedgwick, Library of Congress page of *Touching Feeling: Affect, Pedagogy, Performativity* (2003).

and reparatively resonant, for a writer such as Sedgwick whose right chest revealed her mastectomy scars. Indeed, the pages might 'defiantly' or 'invisibly block' or 'refuse' such painful evocations. However, in spite of the lack of 'gloss', matte paper does not represent a 'textural lack', as Bora emphasizes, but a reparative, reassuring presence, under the reader's sensitised fingers.[69]

Indeed, it is worth returning, in detail, to Bora's article if readers are to bring out fully the texture of *Touching Feeling*. Compared to the overtly gestural and theatrical cover of *Performativity and Performance,* with its prima's right hand stretched towards the viewer (see Figure 3.1), *Touching Feeling*'s paper does not evoke the 'singing surface qualities of materials'. Rather, readers might think about the cream paper as surprisingly *vanilla*, on the spectrum of the 'liminal erotic play between shiny/matte and smooth/rough' or 'smooth/coarse' distinctions. After all, the smooth, frictionless paper is neither nappy nor fuzzy, slippery nor tacky, and offers only the most gentle, unnoticeable resistance to the fingers, as it holds its textural own, even if you give it a good, sustained rub. Straight, rather than 'striated'; planar not volumetric; firm, but not stiff; neither slippery nor sticky, flakey, fluffy, hairy, powdery, feathery, furry, or leathery; dry, with the possibilities of porosity, rather than moist, soggy, or downright wet; and able to be held and turned, but not compressed or stretched, without permanent, damaging obscuration of the text and structural weakening in the appearance of folds. Indeed, the paper is not meant to be bent, maybe even at its outer corners to mark where the reader is up to, and possesses a 'fairly homogenous' or 'flat' tactility.[70]

While the cover depicts the 'folded', 'puckered', and 'wrinkled', in the form of Scott's backcloth, there is, perhaps, a single, textural distinction to be made as readers make their way through the book: between the cover's better-lubed waxiness and the dryer, but rhythmically turned pages that flip from rec-

69 Sedgwick, *Touching Feeling*, 14–15.
70 Bora, 'Outing Texture', 95, 99, 100, 104.

to to verso.⁷¹ That said, the overall experience of waxy and unwaxed papers, and transitions between them, is, in Bora's terms, a 'smooth', 'vanilla' experience, whose utopian ideal involves something comfortingly easy to swallow and digest, like (vegan) cream or ice-cream, perhaps — what Bora calls the mutual vanilla experience of the 'giving and receiving of pleasure without any negative feelings or affect'. In opposition to this is the here-absent s/m dynamic of textural 'bristling', 'roughness' or 'prickling', whose relationality is more tough, frictive, scratchy or penetrative, and hot but potentially painful, perhaps more like rubbing up against Scott's seed-pod or the coarse grain of Piranesi's plates.⁷²

Because of the 'relatively static textures' of the inside pages, and in spite of the persistent presence of the reminding manicules — whose repetitious, structural presence make them paradoxically easy to forget, or to rush past as readers eagerly want to get to the (soya) meat of the argument — it is hard to remember the experience of one's hands, and to recall the 'processes of texturizing and detexturization' that formed the book's paper. After all, as Bora notes, 'the emergence of tactility' to consciousness 'usually involves thrills of the manual' and the disruptive juxtapositions of, and transformations, between different textures, 'from a hard coarseness to a refined flatness to a fuzziness to a hairiness to a shafting or piercing'. In spite of my unusually embodied and materialized account of touching, *Touching Feeling*, its well-lubricated, waxy covers and the sustainedly 'smooth style' of its internal pages offer few such narrative or phenomenological thrills.⁷³

Indeed, there is something perhaps poignantly and pointlessly repetitive about all of those manicules, which following medieval scribal practice, remind us of the tactile difference of vellum compared to paper. And I say 'poignant' because of how often Sedgwick recalls our attention to the tactile experience of

71 Ibid., 106.
72 Ibid., 107, 112, 122–23.
73 Ibid., 117–19, 121.

reading in her codex books, not heavy enough to provide pressure on our wrists, but big and chunky enough not to need care in handling. The manicules are also poignant because of the pessimistic, comically enjoyable parables of 'near-miss pedagogy' that begin *Touching Feeling*'s last chapter that explores human/feline interactions. Here, Sedgwick famously described how cats, rather than following a pointing finger to the thing deictically referred to, in this case the moon, often sniffed the finger instead, more interested in its scent or texture rubbing against their face or fur, or in scenting with their oral glands the hand that fed them, to signal possession, than in the moon their human staff was trying to draw their attention to.[74]

In a second scene of failed pedagogy Sedgwick described the similarly familiar scene of cats bringing home more or less dead prey to their human companions, again not so much to signal that humans are the deity-like tops requiring an offering, but in an endlessly hopeful, failed attempt to teach their cohabitants to go hunting — a pointed scene if the human in question is, like me, somewhere on the vegetarian to vegan spectrum.[75] It would take the strength of a bodhisattva — a *bodhicattva*! — to keep on at this lesson, but that is what Sedgwick's manicules want us to do: to keep turning, as if from scratch, to her text, in the case of the right-pointing manicules, and in on ourselves, in the paired manicules pointing towards one another.

Readers might, however, understand Sedgwick's manicules in more queerly positive ways. There is, after all, also something erotically fixated about her repeated, extended, and potentially dilating fingers, with their helpfully short nails, especially in the context of *Touching Feeling*'s first chapter: 'Shame, Theatricality,

74 Sedgwick, *Touching Feeling*, 153–54. For more, see Lauren Berlant, 'The Pedagogies of Pedagogy of Buddhism', *Supervalent Thought*, March 18, 2010, https://supervalentthought.com/2010/03/18/after-eve-in-honor-of-eve-kosofsky-sedgwick/.

75 Sedgwick, *Touching Feeling*, 153–54. Berlant persuasively argues that Sedgwick's cat is also trying to teach her about her own mortality, and that, through her description of the scene, Sedgwick is trying to help prepare her readers for her own demise ('Pedagogies').

and Queer Performativity in Henry James's *The Art of the Novel*', and since manicules have often been referred to as 'fists' within the history of the book. The chapter examines a range of then-recently-published letters between Henry and William James that focus on the novelist's bowel problems, and that caused Sedgwick to return to the passage she repeatedly pondered, describing James, suffering from a constipation-like writer's block, but confident that a creative bowel movement would come in the end:

> I sit here, after long weeks, at any rate, in front of my arrears, with an inward accumulation of material of which I feel the wealth, and as to which I can only invoke my familiar demon of patience, who always comes, doesn't he?, when I call. He is here with me in front of this cool green Pacific — he sits close and I feel his soft breath, which cools and steadies and inspires, on my cheek. Everything sinks in: nothing is lost; everything abides and fertilizes and renews my golden promise, making me think with closed yes of deep and grateful longing when, in the full summer days of L[amb] H[ouse], my long dusty adventure over, I shall be able to [plunge] my hand, my arm, in deep and far, up to the shoulder — into the heavy bag of remembrance — of suggestion — of imagination — of art — and fish out every little figure and felicity, every little fact and fancy that can be to my purpose. These things are all packed away, now, thicker than I can penetrate, deeper than I can fathom, and there let them rest for the present, in their sacred cool darkness, till I shall let in upon them the mild still light of dear old L[amb] H[ouse] — in which they will begin to gleam and glitter and take form like the gold and jewels of a mine.[76]

As Sedgwick notes, she had previously pondered the passage in *Epistemology of the Closet,* suggesting it represented an image of

[76] Sedgwick, *Touching Feeling,* 47–48. For more on James's anality, see Bora, 'Outing Texture'.

Figure 5.14. Eve Kosofsky Sedgwick, manicule detail of *Touching Feeling: Affect, Pedagogy, Performativity* (2003).

'fisting-as-ecriture'.[77] It recurs in *Touching Feeling* in the context of James's 'fascination with the image of a hand that penetrates a rectum and disimpacts or "fishes out" the treasure imagined as collecting there'. As such, it is the closest the book comes to a 'sustained, directly sexual thematic'.[78] In this later discussion, Sedgwick points to a key intertext for this 'scene of fisting' that resonate with our discussion of manicules that might be understood as the first dilating digits of the fist that follows into James's *Golden Bowels*. Tese are the lines referring to Douglas's 'soft, obstetric hand' from Book Four of Alexander Pope's *Dunciad* (1743), which in turn inspired Sedgwick's own accounts of Humby's fisting 'leathery obstetric hand' in 'The Warm Decembers'.[79]

In addition, when examined closely, Sedgwick's manicule figures must be stood with their backs facing us, because their fingers are nearer to us than their hidden thumbs, a characteristic rear view (see Figure 5.14).

In my earlier discussion, in Chapter One, of the similarly extended hand of Michelangelo's God and Adam in the Sistine Ceiling, I cited Yeats's 'Long Legged Fly' (1939), written in what he feared to be the last days of culture, when he was anxious that 'civilization [...] not sink / Its great battle lost'. The poem,

77 Sedgwick, *Epistemology*, 48.
78 Sedgwick, *Touching Feeling*, 13.
79 Ibid.; *Fat Art*, 149.

is set, in part, in Roman antiquity, and ponders a Caesar looking at maps spread in his tent, his 'hand under his head', just as the women in Sedgwick's *Déjeuner* has her head resting on her hand. Yeats's second stanza, meanwhile, also describes a city aflame, its 'topless towers [...] burnt'. Yeats decided, as we have seen, that these last days might contain a masturbating girl, but no homosexual Adam. In her first artist's book proper, *The Last Days of Pompeii* (c. 2007), Sedgwick similarly pondered the apparent end of a classical civilization, hers aflame with lava. She also included maps spread across the page, but, unlike homophobic Yeats, did not make invisible ancient Greek male same-sexuality. Instead, inspired by ACT-UP, she wheat-pasted lyrics by early-twentieth-century Greek poet Constantin Cavafy to every appropriate surface of Edward Bulwer-Lytton's homophobic 1834 novel, queerly interlarding it in the process, as Chapter Seven goes on to explore.

6

Interlude, Pandagogic, Or, Sedgwick's *Panda Alphabet Valentines*

Relatively widely distributed in her lifetime, although not the subject of an exhibition, Sedgwick's *Panda Alphabet Valentines* (c. 1996?) comprise twenty-six cards. Each features a photographic tableau of one or more, mostly soft-toy pandas and a letter of the alphabet, illustrating a concept beginning with that letter, layered on a photograph of one or more pieces of kimono fabric, a key material resource for Sedgwick.[1] Given to her husband and friends, the cards represent our first foray into her queer craft works beyond the codex book. Nevertheless, they're bookish, sharing many features in common with the books we have encountered so far, demonstrating further her interest in collage, photography, cropping and layering techniques, and the pattern and texture of fabrics.

Unlike the pages of Sedgwick's standard and altered codex books, the *Valentines* are loose, not bound by a spine. As a result, they represent one of her first attempts to find a *spine-less* form to explore further her metastatic predicament. I use the word 'spine-less', with a hyphen, rather than 'spineless', to em-

1 For more, see Terry Satsuki Milhout, *Kimono: A Modern History* (London: Reaktion, 2014), and Rebecca A.T. Stevens and Yoshiko Iwamoto Wada, *The Kimono Inspiration* (San Francisco: Pomegranate, 1996).

Figure 6.1. Eve Kosofsky Sedgwick, 'A: Art', *Panda Alphabet Valentines*, c. 1996. Collection H.A. Sedgwick, © H.A. Sedgwick.

phasize that I don't think her engagement with her dissolving spinal column was weak-willed or purposeless; cowardly, feeble, or ineffectual; inadequate, irresolute, or spiritless. The cards are, rather, *spine-less* in two other senses. Firstly, in being invertebrate, in a literal sense, without a central spinal column, as Sedgwick was, increasingly, herself, just like a number of creatures that came to preoccupy her mind in her coming craft projects. The *Valentines* are also lacking in spines, in the sense of sharp, pointed ridges, as on a prickly pear or porcupine, embracing instead an aesthetic of fat, furry softness and sweetness.

In having her *Valentines* unbound, Sedgwick offered her recipients some new game-based, sequence-based, shape-based, and distribution-based opportunities beyond the sequential page-turning, paper-touching, and weight-bearing digital, manual, tactile, and carpal experiences of her codex books. The cards can be read in alphabetical order or shuffled up and

INTERLUDE, PANDAGOGIC

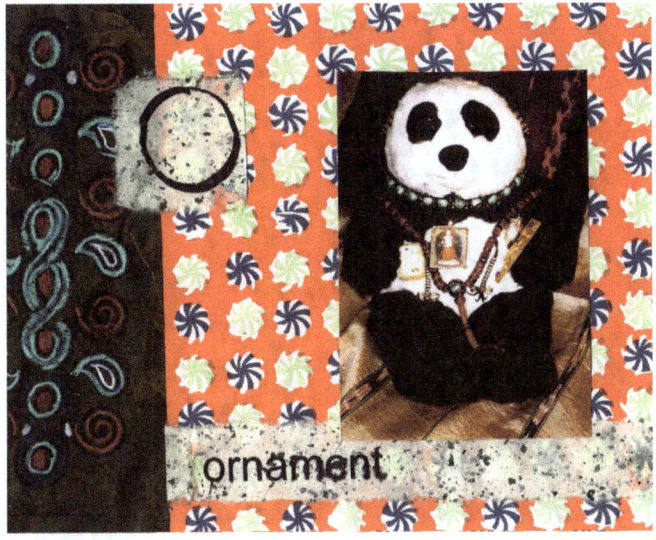

Figure 6.2. Eve Kosofsky Sedgwick, 'O: Ornament', *Panda Alphabet Valentines,* c. 1996. Collection H.A. Sedgwick, © H.A. Sedgwick.

randomized, increasing the element of chance. They could be played by a couple or a group, and used for interactions and competitions with other simultaneous gamers. They might be sorted alphabetically, by concept, pattern, or color. Individual cards could be taken, hidden, or lost — the possibility of partial loss again resonant for the post-operative artist. They could be juxtaposed in different, changing configurations, as in arranging your hand in a game of cards. As the first and fifteenth cards in the sequence both suggest — Art, with its panda in a white-cube gallery space accompanied by a paint palette and open sketchbook, and *Ornament,* with its bead necklace-laden panda — the cards might also be displayed in frames, as pictorial artworks, used for decoration, or employed for referential or non-referential two- or two-and-a-half-dimensional layouts, for example, in the shape of letters of the alphabet, laid adjacently or overlapping (see Figures 6.1 & 6.2). Alternatively, they could

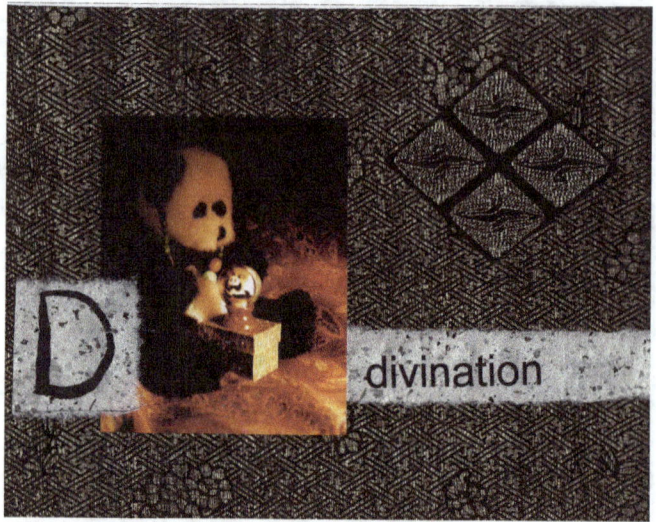

Figure 6.3. Eve Kosofsky Sedgwick, 'D: Divination', *Panda Alphabet Valentines,* c. 1996. Collection H.A. Sedgwick, © H.A. Sedgwick.

be used to build three-dimensional structures, such as a fragile house of cards.

The cards might also be focused on slowly and meditatively, in sequence, or used for speed-based games. They may be handed around, like business cards or Victorian *carte-de-visite,* to stand in for oneself, thus anticipating the cover of the second edition of *Epistemology of the Closet,* or, like Valentine cards, as forms of attempted seduction and tokens of love. In addition, as *Divination* suggests, they could be used for fortune telling activities (see Figure 6.3).

Finally, the cards might function as flashcards that you could commit to memory and test yourself or others with later. As such, the *Valentines* suggest more contingent narrative and relational possibilities than Sedgwick's codex books, an increasing sense of chance she must have felt deeply, in the wake of her diagnosis and metastasis.

Like the recto and verso of book pages, the cards have an obvious front and back, but, in their digitally distributed form — the form in which I received them and in which they survive — the always landscape-oriented, rather than portrait-oriented images are again frontal, suggesting Sedgwick's sustained, Friedian interest in the faciality of pictorial images, as we have repeatedly seen. At the heart of all twenty-six cards, however, is the image of one or more pandas, alone, in pairs, or in larger, often crossgenerational groups, and it is to the meanings of these elusive creatures that I turn first, to ascertain why pandas were so important to Sedgwick.

A Panda in the Hand Is Worth Two in the Bush

Sedgwick was and is not alone in her passion for pandas. According to Ramona and Desmond Morris, pandas hold a secure position amongst the world's top ten favorite animals, especially amongst children.[2] But if the popular sense of the creatures, as 'chubby, clumsy', 'real live black-and-white teddy bear[s]',[3] initially encourages readers to interpret Sedgwick's panda poems and artworks as, at best, peripheral, and, worse, embarrassing, childish aesthetic glitches;[4] her panda calendars represented a crucial space of ontological and aesthetic agency in the years after her metastasis, offering her a motive for another year of life, and marking that year. In 1995, for example, she made a *Panda Garden* calendar; in 1996 an *Affective Life of Pandas* calendar; in 1998, a *Spiritual Lives of Pandas* calendar; and, in 2000, a further, unspecified *Panda* calendar (see Figure 6.4).[5]

2 Ramona Morris and Desmond Morris, M*en and Pandas* (New York: McGraw-Hill, 1966), 22.
3 Ibid., vii, 62.
4 For example, the Morrises describe how a 'sickly sentimental panda plague' had 'infected far more people' than could hope to see a panda in the flesh (ibid., 106, 197).
5 As in her *The Last Days of Pompeii* collage book, as we shall see, Sedgwick may have been inspired in her calendar projects by her friend, the art critic and AIDS activist, Simon Watney, who, in the midst of the AIDS crisis, wondered, in 1994, 'Who'd buy a calendar these days?', reflecting 'they ought

Figure 6.4. Eve Kosofsky Sedgwick, *Panda* calendar, April 2000. Collection H.A. Sedgwick, © H.A. Sedgwick.

The inspiration provided by these calendars perhaps explains why, in one of the last photographs taken of Sedgwick, by David Shankbone, viewers see her smiling, in her home, her head resting, thoughtfully, on her right hand (see Figure 6.5).

Immediately to the left of her is an image of the similarly radiant Dalai Lama and, behind him, a card featuring Ganesha, whom Sedgwick identified with Gary Fisher, and who represents a divinity who carried on successfully with an elephant head when he lost his own, even if Sedgwick was mostly of Audre Lorde's opinion that prostheses were not the way to go.[6] On the right are numerous baby pandas climbing a bamboo shoot — our first encounter with 'Pandas in Trees', the name of one of Sedgwick's most famous late poems.[7]

But if pandas were crucial to Sedgwick's late style, soft-toy pandas represented one of her queer little gods from the start.[8] A revealing, sympathetically black-and-white snapshot we have already encountered, taken by her father around 1953, when she

 to try selling them in monthly installments' (*Practices of Freedom: Selected Writings on HIV/AIDS* [Durham: Duke University Press, 1994], 180).

6 In a c. 1993 poem, 'A Vigil', Sedgwick asked 'Gary, have you ever heard of a divinity, / maybe a Hindu one, who's an elephant? I think he's blue. Who's a god of love / or trickster, turns up all over the place, / named, maybe Ganesh?' The elephant-headed god is on her mind because, in hospital, Fisher is wearing 'a bottle-green, hieratic snout / snapped on for oxygen / over his own, lovely snout', with a 'long large-bore, corrugated azure / transparent nozzle out / from the more than semiotically noble green / muzzle of the thing', a 'green mask' with a 'magical blue trunk': *Fat Art, Thin Art* (Durham: Duke University Press, 1994), 14–15. Sedgwick, meanwhile, mourns the passing of Lorde in *Tendencies* (Durham: Duke University Press, 1993), xii. For more on Lorde's responses to her own breast cancer, including her adamant refusal of prostheses, see Audre Lorde, *The Cancer Journals* (San Francisco: Spinsters Ink, 1988) and *A Burst of Light: Essays* (Ithaca: Firebrand, 1988).

7 For more, see Jason Edwards, ed., *Bathroom Songs* (Earth: punctum books, 2017), 212–22, and the adjacent 'Blake Panda Poems' (223).

8 For more on Sedgwick's queer little gods, see Michael D. Snediker, 'Queer Little Gods: A Conversation with Michael D. Snediker', *Massachusetts Review* 49, nos. 1–2 (2008): 194–218, and Eve Kosofsky Sedgwick, 'Cavafy, Proust, and the Queer Little Gods', in *The Weather in Proust* (Durham: Duke University Press, 2011), 42–69.

Figure 6.5. David Shankbone, c. 2007 photograph of Eve Kosofsky Sedgwick in her studio.

was three, depicts her holding a slightly alarmed-looking, soft-toy panda, staring down at it (see Figure 4.14). She holds it awkwardly, as if it were a baby, her left hand pressing it to her body, her right caressing its furry breast, as if for its pleasure, as if it were a cat. Dressed in an identical outfit to her sister, Sedgwick looks poignantly, but helpfully, separate from the normative family values of her smiling mother, who holds Sedgwick's baby brother, David, cupped in her right arm. At the same time, the right arm of Sedgwick's sister, Nina, who we have already encountered multiple times, is wrapped around her mother's right shoulder, her left hand held in her mother's right hand, looking down with a smile at the baby.[9]

We have also again already encountered a second photograph from around the same time, which again finds Sedgwick

9 Catton explains that the baby-like appeal of pandas results from their flat faces, comparatively short muzzles, and high foreheads (*Pandas*, 1).

with a toy panda pressed to her chest (see Figure 12, Chapter 4, this volume). She is seated, this time, alongside her photographer father, who looks down at her and her panda, with a book open on his lap that has attracted her interest. Above them is a portrait by Chaïm Soutine, the Russian–French painter, who had died a decade or so earlier trying to escape the Nazis, and whose famed still-life portraits of eviscerated mammals might explain why Sedgwick holds her panda quite so close to her.

Taken together, these snapshots suggest something important about her early relation to pandas. They were a key part of her family, in addition to her siblings and parents. They simultaneously provided tactile comfort in the midst of that family, and an escape route from it. And, before Sedgwick formed a comfortingly masturbatory self-relation, as a later way out of her immediate surroundings, soft-toy pandas provided much the same queerly eroticised, escapist, tactile and textural function.[10]

As an adult, Sedgwick's relation to pandas was no less queer. Although belatedly coming out, in *A Dialogue on Love,* as a married woman, answering the question she had strategically resisted in *Epistemology of the Closet,* the performativity of her marriage perversely had pandas at its heart. Indeed, in *A Dialogue on Love,* Sedgwick came out, not as a gay man, as she had earlier done in *Tendencies,* but as a panda, since she told her therapist Shannon Van Wey and her readers of her and her husband's 'PANDA RITUALS' that made her feel, 'AMONG OTHER THINGS', 'MAGNETIC, RARE, AND VALUED EVEN WHILE GAUCHE AND UNSEXUAL' in her 'INTERACTIONS WITH HIM'.[11] This is a scene perhaps captured in Kissing. Here, two seated pandas

10 Sedgwick's infant attachment to pandas reflects the period in which she grew up, when pandas became a 'symbol of international friendship', and in which nine pandas came to the US, launching a soft toy industry that 'almost obliterate[ed]' teddy bears. Whilst panda toys were a novelty, 'much of the groundwork' had been done by earlier teddies, such that 'when the giant panda arrived as a kind of super teddy bear, it was able to build on the reputation of its plain-colored predecessor' (Morris, *Pandas and Men,* 95, 98, 105, 194, 202).

11 Eve Kosofsky Sedgwick, *A Dialogue on Love* (Boston: Beacon, 1999), 58.

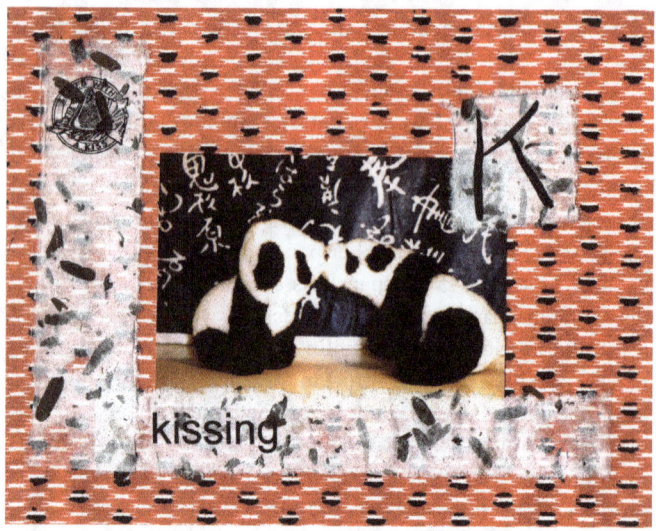

Figure 6.6. Eve Kosofsky Sedgwick, 'K: Kissing', *Panda Alphabet Valentines*, c. 1996. Collection H.A. Sedgwick, © H.A. Sedgwick.

are 'sealed with a kiss', a phrase Sedgwick stamped towards the top-left, recalling an earlier photograph of her and her husband puckering up in profile (see Figures 6.6 & 6.7).

Pandas not only formed part of Sedgwick's unpredictably plushy answer to the not-often-enough-posed question of what straight people do in bed.[12] The Kosofsky-Sedgwicks saw various 'ASPECTS OF THEMSELVES IN THIS ANIMAL', and Van Wey documented that Sedgwick thought of the panda as 'EMBLEMATIC OR SOMEHOW SYMBOLIC' of the Buddha; as a 'STYLISED', 'NOT INDIVIDUALISED' figure; and as 'SOMETHING THAT ENABLE[D] RECOGNITION OF PERSONALLY SPECIFIC THINGS' that were 'LOVE-

12 A plushy is a person with a fetish for stuffed animals, and a furry is a person with a passion for people dressed as stuffed animals. For bears and other critters, see Steven Bruhm, '*All Is True (Henry VIII)*: The Unbearable Sex of Henry VIII', and Richard Rambuss, '*A Midsummer Night's Dream*: Shakespeare's Ass Play', in Shakesqueer, ed. Madhavi Menon (Durham: Duke University Press, 2011), 28–38 and 234–44, respectively.

Figure 6.7. Unknown photographer, colour photograph of Eve Kosofsky Sedgwick and Hal Sedgwick (date unknown).

ABLE', but that 'DEINDIVIDUATE[D]' her and her husband from the logic of 'SUBJECT AND OBJECT', or 'MOTHER AND/OR CHILD'.[13]

13 Sedgwick, *Dialogue*, 58, 215. Whilst Sedgwick's identification of pandas with the Buddha might seem idiosyncratic, panda experts Zhu Jing and Li Yangwen inform readers that its almost complete 'departure from meat-eating' has earned it the name of 'monk among carnivores' since Buddhist monks also abstain from eating meat (*The Giant Panda* [Beijing: Science Press, 1980], 1). In addition, Catton notes that, in second-century China, the giant panda was considered 'semi-divine' (*Pandas,* 5).

There's Nowt So Queer As Pandas?

At first blush, readers might be inclined to minoritize, as plain weird, the Kosofksy-Sedgwicks' panda rituals. But a more universalising perspective is easy to establish from even the 'straightest' ethological evidence, in which pandas quickly emerge as one of the queerest, Kosofskian critters. For example, gendering pandas has proven a difficult feat, with twentieth-century favorites Sung, Su-Lin, Diana, Mei-Lan, Lien-Ho, and Ping-Ping all mistaken for girls, whilst Pan-Dee was taken for a boy.[14] Now, it might be 'easy to smile' at earlier zoologists' 'errors over the sexes' of pandas, but the Morrises caution that the 'external differences' between male and female pandas are 'so subtle that, even today, errors are still being made by skilled anatomists'.[15] And in case readers were in doubt about the potential difficulty, the Morrises reproduce drawings and photographs of panda genitals, asking their readers to guess which was which.[16]

Needless to say, I failed the test. That is because the adult panda's penis, only extruded during sex, is 'ridiculously short for so large an animal, being less than three inches long'.[17] Sexing pandas is also complicated because male pandas have no scrotum, and the 'testes and their wrappings are so embedded in fat' that, even during the mating season, they do not 'produce a swelling in the contour of the body', unless the panda is stretched out on its back. For the rest of the year, the panda's balls are 'inactive and reduced in size'.[18] If pandas seem 'sexless', according to the Morrises, by virtue of appearing to be 'either or neither' gender,[19] readers might further understand their queer, trans, as well as Buddhist aesthetic appeal to a Sedgwick, who made a significant body of work involving the bodhisattva, Kuanyin, as we have seen, and who, she hoped, 'may not have

14 Morris and Morris, *Pandas and Men*, 72, 85, 87, 92, 109, 124.
15 Ibid., 88.
16 Ibid., 168.
17 Ibid., 187.
18 Ibid., 166–67; Catton, *Pandas*, 95.
19 Morris and Morris, *Pandas and Men*, 198.

been shaped or perceived through the eyes of gender at all — not male, not female, not both male and female, and not neither male nor female' (see Figure 1.13).[20]

If pandas' apparent intersex, trans-, or androgynous appearance queers them through the lens of gender, the erotic life of captive pandas reveals them to be queer sexually as well. Many captive pandas have, according to Catton, 'developed what has been euphemistically called an "orientation problem"'.[21] In other words, in the equally normative account of the Morrises, 'sexually frustrated' male pandas will 'often adopt "pseudo-female" sexual postures, just as frustrated females will sometimes mount'.[22] In addition, London Zoo's Chi Chi was something of a cross-species sodomite because of how, when she came into heat in Autumn 1960 and Spring 1961, she was 'attracted to her keeper, and at times appeared to be trying to make herself attractive to him'.[23]

There is also something hyperbolically heterosexist, which is to say straightforwardly sexually abusive, about the elaborate choreography surrounding the various attempts to get Chi-Chi to mate with An-An in 1968. These included attempts to 'trigger' her estrus by injecting her with a cocktail of hormones derived from the bloodstream of a pregnant horse and human chorionic gonadotrophin — brain hormones that encourage the ovaries to release mature eggs.[24] An-An, meanwhile, found himself subjected to the demeaning, invasive, painful, damaging, and equally non-consensual process of 'electro-ejaculation', which involved putting him under general anesthetic, 'inserting an electrode into his rectum and slowly cranking up the voltage'; a

20 Sedgwick, *The Weather in Proust*, 105.

21 Catton, *Pandas*, 98.

22 Morrises, *Pandas and Men*, 167.

23 Henry Nicholls, *The Way of the Panda* (London: Profile, 2010), 118. For more on the idea of sodomy and its queer reclamation, see Jonathan Goldberg, *Sodometries: Renaissance Texts, Modern Sexualities* (Stanford: Stanford University Press, 1992), and *Reclaiming Sodom* (New York: Routledge, 1994).

24 Nicolls, *Way of the Panda*, 135.

process that may have proved fatal, according to Henry Nicholls, and caused An-An to lose his appetite and bleed rectally. Other captive pandas since, meantime, have been shown porn videos of pandas mating and been given Viagra.[25]

Pandas are also self-Sedgwicking in other ways. They are anally oriented, as An-An's rectal stimulation suggests. They defecate up to forty times a day, and, according to Catton, a panda 'travelling through strange territory' is 'continually assaulted' and attracted by a 'battery of smells' excreted by other pandas' ano-genital regions that 'provide detailed information on the sex and social status of the present tenants'. In addition, like Sedgwick, pandas are, 'by nature', solitary, 'avoiding direct contact with others of their own kind', and have 'often been referred to as "shy" or 'timid''', although a 'better description', according to the Morrises, is 'retiring and elusive'.[26]

Like Sedgwick's increasingly reparative queer-theoretical persona, pandas also exhibit few 'panic responses', their 'zoo personality' characterized by 'serenity rather than anxiety' since they are not 'attuned to being hunted'. And like Sedgwick, by her own account, pandas are 'clumsy', having 'all the appeal of a

[25] Nicholls, *Way of the Panda*, 172, 205. Nicholls also documents that, in preparation for her visit to Moscow, a mirror was strung up in Chi-Chi's den at London Zoo so she could 'get used to what a panda looked like', a strategy that proved unsuccessful since, in Moscow, Chi-Chi again 'adopted the full mating posture before one of the Russian zoo staff'. The potential queerness of panda eroticism was not entirely lost on contemporary commentators during the sexual revolution. Writing in the *Guardian* in September 1968, Catherin Storr asked whether it was possible that Chi-Chi just wanted to 'remain single', rather than being 'cold', 'homosexual or neurotic'. Indeed, Storr speculated, might not pandas 'teach us something about integrity', about the fact it 'could be 'normal' to be not exactly like everyone else's idea of what 'normal' is, but to be quietly and triumphantly ourselves?' In addition, Nicholls comments that, since Chi-Chi and An-An 'found their image mass-produced' in the form of toys, trinkets, 'hundreds of cartoons and thousands of photographs', they were not the 'reproductive failures everyone imagined them to be' (*Way of the Panda*, 131, 133–34, 136).

[26] Catton, *Pandas*, 74, 82; Morris and Morris, *Pandas and Men*, 180.

small child that has not yet mastered its muscles'.[27] In addition, even though pandas can apparently 'lay down only a little fat', their soft, round form represents a poster creature for fat studies.[28] Finally, for a long-nineteenth-century specialist, such as Sedgwick, pandas represent a peculiarly Victorian critter that, if known in China since the T'ang dynasty, did not enter European consciousness until the later nineteenth century, when Père Armand David became the first European to spot a giant panda in 1869.[29] And like the late Sedgwick, two well-documented American pandas, Sung and Grandma, suffered from 'some kind of long-standing disease of the spine'.[30]

The newly married Sedgwick seems to have been particularly inspired by the arrival of Richard Nixon's diplomatic pandas, Ling-Ling, in 1970, and Hsing-Hsing, a year later, at the Washington Zoo, a zoo up the road from the Kosofsky family home in Bethesda, near Washington. Indeed, the pandas were seen by some 20,000 people on their first public appearance, and almost certainly by Sedgwick, since they get name-checked in her poem, 'Pandas in Trees'. Hsing-Hsing and Ling-Ling also made the zoo, by Nicholls' estimate, the epicentre of panda culture outside China. At some point between 1988 and 1997, Sedgwick also wrote a number of short, untitled, playful poems, mostly in the vein of William Blake's 'Proverbs of Hell' and 'Augeries of Innocence'.[31] These announced that:

27 Morris, *Pandas and Men*, 176, 180, 201. Sedgwick's c. 1993 poem 'Who Fed This Muse?' describes how she 'knocked / things over all the time' and was prone to 'strange / propulsions' (*Fat Art*, 6).

28 Catton, *Pandas*, 58.

29 Before that, pandas had apparently made 'little, if any, impact either on oriental artists, or story-tellers', failing to appear in Chinese painting, bronzes, or jades (Morris and Morris, *Pandas and Men*, 23, 27).

30 Ibid., 109.

31 Nicholls, *Way of the Panda*, 156, 164. Nixon's pandas continued to make the news for decades. Ling-Ling's every move was panoptically captured on CCTV from July 1983, and Ling-Ling and Hsing-Hsing had a still-born baby in July 1984, and short-lived twins in 1987, who died of pneumonia in 1989 (Nicholls, *Way of the Panda*, 175–77).

> The road of excess leads to the Panda of wisdom.
>
> The Panda, wandering here and there,
> Keeps the human soul from care.
>
> A fool sees not the same Panda that a wise man sees.
>
> One Panda fills immensity.
>
> The blackness of a Panda's paw
> Brands the statesman's brow with awe.
>
> The Pandas of intolerance are wiser than the starfish of instruction.
>
> No Panda wanders too far, if he travels with his own paws.
>
> To create a little Panda is the labor of ages.
>
> The Panda of sweet delight can never be defiled.
> [and]
> Everything possible to be believ'd is an image of Panda.

In addition, Sedgwick noted that, when it came to the panda, its head was 'Sublime, [its] heart Pathos, [its] genitals Beauty', and its 'paws and ears Proportion'.[32] She also encouraged her panda-loving readers to

> Eat bamboo in the morning. Ponder in the noon. Eat bamboo in the evening. Sleep in the night.

Finally, Sedgwick suggested that 'God appears, and God is light, / To those poor souls who dwell in Night', but wondered what 'does a Panda form display / To those who dwell in realms

[32] For those curious about the appearance of panda genitals, see Jing and Yangwen, *Giant Panda*, 75, and for a close up of panda semen, 76.

of Day'? A number of answers appear in her 1996 performance-poem 'Pandas in Trees'.

Surpassing the Love of Men? Or, Pandas, in Zoos and Trees

'Pandas, among other things' form a key 'subject of debate' during the playground performativities Sedgwick evokes in 'Pandas in Trees', where they again emerge as queerly erotic and emblematize a mixed-up, pre-Oedipal maternal dyad. In the poem, a character named Yvonne wonders how, 'since boys and girls look just the same', pandas are supposed to figure out 'with whom they're meant to mate', to which Marsha Lou adds 'It's true! It's true! You're right! They do', [...] / Lively times in the bamboo'.[33] A third character, Joe, thinks pandas resemble the abominable snowman, but then we learn that two more familiar characters have different views: 'Hal perceives them all as mommies' whilst 'David think they look like babies'.[34]

But the poem, written for Carrie Wilner, the youthful daughter of Sedgwick's friend Joshua Wilner, is queer in a number of ways. It tells the story of two young girl friends, Carrie, who was 'fond of hieroglyphics' — perhaps inspired by her real-life Egyptologist mother, Marsha — and her friend, Louise, whom Carrie thinks 'terrific'. What Carrie, however, is really 'insane about' is pandas. And when her peer group impersonate the National Zoo, Carrie, 'always the goofy one,' ends up 'munching thoughtfully on bamboo' and 'knew just how to do it, too' having learned from a book mentioned in the poem we've already cited — Jing and Yangwen's *The Giant Panda* (1980) — that pandas 'have a thumb / (sort of) for holding bamboo shoots / so they can nibble with aplomb'.[35]

33 In reality, pandas can identify their cross-gendered partners through smell and vocalizations (Nicholls, *The Way of the Panda*, 225).

34 Sedgwick, 'Pandas in Trees', *Women and Performance* 8, no. 2 (1996): 179. Hal was the name of Sedgwick's husband, David her younger brother.

35 For more on the panda's pseudo-thumb, 'known as the radial sesamoid' or sixth claw, see Jing and Yangwen, *Giant Panda*, 39.

The poem's narrator finds Carrie's behavior 'very cute', but her friends find something queerly amiss. They declare that, compared to 'lions or monkeys or buffalo', being a panda seemed rather dull. 'Sighing patiently', Carrie defends her panda passion, acknowledging that whilst 'Somebody else might find it so', she feels 'most at ease / looking serene and answering / to some double-barreled Chinese / name like Hsing-Hsing or Ling-Ling'.[36] Initially adopting the 'don't ask, don't tell' logic of the US military current at the time of the poem's publication, but then like the queer kid who has to explain how they came to be so, Carrie finds it necessary to provide a genealogy for her passion for pandas. 'Don't ask me why' she initially suggests, before going on to document that she has 'heard it said / that when [she] was a tiny pup / [her] parents hung above [her] bed / a panda picture postcard up', which might explain why she was 'even as a child / so meditative and urbane / and extra large and extra mild'. At first, 'her friends respected this, as well / they might', but Carrie's African American 'best friend Louise', who also 'considered pandas thoroughly swell / though she cared more for climbing trees', leaps 'to the defense of pandahood' and Carrie. This is prompted by the pair's love for each other, as well as pandas, when Emma spoilingly claims that she had 'hid in the panda house one night / and watched to see the keepers feed / the pandas, and turn out the light' only to hear 'from either cage, a ripping noise, / like Velcro' and, 'without a word / three small blue-suited Chinese boys / who looked like spies',

> one by one
> crawled out of a Velcro opening
> in each of the panda suits! and run
> into the night, abandoning
> the panda house and leaving in it
> two crumpled black-and-white fur coats.

36 Sedgwick, 'Pandas', 176–77.

Hearing this story of gender inversion and queer coming out, with direct relevance to her and Carrie's friendship and panda passion, Louise is, understandably, 'shaken' and stumped 'for about a minute'. But then, this time identifying with a fed horse, or a sexually satisfied person, 'she started feeling her oats / as usual', and is able to announce: 'It isn't true, / I know it isn't', since 'I know Pandas, Emma, and I know you', and 'your story doesn't bounce'. Carrie also chips in, noting that, if 'they'd found / a couple of hollow panda skins / balled up one morning on the ground', the story 'would have been / in all the papers'.

Having learned all about pandas from Jing and Yanwen, meanwhile, Carrie accuses Emmie of being a 'whopping / liar', since the supposed boy spies could not turn bamboo 'into panda droppings, / even if they could really eat it' since 'Panda droppings are different from ours'.[37] In addition, Carrie contends, it would 'be bizarre' that 'with millions of enterprising children', China, 'the biggest country in the world / would choose, if it wanted spies, to send / six small boys and not one girl'. Our heroines win their argument and Emma drops 'her story flat'.[38]

But like Sedgwick, in the period she was most closely identified with Gary Fisher, whose notebooks she published the same year as 'Pandas in Trees', Carrie is a perverse deconstructive close reader thrilled by queer-of-color, cross-racial homoeroticism, sympathetic to fat aesthetics, and alive to the otherwise unperceived contradictions of arguments, in particular claims regarding pandas in trees provided by *The Giant Panda*. For example, in a subsequent scene, readers first learn that Carrie

37 For more on panda droppings, including illustrations, see Jing and Yanwen, *Giant Panda*, 50–51.

38 Sedgwick, 'Pandas', 176–77. Emmie's story probably relates to the arrival of An-An in London Zoo, in September 1968, as a potential partner for Chi-Chi. This prompted the *Sunday Telegraph* to include a cartoon of a bald man sitting against the bars of a cage, wearing a panda suit, who has 'removed the head and, with a bead of sweat running down one cheek, he speaks into a walkie-talkie: "Hello Moscow, this is An-An. They're sending me home. I have failed on my mission, but I've contacted two gorillas who could be useful to the organization"' (cited in Nicholls, *Way of the Panda*, 134–35).

wants to have, like the pandas she loves, 'a round black nose / and small black cookie-cutter ears' like all the pandas in the book, to which Louise smiles gaily, and replies that she does 'already and by nature have / a round black little nose, and two / small round black ears', which make her very 'suave'. This encourages a rotund Carrie to confess, that, like those pandas, she has a 'fluffy round white tum', that Louise, in celebratory fat idiom, thinks is 'also swell'.[39]

But whilst the pair have obviously found *The Giant Panda* physiologically, erotically and relationally reparative, as a paranoid reader Carrie cannot let go a central textual contradiction: the idea that pandas don't climb trees, in a book in which they are illustrated doing just that.[40] At this point in the poem, when the girls have recognized that 'something is amiss' that requires their joint investigation, the scene suddenly shifts, and readers find themselves in a 'troubled' twilight in which it seems 'the pines themselves were whispering' and two grown-up trees, also named Carrie and Louise, are discussing the same topic, that is, whether pandas climb trees, and, if they do, what they do once they are there, since it is certain that they don't sleep. A sniffy, acid, adult women, titillated about the idea of what lesbians could possibly do in bed, I mean what pandas could possibly do in trees, at first claims disinterest, with the first woman suggesting that pandas 'may do whatever else they please, / for anything I care. But surely / they never–almost never–climb trees?' To which a second woman agrees, 'Surely', 'Naturally. Not hardly never. / Imagine pandas climbing trees! / Virtually not whatsoever'.[41] But the pair's erotic energy rises, and a 'distinctly

39 Sedgwick, 'Pandas', 178.
40 On page 46 of *The Giant Panda,* Jing and Yangwen confidently note that 'Pandas seldom climb trees, still less sleep in trees', next to a photograph of a panda in a tree. Photographs of pandas in trees recur on pages 56–67, where readers are again told that 'Pandas do not usually climb trees' and 'Generally they climb trees only in an emergency'. There are further pictures of pandas in trees on pages 6, 15, 24, 54, and 170–71.
41 If Sedgwick's use of the word 'beasties' marks the speaker as Scottish, her 'Nonono' suggests she might be Sedgwick or her mother since 'The Warm Decembers' documents Sedgwick saying 'No no no', and being informed

odd', not to say queer, breeze is 'making both the pine-tips wiggle' until 'Down, down from the peaky trees / floats something like a breezy giggle'. Then 'Nonono', one of the trees declares, with an apparent Scottish accent, 'Other beasties' might 'climb aloft— / but surely not the panda bear, / so lovably inept and soft' and '(how to put it?)—passive'.[42]

The two friends go on with their Mozartian duet of faux-denial, whose lovely interleaving of singing voices suggest they are getting closer to one another, as they protest too much, and increasingly finish each other's sentences. They argue, first, that pandas 'never / or at least not frequently', or 'Really bearly / (you should pardon the expression) / ever', and then 'Quite remarkably rarely' climb trees. If pandas did climb trees, the duet continues, it was only ever with 'much discretion' and 'timidity' — 'As we know from scientific / works of great validity)'. Indeed, one tree suggests, 'Left to [their] own devices', pandas never, well, do what? up trees, or in the terms of the poem, '... up trees'.[43]

Like partially enlightened homophobes, the women *are* prepared to admit some exceptions, but remain keen to deny their significance. 'Perhaps it's just a wayward breeze / that drops the pandas into trees?' one asks, suggesting chance rather than queer intent. 'For otherwise they can't, you know—', to which the other replies skeptically 'They can't?' The first then responds 'Well, only very seldom, / unless necessity compelled 'em'. After all, 'Pandas are not Amazons' and 'do not do such things for fun', since 'Fond as they are of mild diversion / they are not given to exertion'. However, as the poem makes clear, whilst it may be 'distinctly queer' an idea, in fact 'Unheard-of', and potentially 'very very scary', and even if 'people so / infrequently see nose or ear / or little panda furbelow / (ahem)—up trees', that doesn't mean pandas don't climb trees.[44]

 by a friend, who met her mother, that she said '"no no no" like her', to which Sedgwick replies, insistently, that 'No no / no, that's not what I say' (Sedgwick, 'Pandas', 180).

42 Ibid., 180; *Fat Art,* 122.

43 Sedgwick, 'Pandas', 181–82.

44 Ibid., 182–83.

If the poem, then, celebrates queer cross-racial, cross-generational, and cross-species affiliations, in the form of the youthful Carrie and Louise's queer passion for pandas and each other, whilst satirizing their adult avatars' vicariously thrilled denial of such queer possibilities, the poem's nourishing, fat art landscapes — where the sky is 'tea-colored' and the 'heavens to the west are spread / with ochre bars of peanut butter, / which the sunset barely jellies' — bring to mind another passage of *A Dialogue on Love,* and take us to the reparative heart of Sedgwick's closely parallel *Valentines.*[45]

In her memoir, Sedgwick admitted that, with her 'puritanical modernist aesthetic', she 'used to think it was embarrassing, in a religion like Buddhism, to have images of divinity scattered all over the landscape' since it had 'that whiff of idolatry'. But, she confessed to Van Wey, whilst reading one day, she 'happened to look around [her] living room, and what was there? Like twelve or fifteen stuffed pandas and pictures of pandas'. Not because she viewed them 'as gods', or believed in a God, but because to see them, and seeing herself and others 'transmogrified' through the 'presence, gravity, and clumsy comedy of these big, inefficient, contented, very endangered bodies', with all their 'sexual incompetence and soot-black, cookie-cutter ears', made her happy. In addition, it seemed 'obvious that the more such images' there were, the happier she would be, and it meant 'a lot, to be happy'. It might 'even mean: to be good. Ungreedy, unattached, unrageful, unignorant'. Indeed, if she was good, it was because she was 'lucky and happy', rather than the reverse, and the only thing that mattered, 'beyond the Golden Rule' — to treat others as you would be treated — was the idea that 'If you can / be happy, you should'.[46]

45 Ibid., 179–80.
46 Sedgwick, *Dialogue,* 215–16.

INTERLUDE, PANDAGOGIC

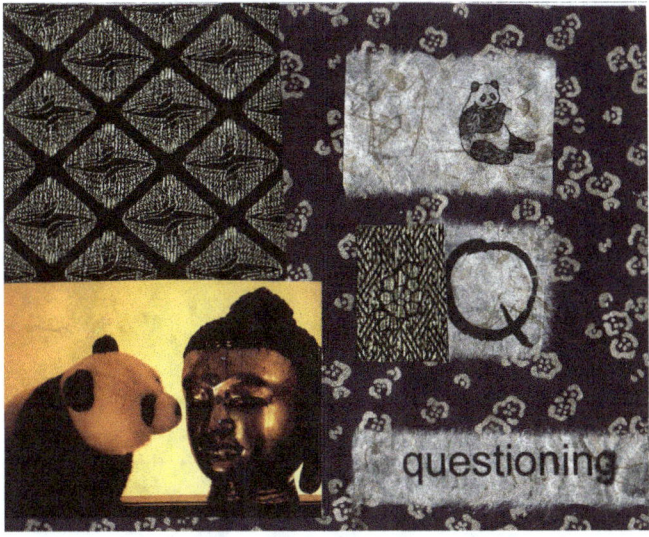

Figure 6.8. Eve Kosofsky Sedgwick, 'Q: Questioning', *Panda Alphabet Valentines,* c. 1996. Collection H.A. Sedgwick, © H.A. Sedgwick.

Queer Little Gods? The 'Valentine Cards'

Having been primed by Sedgwick's pandacious poetry and prose, what might viewers learn from a detailed examination of her *Valentines*? Firstly, that the cards embody many themes we have addressed so far. If Sedgwick had fifteen stuffed pandas in her parlour because she felt more was more, there are nearly fifty pandas across the *Valentines*. Her identification of the pandas with the Buddha finds its echo in the Buddhist importance of *Breath, Insight, Luminosity, Non-Attachment,* and *Yoga*. In *Questioning,* a panda also greets the Buddha's head. In *Xenophilia,* a tired panda also leans against a Buddha. These relationships are

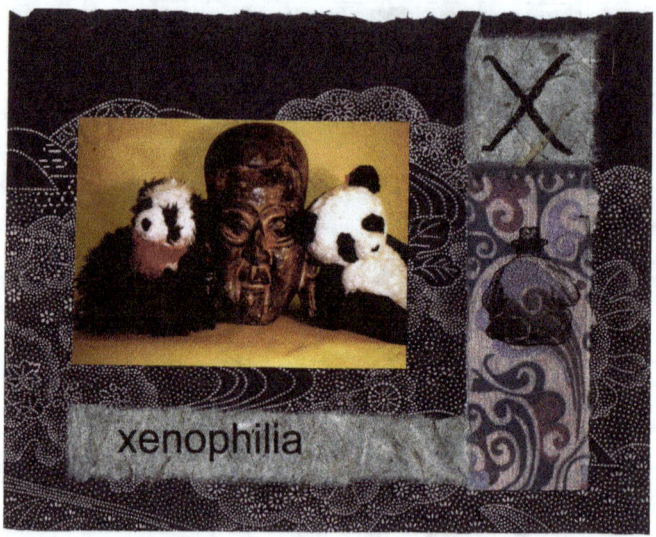

Figure 6.9. Eve Kosofsky Sedgwick, 'X: Xenophilia', *Panda Alphabet Valentines,* c. 1996. Collection H.A. Sedgwick, © H.A. Sedgwick.

not quite in a spirit of 'idolatry' perhaps, but are nevertheless perceived as efficacious (see Figures 6.8 & 6.9).[47]

In addition, Sedgwick's emphasis on how happy pandas made her finds its expression in *Joy,* with its raucously laughing panda on the left, first seen in the earlier *Friends and Fans,* holding its sides lest they split from happiness, accompanied by a more quietly smiling, feminine figure, in a strawberry-sweet bib, and a cute, cross-eyed baby panda, in a polka-dot spotted-blue bow tie (see Figures 6.10 & 6.11).

That strawberry bib is only one of many examples of an appetite-satisfying sweetness that characterize a number of the cards,

47 Understandably more idolatrous, and certainly more maximalist, is the panda in *Ornament,* with its multiple bead necklaces, and divinity pendant. Sedgwick would return to the resonances, histories, and meanings of these severed Buddha heads in her subsequent fiber work.

INTERLUDE, PANDAGOGIC

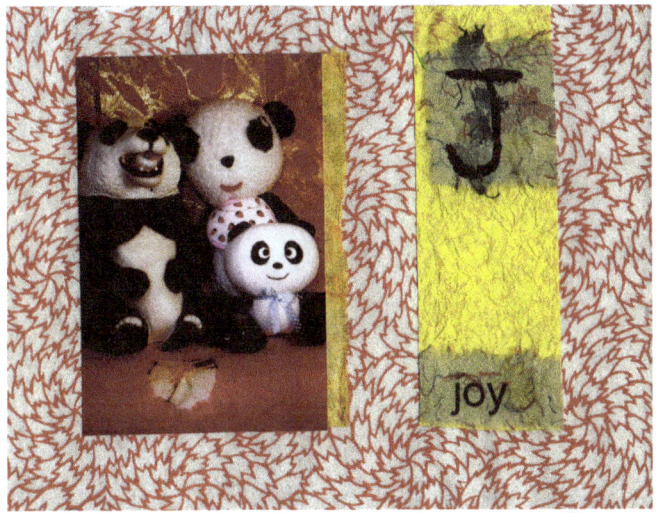

Figure 6.10. Eve Kosofsky Sedgwick, 'J: Joy', *Panda Alphabet Valentines,* c. 1996. Collection H.A. Sedgwick, © H.A. Sedgwick.

emblematic of a happiness that left Sedgwick 'ungreedy' and 'unattached'. It is also apparent in the depiction of individually-wrapped chocolates, in *Valentines,* and of Asian floral candies and numerous, panda-marked, button-like sweets in Sweetness (see Figures 6.12 & 6.13).

Taken together, these various cards encourage viewers to raise their blood sugar, to access an endorphin release, as they lick, suck, or crunch on the sweets of their choice, with the view that such candies might improve their mood, and leave them with a less bitter taste in their mouths, as well as with enjoyably sticky fingers and lips. In a related move, *Refreshment* depicts a panda drinking from a bowl, whose liquid contents seem available all around it, in the form of the gold-on-blue kimono pat-

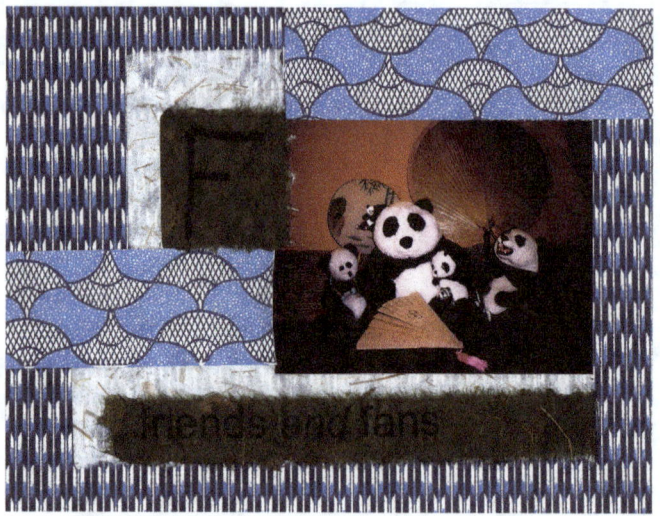

Figure 6.11. Eve Kosofsky Sedgwick, 'F: Friends and Fans', *Panda Alphabet Valentines,* c. 1996. Collection H.A. Sedgwick, © H.A. Sedgwick.

tern in which Proustian flowers swirl on the surfaces of water in motion (see Figure 6.14).[48]

If pandas were often transmogrifying, in Sedgwick's mind, they are repeatedly transmogrified in the *Valentines,* since spectators find just two photographs of actual pandas, on the final card in the sequence, although both possess a clear, queer *Zest* for life (see Figure 6.15).

The one in the top-left, embodying a deliciously fat art, leans back in a field of bamboo, happily replete, with more on offer. The one in the bottom-right, its legs suggestively akimbo, licks

48 The card also brings to mind one of Sedgwick's and Van Wey's favorite Merrill poems, as we saw in Chapter Five, with 'The Kimono', which asks its readers to 'Keep talking while I change into / The pattern of a stream / Bordered with rushes white on blue' (*Dialogue*, 188–89).

INTERLUDE, PANDAGOGIC

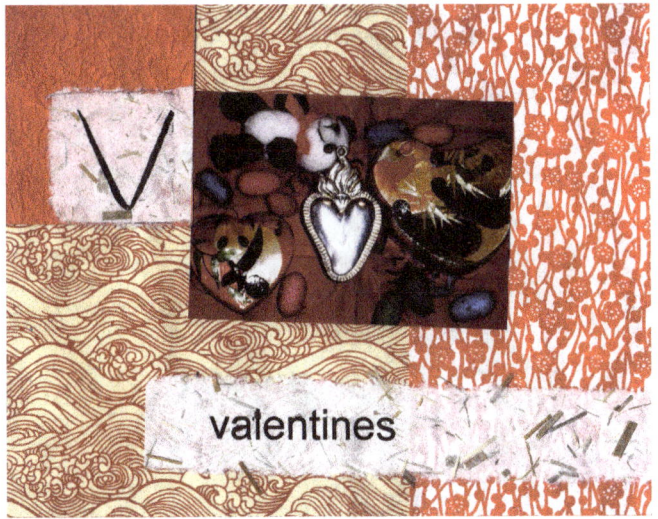

Figure 6.12. Eve Kosofsky Sedgwick, 'V: Valentines', *Panda Alphabet Valentines*, c. 1996. Collection H.A. Sedgwick, © H.A. Sedgwick.

its abdomen, and, in so doing, registers the autoerotic potential pleasures of masturbatory self-relations specifically around its nipples and, if it stretches that bit lower, down towards its genito-anal region, a wonderfully perverse, anatomically-enviable scene of auto-fellatio or -rimming.

Across the rest of the sequence, spectators find reproductions of pandas metamorphosed into a range of different scales and media, in two and three dimensions. Two-dimensional reproductions of pandas can be found in *Art, Privacy, Questioning, Sweetness, Valentines, Yoga,* and *Zest,* and the two-and-a-half dimensional form of hollow panda hand puppets and masks in *Mystery* and *Privacy* (see Figure 6.16).

Sedgwick's three-dimensional repertoire, meanwhile, includes mostly soft toy pandas (*Art, Divination, Friends and Fans, Goodies, Healing, Insight, Joy, Kissing, Non-Attachment, Ornament, Questioning, Refreshment, Transport, The Unexpect-*

285

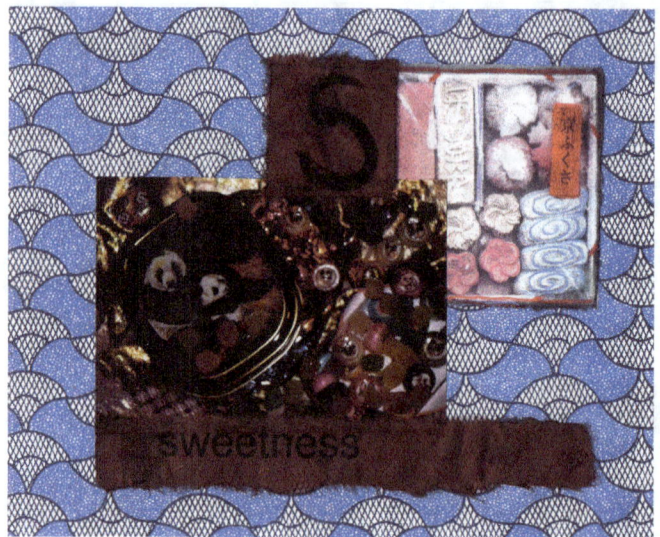

Figure 6.13. Eve Kosofsky Sedgwick, 'S: Sweetness', *Panda Alphabet Valentines*, c. 1996. Collection H.A. Sedgwick, © H.A. Sedgwick.

ed, Valentines, Worldliness, Xenophilia, and *Yoga*), but alongside examples in glass (*Breath*), unfired clay (*Color*), and fired ceramic (*Luminosity*) (see Figures, 6.17, 6.18 & 6.19).

Indeed, questions of the soft and hard, and hard and soft sculpture, are a repeated motif, especially in the cases where Sedgwick juxtaposes soft-toy pandas or panda masks and hand puppets with statuary, as in *Mystery, Privacy, Questioning,* and *Xenophilia*.[49] In *Mystery,* for example, Sedgwick places over the metal head of a Buddha statue, just visible beneath by its large, lucky left ear, the soft, hollowed out head of a panda mask, sug-

[49] The soft sculpture movement emerged in the late 1960s, as evidenced in exhibitions such as *Soft and Apparently Soft Sculpture* (1968–69); *Soft Art* (1969); and *Softness as Art*, in 1973. For more, see Max Kozloff, 'Poetics of Softness', in *Renderings: Critical Essays on a Century of Modern Art* (London: Studio Vista, 1970), 223–35. I am grateful to Jo Applin for putting me on to Kozloff's essay.

INTERLUDE, PANDAGOGIC

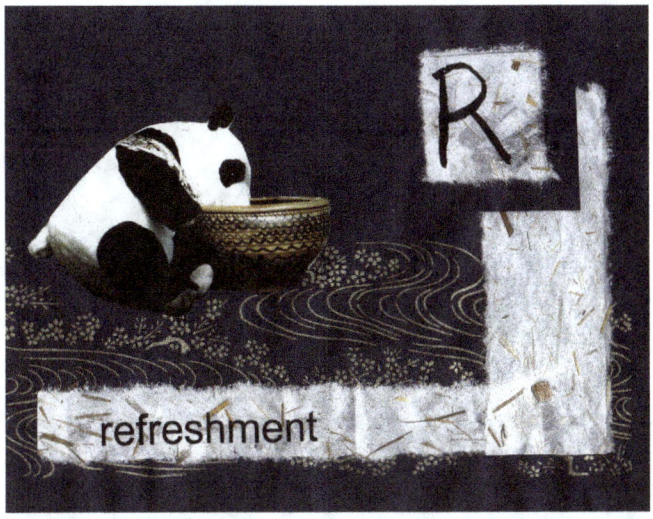

Figure 6.14. Eve Kosofsky Sedgwick, 'R: Refreshment', *Panda Alphabet Valentines,* c. 1996. Collection H.A. Sedgwick, © H.A. Sedgwick.

gesting further the overlap in her mind of pandas and the Buddha, whose open mouth is visible, just below the panda's nose, suggesting that the divinity can, somehow, mysteriously, speak through the charismatic megafauna.

In *Privacy,* Sedgwick similarly places a panda hand puppet on the left hand of a Christian cemetery statue, the first suggestion of a mournful thematics across a number of cards, reminding viewers they were made in Sedgwick's late-life, metastatic bardo (see Figure 6.20).

The statue and the panda lean in, tenderly, towards one another, looking down, as Michael Lynch and Sedgwick do above Dickinson's grave, in the photomontage commencing *Tendencies,* as we have seen. The rigidly hard, persistently upright, phallic or fist-like stone statue supports and fills out the interior of the more flexible, hollow, soft panda, and, in so doing, juxtaposes hard and soft sculpture, art and kitsch. In addition, the photo-

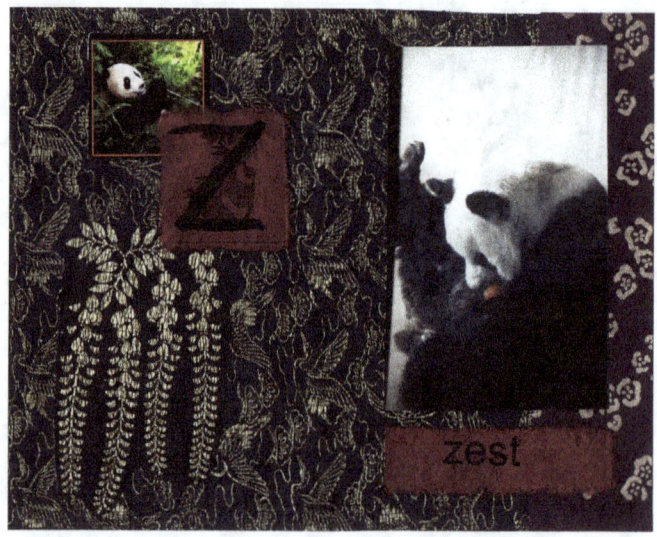

Figure 6.15. Eve Kosofsky Sedgwick, 'Z: Zest', *Panda Alphabet Valentines,* c. 1996. Collection H.A. Sedgwick, © H.A. Sedgwick.

graph offers a characteristic Sedgwickian scene of fisting. Adjacent, meanwhile, is a stamped reproduction of a second panda, lying on its back, eating a piece of bamboo but, in this context, perhaps hungry for something to be inserted into the other end of his digestive tract. This is a common trope across the cards, with similarly oriented pandas found on *Insight,* where the creature may have been knocked off its feet with a surprising idea, or is awaiting diapering, given its nappy-like white midsection; as well as on *Non-Attachment,* where a happy panda lies leisurely back, with a flower under its left arm, but no other agenda, in amongst the leaves and ivy (see Figures 6.21 & 6.22).

In *Questioning,* meanwhile, spectators find another panda engaging with the same head of the Buddha they first encountered in *Mystery,* only this time the Buddha is not speaking through it (see Figure 8 above). Instead, framed against an orange background that suggests a position between going on and

INTERLUDE, PANDAGOGIC

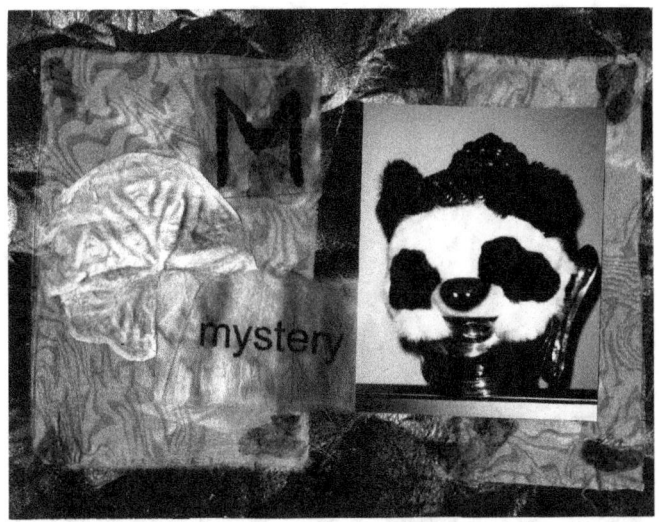

Figure 6.16. Eve Kosofsky Sedgwick, 'M: Mystery', *Panda Alphabet Valentines,* c. 1996. Collection H.A. Sedgwick, © H.A. Sedgwick.

stopping, the panda seems to be whispering in the Buddha's ear, about to plant a kiss on its cheek, or sniffing its scent, whilst we're being watched, questioningly ourselves, by a stamp of a seated panda, recalling the sitting postures of Buddha statues.

In *Xenophilia* (see Figure 6.9 above), viewers are again being observed, this time by a wooden mask of the Buddha, but presumably, given the card's theme, in a welcoming fashion. Two pandas can be seen leaning, exhausted, against the mask for support. The freshly laundered panda on the left wears a red scarf, lucky in the Chinese context, and recalls the similar red bow tie worn by the panda in *Valentines*.[50] It seems to be keeping watch, but the apparent paranoia of its pose is offset by the reparative possibilities of the friendly welcome both pandas receive from the Buddha. Confident in its divine power, the panda

50 Spectators might also think of the potential eroticism of wet fur, given Meret Oppenheim's famed fur teacup (1936).

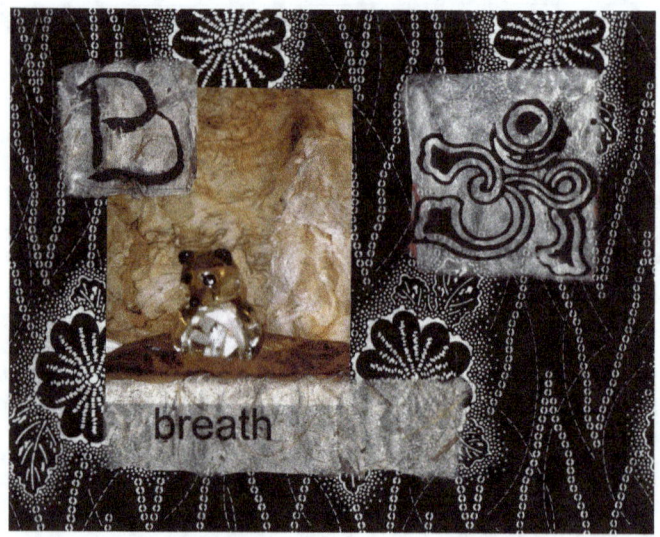

Figure 6.17. Eve Kosofsky Sedgwick, 'B: Breath', *Panda Alphabet Valentines*, c. 1996. Collection H.A. Sedgwick, © H.A. Sedgwick.

on the right is sleeping, its head drooping on its chest, its restful relation to the statue recalling the panda from *Privacy*.

That same confidence is apparent in the preceding card, *Worldliness,* which depicts a panda in a sleeping bag, decorated with a map of the world, getting comfortable, as if ready to rest out in the open, with nothing but a small basket of possessions accompanying it on its light, mendicant travels (see Figure 6.23).

Viewers might, however, again note the position Sedgwick chooses for her bear, bent over a waist-high box, recalling the prone position, ready to be spanked, fisted, or penetrated, central to so much of her fantasy, as we have seen, with the textural contrast of the wicker wrapping paper, fur, and sleeping bag, suggesting the queer pleasures of frottage, of pressing yourself up against, or bending yourself over, a washing machine in full cycle.

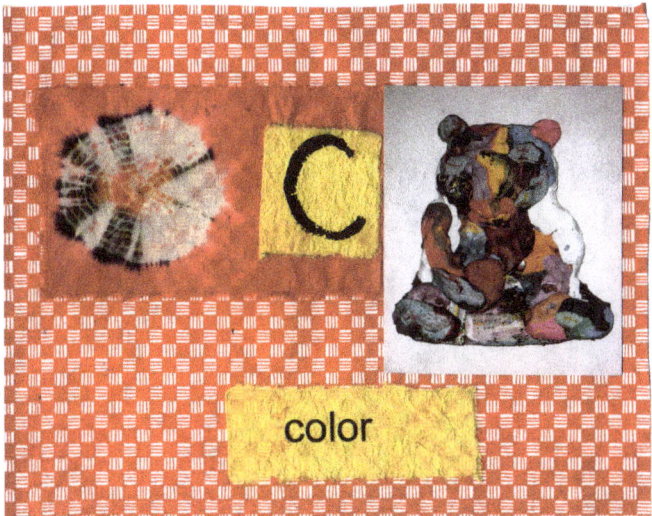

Figure 6.18. Eve Kosofsky Sedgwick, 'C: Color', *Panda Alphabet Valentines*, c. 1996. Collection H.A. Sedgwick, © H.A. Sedgwick.

Sedgwick's juxtaposition of pandas with statues is part of a larger subset of cards concerned with the parallel figuration of pandas with other, differently anthropomorphic forms, as if reminding her viewers and herself, in the midst of her unwilled bodily transformation, that there are many ways to be embodied. In Energy, spectators find no obvious panda at all (see Figure 6.24).

There is a wooden brown bear, marching confidently with two artist's dummies, the one on the left made of wood and unmarked, the one on the right of porcelain, its skin and chakras marked with red paint. In the sequence of the cards, *Energy* signals its energetic and energising qualities in a number of ways. The figures move from being seated, in the previous cards, to walking. The elements of the text, letter, and photo shift from a horizontal, weft orientation, in the previous cards, to a falling or rising diagonal one, whilst the Korean letters stream down verti-

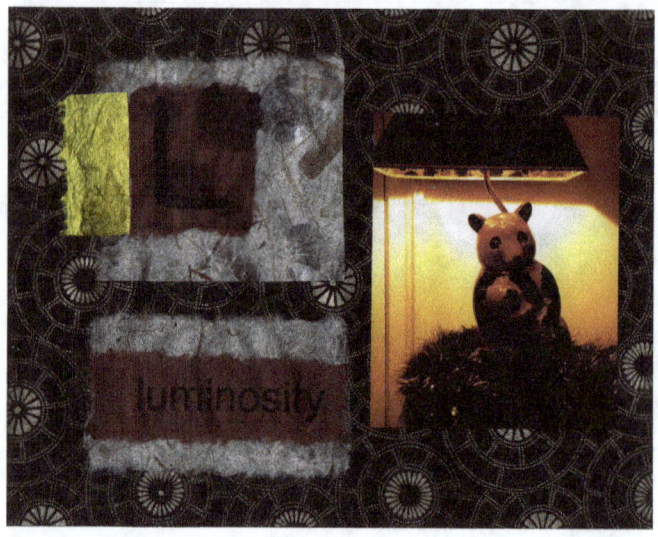

Figure 6.19. Eve Kosofsky Sedgwick, 'L: Luminosity', *Panda Alphabet Valentines,* c. 1996. Collection H.A. Sedgwick, © H.A. Sedgwick.

cally like code on a computer screen. Whilst each of the figures marches forward in a line, their left arms and legs swinging forwards, the brown bear in the middle looks to the sky, anxiously, as he tries to blend in. Viewers needn't ask, his brown body tells us: one of these things is not like the others, although all three are, in their own ways, not quite the same.

The right-hand figure from *Energy* returns in *Goodies,* seated comfortably on the lap of a larger soft-toy panda, as if part of its queer, cross-figural, cross-generational family snapshot or friendship circle, with the card's elements organised in a more stable, horizontal fashion (see Figure 6.25).

Here, the juxtaposition of the two figures evokes a textural difference, of cool ceramic skin against warm panda fur. The larger panda might be awake or asleep, but, as in many of the images, it is hard to tell because its pupils are lost in the black

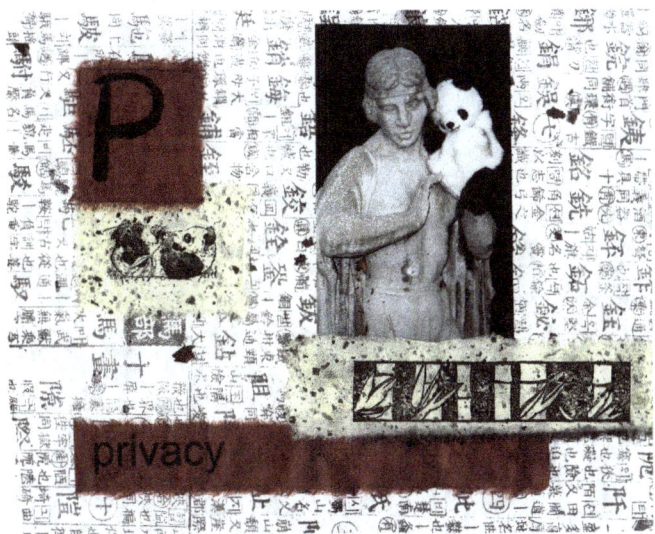

Figure 6.20. Eve Kosofsky Sedgwick, 'P: Privacy', *Panda Alphabet Valentines,* c. 1996. Collection H.A. Sedgwick, © H.A. Sedgwick.

patches around its perhaps lesbian, Dusty Springfield, panda eyes, a singer Sedgwick admired.

The juxtaposition of pandas with a broken human skeleton in Healing, and of the living and the dead represents the most painful card (see Figure 6.26).

Here, the context of potential healing, signalled by the title and body-scan of Sedgwick's figure in the background, which she also employed in her 1999 exhibition *Floating Columns,* is undercut by the presence of the skeleton. Its head, resting on the panda's left leg, is no longer attached to its spine, its left foot detached from its ankle. As such, it offers a powerful evocation of the simultaneous dissolution of Sedgwick's spinal column, resulting in her needing to wear a neck brace, and having sustained pins and needles in her feet. The skeleton is regarded sadly by the larger panda on the right, who has, on its lap, a smaller baby panda wearing a t-shirt from the Mount Sinai Beth Israel

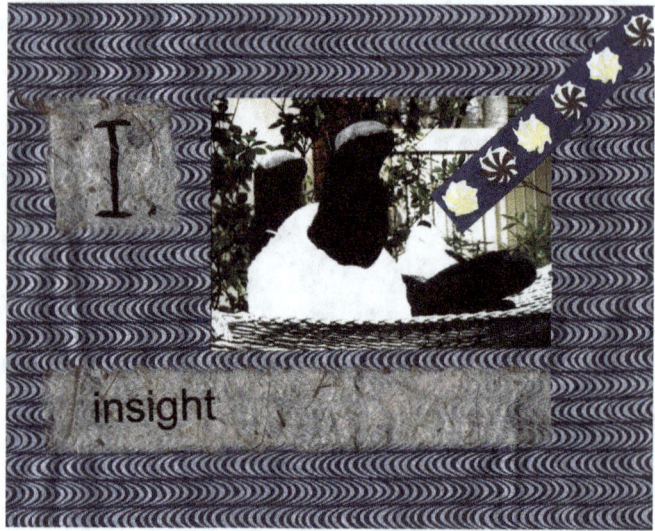

Figure 6.21. Eve Kosofsky Sedgwick, 'I: Insight', *Panda Alphabet Valentines*, c. 1996. Collection H.A. Sedgwick, © H.A. Sedgwick.

Comprehensive Cancer Centre, whose West 15th Street Campus was located a block south of Sedgwick's then apartment, and the place where she received much of her treatment.

If *Healing* evokes what Sedgwick characterized as the pandas' 'very endangered bodies', she evokes a happier, human-panda juxtaposition on *Transport* (see Figure 6.27).

Here, a large-scale, soft-toy panda sits, smiling, contented not to be in the driver's seat, but in the middle ranges of agency on the passenger side of a car outside Sedgwick's former Durham, North Carolina apartment, as if the partner or travelling companion of the man on the left. The butterfly on the right, meanwhile, suggests that, whilst some bodies, such as Sedgwick's, underwent painful, unsought, metastatic metamorphoses, the trajectory, at least in the case from caterpillar to butterfly, need not necessarily be from bad to worse, from mobile to immobile, or from beautiful to ugly — a kind of metamorphosis that would

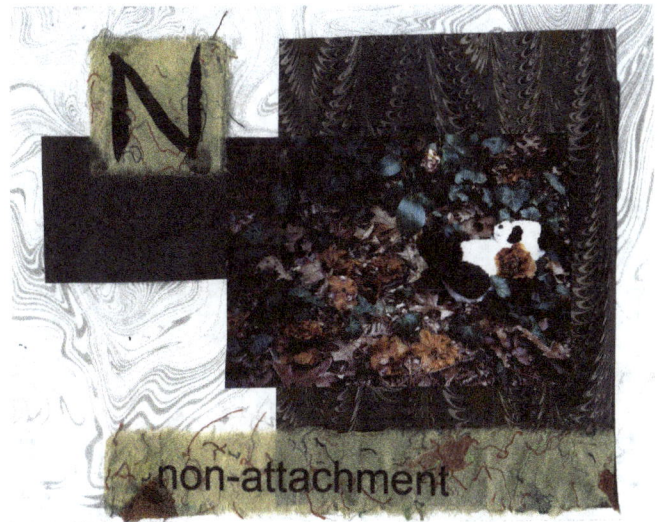

Figure 6.22. Eve Kosofsky Sedgwick, 'N: Non-attachment', *Panda Alphabet Valentines,* c. 1996. Collection H.A. Sedgwick, © H.A. Sedgwick.

again prove central to Sedgwick's thinking in her *Floating Columns* exhibition.[51]

The adjacent *Unexpected*, meanwhile, juxtaposes two creatures in a second, differently encouraging tableau of a couple (see Figure 6.28).

Here, against two tessellating patterns, alternating blue and yellow flowers above, and a wave-like pattern below, Sedgwick places, on the left, a panda dressed in a blue bear's suit, and, on the right, a monkey dressed in a panda's suit. Recalling Emmie's imagined zoo scene in 'Pandas in Trees', in which the Chinese

[51] For related meditations, see Eva Hayward, 'Lessons from a Starfish', in *The Transgender Studies Reader 2*, eds. Susan Stryker and Aren Z. Aizura (London: Routledge, 2013), 178–88, and 'More Lessons from a Starfish: Prefixial Flesh and Transspeciated Selves', *Women's Studies Quarterly* 36, no. 4 (Fall–Winter 2008): 64–84.

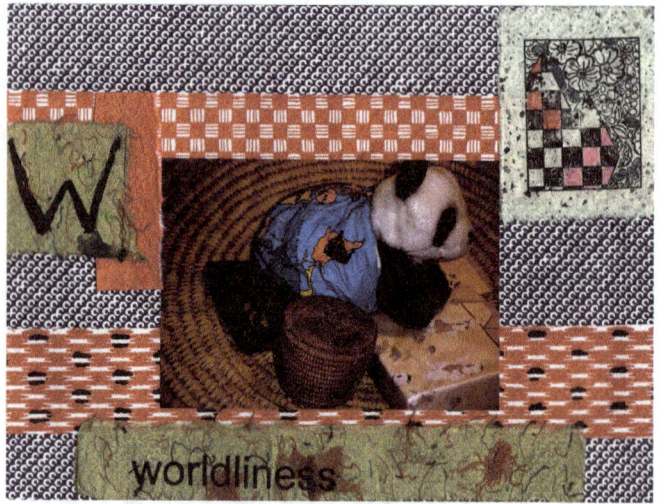

Figure 6.23. Eve Kosofsky Sedgwick, 'W: Worldliness', *Panda Alphabet Valentines,* c. 1996. Collection H.A. Sedgwick, © H.A. Sedgwick.

spies, in blue Yei-Sen Mao suits, unzipped themselves from their panda costumes, the image also evokes a number of sexual fetishes. The first is bears, given the presence of two pandas, and the love of the rounded, hairy, and furry across the sequence, suggesting if Sedgwick were a gay man, she would have been a bear or bear lover. Furries also come into focus. These are individuals, as we have seen, who like to dress up as soft toys. Although unlike the superficially *performative,* cross-species dynamics of furries, the card suggests the deep logic of furries is a *trans* one in which participants make their inside and outside forms align.[52] As a complex coming out scene, *Unexpected* also recalls

52 For contrasting *locus classici* of trans embodiment, see Judith Butler, *Bodies That Matter: On the Discursive Limits of 'Sex'* (Oxford: Routledge, 1993) and Jay Prosser, *Second Skins: The Body Narratives of Transsexuality* (New York: Columbia University Press, 1998). For Butler's reflections on Sedgwick, see 'Capacity', in *Regarding Sedgwick: Essays on Queer Culture*

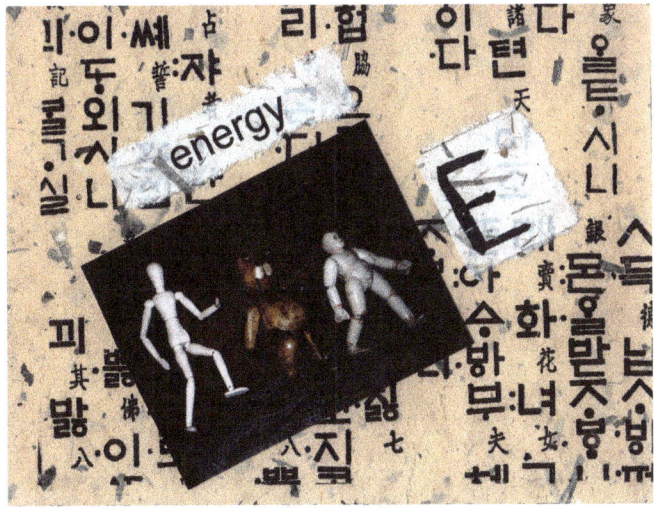

Figure 6.24. Eve Kosofsky Sedgwick, 'E: Energy', *Panda Alphabet Valentines*, c. 1996. Collection H.A. Sedgwick, © H.A. Sedgwick.

the cover of *Epistemology*. Here, the two-person scene suggests an inversion model of homosexuality, in which opposites might either attract or repel. In the scene, the blue bear, with its expansive, welcoming, open arms, comes out as a panda; whilst, in a poignantly mis-aligned moment, a panda comes out as, or, given its anxious face, is revealed to be a monkey, who looks up at spectators for their approval, and encourages them to read the left-hand panda as stepping back in surprised amazement.

and Critical Theory, eds. Stephen Barber and David L. Clark (London: Routledge, 2002), 109–20, and 'Proust at the End', in *Reading Sedgwick,* ed. Lauren Berlant (Durham: Duke University Press, 2011), 63–71.

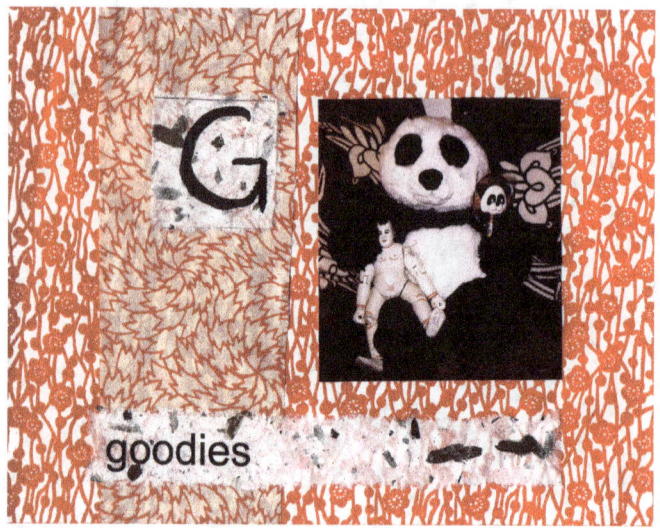

Figure 6.25. Eve Kosofsky Sedgwick, 'G: Goodies', *Panda Alphabet Valentines,* c. 1996. Collection H.A. Sedgwick, © H.A. Sedgwick.

N>2 but <infinity? Practicing Non-Binary Thinking

Focussing on the individual anthropomorphic, figurative, or *animalier* elements of the cards, however, only gets spectators part way to understanding them as a sequence and group. Sedgwick organises each card into a sequential, alphabetical narrative, and each valentine contains not only a concept and an image of one or more pandas, but photographs of various pieces of kimono silk, some of which appear on more than one card, to which viewers also need to attend. Taken alphabetically, the sequence begins, appropriately enough, given Sedgwick's new craft ambitions, with *Art*. Aesthetic questions and possibilities are followed by the need to draw *Breath*, perhaps for literal inspiration or just for pause, but, in either case, with the floral pattern Sedgwick employs suggesting that breath will smell of

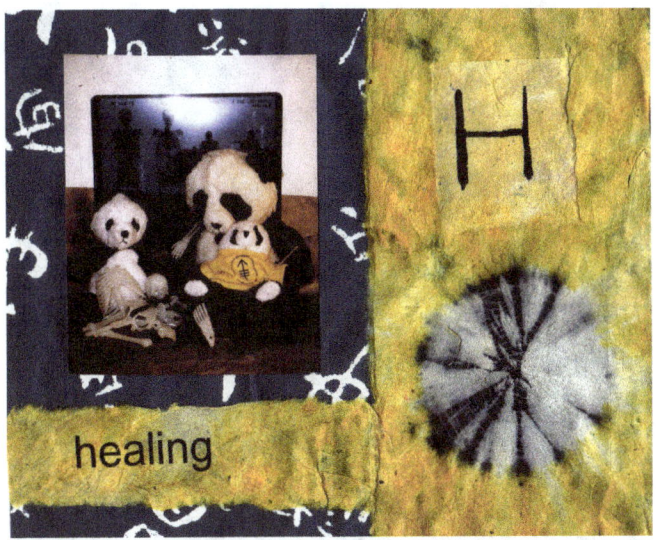

Figure 6.26. Eve Kosofsky Sedgwick, 'H: Healing', *Panda Alphabet Valentines,* c. 1996. Collection H.A. Sedgwick, © H.A. Sedgwick.

something rewarding, or be hay fever-inducing, depending on a given person's sensorium, rather than just neutral.[53]

Sedgwick's next thought is of *Color,* suggesting how important it will be for spectators to return to the kimono fabric backgrounds, especially since the depicted rainbow-colored panda is made of multi-colored clay. Next viewers move to *Divination,* emphasizing the centrality of chance to the cards, and the close connection between the emergence of Sedgwick's craft practice and her growing interest in Taoism.[54] Energy is obviously re-

53 For more on breathing, see Sedgwick, *The Weather in Proust,* 11–13.
54 Sedgwick's interest in Taoism dated back to at least 'The Warm Decembers', whose Chapter Six ends, 'I Ching says,' about *The Warm Decembers,* 'Peace. / The mean decline, the great and good approach. / Good fortune and success' (*Fat Art, Thin Art,* 138). In *The Weather in Proust,* Sedgwick later described how suminagashi 'play[ed] on the immemorial Taoist and Zen fascination with the potent but unwilled

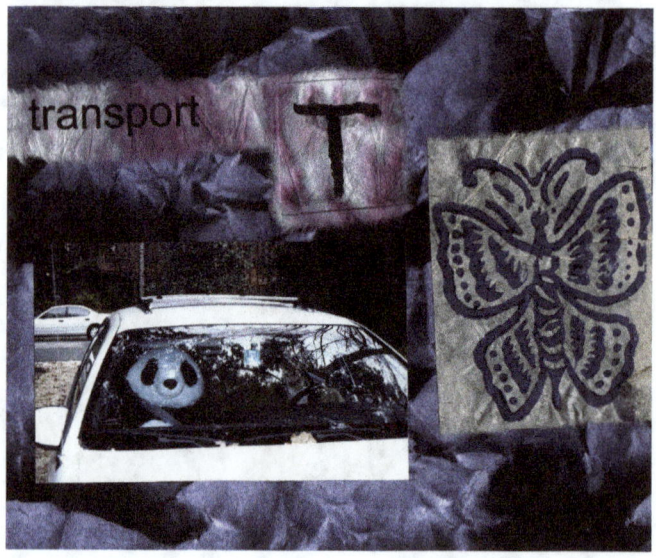

Figure 6.27. Eve Kosofsky Sedgwick, 'T: Transport', *Panda Alphabet Valentines,* c. 1996. Collection H.A. Sedgwick, © H.A. Sedgwick.

quired at this point to make the project work and keep it going. The *Valentines* themselves, meanwhile, featured a close friend, in the case of *Transport,* and were inspired by, and distributed to other *Friends and Fans*.

And here it is worth pausing to note that, in spite of the frequent, apparent cross-gender and cross-generational groupings, signalled by differences in scale and degrees of possible masculinity and femininity of the panda populations, 'F' is not for family. In avoiding the F word, the cards chime with the 'Tales of the Avunculate' essay in its Michael-Lynch-inspired belief that

behaviors of water' (83–84). For more on Taoism, see Stephen Bachelor, trans., *Tao Te Ching* (1988; San Francisco: Harper, 1992); Thomas Cleary, *The Essential Tao* (1991; San Francisco: Harper, 1993); and Stephen Mitchell, *Tao Te Ching: A New English Version* (New York: Harper, 1988).

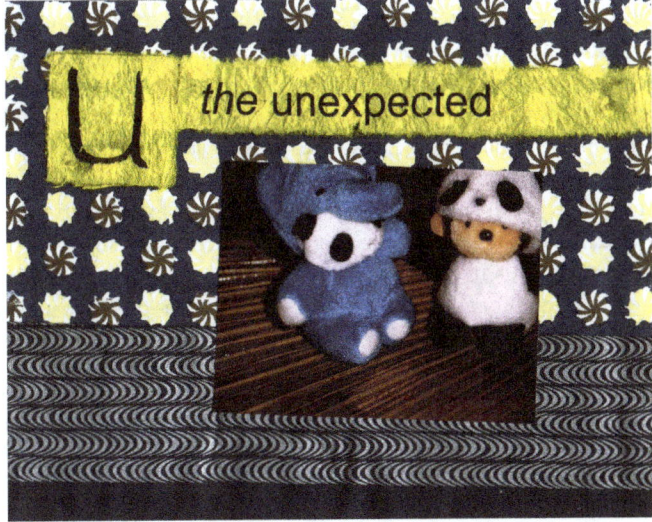

Figure 6.28. Eve Kosofsky Sedgwick, 'U: Unexpected', *Panda Alphabet Valentines,* c. 1996. Collection H.A. Sedgwick, © H.A. Sedgwick.

'family' was a 'dangerous word' for queer theory, and that, as opposed to queer people aspiring to the heterosexist 'idea of the gay family', it would be better if straight families saw themselves 'in terms of friends'.[55]

Goodies are then required to enable this fat art project to flourish further, and sufficient *Healing* to enable it to be pre-posthumously completed. At around the halfway point, suddenly *Insight* occurs, a novel idea that viewers know is right because it leads to *Joy.* Indeed, as Sedgwick noted, in *Dialogue,* when

> the truth comes to you,
> you recognise it because
> it makes you happy.[56]

55 Sedgwick, *Tendencies,* 71–72.
56 Sedgwick, *Dialogue,* 207.

This is obviously the cue for *Kissing*. Then, the sequence takes a more Buddhist turn. A new *Luminosity* dawns, that leads to a novel, and rhyming, sense of *Mystery*. The passion of *Kissing*, itself in the absence of holding in the image, gives way to *Non-Attachment,* and, paradoxically, to self-*Ornament*. A perhaps monastic *Privacy* then leads to further *Questioning*, which, in turn, like joyful insight, brings a state not of exhaustion, but *Refreshment* and a sense of *Sweetness*. The resulting sugar-high *Transport* leads to a surprising sense of the *Unexpected,* and a new relationality akin first to the perhaps hetero- or homo-normative couple logic of *Valentines* and, beyond that, since they were widely distributed, to a greater, queerer sense of *Worldliness* and *Xenophilia*.[57] Penultimately, spectators are invited into a more body-centred practice of *Yoga* — or, in Sedgwick's case in the mid-1990s, tai chi, as we saw in Chapter Four — producing a new *Zest* for life, and perhaps, for the entire samsaric sequence to recommence.

If the alphabet represents the most obvious way to sequence the narrative, however, the cards are not as bound into that sequence as they would be if they were glued in turn along the spine of a book. Lacking a centrally organising spinal column, the cards can be read in other, more random and chance-based ways, or following the different chromatic and textural, rather than alphabetical, cues Sedgwick offers. For example, viewers could group subsets of the cards by color. They might cluster, as predominantly golden brown cards, Art and the background of *Breath*; as black cards *Breath, Luminosity,* and *Mystery*; as red-and-white cards *Color, Goodies, Joy, Kissing, Ornament, Valentines,* and *Worldliness*; as green-gold cards *Divination, Questioning,* and *Zest*; as white cards, *Non-Attachment* and *Privacy*; as purple cards, *Questioning, Xenophilia,* and *Yoga*; as yellow cards *Color, Healing, Joy,* and *The Unexpected*; and, finally, as blue

57 For more on the queer issues around the provincial, urbane, worldly, and man of the world, see Eve Kosofsky Sedgwick, *Between Men: English Literature and Male Homosocial Desire* (New York: Columbia University Press, 1985), xix, and *Epistemology of the Closet* (Los Angeles: University of California Press, 1990), 97–100.

cards, perhaps the most numerous category given Sedgwick's love of the blue spectrum: *Friends and Fans, Healing, Insight, Refreshment, Sweetness, Transport, The Unexpected,* and *Worldliness*. By contrast, tangerine cards are the least popular, with just *Energy* as an example, but it is a colour that we last encountered on the cover of *Epistemology,* as the one on which Sedgwick's name was printed, and as the background hue for Sedgwick's collage, 'Eternity's White Flag', reprinted in monochrome in *Tendencies*.[58]

Spectators might also note the ways in which Sedgwick sometimes employs the same fabric on more than one card. *Goodies* and *Joy* employ a ragged, swirling, tessellating leaf pattern. *Goodies* and *Valentines* share a trellised, floral pattern; whilst *Worldliness* combines the checkerboard pattern of *Kissing* and *Color. Insight* and *The Unexpected* share the same alternating, vertical wave pattern, while *Sweetness* shares the fan pattern of *Friends and Fans,* which features a fan in the main panda image as well as its pattern. *Divination* and *Questioning* also share the same tessellating diamond pattern.

Further groupings are also possible. Both *Energy* and *Privacy* feature Asian, as well as European, scripts, with *Energy* employing ancient Hangul characters from a Korean dictionary, mixed with Chinese characters; and *Privacy* Chinese characters, which require to be rotated ninety degrees to the left to be read. Both were likely derived from translation dictionaries, suggesting that the *Valentines* seek to evoke the experience of learning to read from flash cards, and, in so doing, offering a powerful, queer counter-example of how to bring up your kids panda or gay, as well as bilingual, given the refusal of family values and

[58] There may be a complex relationship between the play of iconography and sequence of color in the cards and Buddhist prayer flags, which were hung in the traditional left-to-right order of blue (symbolizing the sky and space), white (representing the air and wind), red (alluding to fire), green (representing water), and yellow (evoking the earth).

repeated insistence on queer, cross-generational, cross-cultural, and cross-species desires across the sequence.[59]

Amongst the various kimono patterns Sedgwick selects, she has a particular fondness for four kinds of effect. Firstly, those created by *shibori,* or tie-dye, and, perhaps unsurprisingly, *suminagashi*. We find the former in the cell-like forms to the immediate left of the letter in *Color* and below the letter H in *Healing,* the latter forming the main background of *Mystery* and *Non-Attachment*. She is fond of more cybernetic, *Gestalt*-friendly binary tessellating or alternating patterns, in the cases of *Color, Divination, Friends and Fans, Insight, Kissing, Ornament, Questioning, Sweetness, Worldliness,* and *The Unexpected* (which repeats in a different color the same pattern from *Ornament*). Sedgwick also employs a range of more representational floral patterns, with the flowers often seeming to fall through the air, grow up a trellis, or float on water, in the cases of *Breath, Goodies, Luminosity, Ornament, Questioning, Refreshment, The Unexpected, Valentines, Xenophilia,* and *Zest*. And finally, she fashions a number of cards where there is not so much a layered, two-dimensional pattern, as a fatter art depiction of three-dimensional crumpled and puckered texture, as in the cases of *Art, Mystery, Transport,* and *Yoga,* which spectators last encountered on the covers of *Fat Art* and *Touching Feeling*.

In each of these groupings, alphabetic, chromatic, pattern-formal, and textural, as well as in her mix of paper, fabric, photograph, soft toy, sculpture, doll, skeleton and human, Sedgwick offered viewers practice in the conceptual range she and Adam J. Frank had promoted, a year earlier, in 'Shame in the Cybernetic Fold', which is to say, in 'the many-valuedness' of an 'analogical' system which 'refers to *more than two* but also to *finitely many* values or dimensions', rather than the digital system, such as the monochrome black/white contrast of the panda's coloring.[60]

[59] I am grateful to Jiyi Ryu for helping me to think through Sedgwick's Asian scripts.

[60] Eve Kosofsky Sedgwick, *Touching Feeling: Affect, Pedagogy, Performativity* (Durham: Duke University Press, 2003), 108.

As well as being resources for practicing non-dualistic, analogic thinking, Sedgwick's *Valentines* reveal her increasingly worldly and xenophilic interest in East Asian art and philosophy, and a childlike practice exploring the soppy, sloppy, chancy, and abundantly sweet. The calendars, cards, and other craft projects Sedgwick made involving pandas, were, and are, a source of refreshment and sublime transport, luminosity and insight. Finally, the fat art of the pandas' queer, sedentary, solitary, endlessly gustatory lifestyles represented a kind of indolent, far-from-strenuous spiritual and physical anti-yoga practice for Sedgwick, as well as a key source of comfort and healing for an artist whose body was also, increasingly, fatally endangered, as she approached, albeit indolently, her last days.

7

Sodomizing Edward Bulwer Lytton, Or, *The Last Days of Pompeii*

for Monica Pearl and Simon Watney

So far, *Queer and Bookish* has focused primarily on the visual, textural, and material characteristics of the monographs, poetry books, and edited collections Sedgwick published in her lifetime, paying attention to their cover images, typography, and design, and internal discussions of art and craft. Chapter Six, by contrast, explored a book-ish project of another sort, and in another sense, in that Sedgwick's panda *Valentines* only approximated to a book, and a spine-less one at that. This final chapter takes, as its object, a different kind of book again: a unique artist's book by Sedgwick, an abridged copy of Edward Bulwer-Lytton's *The Last Days of Pompeii* (1834), with illustrations by Harold T. King and annotations by Robin Wright, first published in 1976.[1]

[1] Edward Bulwer-Lytton, *The Last Days of Pompeii* (1834; London: Marshall Cavendish, 1976). Quotations from this version of the text will appear as MC. Quotations from the unabridged version, *The Last Days of Pompeii* (1834; London: Dent, 1962) will appear as LD. For more on the 'materialities of the production and diffusion' of the novel, and its 'adaptions and spin-offs', see James C. Simmons, 'Bulwer and Vesuvius: The Topicality

Sedgwick probably produced her version of the book in the period around 2007, when she was formulating her late 'Cavafy, Proust, and the Queer Little Gods' essay, posthumously published in *The Weather in Proust* (2011), since there is significant overlap between her artist's book and essay, her most significant intervention being the addition of 22 lyrics by early-twentieth-century, queer, Greek language poet Constantin Cavafy.[2] But the book may have been in her mind from as early as 2001, when she visited a series of Hellenistic ruins along the coast of Turkey.

Sedgwick's artist's book explored, in a parallel visual idiom, what her Cavafy essay described as his interest in the 'relations of selection and quotation', the 'intimate spatiality of the shrine', and the aesthetics of 'a little house within a house', 'one oriented towards its missing fourth wall, like a doll-house', 'diorama', 'hearth, or puppet theatre'.[3] The parallels between the essay and book are particularly close in the seven moments when the two employ common excerpts, as in the cases of 'Going Back to Greece', 'Anna Dalassini', 'The Souls of Old Men', 'Kleitos' Illness', 'The God Abandons Anthony', 'Trojans' and 'The Footsteps'. In addition, the collage book includes lines from 'The First Step', 'The House of Achilles', 'Chandelier', 'Sculptor of Tyana', 'The

of The Last Days of Pompeii', *Nineteenth-Century Fiction* 24, no. 1 (June 1969): 360–89; 360.

2 Eve Kosofsky Sedgwick, *The Weather in Proust* (Durham: Duke University Press, 2011), 42–68. Whilst Sedgwick brings Cavafy into intertextual relation with Lytton, Cavafy's tastes extended across the English canon. As John P. Anton has noted, the youthful Cavafy, who lived in England between 1872 and 1879, had a 'strong taste' for English fiction and poetry, made a 'careful study' of John Ruskin, translated into Greek Alfred Lord Tennyson's 'Ulysses' (1833), and had a 'deep interest in the British novel', especially the writings of Thomas Hardy, George Gissing, James Thomson, and Samuel Butler. Anton singles out, as especially important, the work of Edward Gibbon, Thomas Macauley, John Keats, Matthew Arnold, and Robert Browning (*The Poetry and Poetics of Constantine P. Cavafy: Aesthetic Visions of Sensual Beauty* [Chur: Harwood Academic Press, 1995], 27, 32, 78, 99, 103, 106, 108, 166, 168, 204). For more on Cavafy's intertextuality, see Gregory Jusdanis, *The Poetics of Cavafy: Textuality, Eroticism, History* (Princeton: Princeton University Press, 1987).

3 Sedgwick, *The Weather in Proust*, 44, 66.

City', 'Since Nine O'clock', 'Kasiarion', 'The Favor of Alexander Valas', 'For the Shop', 'Dareois', 'Ionic', 'In the Evening', and 'Hidden'. At the same time, the essay contains discussions of 'He Had Come There To Be Read', 'Come to Rest', 'To Call Up the Shades', 'Walls', 'Growing in Spirit', 'Myris: Alexandria, AD 340', and 'Prayer'.[4]

The cut-and-paste, Victorian scrapbook aesthetic Sedgwick employed for her *Last Days* had long preoccupied her. In her long narrative poem 'The Warm Decembers' (1978–1987), she had described herself sitting in a car, in her mid-twenties, a notebook open, 'its loose-leaves spread' on her lap, and whose pages revealed a c. 1952 snapshot of the youthful Kosofsky sisters with their kitten, Buttons, along with 'a patchwork of stickers, postcards, clippings [an / inquisitive plaster dog, in armour; Trollope; / a freckled sow with piglets; and so forth]'.[5] The notebook anticipates The *Last Days* in a number of ways. Sedgwick employs, as we shall see, postcards of Duncan Grant's c. 1925 painting *Madonna and Child with Musician Angel* on page 23; the famous antique statue, the *Doryphoros* (c.450–440 BCE), on page 53;[6] and of Cary Grant, in a scene taken from Alfred Hitchcock's *North by Northwest* (1959) on the first title page and page 73.[7] The plaster dog, meanwhile, finds its poignant parallel on page 97, in the form of a plaster cast formed from the space left by a dog's decayed body, in the ash that covered the ancient city,

4 In adding these Cavafy lyrics to the edition, Sedgwick builds on the way in which Lytton, according to Simmons, sought to 'bulk up the text' with 'many songs and ballads' largely incidental to the plot ('Bulwer and Vesuvius', 372). Mindful of Sedgwick's interest in fat art, we shall return to this question of the novel's 'bulk'. Sedgwick's artist book also supports Simmons's claim that *The Last Days* 'cannot be adequately understood if it is regarded solely as an autonomous work of literature' (379).

5 Eve Kosofsky Sedgwick, *Fat Art, Thin Art* (Durham: Duke University Press, 1994), 112.

6 I am grateful to Simon Spier for helping me to identify Grant's image, and to Jeanne Nuechterlein for, coincidentally, sending me the same Doryphoros postcard Sedgwick employs.

7 For more, see James Naremore, *North by Northwest: Alfred Hitchcock, Director* (Rutgers: Rutgers University Press, 1993).

as well as in the illustration, on page 20, of the famous 'Cave Canem' ('Beware of the Dog') mosaic unearthed at Pompeii (see Figures 7.1 & 7.2).[8]

The *Last Days* also bears an uncanny relationship to a dream Sedgwick recalled in her 1999 memoir *A Dialogue on Love,* as filtered through the SMALL CAPITALS of her therapist Shannon Van Wey's notes. The dream contained another of her notebooks, including 'POEMS, LISTS, DRAWINGS, INCLUDING S/M MATERIAL' that somehow ended up in the hands of a 'GROUP PUTTING TOGETHER AN AVANT-GARDE SHOW', who 'CUT IT UP AND REASSEMBLED IT ALONG WITH ADDED MATERIALS INTO AN EXHIBIT PIECE'. 'INSIDE THE BACK COVER' was a 'POCKET WITH LITTLE OBJECTS, FIGURES, STICKERS', of the kind we find across The *Last Days,* for example on page 11, on the first insert between pages 18 and 19, on the insert between pages 34 and 35, and on page 59 (see Figure 7.3).

In the dream, Sedgwick was 'IMPRESSED WITH THE ART PIECE AS A PIECE', which she found 'COMPELLING, MAGNETIC, INTERESTING', but felt abashed at her 'SEXUAL STUFF DISPLAYED'.[9] In her artist's book, by contrast, she was keen to include a raft of queer sexual material to challenge Lytton's staunchly heteronormative account of Pompeian antiquity, and to think back upon the American AIDS crisis that had so preoccupied her in the period from around 1985 to 1996 that we discussed frequently

8 Illustrations of the plaster cast figures from Pompeii, which first appeared in 1863, also appear on pages 96 and 100. For more on these, see Shelley Hales, ed., *Pompeii in the Public Imagination from Its Rediscovery to Today* (Oxford: Oxford University Press, 2011), 97, 156–64. I am grateful to Melissa Gustin for insightful conversations about these.

9 Eve Kosofsky Sedgwick, *A Dialogue on Love* (Boston: Beacon, 1999), 196.

throughout this book.¹⁰ In short, and as my title suggests, Sedgwick wanted to sodomize the straight Lytton.¹¹

Between Men and Women: Erotic Triangulation and Homosocial Desire in *The Last Days of Pompeii*

First published in hardback in 1834, before appearing in paperback in 1879, Edward Bulwer-Lytton's The *Last Days* of Pompeii was hugely influential on the development of historical fiction and one of the most popular novels in the nineteenth century, particularly after coming out of copyright in 1880. First appearing in an abridged edition in 1900, Lytton's novel exemplifies Sedgwick's influential argument, in *Between Men: English Literature and Male Homosocial Desire* (1985), that erotic triangles, and male homosociality and homophobia, form the warp and weft of the nineteenth-century novel.¹²

The book tells the story of a heterosexual, Greek-diasporic couple, Glaucus and Ione, and their blind servant, Nydia, who

10 In so doing, the book engages with what Hales and Paul describe as the 'ongoing difficulties of grappling with the erotic material' from Pompeii, and their suggestion that the 'question of how the revivification of Pompeii is achieved is far from straightforward' (*Pompeii in the Public Imagination*, 2, 9).

11 For more on the meanings of sodomy, see Jonathan Goldberg, *Reclaiming Sodom* (New York: Routledge, 1994) and Jonathan Goldberg, ed., *Sodometries: Renaissance Texts, Modern Sexualities* (Stanford: Stanford University Press, 1992). For Goldberg's reflections on Sedgwick, see 'Editor's Introduction', *The Weather in Proust*, xiii–xvi; 'On the Eve of the Future', *Criticism: A Quarterly for Literature and the Arts* 52, no. 2 (Spring 2010): 283–92; and 'On the Eve of the Future', PMLA 125, no. 2 (March 2010), 374–77; 'Eve's Future Figures', in *Reading Sedgwick*, ed. Lauren Berlant (Durham: Duke University Press, 2019), 121–31; and *Come As You Are: After Eve Kosofsky Sedgwick* (Earth: punctum books, 2021), 19–83. Goldberg's 'Strange Brothers' also appears in Sedgwick's *Novel Gazing: Queer Readings in Fiction* (Durham: Duke University Press, 1997), 465–82.

12 For more on Sedgwick's triangles, see Robyn Wiegman, 'Eve's Triangles: Queer Studies Beside Itself', in *Reading Sedgwick*, ed. Berlant, 242–73. For Wiegman's relation to Sedgwick, see her 'Eve, At a Distance', *Trans-Scripts* 2 (2012): 157–75, and 'The Times We're In: Feminist Criticism and the Reparative "Turn"', *Feminist Theory* 15, no. 1 (2014): 4–25.

QUEER AND BOOKISH

'Holla!—help there—help!' cried a querulous and frightened voice. 'I have fallen down—my torch has gone out—my slaves have deserted me. I am Diomed—the rich Diomed;—ten thousand sesterces to him who helps me!'

At the same moment, Clodius felt himself caught by the feet. 'Ill fortune to thee,—let me go, fool,' said the gambler.

'Oh, help me up!—give me thy hand!'

'There—rise!'

'Is this Clodius? I know the voice! Whither fliest thou?'

'Towards Herculaneum.'

'Blessed be the gods! our way is the same, then, as far as the gate. Why not take refuge in my villa? Thou knowest the long range of subterranean cellars beneath the basement—that shelter, what shower can penetrate?'

'You speak well,' said Clodius musingly. 'And by storing the cellar with food, we can remain there even some days, should these wondrous storms endure so long.'

TERRACOTTA POT

The air was now still for a few minutes: the lamp from the gate streamed out far and clear; the fugitives hurried on—they gained the gate—they passed by the Roman sentry; the lightning flashed over his livid face and polished helmet, but his stern features were composed even in their awe! He remained erect and motionless at his post. That hour itself had not animated the machine of the ruthless majesty of Rome into the reasoning and self-acting man. There he stood, amidst the crashing elements: he had not received the permission to desert his station and escape.

They hurried on—they arrived at the house of Diomed—they laughed aloud as they crossed the threshold, for they deemed the danger over.

Diomed ordered his slaves to carry down into the subterranean gallery, before described, a profusion of food and oil for lights; and there Julia, Clodius, the greater part of the slaves, and some frightened visitors and clients of the neighbourhood, sought their shelter.

GLASS JUG

'Oh, blessed be he who invented gates to a city!' cried Diomed. 'See!—they have placed a light within yon arch: by that let us guide our steps.'

BRONZE POT

THE PROGRESS OF THE DESTRUCTION

The cloud, which had scattered so murkiness over the day, had now set a solid and impenetrable mass. It re less even the thickest gloom of a nigh open air than the close and blind dar some narrow room. But in proportio blackness gathered, did the lightnings Vesuvius increase their vivid and sc glare. Nor was their horrible beauty to the usual hues of fire; no rainbo rivalled their varying and prodigal dy brightly blue as the most azure dep southern sky—now of a livid and s green, darting restlessly to and fro folds of an enormous serpent—now o and intolerable crimson, gushing through the columns of smoke, far an and lighting up the whole city from arch,—then suddenly dying into— paleness, like the ghost of their own l

In the pauses of the showers, you h rumbling of the earth beneath, and th ing waves of the tortured sea; or, lo and audible but to the watch of fear, the grinding and hissing murmu escaping gases through the chasms distant mountain. Sometimes the appeared to break from its solid ma by the lightning, to assume quaint mimicries of human or of monster striding across the gloom, hurtling the other, and vanishing swiftly turbulent abyss of shade.

The ashes in many places were knee-deep; and the boiling showers came from the steaming breath of the forced their way into the houses, bea them a strong and suffocating va some places, immense fragments hurled upon the house roofs, bore du the streets masses of confused rui yet more and more, with every h structed the way; and, as the day a the motion of the earth was more felt—the footing seemed to slide nor could chariot or litter be kep even on the most level ground.

Sometimes the huger stones striking each other as they fell, broke into fragments, emitting sparks of fire caught whatever was combustible wit reach; and along the plains beyond the darkness was now terribly relie several houses, and even vineyards, set on flames; and at various inte fires rose suddenly and fiercely ag solid gloom. To add to this partial

Figure 7.1. Eve Kosofsky Sedgwick, *The Last Days of Pompeii/Cavafy collage book* (c. 2007), pp. 96–97. Photo: Kevin Ryan, Collection H.A. Sedgwick, © H.A. Sedgwick.

When he was gone, Arbaces, drawing his seat nearer to the fair Neapolitan's, said in those bland and subdued tones, in which he knew so well how to veil the mingled art and fierceness of his character,—

'Think not, my sweet pupil, if so I may call you, that I wish to shackle that liberty you adorn while you assume: but which, if not greater, as you rightly observe, than that possessed by the Roman women, must at least be accompanied by great circumspection, when arrogated by one unmarried. Continue to draw crowds of the gay, the brilliant, the wise themselves, to your feet but reflect, at least, on those censorious tongues which can so easily blight the tender reputation of a maiden; and while you provoke admiration, give, I beseech you, no victory to envy.'

'What mean you, Arbaces?' said Ione, in an alarmed and trembling voice: 'I know you are my friend, that you desire only my honour and my welfare. What is it you would say?'

'Your friend—ah, how sincerely! May I speak thee as a friend, without reserve and without offence?'

'I beseech you do so.'

'This young profligate, this Glaucus, how didst thou know him? Hast thou seen him often?' And as Arbaces spoke, he fixed his gaze steadfastly upon Ione, as if he sought to penetrate into her soul.

Recoiling before that gaze, with a strange fear which she could not explain, the Neapolitan answered with confusion and hesitation,—'He was brought to my house as a countryman of my father's, and I may say of nine. I have known him only within this last week or so: but why these questions?'

'Forgive me,' said Arbaces; 'I thought you might have known him longer. Base insinuator that he is!'

'How! what mean you? Why that term?'

'It matters not: let me not rouse your indignation against one who does not deserve so grave an honour.'

'I implore you speak. What has Glaucus insinuated? or rather, in what do you *suppose* he has offended?'

Smothering his resentment at the last part of Ione's question, Arbaces continued,—'You know his pursuits, his companions, his habits; the comissatio and the alea (the revel and the dice) make his occupation,—and amongst the associates of vice how can he dream of virtue?'

'Still you speak riddles. By the gods! I entreat you, say the worst at once.'

'Well, then, it must be so. Know, my Ione, that it was but yesterday that Glaucus boasted openly—yes, in the public baths—of your love to him. He said it amused him to take advantage of it. Nay, I will do him justice, he praised your beauty. Who could deny it? But he laughed scornfully when his Clodius, or his Lepidus, asked him if he loved you enough for marriage, and when he purposed to adorn his door-posts with flowers?'

'Impossible! How heard you this base slander?'

'Nay, would you have me relate to you all the comments of the insolent coxcombs with which the story has circled through the town? Be assured that I myself disbelieved at first, and that I have now painfully been convinced by several ear-witnesses of the truth of what I have reluctantly told thee.'

Ione sank back, and her face was whiter than the pillar against which she leaned for support.

Most cunningly had the Egyptian appealed to Ione's ruling foible—most dexterously had he applied the poisoned dart to her pride. He fancied he had arrested what he hoped, from the shortness of the time she had known Glaucus, was, at most, but an incipient fancy; and hastening to change the subject, he now led her to talk of her brother. Their conversation did not last long. He left her, resolved not again to trust so much to absence, but to visit—to watch her—every day.

No sooner had his shadow glided from her presence, than woman's pride—her sex's dissimulation—deserted his intended victim, and the haughty Ione burst into passionate tears.

A MINIATURE LIKENESS OF THE ROMAN BATHS

When Glaucus left Ione, he felt as if upon air. In the interview with which just been blessed, he had for the fi gathered from her distinctly that his not unwelcome to, and would not rewarded by, her. This hope filled hi rapture for which earth and heaven too narrow to afford a vent. Uncons the sudden enemy he had left behi forgetting not only his taunts but existence, Glaucus passed through streets, repeating to himself, in the ness of joy, the music of the soft air t Ione had listened with such intentne now he entered the Street of Fortu its raised footpath—its houses painte out, and the open doors admitting of the glowing frescoes within.

Sauntering through the crowd, soon found himself amidst a group merry and dissipated friends.

'What news from Rome?' said Lep he languidly joined the group.

'The emperor has been giving a s supper to the senators,' answered Sallu

'He is a good creature,' quoth L 'they say he never sends a man away granting his request.'

'Perhaps he would let me kill a slave reservoir of lampreys?' returned eagerly.

'Not unlikely,' said Glaucus; 'for grants a favour to one Roman, must al it at the expense of another. Be sure, every smile Titus has caused, a hundr have wept.'

'Long live Titus!' cried Pansa, over the emperor's name, as he swept pa ingly through the crowd; 'he has pr my brother a quæstorship, because run through his fortune.'

'Ah, Glaucus! how are you?' gay said Clodius, joining the group.

'Are you come to sacrifice to Fo said Sallust.

'I sacrifice to her every night,' retur gamester.

'I do not doubt it. No man has mad victims!'

'By Hercules, a biting speech!' Glaucus, laughing.

'The dog's letter is never out of your Sallust,' said Clodius, angrily: 'y always snarling.'

'I may well have the dog's letter mouth, since, whenever I play with

BEWARE OF THE DOG (FROM A MOSAIC)

CAVE CANEM

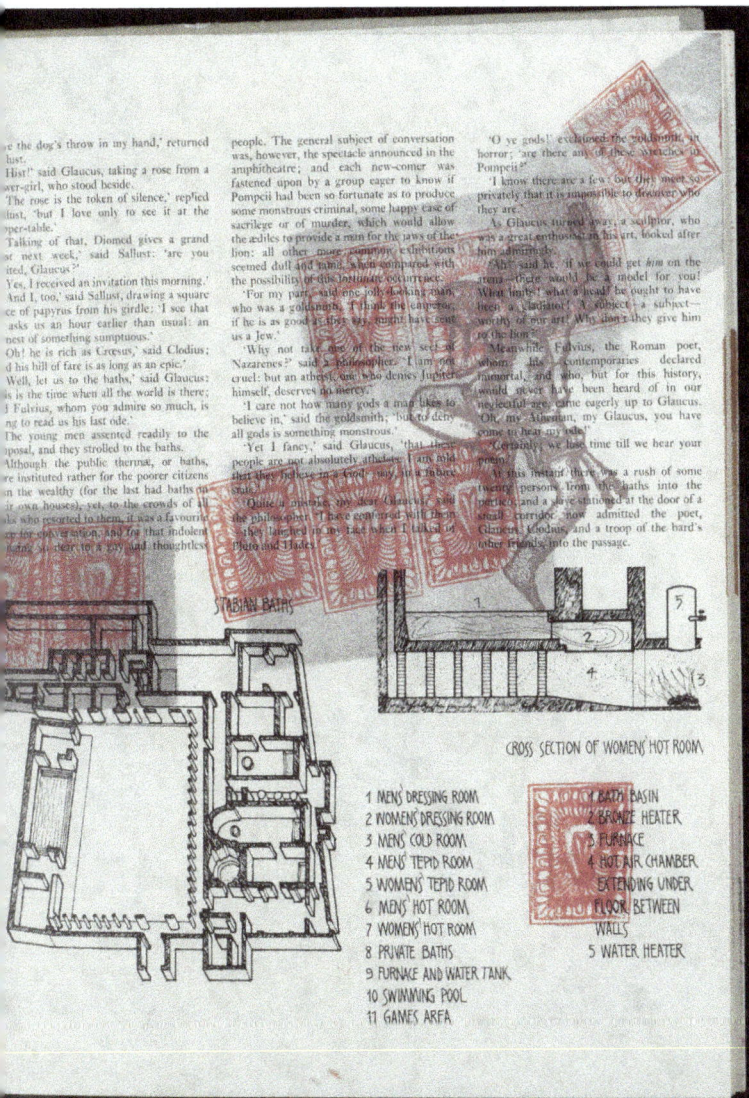

Figure 7.2. Eve Kosofsky Sedgwick, *The Last Days of Pompeii/Cavafy collage book* (c. 2007), pp. 20–21. Photo: Kevin Ryan, Collection H.A. Sedgwick, © H.A. Sedgwick.

THE BLIND FLOWER-GIRL

Talking lightly on a thousand matters, the two young men sauntered through the streets; they were now in that quarter which was filled with the gayest shops, their open interiors all and each radiant with the studyyet harmonious colours of frescoes, not perceivably varied in fancy and design. The sparkling fountains, that at every vista threw upwards their grateful spray in the summer air; the crowd of passengers, or rather loiterers, mostly clad in robes of the Tyrian dye; the gay groups collected round each more attractive shop; the slaves passing to and fro with buckets of bronze, cast in the most graceful shapes, and borne upon their heads; the country girls stationed at frequent intervals with baskets of blushing fruit and flowers more alluring to the ancient Italians than to their descendants; the numerous haunts which fulfilled with that idle people the office of cafés and clubs at this day; the shops, where on shelves of marble were ranged the vases of wine and oil, and before whose thresholds, seats, protected from the sun by a purple awning, invited the weary to rest and the indolent to lounge—made a scene of such glowing and vivacious excitement, as might well give the Athenian spirit of Glaucus an excuse for its susceptibility to joy.

'Talk to me no more of Rome,' said he to Clodius. 'Pleasure is too stately and ponderous in those mighty walls: even in the precincts of the court—even in the Golden House of Nero, and the incipient glories of the palace of Titus, there is a certain dulness of magnificence—the gay aches—the spirit is wearied; besides, my Clodius, we are discontented when we compare the enormous luxury and wealth of others with the mediocrity of our own state.'

'It was from that feeling that you chose your summer retreat at Pompeii?'

'It was. I prefer it to Baiæ: I grant the charms of the latter, but I love not the pedants who resort there, and who seem to weigh out their pleasures by the drachm.'

'Yet you are fond of the learned, too; and as for poetry, why your house is literally eloquent with Æschylus and Homer, the epic and the drama.'

Thus conversing, their steps were arrested by a crowd gathered round an open space where three streets met; and, just where the porticoes of a light and graceful temple threw their shade, there stood a young girl, with a flower-basket on her right arm, and a small three-stringed instrument of music in the left hand, to whose low and soft tones she was

10

modulating a wild and half-barbaric air. At every pause in the music she gracefully waved her flower-basket round, inviting the loiterers to buy; and many a sesterce was showered into the basket, either in compliment to the music or in compassion to the songstress—for she was blind.

'I must have yon bunch of violets, sweet Nydia,' said Glaucus, pressing through the crowd, and dropping a handful of small coins into the basket; 'your voice is more charming than ever.'

The blind girl started forward as she heard the Athenian's voice; then as suddenly paused, while the blood rushed violently over neck, cheek, and temples.

'So you are returned!' said she, in a low voice; and then repeated half to herself, 'Glaucus is returned!'

'Yes, child; I have not been at Pompeii above a few days. My garden wants your care, as before; you will visit it, I trust, to-morrow. And mind, no garlands at my house shall be woven by any hands but those of the pretty Nydia.'

Nydia smiled joyously, but did not answer; and Glaucus, placing in his breast the violets he had selected, turned gaily and carelessly from the crowd.

'So she is a sort of client of yours, this child?' said Clodius.

'Ay—does she not sing prettily? She interests me, the poor slave! Besides, she is from the land of the Gods' hill—Olympus frowned upon her cradle—she is of Thessaly.'

'The witches' country.'

'True: but for my part I find every woman a witch; and at Pompeii, by Venus! the very air seems to have taken a love... handsome does every face with... seen in my eyes.'

'And lo! one of the handsomest, old Diomed's daughter, the rich Clodius, as a young lady, her face her veil, and attended by two fe... approached them, in her way to...

'Fair Julia, we salute thee!' sai... Julia partly raised her veil, with coquetry to display a bold Rom... full dark, bright eye, and a cheek... natural olive art shed a fairer and...

'And Glaucus, too, is returned... glancing meaningly at the Athen... forgotten.' She added, in a half-friends of the last year?'

'Beautiful Julia! even Lethe... disappear in one part of the cart... in another. Jupiter does not allo... forget for more than a moment more thirsty will, vouchsafes... moment's oblivion.'

'Glaucus is never at a loss for... 'Who is, when the object of the...

'We shall see you both at my... soon,' said Julia, turning to Clo...

'We will mark the day in w... you with a white stone,' a... gamester.

Julia dropped her veil, but sh... her last glance rested on the A... affected timidity and real boldne... bespoke tenderness and reproac... The friends passed on.

'Julia is certainly handsome,'...

'And last year you would ha... confession in a warmer tone.'...

Figure 7.3. Eve Kosofsky Sedgwick, *The Last Days of Pompeii/Cavafy collage book* (c. 2007), pp. 10–11. Photo: Kevin Ryan, Collection H.A. Sedgwick, © H.A. Sedgwick.

317

is also in love with Glaucus. It explores the further triangular romantic trials they endure from other rivals for Glaucus's affection, in the form of the Roman Julia, and for Ione's, in the form of the Egyptian Arbaces, before the entire Pompeian population, including Nydia, are genocidally sacrificed to ensure Glaucus and Ione can have a happy, hetero ending.

For example, in the context of the triangular relationship between Nydia, Ione, and Glaucus, readers are told that Nydia's 'feelings for Ione ebbed and flowed with every hour; now she loved her because *he* did; now she hated him for the same cause'.[13] Julia also does not know if she loves Glaucus but would see herself 'triumph over a rival', as she is 'urged on by jealousy and the pique of rivalship, even more than love'.[14] Later, she also 'glow[s] at the thought of her coming triumph over the hated Neapolitan'. Readers additionally learn that Clodius wants Glaucus to marry Julia so that he, Clodius, can gain access to her fortune, commenting that 'A wife is a good thing — when it belongs to another man!'[15]

The novel complements the supposedly endlessly interesting machinations of triangulated heterosexual coupledom and rivalry with a straightforward homophobia as well as an identification of other forms of queer desire with fatal illness. For instance, in a context closely resembling the global AIDS crisis

13 Lytton, *LD*, 180.
14 Lytton, *LD*, 207, 209.
15 Lytton, *LD*, 229. The queer Clodius is described as wearing a tunic with 'loose and effeminate folds', and is accompanied by a 'fat slave'. His 'utter corruption' is paired with Lepidus's 'prostrate effeminacy'. A flirtatious dialogue with Arbaces, meanwhile, later begins with Clodius: 'Many say you can be gay — why not let me initiate you into the pleasures of Pompeii? — I flatter myself no one knows them better'. When Arbaces contends that, at his age, he might be 'an awkward pupil', Clodius retorts, 'Oh, never fear, I have made converts of fellows of seventy'. Sedgwick, however, challenges Lytton's earlier notion that women's relations with one another can *only* be rivalrous, by including on page 19 a more peaceful, harmonious, lavender-stamped image of two women sitting together, one playing a lute, whilst the other listens, to counter, on the same page, the views of a 'cynic' who 'hated women' and who thinks they 'should keep within doors, and there converse' (*MC*, 9, 19, 36, 59, 68).

still unfolding around Sedgwick whilst she was working on the project, Lytton describes a 'ditty of love and a description of the plague' as 'much the same thing', and the 'favorite freedman' of a certain 'boy sophist' is discovered 'just dead of a fever'.[16]

In a novel in which readers are told that 'there is but one Eros, though there are many counterfeits of him', however, the language of gayness is surprisingly recurrent, especially towards the start, when the couples are not yet established, but only as an irresponsible, juvenile phase to be grown out of as happy, healthy, heterosexual coupledom beckons. For example, Lytton describes a party of male revelers as 'for night too gay'. Glaucus turns 'gaily and carelessly from the crowd' and speaks 'gaily'. Readers learn, also, of the 'gaieties' of the night that partly take place in a 'fairy mansion'. There is a 'profusion of gay flowers'. Musicians direct a 'melody into a more soft, a more gay, yet it may be a more intellectual strain'; 'a feat that, effeminate as it seems to us, was simple enough for the gorgeous revelry of the time'. Isis's temple, by contrast, does not welcome the 'gay, [...], proud, ministers of Jupiter'. Ione is instructed that she should not be too fascinated with the young, beautiful, and 'gay' and, as a result, remains 'bright, pure, unsullied, in the midst of the gayest and most profligate gallants'. At a party, the various guests converse 'gaily with each other' and Glaucus hastens 'gaily to reply'.[17]

Pompeii is also a town of 'gay dresses' and 'gay summer skies' in which 'the bustle, the gaiety, the animation, the flow and flush of life' are all around. Ione draws 'crowds of the gay' to her feet. When Arbaces tells Ione that Glaucus has been boasting of her in the public baths, it is because he believes that 'a gay thing like this could never have been honored' by her. Later, we hear of the 'elastic tone' of Glaucus's 'own natural gaiety'; and that Glaucus has, formerly, and suggestively, 'trod the same sod as Harmodius, and breathed the same air as Socrates' although emerging triumphantly unsullied. The Christian Apaecides, by

16 Lytton, *LD*, 13.
17 Lytton, *MC*, 20; *LD*, 13, 15–16, 18, 20, 22–23, 25, 31–32, 37, 40, 46, 50, 53, 61.

contrast, who does not form part of the novel's romantic plot, and has 'taken the vows of celibacy', has hands that are 'small to effeminacy'.[18]

Chapter 7, meanwhile, which takes place at the Roman baths, is entitled 'The Gay Life of the Pompeian Lounger', steamy Roman baths recalling the dense, moisture-laden atmosphere of the Piranesian cover of Sedgwick's earlier *The Coherence of Gothic Conventions* (1985), complete with harnesses, as we saw in Chapter One. Lytton's Roman baths are, we learn, a place characterised by both 'smegmata' — a sebaceous secretion in the folds of the skin, especially under a man's foreskin — and include a visitor whose 'cheeks' are 'red' and 'inflamed' by the 'sudatory and the scraping he had so lately undergone'. Readers hear also, in this vicinity, of 'male prostitutes, who sell their strength as women their beauty; beast in act, but baser than beasts in motive, for the last, at least, do not mangle themselves for money'.[19]

Whilst Pompeii and its male inhabitants are remarkably gay, however, the word *gay* simultaneously conjures up and wards off the specter of actual queer desire. For example, readers learn that, once with Ione, Glaucus 'existed no longer for his gay companions' and in the evenings 'forsook the crowded haunts of the gay'. Readers also know, in advance, that this gay town and its inhabitants will soon, apparently deservedly, come to a fiery, Sodom-and-Gomorrah-like end.[20] In addition, much of the evil

18 Lytton, *LD*, 56, 60, 63–64, 155, 219, 254, 292.
19 Pompeii's 'street of Tombs' is another peculiarly 'gay neighborhood, despite the dead'. There, a door is 'painted gaily' and there is a 'gay villa, half hid by trees' (Lytton, *LD*, 73, 102, 192–93).
20 Lytton, *MC*, 43. Indeed, the novel is explicit about this. Once the volcano has erupted, someone is heard shouting 'The New Gomorrah is doomed' (*MC*, 94). And, as Simmons notes, if 'before the *Last Days*, the idea that the Pompeians had brought their destruction on themselves was not widespread', in the novel, and thanks to its influence, 'Pompeii was unequivocally added to the list of cities, including Sodom and Gomorrah' that the 'Judaeo-Christian god had righteously punished' ('Bulwer and Vesuvius', 364). For more on the 'politics of the volcano', see Nicholas Daly, 'The Volcanic Disaster Narrative: From Pleasure Garden to Canvas, Page, and Stage', *Victorian Studies* 53, no. 2 (Winter 2011): 255–85; 268–69. As Eric M. Moormann has noted, such views were not entirely alien in antique

in the book emerges from the 'bowels of the earth', in the form of the witch's machinations, that derail the romantic plot, and the lava that eventually kills just about everyone. For instance, the evil Arbaces dreams that he had been 'transported to the bowels of the earth', from whence he came. Other men, meanwhile, are singled out in more negatively queer terms. Lytton describes Lepidus's nature as having been 'twisted and perverted from every natural impulse, and curdled into one dubious thing of effeminacy and art', as, suddenly 'all eagerness, and energy, and life', he pats the 'vast shoulders of the gladiators' with his 'blanched and girlish hand, feeling with a mincing gripe their great brawn and iron muscles, all lost in calculating admiration at the manhood which he had spent his life in carefully banishing from himself'.[21]

Images of lesbianism also recur, though less frequently, in the early part of the novel, but predictably in the titillating service of foreplay to heterosexual coupling. Revelers are invited to 'taste this Lesbian' wine. A still single Ione is compared to Sappho and her lover Erinna, and Glaucus plays to Ione 'one of the Lesbian airs', while Ione plays the 'music of Erinna'. In case we were in any doubt about the sexual politics of the novel, though, Ione has a troublingly 'almost masculine liberty of life' before she is properly coupled with Glaucus, and the editor gives little away when he refers to Sappho, in the glossary, as a 'great female poet of the 7th century'.[22]

In order to straighten out further classical antiquity, Lytton repeatedly compares the Greek-born Glaucus, Ione, and Nydia

Pompeii, since someone graffitied 'Sodom Gomora' on a house on the Via dell'Abbondanza ('Christians and Jews at Pompeii in Late Nineteenth-Century Fiction', in Hales and Paul, eds., *Pompeii in the Public Imagination*, 171–84; 171).

21 Lytton, *MC*, 29; *Last Days*, 226–27, 353.

22 Lytton, *LD*, 34, 46, 60, 62–63; *MC*, 13, 107. For more on the difficulties of finding queer information in official sources, see Eve Kosofsky Sedgwick, 'Writing the History of Homophobia', in *Theory Aside*, eds. Jason Potts and Daniel Stout (Durham: Duke University Press, 2014), 29–34, and Eve Kosofsky Sedgwick, *Censorship and Homophobia*, ed. Sarah McCary (New York: Guillotine, 2013).

to ancient statues, heterosexualizing the queer Greco-Roman sculptural tradition. For example, 'a sculptor, who was a great enthusiast in his art, looked after [Glaucus] admiringly'; and he is elsewhere described as having that 'slender and beautiful symmetry from which the sculptors of Athens drew their models'. Similarly, as Nydia runs her hands over Ione's 'Parian face', we learn that it resembles an 'all-wondrous, statue', 'before which all the beauty of the Florentine Venus is poor and earthly'.[23]

In spite of all this, however, the novel does allow for some geographical and theological overlap between its vision of antiquity and that of Sedgwick's favorite queer Greek poet, Cavafy. Like Cavafy and Sedgwick, Lytton is interested in 'images of the household gods;—the hospitable hearth, often mentioned by the Roman poets, and consecrated to the Lares'; and we are told that 'the Lares themselves must have tended' the flowers in the viridarium.[24] In addition, a song, in the novel, 'The Coronation of the Loves', addressed to Lesbia, tells of how

> Among the toys a Casque they found,
> It was the helm of Ares;
> With horrent plumes the crest was crown'd,
> It frightened all the Lares.

These doggerel lyrics 'greatly suited the gay and lively fancy of the Pompeians'.[25] The song has significant thematic and theological overlap with Cavafy's 'The Footsteps', a poem Sedgwick

23 Lytton, *LD*, 70, 127–28; *MC*, 9. More precisely, according to Margaret Malamud, Glaucus self-consciously 'brings to life the famous Greek statue known as the Apollo Belvedere' ('On the Edge of the Volcano: *The Last Days of Pompeii* in the Early American Republic', in *Pompeii in the Public Imagination*, eds. Hales and Paul, 199–220; 209). For more on Victorian parianware, see Dennis Barker, *Parianware* (Aylesbury: Shire, 1985); Paul Atterbury and Maureen Batkin, *The Parian Phenomenon: A Survey of Victorian Parian Porcelain Statues and Busts* (Somerset: Richard Dennis, 1989); and Robert Copeland, *Parian: Copeland's Statuary Porcelain* (Woodridge: Antique Collectors' Club, 2006).
24 Lytton, *LD*, 24, 49.
25 Lytton, *LD*, 261–63.

discusses in her essay and collages onto the back page of her artist's book, whose similarly trembling, miserable little Lares, 'try to hide their insignificant bodies' from the arriving Furies, as they 'faint with fear' and seek to 'scramble to the back of the shrine, / shoving each other and stumbling, / one little god falling over another' (see Figure 7.4).[26]

In some ways, Sedgwick's interest in these diminutive household shrines takes us back to the beginning of this book, since with their audience-oriented proscenium arches they are a model of Friedian *theatricality*, emphatically resisting, in the queer little gods' desire for a devoted audience and the worshipper's need of the queer little gods, that more or less indifferent pictorial frontality that Sedgwick found so alluring and simultaneously repelling at the start of her career, as we saw in Chapter One.[27]

In addition, Lytton, like Cavafy, is interested in the 'cities of Magna Graecia'. Indeed, the novel's merchants constantly seek to 'know the fate our vessels, which sail for Alexandria', Cavafy's home, and speculate on the 'chance of the trade with Alexandria'. But Egypt, especially as represented by Arbaces, the novel's anti-hero, ultimately represents the source of all evil, and Alexandrians repeatedly criticized. A 'merchant engaged in the Alexandrian trade' is blamed for introducing to Pompeii the 'worship of the Egyptian goddess', Isis, who with Arbaces, is demonized in the novel, even more than Greco-Roman paganism, for her immorality.[28]

26 For Sedgwick's discussion of the poem, see *The Weather in Proust*, 43–44. An illustration of a 'domestic altar for the Lares or house gods' (MC, 4) appears on page 59 of the text and is reprinted, at a larger scale, on page 110. Readers learn more about the Lares, and see another depiction of a 'typical house altar' on the insert between pages 34 and 35, pages Sedgwick does not alter. For more on the Lares, see MC, 61.

27 For more, see Michael Fried, *Absorption and Theatricality: Painting and Beholder in the Age of Diderot* (Berkeley: University of California Press, 1980).

28 Lytton, LD, 40–41, 67. For more on Cavafy's Alexandria, see Michael Haag, *Vintage Alexandria, 1860–1960* (Cairo: American University in Cairo Press, 2008).

... faint with fear, the miserable Lares
scramble to the back of the shrine,
shoving each other and stumbling,
one little god falling over another,
because they know what kind of sound that is,
know by now the footsteps of the Furies.

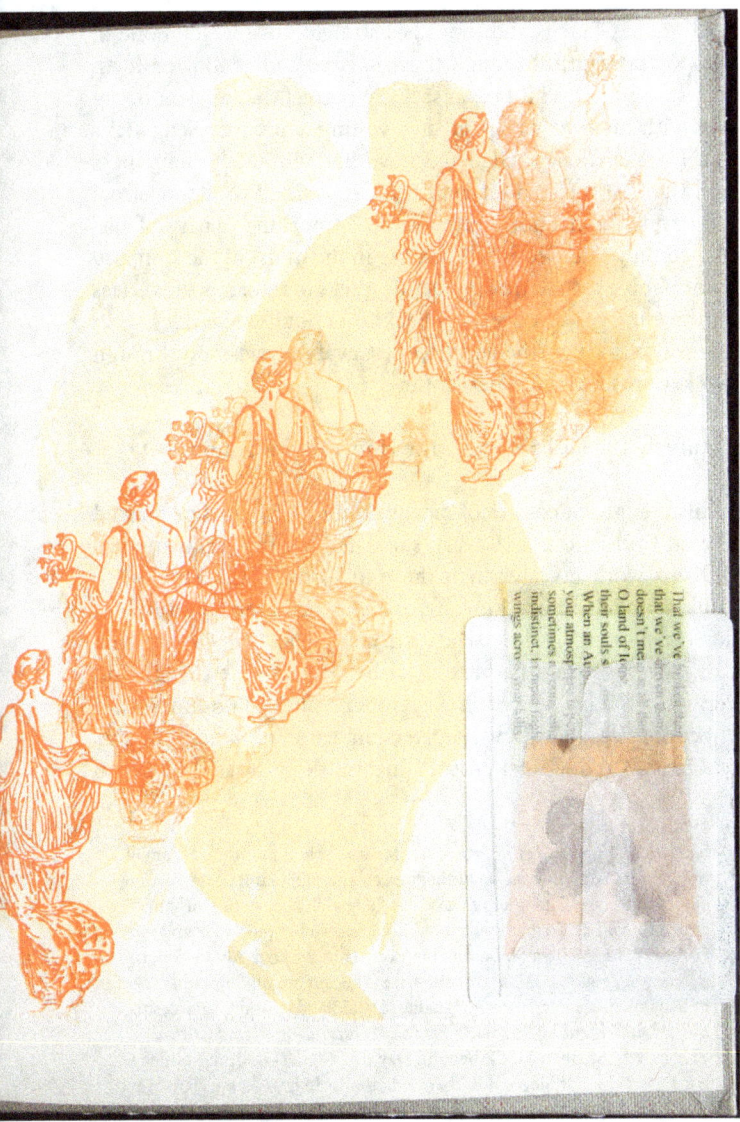

Figure 7.4. Eve Kosofsky Sedgwick, *The Last Days of Pompeii/Cavafy collage book* (c. 2007), inside back cover pages. Photo: Kevin Ryan, Collection H.A. Sedgwick, © H.A. Sedgwick.

If, then, Glaucus and Ione's is a straight 'love which none of our poets, beautiful though they may be, had shadowed forth in description'; and if Lytton seeks to correct that ancient omission with his own 400-page, five-volume emission; Sedgwick's *Last Days* challenges Glaucus's idea that, ultimately, 'happiness could not be gay'. And if Lytton is determined to demonstrate the strong connection between the Pompeians' 'gaiety of life' and 'coming fate', Sedgwick, writing in the midst of the similarly homophobic global AIDS pandemic, seeks to return positive, less punitive images of queerness back to antiquity. She does so in two ways: through the addition of Cavafy's lyrics and through two key art historical interventions.[29]

Cavafy vs *The Last Days*, or, The House of the Tragic Poet

Whilst Sedgwick could not recall when or why she first started to read translations of Cavafy, she dated her first acquaintance with his work no later than the mid-1970s.[30] She returned to think seriously about him in 2007, having received an invitation to participate in a Harvard conference on Cavafy that year. She gave the first version of her paper, 'C.P. Cavafy and Periperformative Space', on November 3 at the London School of Economics; giving a variant version, combining her thoughts on Cavafy's and Marcel Proust's queer little gods, at Harvard on

29 Lytton, *LD*, 166, 17, 407
30 Sedgwick, *The Weather in Proust*, 42. Melissa Solomon recalled 'a small minyan of Cavafy lovers', including herself and Stephen Barber, 'reading aloud' their favourite lines of Cavafy at Sedgwick's house in Durham, North Carolina, during her time at Duke, and so between 1988 and 1997. For more, see Melissa Solomon, 'Eighteen Things I Love About You', in *Reading Sedgwick*, ed. Berlant, 236–41; 236. For more on Solomon's relation to Sedgwick, see her 'Flaming Iguanas, Dalai Pandas, and Other Lesbian Bardos', in *Regarding Sedgwick: Essays on Queer Culture and Critical Theory*, eds. Stephen M. Barber and David L. Clark (London: Routledge, 2002), 201–16. For Stephen Barber's relation to Sedgwick, see Barber and Clark, eds., *Regarding Sedgwick*, and his review of *The Weather in Proust* (2011), in *Psychoanalysis, Culture and Society* 18, no. 4 (2013): 431–33. Barber's 'Lip-Reading: Woolf's Secret Encounters', also appears in Sedgwick, ed., *Novel Gazing*, 401–43.

December 7. Parts of the paper also subsequently appeared in a talk she gave at the Centre de Recherche CLIMAS de l'Université Michel de Montaigne Bordeaux 3 on June 7, 2008, before she published a final version in 2010: 'Cavafy, Proust, and the Queer Little Gods'.[31]

If Sedgwick's essay paralleled Proust and Cavafy, *Last Days* juxtaposes Cavafy and Lytton, as well as the text's internal commentator, Wright, using the poet as a queer foil to Lytton and Wright's murderously heteronormative antiquity. I mention Wright because his homophobic values come out, from his introductory glosses onwards, which describe how Arbaces is 'prone to corrupting the young', Clodius is a 'delicate young parasite, addicted to the dice', Calenus 'an unprepossessing and grasping assistant to Arbaces', and Sallust a 'young poet, over fond of eating'; evidence of Wright's thin art, cross-generationally phobic, as well as homophobic, preferences. If this is the text's official commentary, then Sedgwick's interventions provide a queer alternative.[32]

Sedgwick's major verbal intervention in the text is, as I have already briefly indicated, the addition of numerous Cavafy quotations, on colored rectangles of paper, and through graffitiing his name, in white, painted through a D-Day stencil font (see Figure 7.5).

The first occurs on the inside cover, which she makes into a new half-title page, against a *suminagashi* background again recalling the cover of *Epistemology of the Closet*, whose floating ink technology suggests that the print in this particular text will be in motion, rather than stable. Her choice of font, meanwhile,

[31] For more on Cavafy and the performative, see Maria Boletsi, 'How to Do Things with Poems: Performativity in the Poetry of C.P. Cavafy', *Arcadia* 41, no. 2 (2006): 396–418. Boletsi's insight that Cavafy employed a 'sedimented discourse in a way that leads to its mockery and subversion rather than valorization' in order to 'question historiography's claims to validity and objectivity' is apt in the context of Sedgwick's *Last Days* (410).

[32] Lytton, *MC*, 7. That said, the two may share a predilection towards an S/M idiom, if the 'inadvertent' repetition of number 67 in the 'List of Illustrations' is anything to go by, so that the leg irons 'used to punish gladiators' occur twice in the list (*MC*, 4–5).

Figure 7.5. Eve Kosofsky Sedgwick, *The Last Days of Pompeii/Cavafy collage book* (c. 2007), inside front cover. Photo: Kevin Ryan, Collection H.A. Sedgwick, © H.A. Sedgwick.

seems appropriate for this similarly last day novel, and suggests the significant presence of queers within the military, in the context of the US-government's 'Don't ask, don't tell' policy, officially in place from February 1994 until September 2011, and so at the time Sedgwick was at work on the project (see Figure 7.6).[33]

On the main title page, meanwhile, Sedgwick adds the first of her four postcards, and the first of two appearances of the one depicting Cary Grant in *North by Northwest*, at the thrilling moment he is pursued through the countryside by a crop-spraying plane. In the context of Sedgwick's book, Grant is additionally chased by various other, hand-stamped flying figures, including three angels, a kite-like man, a bee, and a winged, fat woman in a kimono, perhaps standing for Sedgwick herself, given her love of kimono swatches as we saw in Chapter Six, as a third author of the volume, given the appearance of Lytton and Cavafy's names on this page. The collage suggests, from the outset, the idea of the book's pages as a screen for Sedgwick's projections, and anticipates one of the major sub-plots of the novel, when Glaucus, like Grant, flees for his life, having been wrongly accused of a crime. In this context, however, the postcard suggests, in Sedgwick's gentle pursuit, a Lytton who will be hunted down for his sexual-political views, with Sedgwick standing in for one of Cavafy's vengeful furies from 'The Footsteps'.[34]

The first of Sedgwick's Cavafian lyric interventions occurs on the Contents page, where she inscribes a line from 'Kaisarion': 'And there you were with your indefinable charm' (see Figure 7.7).

33 Sedgwick also stencils Cavafy's name to obliterate entirely Lytton's text on page 15, and much of the text on pages 87 and 95. Her graffiti echoes the inclusion, in the text, of a Pompeian 'graffito of a gladiator' (Lytton, MC, 26), and recalls the wheat-paste postering of ACT-UP New York, who were also partial to the D-Day font. For more, see Gran Fury and Michael Cohen, eds., *Gran Fury: Read My Lips* (New York: 80WSE, 2011).

34 The image returns on page 73, this time torn raggedly at the top left-hand corner, and missing the top right-hand section, suggesting the increasing urgency of the narrative. For more on 'The Footsteps', see *The Weather in Proust*, 43–44.

She prints this on a slither of opaque green paper, stuck on a glittered, green, playing-card-shaped rectangle, glued vertically, rather than horizontally across the text, to encourage, from the start, the reader's micro-positional flexibility, one of the characteristics of her art involving words. Cavafy's poem describes how its narrator, to pass the time, and seeking historical information, as Sedgwick did whilst researching Cavafy, picked up 'a volume of inscriptions about the Ptolemies'.[35] There, he found plenty of facts, but only the briefest allusion to the one thing he desired from the past, a 'brief, insignificant mention' of the tragic youth Kaiserion that suddenly caught his eye. Here we find an analogy for Sedgwick's practice throughout the book. Searching in vain for a queer antiquity in Lytton's text, she inscribed the novel with the more 'good looking and sensitive' Cavafy; 'a dreamy' and 'appealing' queer antique beauty, who, in Cavafy's source poem, 'came into' his room, perhaps explaining Sedgwick's repeated preference for color sprayed onto, and spurted across, Lytton's pages, as well as the sticky, adhesive, Whitmanian glue binding pages together and text onto pages.[36] Indeed, a certain thick, sticky white liquid can be found as early as this page, transforming the 'Contents' into a kind of altered poem, 'Book Two' becoming a 'Boo t', 'Book Three' a 'Tree', and 'enmity' transformed into a 'Friendship softened'.

35 One of Sedgwick's key go-to texts was Peter Jay, ed., *The Greek Anthology and Other Ancient Epigrams* (London: Penguin, 1981).

36 Sedgwick glues together the first two pages of the book, and pages 12–13, fattening the individual pages, and suggesting the classic masturbatory image of semen-stuck pornographic pages, and the idea that this chapter might have been called 'Edward Bulwer-Lytton and the Masturbating Girl'. For more on Whitman's queer adhesiveness, see Michael Moon, *Disseminating Whitman: Revision and Corporeality in 'Leaves of Grass'* (Cambridge: Harvard University Press, 1991), 12–13, 50, 156. Readers might also think about Sedgwick's layered texturing of the pages as designed to appeal to a reader, such as the blind Nydia, more alive to texture than text, to braille rather than print. The idea that Sedgwick sought to fatten up Lytton with Cavafy is also resonant in the context in which Cavafy, called by his mother 'the *Thin One*', would address her fondly as 'My Fat One' (Robert Liddell, *A Critical Biography* [London: Duckworth, 1974], 95–97.

QUEER AND BOOKISH

Edward George Earle Lytton Bulwer-Lytton, was born in London in 1803. He entered politics in 1831 and wrote THE LAST DAYS OF POMPEII in 1834. He was the author of many other books, plays, and poems during his life-time but this book was the most successful and remained the best known. He became a peer in 1855 and died in 1873.

Figure 7.6. Eve Kosofsky Sedgwick, *The Last Days of Pompeii/Cavafy collage book* (c. 2007), full title page. Photo: Kevin Ryan, Collection H.A. Sedgwick, © H.A. Sedgwick.

QUEER AND BOOKISH

Published by Marshall Cavendish Publications Limited
58 Old Compton Street, London W1V 5PA.

Annotations and illustrations © 1976 by the Felix Gluck Press Limited,
Twickenham.
All rights reserved, including the right to reproduce this book, or parts thereof,
in any form, except for review purposes.
Illustrated by Harold T. King
Abridged text annotated and edited by Robin Wright, B.A. (Oxon.)
Historical Consultants: Dr. J. Ward-Perkins, former Director of the
British School in Rome, and Amanda Claridge

This volume first published in 1976
Printed by Sackville Smeets Ltd., London, typesetting by Ronset Ltd.,
Darwen, Lancs.

ISBN 0 85685 250 3

CONTENTS

	List …		F UR	A classic host, cook, and kitchen	57
	List …			A fashionable party	59
NE	The …			halts for a moment	62
	The …			The philtre	63
	The …			A union of different actors	64
	The …			Friendship softened	67
	Mor…			funeral	70
	The …			An adventure happens to Ione	71
	A m…			What become of Nydia in the house of Arbaces	72
	Arba…			Nydia affects the sorceress	73
O T	A fla…			A wasp ventures into the spider's web	74
	Two …			The slave consults the oracle	75
	Glau…			Nydia accosts Calenus	77
	The rival of Glaucus presses onward in the race	31		Arbaces and Ione	78
	The poor tortoise – new changes for Nydia	33	BOOK FIVE	The dungeon and its victims	79
	The			A chance for Glaucus	81
	blind slave	34		The dream of Arbaces	84
	entrapped	36		theatre	85
	Ione in the house of Arbaces	37		Sallust reads Nydia's letter	90
T REE	The forum of the Pompeians	40		The atre once more	91
	The congregation	41		The cell of the prisoner of the dead	94
	A wedding date is fixed	43		Calenus and Burbo	95
	Nydia encounters Julia	44		the destruction	96
	The porter – the girl – and the gladiator	45		Arbaces encounters Glaucus and Ione	98
	The dressing room of a Pompeian beauty	47		The despair of the lovers	99
	Julia seeks Arbaces	49		The next	101
	A storm in the south – the witch's cavern	50		Appendix	103
	The lord of the burning belt and his minion	53			
	The plot thickens	54			

Figure 7.7. Eve Kosofsky Sedgwick, *The Last Days of Pompeii/Cavafy collage book* (c. 2007), contents pages. Photo: Kevin Ryan, Collection H.A. Sedgwick, © H.A. Sedgwick.

Sedgwick's second Cavafian intervention occurs on page 11, as we have seen (see Figure 3 above). Here, inserted into an illustrated silver drinking cup decorated with skeletons is a piece of purple paper with an extract from 'The Favor of Alexander Valas' on it, whose text is only partially visible unless removed from its context:

> I'm not the least put out
> that my chariot wheel broke
> and I lost that silly race.
> I'll drink great wines the whole night long
> lying among the lovely roses.

The poem represents Sedgwick's first refusal of the dominant hetero- and gender-normative thrust of the novel, with the speaker refusing the masculine heroics of the chariot race, in favor of taking some time to smell the roses, and, in the unquoted section, coming out as the 'most celebrated young man in town', and as 'Valas' weakness'.[37]

[37] Bones, like those of the skeletons, form a key part of the illustrations opposite page 19, in the form of both 'ivory pieces from various games' and 'knucklebones', often 'from the ankle joint of a cloven-hoofed animal', a game in which the bones were thrown into the air and then (hopefully) caught on the back of the player's hand. Bones separated out and floating in the air must have been a poignant image to Sedgwick, whose spinal column was dissolving at the time. With the exception of the four bones at the top, the illustrations are almost completely obliterated with red sponged rectangles, and purple I Ching characters, suggesting how closely integrated Sedgwick's spinal column was with chance. For a remarkably intact spinal image that Sedgwick left untouched, see the 'Leg irons used for punishing gladiators' on page 67. In this context, readers might also think about the unusual triple-column format of the edition of Lytton Sedgwick chose, as if offering her an abundant image of stable columns, although there may also be queer resonance here, given Cavafy's frequent employment of poems divided, like buttocks, into two separate columns. For more straight readings of Cavafy's use of columns, see Jane Lagoudis, *Alexandria Still: Forster, Durrell, and Cavafy* (Princeton: Princeton University Press, 1977), 34.

The perverse *fleur-du-mal* pleasures of another handsome man appear on page 18, as Sedgwick adds to an illustration, in the text, of a bronze vase, a single rose, and, immediately below it, a passage from Cavafy's 'For the Shop' on a rectangle of chromatically-appropriately green paper, layered onto an equally appropriate violet frame (see Figure 7.8).

This tells how an anonymous man wrapped carefully and neatly, in expensive green silk, 'Roses of Rubies, lilies of pearl / violets of amethyst: beautiful according to his taste, / to his desire, his vision' and emphatically not 'as he saw them in nature'. Sedgwick's choice of palette thus echoes Cavafy's *contra naturam* aesthetic drawing on the rhetoric of J.K. Huysmans's 1891 novel, *Against Nature,* widely understood to be a synonym for male homosexuality in the period.[38]

Immediately opposite, Sedgwick includes a passage from Cafavy's 'Going Back Home from Greece', this time on a rectangle of purple paper against a frame of green, thus reversing the relation of figure and ground, as her interventions do throughout the text, reducing Lytton's prose to a ground or frame for her more foregrounded interventions, a product in part of her broader interest in gestalt psychology in this period. The poem is juxtaposed with a map, included in the illustrated text, of the area surrounding Pompeii and Herculaneum. The passage focuses on what it means to be 'properly Greek', and suggests the pleasure of getting ever further away from Greece. Especially as the angled passage points down directly towards 'gay' Pompeii and Herculaneum on the map, this is the opposite trajectory to the one Lytton asserts in the book, where the return to Athens, for Ione and Glaucus, is identified with the heterosexual consummation of the novel. Sedgwick's Cavafian intervention also contests what it means to be 'properly Greek', i.e., vanilla heterosexual, rather than queer, in another way, given how perverse it

38 For more, see J.K. Huysmans, *Against Nature* (1891; Oxford: Oxford University Press, 2009) and Charles Baudelaire, *Les Fleurs du Mal* (1857; Oxford: Oxford University Press, 2008).

QUEER AND BOOKISH

a small party of chosen friends, were returning from an excursion round the bay; their vessel skimmed lightly over the twilight waters, whose lucid mirror was only broken by the dripping oars. As the rest of the party conversed gaily with each other, Glaucus lay at the feet of Ione, and he would have looked up in her face, but he did not dare. Ione broke the pause between them.

'My poor brother,' said she, sighing, 'how once he would have enjoyed this hour!'

'Your brother!' said Glaucus; 'I have not seen him. Occupied with you, I have thought of nothing else, or I should have asked if that was not your brother for whose companionship you left me at the Temple of Minerva, in Neapolis?'

'It was.'
'And is he here?'
'He is.'
'At Pompeii! and not constantly with you? Impossible!'
'He has other duties,' answered Ione, he is a priest of Isis.'
'So young, too; and that priesthood laws at least, so severe!' said the bright-hearted Greek, in surprise 'And he does not repent his choi he is happy.'
Ione sighed deeply, and low over her eyes.

'I wish,' said she, after a pause, 'that he had not been so hasty. Perhaps, like all who expect too much, he is revolted too easily!'

'Then he is not happy in his new condition. And this Egyptian, was he a priest himself? was he interested in recruits to the sacred band?'

'No. His main interest was in our happiness. He thought he promoted that of my brother. We were left orphans.'

'Like myself,' said Glaucus, with a deep meaning in his voice.

'And Arbaces sought to supply the place of our parent. You must know him. He loves genius.'

'Arbaces! I know him already; at least, we speak when we meet. But for your praise I would not seek to know more of him. My his gloomy brow Epi

BRONZE VASE

THE FOWLER SNARES THE BIRD AGAIN

Arbaces had not of late much frequ house of Ione; and when he had v he had not encountered Glaucus, he, as yet, of that love which had so sprung up between himself and his In his interest for the brother of Ior been forced, too, a little while, to su interest in Ione herself. His pride selfishness were aroused and alarm sudden change which had come spirit of the youth. He trembled lest should lose a docile pupil, and enthusiastic servant. Apœcides had seek or to consult him. He was ra found; he turned sullenly from the —nay, he fled when he perceived distance.

Arbaces passed through a thick the city, which lay between his I that of Ione, in his way to the le there, leaning against a tree, and the ground, he came unawares on priest of Isis.

'Apœcides!' said he, —and he late affectionately on the young man's sh

The priest started; and his fir seemed to be that of flight. 'My son Egyptian, what has chanced that to shun me?'

Apœcides remained silent and su ing down on the earth, as his lips and his breast heaved with emotion

'Speak to me, my friend,' con Egyptian. 'Speak. Something bu spirit. What hast thou to reveal?'

'To thee—nothing.'

'And why is it to me thou ar confidential?'

Roses of rubies, lilies of pearl
violets of amethyst: beautiful according to his taste,
to his desire, his vision—not as he saw them in nature
or studied them.

en my ene
d Arbaces,
reluctant
ed him to
red within
spring of
exhausted
tian; his d
worn and
, and sho
lare: his fr
prematurely, and in his hands th swollen veins indicated the las weakness of the relaxed fibres. Yo face a strong resemblance to Ion expression was altogether differe majestic and spiritual calm which divine and classical a repose over beauty.

Figure 7.8. Eve Kosofsky Sedgwick, *The Last Days of Pompeii/Cavafy collage book* (c. 2007), p. 18 and opposite inset page. Photo: Kevin Ryan, Collection H.A. Sedgwick, © H.A. Sedgwick.

is, in the poem, that to be 'properly Greek' involves being ever 'further' from Greece.[39]

Just over the page, in a stamped, open, transparent envelope, set, appropriately enough, against a map of the city, are lines tacitly addressed to the reader from Cavafy's 'In the Street' (see Figure 7.9).[40]

The lines describe how a youthful-looking, twenty-five year-old man — his 'attractive face a bit pale, / his chestnut eyes looking tired, dazed' and with 'something of the artist in the way he dresses' — 'drifts aimlessly down the street, / as though still hypnotized by the illicit pleasure, / the very illicit pleasure that has just been his'. The lines help make sense of the silhouetted form of the patterned marionette figure opposite, its body articulated at the ankles, knees, hips, and elbows. Looking initially like a plaster cast Pompeian corpse laid out on the ground, the figure takes on new life, as it not so much drifts aimlessly down the street, but dances, floats, or, given the numerous flying birds that traverse its form, takes flight, perhaps after an exciting cottaging experience at the 'Public toilets' marked on the map.[41]

39 Sedgwick discusses 'Going Back Home from Greece' in *The Weather in Proust*, 62–63. The map, in providing an image of the circum-Mediterranean world, the world of Cavafy's poetry, reminds us that Sedgwick and Andrew Parker had earlier published Joseph Roach's account of 'Culture and Performance in the Circum-Atlantic World', in *Performativity and Performance* (London: Routledge, 1995), 45–63. For more on Sedgwick's geographies, see Gavin Brown and Kath Browne, *Progress in Human Geography* 35, no. 1 (2011), 121–31.

40 The ghost of Dickinson may again be hovering here, given her parallel interest in poems written on envelopes. For more, see Marta Werner and Jen Bervin, *Emily Dickinson: The Gorgeous Nothings* (New York: The Christine Burgen Gallery/Granary, 2013). I am grateful to Katie Kent for putting me onto Dickinson's envelope poems.

41 A more three-dimensional marionette figure, probably of a gladiator, appears on page 84, where the combatants are described, in the novel, at this point, as wearing armor 'intricately woven with bands of iron' — this one with a metal speech bubble attached to its head, reading 'MY DREAM', and dressed in a woven smock made up of various fibers, that represents a kind of miniature version of Sedgwick's other, larger-scale weaving projects (*MC*, 86–87) and the marionette figures she will return to in a subsequent fiber piece, *Then My Grandmother Came In*. In the novel, Albaces

Sedgwick employs parts of Cavafy's 'The Souls of Old Men', on page 29, as part of her more general critique of the forms of straight life celebrated by the novel (see Figure 7.10).[42]

Cutting the lines of the poem that anchor it in the 'worn, tattered bodies' and 'souls of old men', in their 'old, threadbare skins', Sedgwick reproduces her selected lines, as if in the form of the commentary of a gaily happy Greek chorus on the heterosexual action of the play: 'How unhappy the poor things / and how bored by the pathetic life they live. How they tremble for fear of losing that life, and much / they love it, those befuddled and contradictory souls'. But, given the predominance of skeletons that Sedgwick adds throughout the text, with five examples occurring on pages 24–25 alone, viewers might also read the commentary from the perspective of an author by then long familiar with questions of life, death, and the bardos between. Indeed, from that perspective, readers might think about *The Last Days,* as another, novel way of thinking the bardo, with any secure sense of a peaceful spectatorial position beyond it quickly undone by the quotation on the insert following page 34 (see Figure 7.11).

This derives from Cavafy's 'Simeon', which, perhaps from Sedgwick's Bu-Jew (Buddhist–Jewish) perspective, reads, not without a certain homoerotic frisson:

I slipped in among the Christians
praying and worshipping in silence there,
revering him. Not being a Christian myself
I couldn't share their spiritual peace —
I trembled all over and suffered;
I shuddered, disturbed, terribly moved.

is the one who has the fantasy that 'I weave — I warp — I mould them at my will' (*MC*, 15). But readers might also think about the unusual vertical three-column form of the edition Sedgwick chooses, often interspersed with horizontally oriented images, as a kind of woven form. For Sedgwick on puppets, see *The Weather in Proust,* 21–22, 66.

42 Sedgwick also discusses the poem in *The Weather in Proust,* 49.

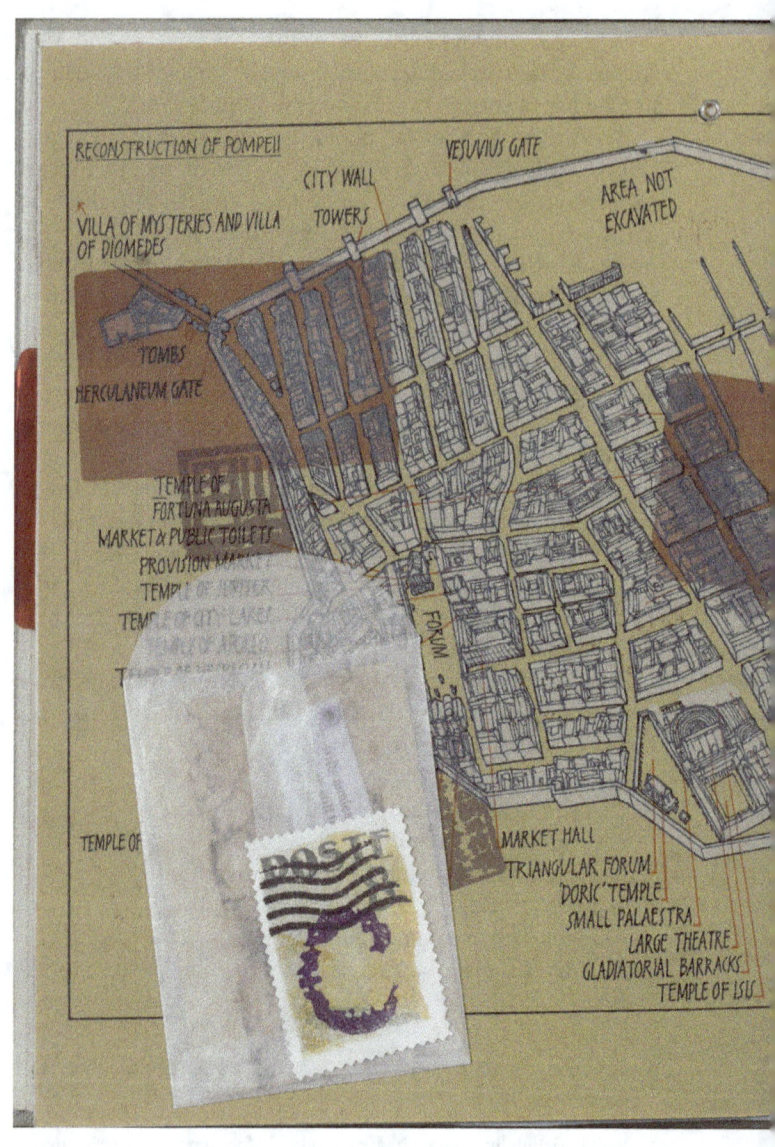

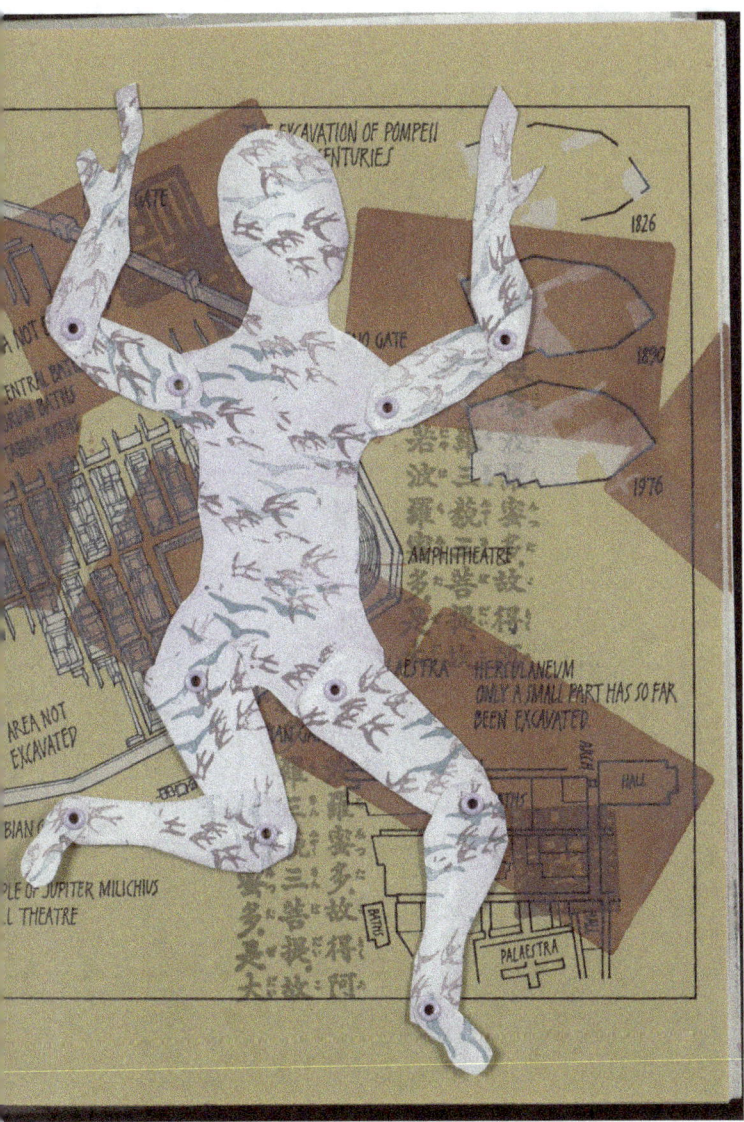

Figure 7.9. Eve Kosofsky Sedgwick, *The Last Days of Pompeii/Cavafy collage book* (c. 2007), central spread, inset between pp. 18–19. Photo: Kevin Ryan, Collection H.A. Sedgwick, © H.A. Sedgwick.

ductile and clever, sings well, and is of good blood, I assure you." "Of what country?" said I. "Thessalian." Now I knew the Thessalians were acute and gentle; so I said I would see the girl. I found her just as you see her now, scarcely smaller and scarcely younger in appearance. She looked patient and resigned enough, with her hands crossed on her bosom, and her eyes downcast. I asked the merchant her price: it was moderate, and I bought her at once. The merchant brought her to my house, and disappeared in an instant. Well, my friends, guess my astonishment when I found she was blind! Ha! ha! a clever fellow that merchant! I ran at once to the magistrates, but the rogue was already gone from Pompeii. So I was forced to go home in a very ill humour, I assure you; and the poor girl felt the effects of it too. But it was not her fault that she was blind, for she had been so from her birth. By degrees, we got reconciled to our purchase. True, she had not the strength of Staphyla, and was of very little use in the house, but she could soon find her way about the town, as well as if she had the eyes of Argus; and when one morning she brought us home a handful of sesterces, which she said she had got from selling some flowers she had gathered in our poor little garden, we thought the gods had sent her to us. So from that time we let her go out as she likes, filling her basket with flowers, which she wreathes into garlands after the Thessalian fashion, which pleases the gallants; and the great people seem to take a fancy to her, for they always pay her more than they do any other flower-girl, and she brings all of it home to us, which is more than any other slave would do. So I work for myself, but I shall soon afford from her earnings to buy me a second Staphyla; doubtless, the Thessalian kidnapper had stolen the blind girl from gentle parents. Besides her skill in the garlands, she sings and plays on the cithara, which also brings money, and lately—but *that* is a secret.'

'*That* is a secret! What!' cried Lydon, 'art thou turned sphinx?'

'Sphinx, no!—why sphinx!'

'Cease thy gabble, good mistress, and bring us our meat—I am hungry,' said Sporus, impatiently.

'And I, too,' echoed the grim Niger, whetting his knife on the palm of his hand.

The amazon stalked away to the kitchen, and soon returned with a tray laden with large pieces of meat half-raw: they drew round the table with the eyes of famished wolves—the meat vanished, the wine flowed. So leave we those important personages of classic life to follow the steps of Burbo.

TWO WORTHIES

In the earlier times of Rome the priesthood was a profession, not of lucre but of honour. It was embraced by the noblest citizens—it was forbidden to the plebeians. Afterwards, and long previous to the present date, it was equally open to all ranks; at least, that part of the profession which embraced the flamens, or priests,—not of religion generally, but of peculiar gods. Even the priest of Jupiter (the Flamen Dialis) preceded by a lictor, and entitled by his office to the entrance of the senate, at first the especial dignitary of the patricians, was subsequently the choice of the people. The less national and less honoured deities were usually served by plebeian ministers, and many embraced the profession less from the impulse of devotion than the suggestions of a calculating poverty. Thus Calenus, the priest of Isis, was of the lowest origin. His relations, though not his parents, were freedmen. He had received from them a liberal education, and from his father a small patrimony, which he had soon exhausted. He embraced the priesthood as a last resource from distress.

Calenus had but one surviving relative at Pompeii, and that was Burbo. Various dark and disreputable ties, stronger than those of blood, united together their hearts and interests; and often the minister of Isis stole disguised and furtively from the supposed austerity of his devotions;—and gliding through the back door of the retired gladiator, rejoiced to throw off the last rag of hypocrisy.

Wrapped in a large mantle Calenus now sat in the small and private chamber of the wine-cellar, whence a small passage ran at once to that back entrance, with which nearly all the houses of Pompeii were furnished.

Opposite to him sat the sturdy Burbo, carefully counting on a table between them a little pile of coins which the priest had just poured from his purse—for purses were as common then as now, with this difference—they were usually better furnished!

'You see,' said Calenus, 'that we pay you handsomely, and you ought to thank me for recommending you to so advantageous a market.'

'I do, my cousin, I do,' replied Burbo, affectionately, as he swept the coins into a leathern receptacle, which he then deposited in his girdle. 'And by Isis, Pisis, and Nisis, or whatever other gods there may be in Egypt, my little Nydia is a very Hesperides—a garden of gold to me.'

PURSE

'She sings well, and plays lik[e]...' returned Calenus, 'those are virt[...] who employs me always pays libe[...]

'He is a god,' cried Burbo, enth[...] 'every rich man who is generous [...] be worshipped. But come, a cup o[...] friend; tell me more about it. Wh[...] do? she is frightened, talks of h[...] reveals nothing.'

'Nor will I, by my right hand! [...] taken that terrible oath of secrecy [...]

'Oath! what are oaths to men li[...]

'True oaths of a common fashio[...] —and the stalwart priest shudd[...] spoke. 'Yet,' he continued, in [...] huge cup of unmixed wine, 'I c[...] thee, that it is not so much the [...] dread as the vengeance of him wh[...] it.'

At this moment they heard a sl[...] the door, as of one feeling the [...] priest lowered the hood over his [...]

'Tush!' whispered the host, 'i[...] blind girl,' as Nydia opened the[...] entered the apartment.

'Ho! girl, and how durst [...] lookest pale,—thou hast kept le[...] matter, the young must be always [...] said Burbo, encouragingly.

The girl made no answer, but s[...] on one of the seats with an air [...] Her colour went and came rapidl[...] the floor impatiently with her sm[...] she suddenly raised her face, and [...] determined voice,—

'Master, you may starve me if [...] you may beat me,—you may me[...] with death,—but I will go no m[...] unholy place!'

GLAUCUS MAKES A PURCHASE

How unhappy the poor things are
and how bored by the pathetic life they live.
How they tremble for fear of losing that life, and how much
they love it, those befuddled and contradictory souls.

Figure 7.10. Eve Kosofsky Sedgwick, *The Last Days of Pompeii/Cavafy collage book* (c. 2007), pp. 28–29. Photo: Kevin Ryan, Collection H.A. Sedgwick, © H.A. Sedgwick.

QUEER AND BOOKISH

RELIGIONS AND THEIR GODS

The ancient Romans had only minor gods, mostly concerned with the family and agriculture - the only exceptions were Juno and Jupiter. Most of the major State gods were borrowed from Greece, while the la[ter "eastern"] gods were imported from [...]. Religi[...] gener[...] servan[...] of the [...] in any [...] called [...] Priests were elected by the people for a term of office. They did not work full time and they usually had other duties. Nor did they serve in a particular temple; they helped in and supervised the rites in all the State temples.

> I slipped in among the Christians praying and worshipping in silence there. revering him. Not being a Christian myself I couldn't share their spiritual peace— I trembled all over and suffered; I shuddered, disturbed, terribly moved.

MINERVA

JUNO

TEMPLE OF JUPITER: OUTSIDE, SPEAKERS PLATFORM (BY THE STAIRS) INSIDE, SMALL SHRINES TO JUNO AND MINERVA.

PLAN OF THE FORUM IN POMPEII, SHOWING HOW CLOSELY PUBLIC BUILDINGS AND STATE TEMPLES WERE RELATED

TEMPLES OF 1 JUPITER 2 APOLLO
3 VESPASIAN 4 CITY LARES
PUBLIC BUILDINGS 5 MARKETS
6 TREASURY 7 MUNICIPAL BUILDINGS
8 VOTING ROOMS 9 MEETING PLACE
10 ARCH OF TIBERIUS

VENUS FROM A POMPEIAN INLAID MARBLE

VENUS
GODDESS OF LOVE AND NAT[URE]
THE GREEK APHRODITE, HER [...]
WAS PAINTED AND SCRATCHED E[...]
WHERE IN POMPEII, ON SHOPS
AND TAVERNS. PATRON SAINT [OF]
POMPEII.

JUPITER
BRINGER OF STORMS AND TH[E]
CHIEF GOD OF ROMAN WORSHIP
LINKED WITH JUNO AND MINE[RVA]
AS PROTECTOR OF THE STATE.

BUST O[F]
FROM

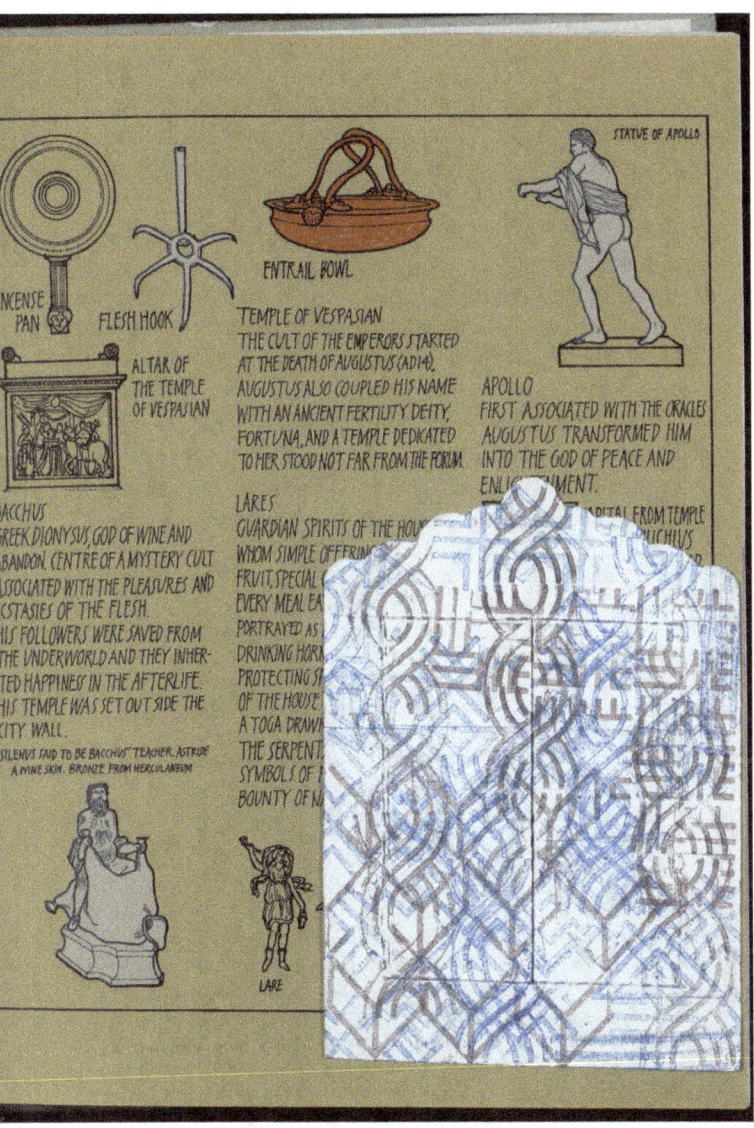

Figure 7.11. Eve Kosofsky Sedgwick, *The Last Days of Pompeii/Cavafy* collage book (c. 2007), central spread, inset between pp. 34–35. Photo: Kevin Ryan, Collection H.A. Sedgwick, © H.A. Sedgwick.

The passage also speaks to another key plot, the one in which various characters convert to Christianity, including, finally, Glaucus and Ione. This is a conversion that only straightens the characters further, and that Sedgwick might have wanted to resist with this erotic poem, with its 'slipping in', 'shuddering', and male–male relationality (see Figure 7.12).[43]

Immediately before the poem, opposite page 34, is another passage, looking like a queer little god in its household niche, that Sedgwick places vertically in an open, transparent-white envelope, addressed to readers and requiring them to take the Cavafian letter out of the envelope, having either reoriented themselves or the book through ninety degrees to read the text; a requirement for sympathetic action at the heart of the poem.[44] The passage, from 'Kleitos Illness' is sympathetically set against a page depicting a 'painting of a temple ceremony', describing what occurs and is found inside, illustrated by various votive

[43] Whilst we might expect the Christian characters to provide a straightforward foil to their gay pagan peers, the novel is more interesting in that, from a distance, spectators might mistake Christian and gay characters. As if cruising with alert gaydar, the secret, exclusively male Christian converts can recognize each other with a 'significant glance, a slight sign'. For example, as if in a Simeon Solomon painting, Apaecides meets Olinthus in a shady, woody place down by the river and feels 'attracted toward him by an irresistible sympathy'. He then 'approached him as by an instinct' and 'fell on his knees before him', so that the old man can, wait for it, lay 'his hand on the priest's head, and bless him, but not aloud'. As a result, his 'lips moved, his eyes were upturned, and tears — those tears that good men only shed in the hope of happiness to another — flowed fast down his cheeks'. Later, when he has 'crossed the fatal river', he becomes conscious of the 'hatred and the horror he should provoke amongst the pious' pagans, and worries about 'what penalties' he might 'incur for an offence hitherto unheard of — for which no specific law, derived from experience was prepared, and which, for that very reason, precedents, dragged from the sharpest armory of obsolete and inapplicable legislation, would probably be distorted to meet' (MC, 41–42, 57). For more on the false dichotomy 'Greek/Christian', see Eve Kosofsky Sedgwick, *Epistemology of the Closet* (Los Angeles: University of California Press, 1990), 136–41.

[44] The letter is well placed to queer the text. Immediately opposite, Lytton describes the scene of Ione receiving a letter from Glaucus (MC, 34).

objects. The poem describes how a woman, an old servant who brought Kleitos up, and recently converted to Christianity,

> secretly brings some votive cake, some votive wine and honey,
> and places them before the idol. She chants whatever phrases
> she remembers from old prayers: odds and ends. The ninny doesn't realize that the black demon couldn't care less whether a Christian gets well or not.

The poem can, again, be read in a number of ways. Firstly, in relation to how hopeless Sedgwick might have felt around her illness, when it came to divine intervention. Secondly, as a kind of queer Greek revenge on a Christianity that, in the novel, sought to replace it and characterize it as sinful. But, taken in full, the poem suggests Cavafy's devoted love, in the period around the first world war, and Sedgwick's, in the midst of the AIDS crisis, for a series of 'seriously ill', highly intelligent, 'likeable young' men, aged 'about twenty-three years old', with a 'rare knowledge of Greek', who have 'caught the fever / that reaped a harvest this year in Alexandria', and who need a miraculous cure.[45]

Indeed, Cavafy's writing is surprisingly resonant in the context of the AIDS crisis, especially in epitaph poems in which, as Edmund Keeley has noted, his young men were 'to be mourned without being blamed'.[46] For example, Jane Lagoudis documented that Cavafy took 'pride in the risk that living the sensuous passionate life brings', whilst Lawrence Durrell discussed how 'all the grandeur of Cavafy' lay in his 'patient, loving, miserly way of looking at objects — *reinfecting* memory time and time again with the passionate actuality of something that ha[d] disturbed him' [emphasis mine].[47]

45 Sedgwick also discusses 'Kleitos' Illness' in *The Weather in Proust*, 61.
46 Edmund Keeley, *Cavafy's Alexandria: Study of a Myth* (Cambridge: Harvard University Press, 1976), 82.
47 Lagoudis, *Alexandria Still*, 61, 74.

THE HAPPY BEAUTY
AND THE BLIND SLAVE

A slave entered the chamber of Ione. A messenger from Glaucus desired to be admitted.

Ione hesitated an instant.

'She is blind, that messenger,' said the slave; 'she will do her commission to none but thee.'

Base is that heart which does not respect affliction! The moment she heard the messenger was blind, Ione felt the impossibility of returning a chilling reply. Glaucus had chosen a herald that was indeed sacred—a herald that could not be denied.

'What can he want with me? what message can he send?' and the heart of Ione beat quick. The curtain across the door was withdrawn; a soft and echoless step fell upon the marble; and Nydia, led by one of the attendants, entered with her precious gift.

She stood still a moment, as if listening for some sound that might direct her.

'Will the noble Ione,' said she, in a soft and low voice, 'deign to speak, that I may know whither to steer these benighted steps, and that I may lay my offerings at her feet?'

'Fair child,' said Ione, touched and soothingly, 'give not thyself the pain to cross these slippery floors; my attendant will bring to me what thou hast to present;' and she motioned to the handmaid to take the vase.

'I may give these flowers to none but thee,' answered Nydia; and, guided by her ear, she walked slowly to the place where Ione sat, and kneeling where she came before her, proffered the vase.

Ione took it from her hand, and placed it on the table at her side. She then raised her gently, and would have seated her on the couch, but the girl modestly resisted.

'I have not yet discharged my office,' said she; and she drew the letter of Glaucus from her vest. 'This will, perhaps, explain why he who sent me chose as unworthy a messenger to Ione.'

The Neapolitan took the letter with a hand, the trembling of which Nydia at once felt and sighed to feel. With folded arms, and downcast looks, she stood before the proud and stately form of Ione;—no less proud, perhaps, in her attitude of submission. Ione waved her hand, and the attendants withdrew; she gazed again upon the form of the young slave in surprise and beautiful compassion; then, retiring a little from her, she opened and read the following letter:—

'Glaucus to Ione sends more than he dares to utter. Is Ione ill? thy slaves tell me "No," and that assurance comforts me. Has Glaucus offended Ione?—ah! that question I may not ask from *them*. For five days I have been banished from thy presence. Has the sun shone?—I know it not. Has the sky smiled?—it has had no smile for me. My sun and my sky are Ione. Do I offend thee? Am I too bold? Do I say that on the tablet which my tongue has hesitated to breathe? Alas! it is in thine absence that I feel most the spells by which thou hast subdued me. And absence, that deprives me of joy, brings me courage. Thou wilt not see me; thou hast banished also the common flatterers that flock around thee. Canst thou confound me with them? It is not possible! Thou knowest too well that I am not of them—that their clay is not mine. For even were I of the humblest mould, the fragrance of the rose hath penetrated me, and the spirit of thy nature hath passed within me, to embalm, to sanctify, to inspire. Have they slandered me to thee, Ione? Thou wilt not believe them. Did the Delphic oracle itself tell me thou wert unworthy, I would not believe it; and am I less incredulous than thou? I think of the last time we met—of the song which I sang to thee—of the look that thou gavest me in return. Disguise it as thou wilt, Ione, there is something kindred between us, and our eyes acknowledged it, though our lips were silent. Deign to see me, to listen to me, and after that exclude me if thou wilt. I meant not so soon to say I loved. But those words rush to my heart—they will have way. Accept, then, my homage and my vows. We met first at the shrine of Pallas; shall we not meet before a softer and a more ancient altar?

'Beautiful! adored Ione! If my hot youth and my Athenian blood have misguided and allured me, they have but taught my wanderings to appreciate the rest—the haven they have attained. I hang up my dripping robes on the Sea-god's shrine. I have escaped shipwreck. I have found THEE. Ione, deign to see me; thou art gentle to strangers, wilt thou be less merciful to those of thine own land? I await thy reply. Accept the flowers which I send—their sweet breath has a language more eloquent than words. They take from the sun the odours they return—they are the emblem of the love that receives and repays tenfold—the emblem of the heart that drunk thy rays, and owes to thee the germ of the treasures that it proffers to thy smile. I send these by one whom thou wilt receive for her own sake, if not for mine. She, like us, is a stranger; her fathers' ashes lie under brighter skies: but, less happy than we, she is blind and a slave. Poor Nydia! I seek as much as possible to repair to her the cruelties of Nature and of Fate, in asking permission to place her with thee. She is gentle, quick, and docile. She is skilled in music and the song; and she is a very Chloris to the flowers. She thinks Ione, that thou wilt love her: if thou dost her back to me.

'One word more,—let me be Why thinkest thou so highly of Egyptian? he hath not about him honest men. We Greeks learn man our cradle; we are not the less pro that we affect no sombre mien; our but our eyes are grave—they obse note—they study. Arbaces is not credulously trusted: can it be tha wronged me to thee? I think it, fo with thee; thou sawest how my stung him; since then thou hast not me. Believe nothing that he can s disfavour; if thou dost, tell me so at this Ione owes to Glaucus. Fare letter touches thy hand; these chara thine eyes—shall they be more ble he who is their author. Once more,

It seemed to Ione, as she read t as if a mist had fallen from her ey had been the supposed offence of G that he had not really loved! plainly, and in no dubious terms, he that love. From that moment his p fully restored. At every tender wo letter, so full of romantic and trustfu her heart smote her. And had she d faith, and had she believed another she not, at least, allowed to him the right to know his crime, to plea defence?—the tears rolled down h —she kissed the letter—she placed bosom; and, turning to Nydia, she the same place and in the same po

'Wilt thou sit, my child,' said sh write an answer to this letter?'

'You will answer it, then?' sa coldly. 'Well, the slave that accomp will take back your answer.'

'For you,' said Ione, 'stay with me, your service shall be light.'

Nydia bowed her head.

'What is your name, fair girl?'

'They call me Nydia.'

'Your country?'

'The land of Olympus—Thessal

'Thou shalt be to me a friend,' caressingly, 'as thou art alread countrywoman. Meanwhile, I bese stand not on these cold and glassy r There! now that thou art seated, thee for an instant.'

'Ione to Glaucus greeting,—co Glaucus,' wrote Ione,—'Come t morrow. I may have been unjust to I will tell thee, at least, the fault ha imputed to thy charge. Fear not, h the Egyptian—fear none. Thou s hast expressed too much—alas! hasty words I have already done so.

As Ione reappeared with the let she did not dare to read after she h

34

Figure 7.12. Eve Kosofsky Sedgwick, *The Last Days of Pompeii/Cavafy collage book* (c. 2007), inset opposite p. 34. Photo: Kevin Ryan, Collection H.A. Sedgwick, © H.A. Sedgwick.

Particularly resonant in this context is Cavafy's poem, 'The Bandaged Shoulder', in which the narrator describes enjoying 'looking at the blood' of his beloved and, putting part of his beloved's 'dressing', 'a bloody rag', to his lips, rather than 'into the garbage', wanting for a 'long while / the blood of love against my lips'.[48] Whilst these 'bug-chasing' readings are obviously anachronistic, they are characteristic of the complex, overlapping time frames of Lytton's novel, Cavafy's verse, and Sedgwick's collage. For example, Daly notes how *The Last Days* is 'as much a novel of 1834 as it is of 79 CE', and Lytton's 'metaleptic footnotes and narratorial injections' repeatedly 'interrupt the narrative flow to anchor the diegesis to the narrator's (and arguably reader's) present'.[49] And 'The Spectacle of AIDS', the famous essay on the visual culture of the pandemic by Sedgwick's close friend, Simon Watney, to whom we shall return, poignantly begins with a quotation from Cavafy's 'Waiting for the Barbarians'.[50]

48 Robert Liddell shared his fantasy that, after Cavafy's death and the decay of his body into dust, the citizens of Alexandria could 'still wipe their eponymous hero from their noses, or comb him from their hair' (*Cavafy: A Critical Biography*, 209). For more on such ideas, see Tim Dean, *Unlimited Intimacy: Reflections on the Subculture of Barebacking* (Chicago: University of Chicago Press, 2009), and Kathryn Bond Stockton, 'Reading as Kissing, Sex with Ideas: 'Lesbian' Barebacking', *Los Angeles Review of Books*, March 15 2015, https://lareviewofbooks.org/article/reading-kissing-sex-ideas-lesbian-barebacking/, as well as *Making Out* (New York: NYU Press, 2019).

49 Daly, 'Volcanic Disaster', 273–74.

50 Simon Watney, *The Practices of Freedom: Selected Writings on HIV/AIDS* (Durham: Duke University Press, 1994), 46. In this context, Cavafy's poem might again bring to mind the NAMES memorial quilt, given the importance of the blood transmission of HIV and the queer 'Memorial Rags' that Sedgwick's friend Michael Moon discussed in a 1995 essay, in a volume dedicated to the memory of their mutual friend Michael Lynch, who died of AIDS-related illness. Moon focused on the 'superabundance of wounds and ragged bandages' in Walt Whitman's war poetry, amongst a range of queer fabrics including 'rags, bandages, torn garments, and blankets that cover the dead and enfold them for burial'. Indeed, his description of the poet's 'ragged strips of bloody cloth' seems peculiarly resonant here. For Moon, such rags were important because such 'caregiving' as the 'undressing, bathing, drying, and dressing' of the 'wounds' of friends and loved ones who were 'patients' could be 'erotically charged'.

As if to provide encouragement to readers struggling to know what to do in this poignant context, Sedgwick provides some words on encouragement on page 34, on a thin strip of green paper, angled down so as to appear to be a kind of speech bubble rising up from the illustration on the pen on the page (see Figure 7.13).

The two lines, 'To have come this afar is a glorious achievement: / what you have done is already a glorious thing', derive from Cavafy's 'The First Step' and quote Theocritus, encouraging a disheartened young poet, Eumenis, who wants to give up his vocation, having only managed to write one good idyll in a two-year period. In the context of The *Last Days*, however, the passage draws attention to the significant layering or *interlarding* aesthetic of the book. This is a stratigraphic layering formally appropriate to a city steeped in ash and later uncovered by archaeologists, layer-by-layer. It is also a layering technique that *fattens* up the book, making its pages thicker, and putting additional pressure on its spine, by adding to the text's weight and thickness; a stressed spine highly resonant for Sedgwick, as we have seen. After all, as the poem appears in the text, the reader reads Sedgwick quoting an English translation of a Greek Cavafy original, quoting Theocritus, on the top of a later set of illustrations to an original Lytton text. The materiality of the ink on the green paper of Sedgwick's addition, on the ink on the

This was a sexy caretaking particularly crucial for queer people's erotic identity in the midst of the AIDS crisis, and in the later stages of the syndrome. In addition, Moon emphasized that the resulting fabrics, the 'remnants', 'remainders, and reminders' of the loved one's body need not be shamefully put away, but might be displayed and worked with, to resist the 'sexist, heterosexist, and homophobic trajectory of Freud's account' of mourning and melancholia, which had a 'fundamentally normalizing' effect in the context of the crisis. For Cavafy, Moon, and Sedgwick, such memorial medical cloths were not a shameful secret to be disposed of and got over as quickly as possible. They were to be cherished and displayed, lovingly, care-fully, and erotically, as proudly perhaps as 'the cloth of [a] banner' or flag. For more, see Michael Moon, 'Memorial Rags', in *Professions of Desire,* eds. George E. Haggerty and Bonnie Zimmerman (New York: MLA, 1995), 233–40.

Figure 7.13. Eve Kosofsky Sedgwick, *The Last Days of Pompeii/Cavafy collage book* (c. 2007), inset opposite p. 35. Photo: Kevin Ryan, Collection II.A. Sedgwick, © H.A. Sedgwick.

white paper, of Lytton's original, meanwhile, only adds to this palimpsest aesthetic.[51]

Perhaps Sedgwick's queerest intervention, however, occurs approximately halfway through the book, across pages 48 and 49, where her intervention is again less straight illustration, than queer interruption (see Figure 7.14).

Her Sedgwick adds the opening lines from Cavafy's 'The Horses of Achilles' in the context of a novel that kills an entire 'gay' population without shedding a tear, so long as its lone straight couple survive, and in the specific context of the heterosexual machinations of Julia and Arbaces over what Lytton refers to as 'our lovers' — Glaucus and Ione.[52] Sedgwick largely obliterates Lytton's text through the addition of numerous, overlapping blue, violet, yellow and pink, playing-card shaped rectangles of color, and numerous groups of stamped horses, happily playing together. These mechanically-repetitive elements again put the emphasis on the same, rather than the different; the homo, rather than the hetero. In addition, Sedgwick provides more than fifteen horses to mourn the body of another dead gay man: Achilles' boy-lover Patroklus. Cavafy's text reads:

> When they saw Patroklus dead,
> so brave and strong, so young —
> the horses of Achilles began to weep;

51 The book refers to such over-layings and intermixtures as 'interlarding', when the narrator describes 'a strange and barbarous Latin, interlarded with some more rude and ancient dialect' (MC, 50). An anonymous, untitled March 1835 review of the book, in the *Dublin University Magazine* of 1835, also criticized Lytton's habit of 'interlarding the dialogues of his characters with Greek and Latin expression' (292). Interlarding — interspersing or embellishing speech or writing with different material — is exactly the word for Sedgwick's queer fattening of Lytton's text. Whilst she does not work on every single page, it might be worth noting, in the context of thinking about her breast cancer, and the surgeries associated with it, that she skips page 65, with its half-page illustration of Pompeian 'surgical instruments' (65). Like Sedgwick, Cavafy had cancer, towards the end of his life, in his larynx as a result of his heavy smoking (Anton, *Poetry and Poetics*, 73).

52 Lytton, MC, 50.

their immortal nature was upset deeply
by this work of death they had to look at.

Far from *contra naturam* this time, here Achilles and Patroklus' cross-generational, same-sex love is so natural that horses find it easy to weep for them; an example of Sedgwick strategically employing the kind of contradictory discourses surrounding homosexuality that was the subject of *Epistemology of the Closet*.[53] But, as readers learned from Tendencies, something about queer was 'inextinquishable', where Sedgwick was concerned, as it represented a 'continuing moment, movement, motive — recurrent, eddying, *troublant*' (see Figure 7.15).[54]

And the next citation from Cavafy, on page 51 makes just that point, that if Lytton sought to destroy an entire 'gay' population through the fires of Vesuvius, and the actions of the Witch's Cavern, text that Sedgwick obliterates through her pink stamps, then Sedgwick and Cavafy thought that queer life was itself like a volcano, in that it could only be extinguished temporarily.

The poem Sedgwick cites, meanwhile, 'Chandelier', describes a room, 'empty, small, four walls only', perhaps like the pages of a book, but 'covered with green cloth', just as Sedgwick prints her text on a piece of green paper, and collages a glittering green diamond as if emerging out of the clay lamp reproduced on the page. This seems to stand for the beautiful, burning chandelier, 'all fire', in each of whose flames burns and glows a hot 'sensual fever, / a lascivious urge'. Then come the lines that Sedgwick quotes: 'In the small room, radiantly lit / by the chandelier's hot fire, / no ordinary heat breaks out. / Not for timid bodies / the

53 For example, Sedgwick there argues that in 'the historical search for a Great Paradigm Shift', Michel Foucault's claims for the 'birth of modern homosexuality' in 1870, misleadingly imagines that contemporary accounts of male same-sex desire comprise a 'coherent definitional field rather than a space of overlapping, contradictory, and conflictual definitional forces' (*Epistemology*, 44–45). For more, see Whitney Davis, 'Triple Cross: Binarisms and Binds in *Epistemology of the Closet*', *Representations* 149, no. 1 (Winter 2020), 134–58.

54 Eve Kosofsky Sedgwick, *Tendencies* (Durham: Duke University Press, 1993), xii.

QUEER AND BOOKISH

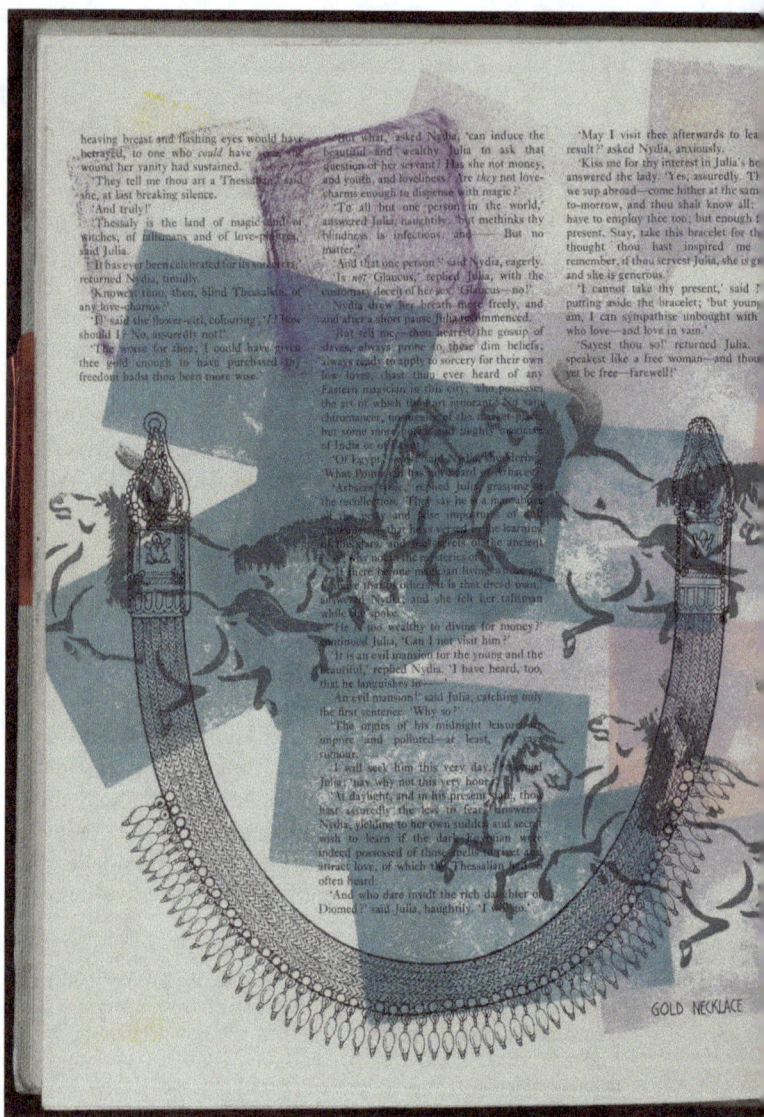

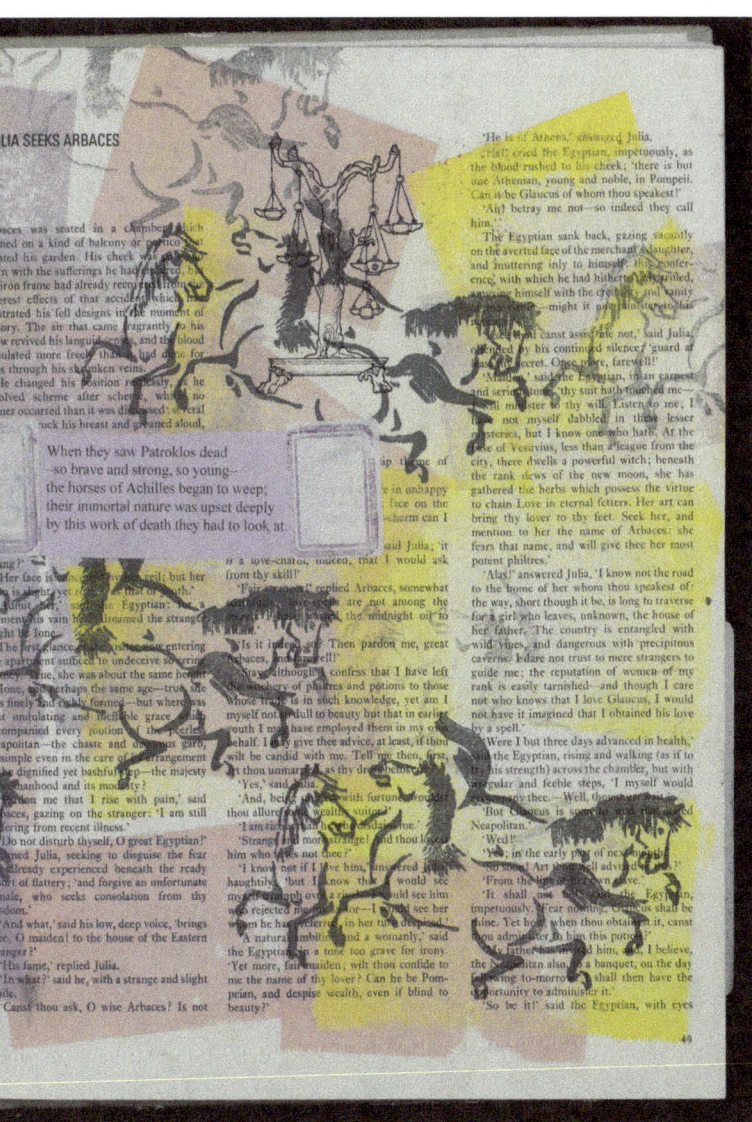

Figure 7.14. Eve Kosofsky Sedgwick, *The Last Days of Pompeii/Cavafy collage book* (c. 2007), pp .48–49. Photo: Kevin Ryan, Collection H.A. Sedgwick, © H.A. Sedgwick.

flashing such fierce joy, that Julia's gaze sank trembling beneath them. 'To-morrow eve, then, order thy litter.'

Left alone, Arbaces summoned one of his slaves, bade him hasten to track the steps of Julia, and acquaint himself with her name and condition. This done, he stepped forth into the portico. The skies were serene and clear; but he, deeply read in the signs of their various change, beheld in one mass of cloud, far on the horizon, which the wind began slowly to agitate, that a storm was brooding above.

'It is like my vengeance,' said he, as he gazed; 'the sky is clear, but the cloud moves on.'

THE WITCH'S CAVERN

It was when the heats of noon died gradually away from the earth, that Glaucus and Ione went forth to enjoy the cooled and grateful air. At that time, various carriages were in use among the Romans; the one most used by the richer citizens, when they required no companion in their excursions, was the *biga*, already described in the early portion of this work; that appropriated to the matrons, was termed *carpentum*, which had commonly two wheels; the ancients used also a sort of litter, a vast sedan-chair, more commodiously arranged than the modern, inasmuch as the occupant thereof could lie down at ease, instead of being perpendicularly and stiffly jostled up and down. There was another carriage, used both for travelling and for excursions in the country; it was commodious, containing three or four persons with ease, having a covering which could be raised at pleasure; and, in short, answering very much the purpose of, (though very different in shape from) the modern britska. It was a vehicle of this description that the lovers, accompanied by one female slave of Ione, now used in their excursion. About ten miles from the city, there was at that day an old ruin, the remains of a temple, evidently Grecian; and as for Glaucus and Ione everything Grecian possessed an interest, they had agreed to visit these ruins: it was thither they were now bound.

They arrived at the ruins; they examined them with that fondness with which we trace the hallowed and household vestiges of our own ancestry—they lingered there till Hesperus appeared in the rosy heavens, and then returning homeward in the twilight, they were more silent than they had been yet; in the shadow and beneath the stars they felt more oppressively their mutual love.

It was at this time that the storm began to creep visibly over them. At first, a low and distant thunder gave warning of the approaching conflict of the elements; and then rapidly rushed above the dark ranks of the serried clouds. The suddenness of storms in that climate is something almost preternatural, and might well suggest to early superstition the notion of a divine agency—a few large drops broke heavily among the boughs that half overhung their path, and then, swift and intolerably bright, the forked lightning darted across their very eyes, and was swallowed up by the increasing darkness.

'Swifter, good Carrucarius!' cried Glaucus to the driver, 'the tempest comes on apace.'

The slave urged on the mules—they went swift over the uneven and stony road—the clouds thickened, near and more near broke the thunder, and fast rushed the dashing rain.

'Dost thou fear?' whispered Glaucus, as he sought excuse in the storm to come nearer to Ione.

'Not with thee,' said she, softly.

At that instant, the carriage, fragile and ill-contrived (as, despite their graceful shapes, were, for practical uses, most of such inventions at that time), struck violently into a deep rut, over which lay a log of fallen wood; the driver, with a curse, stimulated his mules yet faster for the obstacle, the wheel was torn from the socket, and the carriage suddenly overset.

Glaucus, quickly extricating himself from the vehicle, hastened to assist Ione, who was fortunately unhurt; with some difficulty they raised the carruca (or carriage) and found that it ceased any longer even to afford them shelter; the springs that fastened the covering were snapped asunder, and the rain poured fast and fiercely into the interior.

In this dilemma, what was to be done? They were yet some distance from the city—no house, no aid, seemed near.

'There is,' said the slave, 'a smith about a mile off; I could seek him, and he might fasten at least the wheel to the carruca—but, Jupiter! how the rain beats; my mistress will be wet before I come back.'

'Run thither at least,' said Glaucus, 'we must find the best shelter we can till you return.'

The lane was overshadowed with trees, beneath the amplest of which Glaucus drew Ione. He endeavoured, by stripping his own cloak, to shield her yet more from the rapid rain; but it descended with a fury that broke through all puny obstacles: and suddenly, while Glaucus was yet whispering courage to his beautiful charge, the lightning struck one of the trees immediately before them, and split with a mighty crash its huge trunk in twain. This awful incident apprised them of the danger they braved in their present shelter, and Glaucus looked anxiously round for some less perilous place of refuge. 'We are

now,' said he, 'half-way up the ascent of Vesuvius; there ought to be some caverns hollow in the vine-clad rocks, could we find it, in which the deserting Nymphs left a shelter.' While thus saying he rose from the trees, and, looking wistfully towards the mountain, discovered through the advancing gloom a red and tremulous light at a considerable distance. 'That must come,' he, 'from the hearth of some shepherd or vine-dresser—it will guide us to a hospitable retreat. Wilt thou stay here, while I—yet no—that would be to leave thee in danger.'

'I will go with you cheerfully,' said Ione. 'Open as the space seems, it is better than treacherous shelter of these boughs.'

Half leading, half carrying Ione, Glaucus accompanied by the trembling female slave, advanced towards the light, which yet burned red and steadfastly. At length the space no longer open, wild vines entangled his steps, and hid from them, save by impetuous intervals, the guiding beam. But faster fiercer came the rain, and the light assumed its most deadly and blasting hues; they were still, therefore, impelled onward, hoping, at last, if the light eluded them to arrive at some cottage of some friend cavern. The vines grew more and more intricate—the light was entirely unable from them; but a narrow path, which trod with labour and pain, guided only by constant and long-lingering flashes of storm, continued to lead them toward direction. The rain ceased suddenly; precipitous and rough crags of scorched lava from before them, rendered more fearful by lightning, that illumined the dark dangerous soil. Sometimes the blaze lingered over the iron-grey heaps of scoriae, covered part with ancient mosses or stunted trees it seeking in vain for some gentler produce earth, more worthy of its ire; and at other leaving the whole of that part of the scene darkness, the lightning, broad and sheer hung redly over the ocean, tossing far below until its waves seemed glowing into fire; so intense was the blaze, that it brought vividly into view even the sharp outline of more distant windings of the bay, from the Cernal Misenum, with its lofty brow, to beautiful Sorrentum, and the giant behind.

Our lovers stopped in perplexity and doubt when suddenly, as the darkness that gloomed between the fierce flashes of lightning more wrapped them round, they saw near but high, before them, the mysterious light Another blaze, in which heaven and earth were reddened, made visible to them the whole expanse; no house was near, but where they had beheld the light, they thought they saw in the recess of the cavern the out

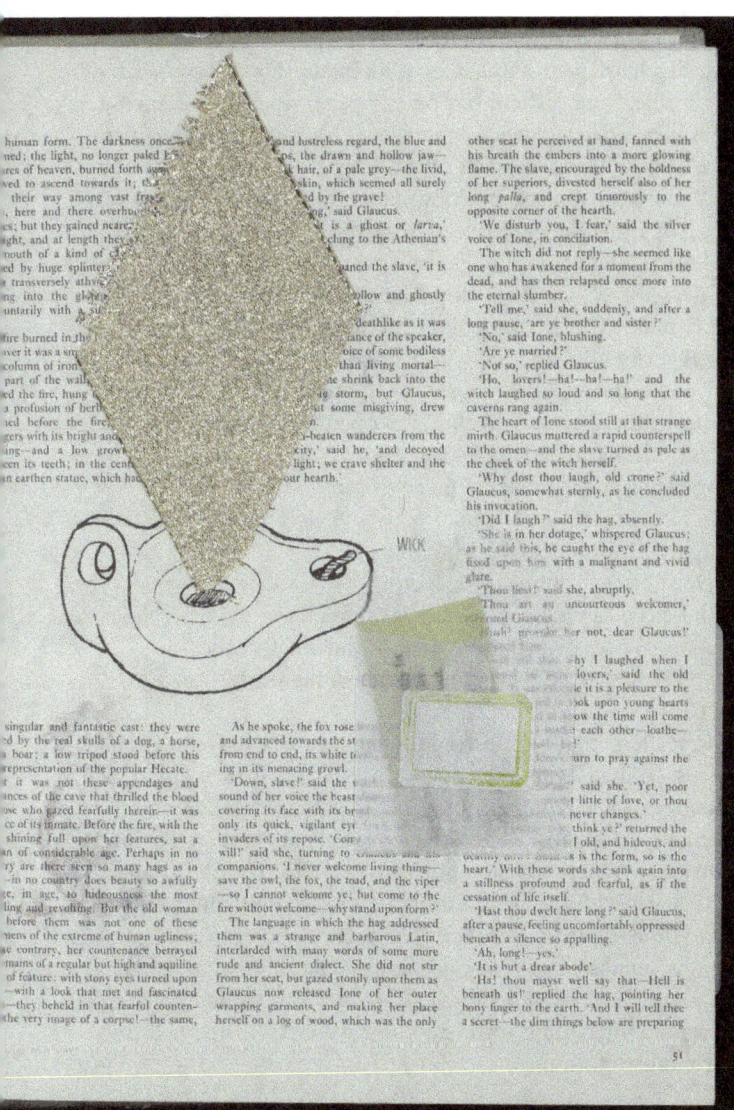

Figure 7.15. Eve Kosofsky Sedgwick, *The Last Days of Pompeii/Cavafy collage book* (c. 2007), pp. 50–51. Photo: Kevin Ryan, Collection H.A. Sedgwick, © H.A. Sedgwick.

rapture of this heat'. Or, as Walter Pater put it: 'to burn always with this hard, gem-like flame, to maintain this ecstasy, is success in life'.[55] But, as laid out on the page, reaching for such a life is easy, since Sedgwick again places Cavafy's text in an open envelope, tacitly addressed to the reader.

A more pessimistic position, however, follows on page 59, suggesting that the narrative of Sedgwick's *Last Days* represents a Melanie Kleinian volley between the paranoid-schizoid and the depressive, that good and bad are inseparable at every level, rather than a narrative teleology in any one sustained direction (see Figure 7.16).[56]

I make this claim because she quotes the final lines from Cavafy's 'The City' within a kind of open pouch, also holding a human-like figure, and juxtaposed with another 'domestic altar' whose efficacy the book has given us cause to question:

> You will always end up in this city.
> Don't hope for things elsewhere;
> there is no ship for you, there is no road.
> As you've wasted your life here, in this small corner,
> you've destroyed it everywhere else in the world.

Now, readers might again read the passage as a vengeful Greek chorus, seeing Cavafy's words as addressed at Glaucus and Ione who may escape Pompeii, but will stick with their tedious heterosexuality in Athens. Alternatively, viewers might read the lines from a more liberationist, nihilist, anti-dualist, Buddhist stance, particularly with the *Heart Sutra* in mind, as an encouragement not to think samsara — this city, Pompeii — and nirvana — Athens — as a happy elsewhere, or opposite, but instead to knuckle down and be at peace with where we are now, without looking for a road, or hoping for a ship, to save us from the volcanic inevitability of death.[57]

[55] Walter Pater, *The Renaissance: Studies in Art and Poetry* (London: Macmillan, 1873), 233.

[56] For more, see Sedgwick's 'Melanie Klein and the Difference Affect Makes', *The Weather in Proust*, 123–44. For more on Sedgwick's relation to Klein, see Deborah P. Britzman, 'Theory Kindergarten', in *Regarding Sedgwick*, eds. Barber and Clark, 121–24.

[57] For Sedgwick's responses to the Heart Sutra, which claims that 'form is emptiness, emptiness is form', and that there is 'no aging and death' but

This same melancholy mood colors Sedgwick's next quotation, printed on a piece of purple paper, pointing, like an arrow, to Alexandria, on a map on the insert between pages 66 and 67 (see Figure 7.17).

The final three lines of the poem 'The God Abandons Antony', and the final three lines of the 'Queer Little Gods' essay, the text reads: 'Listen — your final delectation — to the voices, / to the exquisite music of that strange procession, / and say goodbye to her, to the Alexandria you are losing.'[58] As quoted, the poem seems like a bardo-like farewell from Cavafy to his hometown, and from Sedgwick to her readers and life. As excerpted, however, the poem reads like an instruction: we are told what to do — to listen — and to what — the exquisite music all around us — as we say goodbye. But the longer context of the poem suggests how much work goes into being able to be in such a peaceful, passive, harmonious, present tense at the end of one's life, and is a far cry from the scrambled scenes of unprepared panic that dominate the last part of the novel. These scenes are suggested by the numerous illustrations, across the spread, of different kinds of transport to try to escape from the city, and of roads, seen from a birds'-eye view and in stratigraphic profile.

Like the end of the novel, the poem begins with a similar sense of shock, 'When suddenly, at midnight' we hear the invisible procession going by, but, 'As one long prepared, and graced with courage', readers are not to mourn 'uselessly' a 'luck that's failing now, / work gone wrong,' and 'plans / all proving deceptive', and are not to 'degrade' ourselves 'with empty hopes'. We are to listen and let go. Unlike Lytton's population, but like his readers, we have been warned, even if we cannot escape the in-

'also no extinction of aging and death', 'no suffering, no cause of suffering, no suppression of suffering', but also 'no path to annihilation of suffering', 'no path, no wisdom, and no gain', see *The Weather in Proust*, 75, and her poem 'Death', in *Bathroom Songs: Eve Kosofsky Sedgwick as a Poet*, ed. Jason Edwards (Earth: punctum books, 2017), 208, which ends with a Sanskrit quotation from it.

58 For more on 'The God Abandons Anthony', see *The Weather in Proust*, 67–68.

democrats in the pure and lofty acceptation of that perverted word,—Christianity would have perished in its cradle!

As each priest in succession slept several nights together in the chambers of the temple, the term imposed on Apæcides was not yet completed; and when he had risen from his couch, attired himself, as usual, in his robes, and left his narrow chamber, he found himself before the altars of the temple.

In the exhaustion of his late emotions he had slept far into the morning, and the vertical sun already poured its fervid beams over the sacred place.

'Salve, Apæcides!' said a voice, whose natural asperity was smoothed by long artifice into an almost displeasing softness of tone. 'Thou art late abroad; has the goddess revealed herself to thee in visions?'

'Could she reveal her true self to the people, Calenus, how inconceless would be these altars!'

'That,' replied Calenus, 'may possibly be true; but the deity is wise enough to hold commune with none but priests.'

'A time may come when she will be unveiled without her own acquiescence.'

'It is not likely: she has triumphed for countless ages. And that which has so long stood the test of time rarely succumbs to the lust of novelty. But hark ye, young brother! these sayings are indiscreet.'

'It is not for thee to silence them,' replied Apæcides, haughtily.

'So hot!—yet I will not quarrel with thee. Why, my Apæcides, has not the Egyptian convinced thee of the necessity of our dwelling together in craft? Has he not convinced thee of the wisdom of deluding the people and enjoying ourselves? If not, oh, brother! he is not that great magician he is esteemed.'

'Thou, then, hast shared his lessons?' said Apæcides, with a hollow smile.

'Ay! but I stood less in need of them than thou. Nature had already gifted me with the love of pleasure, and the desire of gain and power. Long is the way that leads the voluptuary to the severities of life; but it is only one step from pleasant sin to sheltering hypocrisy. Beware the vengeance of the goddess, if the shortness of that step be discursed!'

'Beware, thou, the hour when the tomb shall be rent and the rottenness exposed,' returned Apæcides, solemnly. '*Vale!*'

With these words he left the flamen to his meditations. When he got a few paces from the temple, he turned to look back. Calenus had already disappeared in the entry room of the priests, for it now approached the hour of that repast which, called *prandium* by the ancients, answers in point of date to the breakfast of the moderns. The white and graceful fane gleamed brightly in the sun. Upon the altars before it rose the incense and bloomed the garlands. The priest gazed long and wistfully upon the scene—it was the last time that it was ever beheld by him!

He then turned and pursued his way slowly towards the house of Ione; for before possibly the last tie that united them was cut in twain—before the uncertain peril of the next day was incurred, he was anxious to see his last surviving relative, his fondest as his earliest friend.

He arrived at her house, and found her in the garden with Nydia.

'This is kind, Apæcides,' said Ione, joyfully; 'and how eagerly have I wished to see thee!—what thanks do I not owe thee? How churlish hast thou been to answer none of my letters—to abstain from coming hither to receive the expressions of my gratitude! Oh! thou hast assisted to preserve thy sister from dishonour! What, what can she say to thank thee, now thou art come at last?'

'My sweet Ione, thou owest me no gratitude, for my cause was mine. Let us avoid that subject, let us recur not to that impious man —how hateful to both of us! I may have a speedy opportunity to teach the world the nature of his pretended wisdom and hypocritical severity. But let us sit down, my sister; I am wearied with the heat of the sun; let us sit in yonder shade, and, for a little while longer, be to each other what we have been.'

Beneath a wide plane-tree, with the cistus and the arbutus clustering round them, the living fountain before, the greensward beneath their feet; the gay cicada, once so dear to Athens, rising merrily ever and anon amidst the grass; the butterfly, beautiful emblem of the soul, dedicated to Psyche, and which has continued to furnish illustrations to the Christian bard, rich in the glowing colours caught from Sicilian skies, he about the sunny flowers, itself like a flower—in this spot, and this sce brother and the sister sat together for time on earth.

'Ione, my sister,' said the young c 'place your hand upon my brow; let your cool touch. Speak to me, too, f gentle voice is like a breeze that hath h as well as music. Speak to me, but *f bless me!* Utter not one word of tho of speech which our childhood was t consider sacred!'

'Alas! and what then shall I sa language of affection is so woven wit worship, that the words grow chil trite if I banish from them allusion gods.'

'*Our gods!*' murmured Apæcides shudder: 'thou slightest my request 'Shall I speak then to thee only of 'The Evil Spirit? No, rather be d ever, unless at least thou canst—b away this talk! Not now will we dis, cavil; not now will we judge harshl other. Thou, regarding me as an a and I all sorrow and shame for thi idolater. No, my sister, let us see topics and such thoughts. In the presence a calm falls over my spir little while I forget.'

'I will talk to thee then of our ear said Ione. 'Shall yon blind girl sin of the days of childhood?' Her voic and musical, and she hath a song theme which contains none of those it pains thee to hear.'

'Dost thou remember the we sister?' asked Apæcides.

'Methinks yes; for the tune, simple, fixed them on my memory. 'Sing to me then thyself. My ca unison with unfamiliar voices; a

Figure 7.16. Eve Kosofsky Sedgwick, *The Last Days of Pompeii/Cavafy collage book* (c. 2007), pp. 58–59. Photo: Kevin Ryan, Collection H.A. Sedgwick, © H.A. Sedgwick.

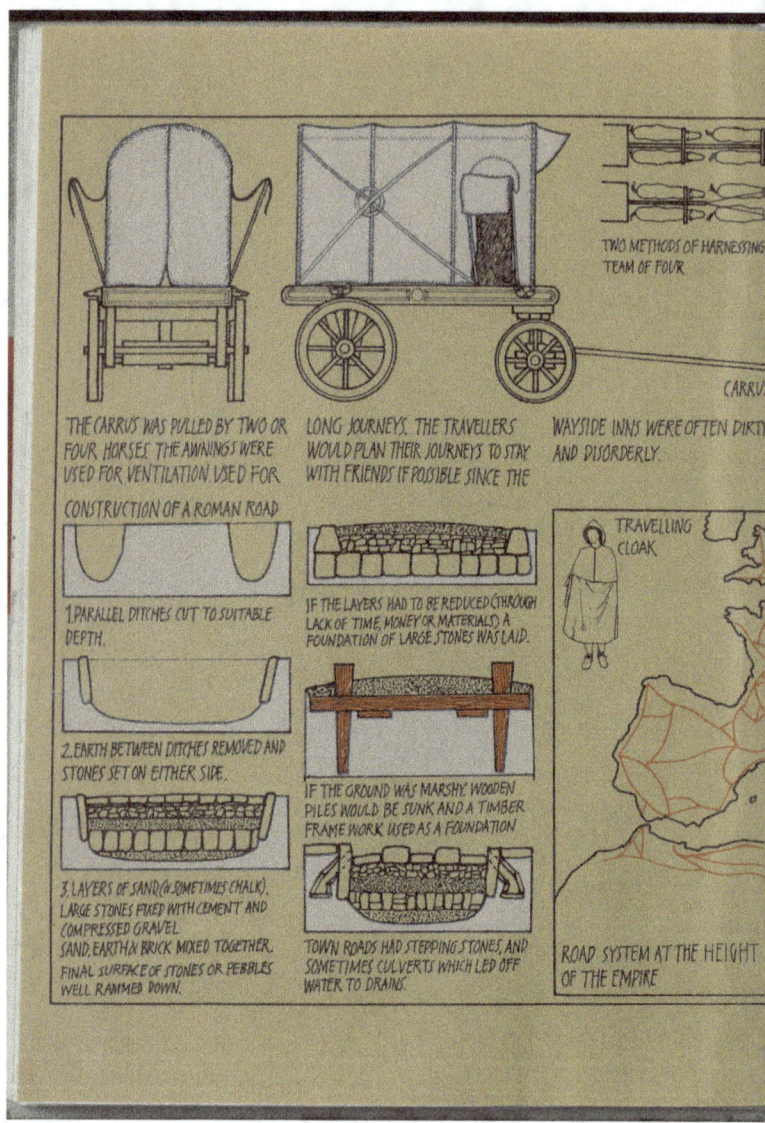

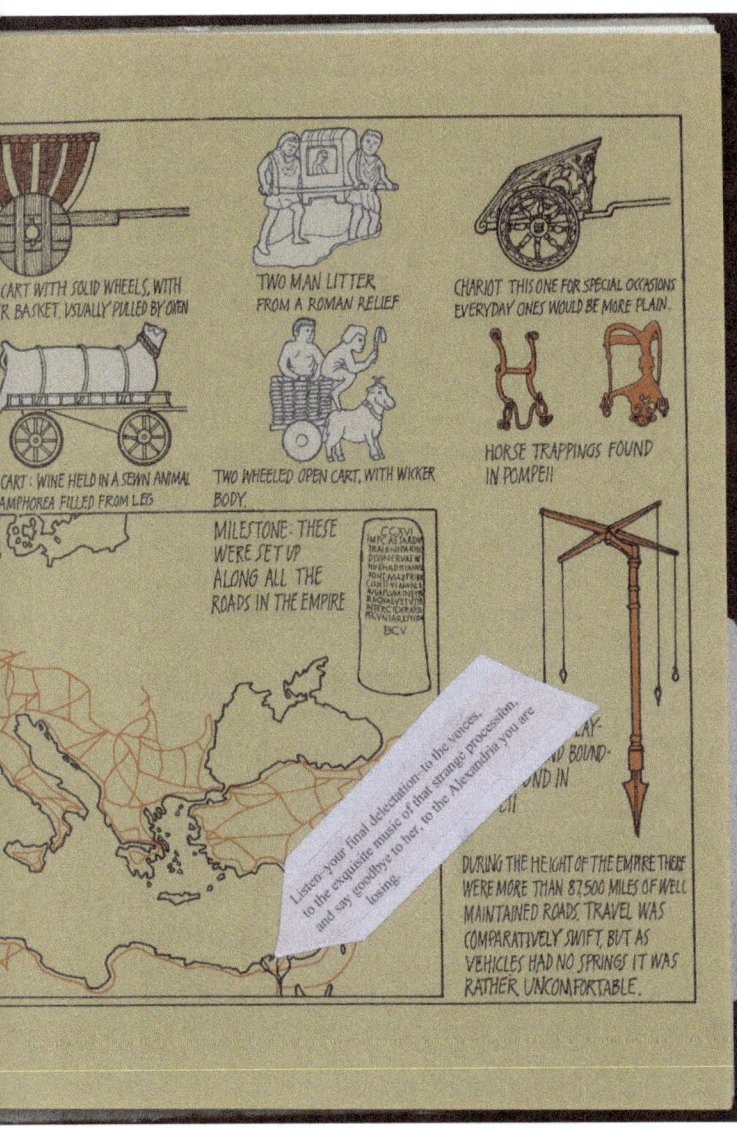

Figure 7.17. Eve Kosofsky Sedgwick, *The Last Days of Pompeii/Cavafy collage book* (c. 2007), central spread, inset between pp. 66–67. Photo: Kevin Ryan, Collection II.A. Sedgwick, © II.A. Sedgwick.

evitable. After all, the title of the novel, *The Last Days of Pompeii* reveals it to be a bardo-space. The least we can do, Sedgwick suggests, in addition to critiquing its sexual politics, is make use of the reparative spiritual opportunity it provides, to put us in touch with the sustained, intensifying reality of our own approaching last days.

Sedgwick's next Cavafian intervention, from the poem 'Since Nine O'clock', occurs on a blood-stained page 71, that contains the description of Apaecides' funeral, complete with urns and tombstones, on which she stamped the words 'Ave' and 'Vale', hail and farewell (see Figure 7.18).

This mourns, appropriately in the context of Pompeii, 'streets now unrecognizable, / bustling night clubs now closed,' and 'theatres and cafes no longer there'. In addition, Cavafy misses, as the novel does not, 'shut scented rooms' where 'past sensual pleasure — what daring pleasure' took place. As such, the poem again calls to mind a context that we discussed in Chapter One: the then-recently, strategically re-zoned New York, at the time Sedgwick was working on *Last Days*, famously sanitized and de-queered.[59] The characteristically cross-generational, self-relational passage she quotes, however, points to additional losses:

> The shade of my young body
> also brought back the things that make us sad:
> family, grief, separations,
> the feelings of my own people, feelings
> of the dead so little acknowledged.

It is unclear whether a biological family might be included in the causes of sadness, for example in the grief caused by the separation from an estranged sister, or the loss of a family through coming out. The poem might also refer to the loss of a queer

[59] For more, see Samuel R. Delaney, *Times Square Red, Times Square Blue* (New York: New York University Press, 1999), and Sarah Schulman, *The Gentrification of the Mind: Witness to a Lost Imagination* (Berkeley: University of California Press, 2012).

family, understood as 'my own people', a generation lost to AIDS so unbearable they had to be quickly forgotten and could not long be acknowledged; what Sedgwick referred to as the 'resolute disavowal of relation to the historical and continuing AIDS epidemic'.[60]

Sedgwick evokes a more sex-positive memory a few pages later, on page 75, when she quotes the first two lines of Cavafy's 'Come Back' (see Figure 7.19).

This reads 'Come back and take hold of me, / sensation that I love come back and take hold of me'. Here the context of the book provides the perverse substrate. A chained, clown-like figure, posed balletically on his right leg — a sadomasochistic balletic scene Sedgwick had repeatedly pondered, as we have seen — looks over his right shoulder at the poem's lines, printed on purple card, located in his sightline. Immediately behind that, on the opposite page is a 'money changer's booth' that could easily function as the kind of table over which Sedgwick had so often phantasmatically bent herself, as we have again seen. The title of the section in which the poem appears is equally resonant of her masochism: 'The Slave Consults the Oracle' (see Figure 7.20).[61]

Another Cavafy poem is being rewritten, and written again a few pages later, on page 90, where a quotation from Cavafy's 'In the Evening' is bent over an illustration of a 'bed also used as a couch for reclining', at a forty-five-degree angle, alongside a 'decoration for a bedstead'. This similarly mourns that 'It was soon over, that wonderful life, / Yet how strange the scents were, / what a magnificent bed we lay in, / what pleasure we

60 Eve Kosofsky Sedgwick, *Touching Feeling: Affect, Pedagogy, Performativity* (Durham: Duke University Press, 2003), 13.

61 The illustration also brings to mind Cavafy's description of how the Byzantine period was 'like a closet with many drawers. If I want something, I know where to find it, into which drawer to look', cited in Peter Jeffreys, *Eastern Questions: Hellenism and Orientalism in the Writings of E.M. Forster and C.P. Cavafy* (Greensboro: University of North Carolina Press, 2005), 105.

A CLASSIC FUNERAL

While Arbaces had been thus employed, Sorrow and Death were in the house of Ione. It was the night preceding the morn in which the solemn funeral rites were to be decreed to the remains of the murdered Apaecides. The corpse had been removed from the temple of Isis to the house of the nearest surviving relative, and Ione had heard, in the same breath, the death of her brother and the accusation against her betrothed. That first violent anguish which blunts the sense to all but itself, and the forbearing silence of her slaves, had prevented her learning minutely the circumstances attendant on the fate of her lover. His illness, his frenzy, and his approaching trial, were unknown to her. She learned only the accusation against him, and at once indignantly rejected it; nay, on hearing that Arbaces was the accuser, she required no more to induce her firmly and solemnly to believe that the Egyptian himself was the criminal.

The stars were fading one by one from the grey heavens, and night slowly receding before the approach of morn, when a dark group stood motionless before Ione's door. High and slender torches, made paler by the unmellowed dawn, cast their light over various countenances, hushed for the moment in one solemn and intent expression. And now there arose a slow and dismal music, which accorded sadly with the rite, and floated far along the desolate and breathless streets.

As the hymn died away, the group parted in twain; and placed upon a couch, spread with a purple pall, the corpse of Apaecides was carried forth, with the feet foremost. The designator, or marshal of the sombre ceremonial, accompanied by his torch-bearers, clad in black, gave the signal, and the procession moved dreadly on.

First went the musicians, playing a slow march—the solemnity of the lower instruments broken by many a louder and wilder burst of the funeral trumpet: next followed the hired mourners, chanting their dirges to the dead; and the female voices were mingled with those of boys, whose tender years made still more striking the contrast of life and death—the fresh leaf and the withered one. But the players, the buffoons, the archimimus (whose duty it was to personate the dead)—these, the customary attendants at ordinary funerals, were banished from a funeral attended with so many terrible associations.

The priests of Isis came next in their snowy garments, barefooted, and supporting sheaves of corn; while before the corpse were carried the images of the deceased and his many Athenian forefathers. And behind the bier followed, amidst her women, the sole surviving relative of the dead—her head bare,

her locks dishevelled, her face paler marble, but composed and still, save eve anon, as some tender thought—awaken the music, flashed upon the dark letha woe, she covered that countenance wit hands, and sobbed unseen; for hers wes the noisy sorrow, the shrill lament ungoverned gesture, which characte those who honoured less faithfully. I age, as in all, the channel of deep grief fl hushed and still.

And so the procession swept on, till i traversed the streets, passed the city gate gained the Place of Tombs without the which the traveller yet beholds.

Raised in the form of an altar—o polished pine, amidst whose interstices placed preparations of combustible mat stood the funeral pyre; and around it dr the dark and gloomy cypresses so consec by song to the tomb.

As soon as the bier was placed upor pile, the attendants parting on either Ione passed up to the couch, and motionless and silent. The features o dead had been composed from the agonised expression of violent death. sister gazed, and not a sound was

CROSS SECTION OF URN

CROSS SECTION OF TOMB WITH URNS IN NICHES

amidst the crowd; there was somet terrible, yet softening, also, in the silence; when it broke, it broke sudden and abru it broke, with a loud and passionate cry vent of long-smothered despair.

'My brother! my brother!' cried the orphan, falling upon the couch; 'thou w the worm on thy path feared not— enemy couldst thou provoke? Oh, is truth come to this? Awake! awake! We together! Are we thus torn asunder? T art not dead—thou sleepest. Awake! awa

The sound of her piercing voice aro the sympathy of the mourners, and broke into loud and rude lament.

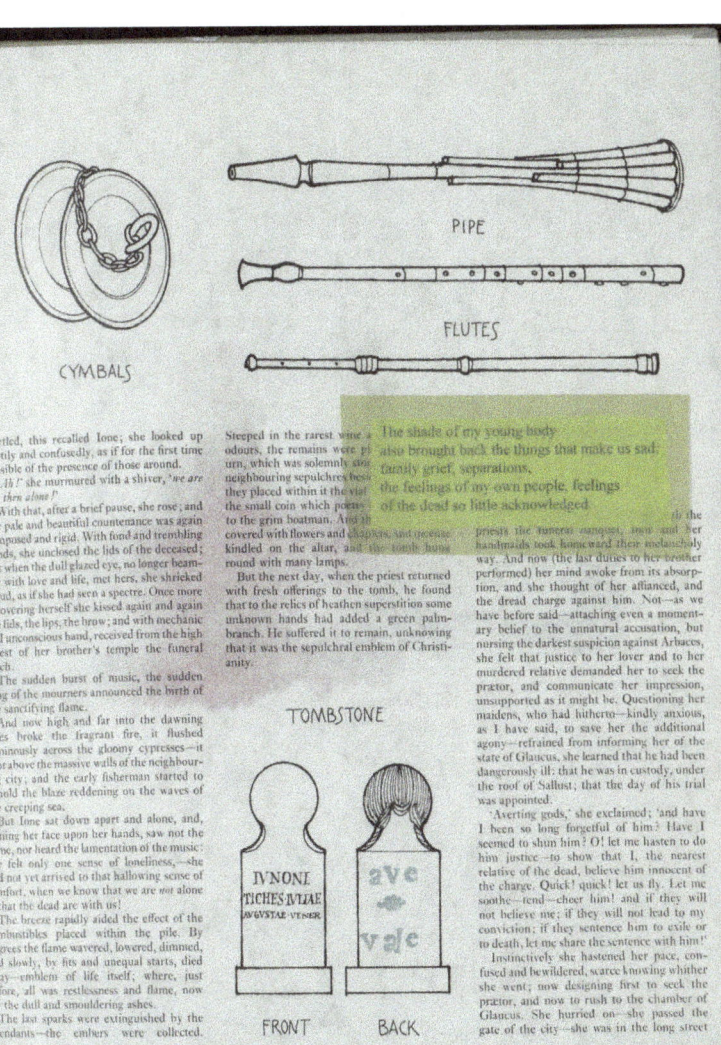

Figure 7.18. Eve Kosofsky Sedgwick, *The Last Days of Pompeii/Cavafy collage book* (c. 2007), pp. 70–71. Photo: Kevin Ryan, Collection H.A. Sedgwick, © H.A. Sedgwick.

A WASP VENTURES INTO THE SPIDER'S WEB

'I trust,' said Sosia, tremulously, 'that there is nothing very frightful in the operation? I have no love for apparitions.'

'Fear not; thou wilt see nothing; thou wilt only hear by the bubbling of water whether or not thy suit prospers. First, then, be sure, from the rising of the evening star, that thou leavest the garden-gate somewhat open, so that the demon may feel himself invited to enter therein; and place fruits and water near the gate as a sign of hospitality; then, three hours after twilight, come here with a howl of the coldest and purest water, and thou shalt learn all, according to the Thessalian lore my mother taught me. But forget not the garden-gate—all rests upon that: it must be open when you come, and for three hours previously.'

'Trust me,' replied the unsuspecting Sosia; 'I know what a gentleman's feelings are when a door is shut in his face, as the cookshop's hath been in mine many a day; and I know, also, that a person of respectability, as a demon of course is, cannot but be pleased, on the other hand, with any little mark of courteous hospitality. Meanwhile, pretty one, here is thy morning's meal.'

'But what of the trial?'

'Oh, the lawyers are still at it—talk, talk—it will last over till to-morrow.'

'To-morrow? You are sure of that?'

'So I hear.'

'And Ione?'

'By Bacchus! she must be tolerably well, for she was strong enough to make my master stamp and bite his lip this morning. I saw him quit her apartment with a brow like a thunder-storm.'

'Lodges she near this?'

'No—in the upper apartments. But I must not stay prating here longer—Vale!'

The second night of the trial had set in; and it was nearly the time in which Sosia was to brave the dread Unknown, when there entered, at that very garden-gate which the slave had left ajar—not, indeed, one of the mysterious spirits of earth or air, but the heavy and most human form of Calenus, the priest of Isis. He scarcely noted the humble offerings of indifferent fruit, and still more indifferent wine, which the pious Sosia had deemed good enough for the invisible stranger they were intended to allure. 'Some tribute,' thought he, 'to the garden god. By my father's head! if his deityship were never better served, he would do well to give up the godly profession. Ah! were it not for us priests, the gods would have a sad time of it. And now for Arbaces—I am treading a quicksand, but it ought to cover a mine. I have the Egyptian's life in my power—what will he value it at?'

As he thus soliloquised, he crossed through the open court into the peristyle, where a few lamps here and there broke upon the empire of the starlit night; and issuing from one of the chambers that bordered the colonnade, suddenly encountered Arbaces.

'Ho! Calenus—seekest thou me?' said the Egyptian; and there was a little c[...] ment in his voice.

'Shall we within to your chamber.'

'As you will; but the night is balmy—I have some remains of la[...] lingering on me from my recent ill[...] air refreshes me—let us walk in the we are equally alone there.'

'With all my heart,' answered t[...] and the two *friends* passed slowly the many terraces which, bordered vases and sleeping flowers, inters[...] garden.

'It is a lovely night,' said Arbac[...] and beautiful as that on which, tw[...] ago, the shores of Italy first broke view. My Calenus, age creeps up[...] us, at least, feel that we have lived.

'Thou, at least, mayst arrogate th[...] said Calenus, beating about, as it w[...] opportunity to communicate the se[...] weighed upon him, and feeling his of Arbaces still more impressively from the quiet and friendly tone o[...] condescension which the Egyptian a[...] 'Thou, at least, mayst arrogate [...] Thou hast had countless wealth—[...] whose close-woven fibres disease c[...] spare to enter—prosperous love[...] rible pleasure—and, even at t[...] triumphant revenge.'

'Thou alludest to the Athenian? morrow's sun the fiat of his dea[...] forth. The senate does not relent mistakest: his death gives me gratification than that it releases [...] rival in the affections of Ione. I c[...] other sentiment of animosity ag[...] unfortunate homicide.'

'Homicide!' repeated Calenus, meaningly; and, halting as he upl[...] his eyes upon Arbaces. The stars and steadily on the proud face prophet; but they betrayed there [...] the eyes of Calenus fell disapp[...] abashed. He continued rapidly—'it is well to charge him with that thou, of all men, knowest that he i[...]

'Explain thyself,' said Arbaces, he had prepared himself for th[...] secret fears had foretold.

'Arbaces,' answered Calenus, voice into a whisper, 'I was in grove, sheltered by the chapel an[...] rounding foliage. I overheard—I [...] whole. I saw thy weapon pierce [...] Apæcides, I blame not the deed—i[...] a foe and an apostate.'

'Thou sawest the whole!' said drils; 'so I imagined—thou wert a[...]

'Alone!' returned Calenus, surp[...] Egyptian's calmness.

'And wherefore wert thou hid [...] chapel at that hour?'

MONEY CHANGERS BOOTH

Figure 7.20. Eve Kosofsky Sedgwick, *The Last Days of Pompeii/Cavafy collage book* (c. 2007), pp. 90–91. Photo: Kevin Ryan, Collection H.A. Sedgwick, © H.A. Sedgwick.

Figure 7.19. Eve Kosofsky Sedgwick, *The Last Days of Pompeii/Cavafy collage book* (c. 2007), pp. 74–75. Photo: Kevin Ryan, Collection H.A. Sedgwick, © H.A. Sedgwick.

gave our bodies', even if, as in the novel, 'Fate did put an end to it a bit abruptly'.

In an unprecedented editorial move, another section of the poem continues a few pages later, in the insert opposite page 94 (see Figure 7.21).

This offers an example of intensely sustained enjambment stretching from the line break before the quoted section, through a number of turned pages, to where the lyric continues. As the volcano begins to destroy the gay Pompeians, Sedgwick *stretches* and *spreads* out Cavafy's otherwise too brief pleasure. She locates the final lines adjacent to a spreading gritty, glittery, green stain that has emerged from the previous page and seems again as much like sexual fluid as lava. She also locates the lines at the first story height of an illustration of the 'house of Pansa' complete with numerous other 'shops and houses [...] built around it'. Here, Cavafy's narrator speaks:

> Then, sad, I went out on the balcony,
> went out to change my thoughts at least by seeing
> something of this city I love,
> a little movement in the streets and shops.

What Cavafy and his readers would have been able to see, as they move towards the murderous, dramatic climax of the plot, is the end of Pompeii (see Figure 7.22).

At this point, Sedgwick's quotations tie back into the novel, and she employs the final nine lines of 'Trojans', on page 98, to think further, and compassionately, about the scenes amidst the lava:

> But when the great crisis came,
> our boldness and resolution vanish;
> our spirit falters, paralyzed,
> and we scurry around the walls
> trying to save ourselves by running away.

'Yet we're sure to fail. Up there, / high on the walls', where we have just been, at the end of the last intervention, 'the dirge has already begun. / They're mourning the memory, the aura of our days. / Priam and Hecuba mourn for us bitterly'; along, we can see, with Cavafy and Sedgwick.[62]

The final poem Sedgwick chooses occurs on the last inside page of the book, long after the narrative has finished, and following an appendix, glossary, and bibliography (see Figure 7.23). This belated intervention is the only time she quotes an entire poem, 'Ionic':

> That we've broken their statues,
> that we've driven them out of their temples,
> doesn't mean at all that the gods are dead.
> O land of Ionia, they're still in love with you,
> their souls still keep your memory.
> When an August dawn wakes over you,
> your atmosphere is potent with their life,
> and sometimes a young ethereal figure,
> indistinct, in rapid flight,
> wings across your hills.

After so many poems depicting the trembling, miserable, paralyzed, and faltering last moments of life, in spite of attempts to listen to the exquisite music of death, the poem provides a queer happy ending to the book. Unlike Lytton's novel, where the gay population burns to death, in Sedgwick's *Last Days* it is the gay Cavafy who burns always with a Paterian hard, gemlike flame, survives, and has the last word. Greek homoeroticism may seem to have departed, Greek statues broken, Greek temples destroyed, but beautiful Greek divinities are far from dead and buried. Rather, like the historical city of Pompeii, they can be unearthed and brought back to life, bringing with them the gorgeous atmosphere of August sunshine, and beautiful male and female figures delighted by their same-sex, cross genera-

62 For more on 'Trojans', see *The Weather in Proust*, 49.

QUEER AND BOOKISH

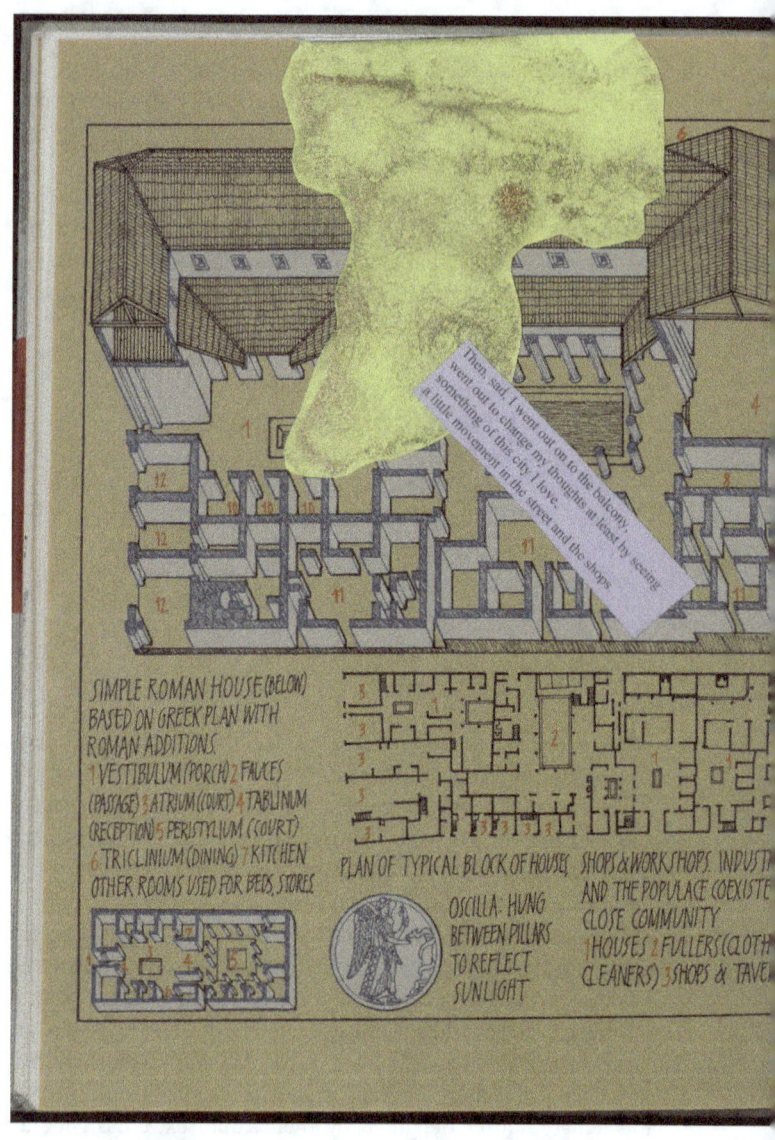

Then, said, I went out on to the balcony, went out to change my thoughts at least by seeing something of this city I love, a little movement in the street and the shops

Figure 7.21. Eve Kosofsky Sedgwick, *The Last Days of Pompeii/Cavafy collage book* (c. 2007), pp. 94–95. Photo: Kevin Ryan, Collection H.A. Sedgwick, © H.A. Sedgwick.

He caught his beloved in his arms, and with difficulty and labour gained the temple. He bore her to the remoter and more sheltered part of the portico, and leaned over her, that he might shield her, with his own form, from the lightning and the showers! The beauty and the unselfishness of love could hallow even that dismal time!

'Who is there?' said the trembling and hollow voice of one who had preceded them in their place of refuge. 'Yet, what matters the crush of the ruined world forbids to friends or foes.'

Ione turned at the sound of the voice, and, with a faint shriek, cowered again beneath the arms of Glaucus; and he, looking in the direction of the voice, beheld the cause of her alarm. Through the darkness glared forth two burning eyes—the lightning flashed and lingered athwart the temple—and Glaucus, with a shudder, perceived the lion to which he had been doomed couched beneath the pillars; —and, close beside it, unwitting of the vicinity, lay the giant form of him who had accosted them—the wounded gladiator, Niger.

That lightning had revealed to each other the form of beast and man; yet the instinct of both was quelled. Nay, the lion crept nearer and nearer to the gladiator, as for companionship; and the gladiator did not recede or tremble. The revolution of Nature had dissolved her lighter terrors as well as her wonted ties.

While they were thus terribly protected, a group of men and women, bearing torches, passed by the temple. They were of the congregation of the Nazarenes; and a sublime and unearthly emotion had not, indeed, quelled their awe, but it had robbed awe of fear. They had long believed, according to the error of the early Christians, that the Last Day was at hand; they imagined now that the Day had come.

The Nazarenes paced slowly on, their torches still flickering in the storm, their voices still raised in menace and solemn warning, till, lost amid the windings in the streets, the darkness of the atmosphere and the silence of death again fell over the scene.

There was one of the frequent pauses in the showers, and Glaucus encouraged Ione once more to proceed. Just as they stood, hesitating, on the last step of the portico, an old man, with a bag in his right hand and leaning upon a youth, tottered by. The youth bore a torch. Glaucus recognised the two as father and son—miser and prodigal.

'Father,' said the youth, 'if you cannot move more swiftly, I must leave you, or we *both* perish!'

'Fly, boy, then, and leave thy sire!'

'But I cannot fly to starve; give me thy bag of gold!' And the youth snatched at it.

'Wretch! wouldst thou rob thy father?'

'Ay! who can tell the tale in this hour? Miser, perish!'

The boy struck the old man to the ground, plucked the bag from his relaxing hand, and fled onward with a shrill yell.

'Ye gods!' cried Glaucus: 'are ye blind, then, even in the dark? Such crimes may well confound the guiltless with the guilty in one common ruin. Ione, on!—

ARBACES ENCOUNTERS GLAUCUS AND IONE

Advancing, as men grope for ... dungeon, Ione and her lover ...
... At the moment they were ... by that ... sister and ...other ...
... presented ... encourage their path. In part ashes lay dry, and uncommon boiling torrents, cast upward mountain at capricious interval of the earth presented a leprous white. In other places, cinder matted in heaps, from he...

But when the great crisis comes,
our boldness and resolution vanish,
our spirit falters, paralyzed,
and we scurry around the walls trying to save
ourselves by running away.

Yet we're sure to fail. Up there,
high on the walls, the dirge has already begun.
They're mourning the memory, the aura of ...
Priam and Hecuba mourn for us bitterly.

the wind! Ha! they live through doubtless, fugitives to the sea them.'

As if to aid and reanimate winds and showers came to a ... the atmosphere was profou... mountain seemed at rest, gath... fresh fury for its next burst, th... moved quickly on. 'We are n... said, in a calm voice, the perso... 'Liberty and wealth to each slav... this day! Courage! I tell you themselves have assured me o... On!'

Redly and steadily the torc... on the eyes of Glaucus and trembling and exhausted ... Several slaves were bearing panniers and coffers, heavily of them,—a drawn sword towered the lofty form of Arb...

'By my fathers!' cried De... smiles upon me even through and, amidst the dreadest asp... death, bodes me happiness a Greek! I claim my ward, Ion...

'Traitor and murderer!' glaring upon his foe, 'Neme...

CORINTHIAN COLUMN

Figure 7.22. Eve Kosofsky Sedgwick, *The Last Days of Pompeii/Cavafy collage book* (c. 2007), pp. 98–99. Photo: Kevin Ryan, Collection H.A. Sedgwick, © H.A. Sedgwick.

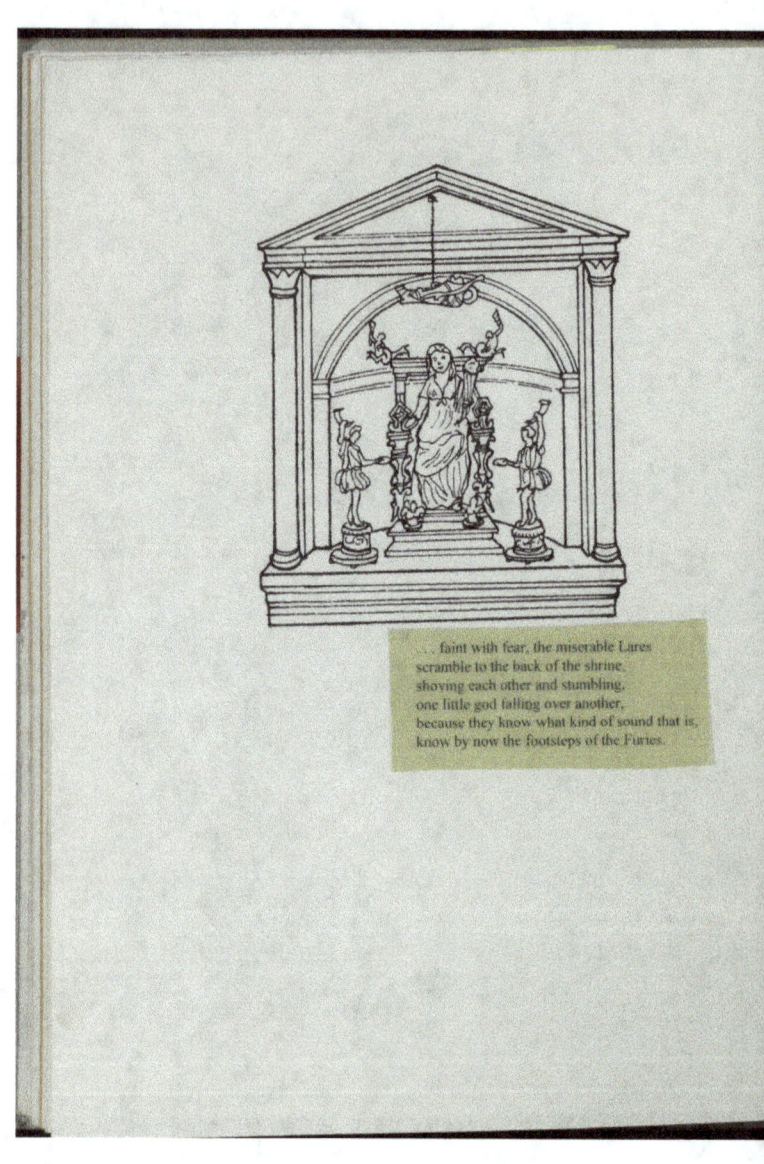

... faint with fear, the miserable Lares
scramble to the back of the shrine,
shoving each other and stumbling,
one little god falling over another,
because they know what kind of sound that is,
know by now the footsteps of the Furies.

Figure 7.23. Eve Kosofsky Sedgwick, *The Last Days of Pompeii/Cavafy collage book* (c. 2007), inside back pages. Photo: Kevin Ryan, Collection H.A. Sedgwick, © H.A. Sedgwick.

tional, and other perverse pleasures. As Proust's narrator might say, 'Ah, fine weather at last'.[63]

Having considered Sedgwick's Cavafian literary interventions in Lytton's *Last Days*, in the remaining two sections we consider two of her related art historical interventions.

Doryphoros and Duncan Grant vs *The Last Days*

In the 1870s, according to Simon Goldhill, Tauchnitz published an edition of The *Last Days* of Pompeii 'interleaved with blank pages, designed for tourists to insert postcards bought on their trip to Pompeii to illustrate the volume', so that 'by purchasing pre-produced images of the site and sticking them in', readers could 'participate in the commercialized interchange between the fictional narrative and the facts on and under the ground' (see Figure 7.24).[64]

Sedgwick's inclusion of the Doryphoros postcard clearly fits into this tradition, with a twist, since her statue does not derive from Pompeii or Herculaneum but is housed in a Berlin museum. In addition, she does not reproduce the most famous nineteenth-century, Anglo-American statue relating to the novel: Randolph Rogers' *Nydia: The Blind Flower Girl of Pompeii* (1853–1854). Instead, she chooses a characteristically cropped postcard of an antique spear-bearer. This was the signature work of fifth-century BCE sculptor, Polykleitos of Argos, in the form of a Roman marble copy of a now lost original Greek bronze, found in numerous versions across Italy, Greece, Asia Minor, North Africa, and southern France.[65]

63 For Sedgwick's discussion of the relevant passage in Proust, see *The Weather in Proust*, 8–9.
64 Simon Goldhill, 'A Writer's Things: Edward Bulwer Lytton and the Archaeological Gaze; or, What's in a Skull?', *Representations* 119, no. 1 (Summer 2012): 92–118; 99.
65 For more on the Doryphorus, see Warren G. Moon, ed., *Polykleitos, the Doryphoros, and Tradition* (Madison: University of Wisconsin Press, 1995). For more on Rogers, see Millard F. Rogers, *Randolph Rogers: American Sculptor in Rome* (Boston: University of Massachusetts Press, 1971), especially 33–40. That said, and challenging Lytton's sacrifice of Nydia to the

First attributed to Polykleitos in 1863, by Karl Friederichs, the statue is, in many ways, a piece of Victorian sculpture, as much as an example of ancient art, and so one appropriate, in terms of period aesthetics, to the novel.[66] Originally popular during the late Roman Republic and early Roman Empire, the Doryphoros was widely understood to reflect Polykleitos' 'dual identity as a craftsman and [...] intellectual'.[67] It thus resonates with Sedgwick's similar identity in the text. The statue also reputedly represented an ideal male beauty because of its careful balancing of what Jeffrey M. Hurwitt characterized as its 'right and left, taut and loose', 'resting and moving', and, most evocatively, 'straight and bent' elements; and what Gregory V. Leftwich described as the 'moving/nonmoving', 'contracted and relaxed', as well as the again evocative 'active and passive' elements, visible in the tensed and relaxed buttocks in Sedgwick's postcard.[68]

Sedgwick's characteristic rear view is not exceptional in the scholarship, with the most recent monographic account featuring numerous reproductions of the statue in the round, with a series of rear views as part of the German *Kopienkritik* tradition, in which surviving versions of sculptures are lined up and their various different takes on the anatomy compared, to establish

happily heterosexual honeymoon of Ione and Glaucus, Sedgwick significantly adds more illustrations of Nydia to her version of the text, making a reproductive stamp out of the illustration on page 17 and reprinting it twice on the cover, as well as the back page, and at least 8 times on page 111. As a result, she challenges Nydia's final disappearance and sacrifice to heterosexual family values (*MC*, 101). For an early piece of art criticism on a related British, nineteenth-century neoclassical statue, see Eve Kosofsky Sedgwick, 'Sabrina Doesn't Live Here Anymore', *Amherst* 37, no. 3 (Winter 1985): 12–17, 21. For more, see Andrew Parker, 'Eve At Amherst', *PMLA* 125, no. 2 (May 2010): 385–86. For Sedgwick's later reading of nineteenth-century American neoclassical sculptor Hiram Powers' *Greek Slave* (1844), see *Touching Feeling*, 80–81.

66 For more, see Elizabeth Prettejohn, *The Modernity of Ancient Sculpture* (London: I.B. Taurus, 2012).

67 Moon, Polykleitos, ix.

68 Hurwitt and Leftwich, in *Polykleitos*, ed. Moon 11, 47. For more on Polykleitos as a conceptual craftsman, see Ira S. Mark, 'The Lure of Philosophy: Craft and Higher Learning in Greece', in *Polykleitos*, ed. Moon, 25–29.

wrath for ye above—you, the young, and the thoughtless, and the beautiful.'

'Thou utterest but evil words, ill becoming the hospitable,' said Glaucus; 'and in future I will brave the tempest rather than thy welcome.'

'Thou wilt do well. None should ever seek me—save the wretched!'

'And why the wretched?' asked the Athenian.

'I am the witch of the mountain,' replied the sorceress, with a ghastly grin; 'my trade is to give hope to the hopeless: for the crossed in love I have philtres; for the avaricious, promises of treasure; for the malicious, potions of revenge; for the happy and the good, I have only what life has—curses! Trouble me no more.'

With this the grim tenant of the cave relapsed into a silence so obstinate and sullen, that Glaucus in vain endeavoured to draw her into farther conversation. She did not evince, by any alteration of her locked and rigid features, that she even heard him. Fortunately, however, the storm, which was brief as violent, began now to relax; the rain grew less and less fierce; and at last, as the clouds parted, the moon burst forth in the purple opening of heaven, and streamed clear and full into that desolate abode. Never had she shone, perhaps, on a group more worthy of the painter's art. The young, the all-beautiful Ione, seated by that rude fire—her lover already forgetful of the presence of the hag, at her feet, gazing upward to her face, and whispering sweet words—the pale and affrighted slave at a little distance—and the ghastly hag resting her deadly eyes upon them; yet seemingly serene and fearless (for the companionship of love hath such power) were these beautiful beings, things of another sphere, in that dark and unholy cavern, with its gloomy quaintness of appurtenance. The hag regarded them from his corner with his keen and fiery eye: and as Glaucus now turned towards the witch, he perceived for the first time, just under her seat, the bright gaze and crested head of a large snake: whether it was that the vivid colouring of the Athenian's cloak, thrown over the shoulders of Ione, attracted the reptile's anger—its crest began to glow and rise, as if menacing and preparing itself to spring upon the Neapolitan;—Glaucus caught quickly at one of the half-burned logs upon the hearth—and, as if enraged at the action, the snake came forth from its shelter, and with a loud hiss raised itself on end till its height nearly approached that of the Greek.

'Witch!' cried Glaucus, 'command thy creature, or thou wilt see it dead.'

'It has been despoiled of its venom!' said the witch, aroused at his threat; but ere the words had left her lip, the snake had sprung

GLASS JUGS

upon Glaucus; quick and watchful, the agile Greek leaped lightly aside, and struck so fell and dexterous a blow on the head of the snake, that it fell prostrate and writhing among the embers of the fire.

The hag sprung up, and stood confronting Glaucus with a face which would have befitted the fiercest of the Furies, so utterly dire and wrathful was its expression—yet even in horror and ghastliness preserving the outline and trace of beauty—and utterly free from that coarse grotesque at which the imaginations of the North have sought the source of terror.

'Thou hast,' said she, in a slow and steady voice—which belied the expression of her face, so much was it passionless and calm—'thou hast shed blood under my roof, and warmth at my hearth; thou hast returned evil for good; thou hast smitten and haply slain the thing that loved me and was mine: nay, more, the creature, above all others, consecrated to gods and deemed venerable by man —now hear thy punishment. By the moon, who is the guardian of the sorceress—by Orcus, who is the treasurer of wrath—I curse thee! and thou art cursed! May thy love be blasted—may thy name be blackened—may the infernals mark thee—may thy heart wither and scorch—may thy last hour recall to thee the prophet voice of the Saga of Vesuvius! And thou,' she added, turning sharply towards Ione, and raising her right arm—when Glaucus burst impetuously on her speech:—

'Hag!' cried he, 'forbear! Me thou hast cursed, and I commit myself to the gods—I

defy and scorn thee! but breathe b[ut a] word against yon maiden, and I will c[hange] the oath on thy foul lips to thy dying [groan] Beware!'

'I have done,' replied the hag, la[ughing] wildly; 'for in thy doom is she who lov[es thee] accursed. And not the less, that I he[ard thy] lips breathe thy name, and know b[y what] word to commend thee to the d[emons]— Glaucus—thou art doomed!' So sayi[ng the] witch turned from the Athenian, and k[neeling] down beside her wounded favourite, [...] she dragged from the hearth, she tu[rned on] them her face no more.

'O Glaucus!' said Ione, greatly t[errified] 'what have we done?—Let us haste[n from] this place; the storm has ceased[. My] mistress, forgive him—recall thy wor[ds; he] meant but to defend himself—acce[pt this] peace-offering to unsay the said.' an[d she] stooping, placed her purse on the hag'[s lap].

'Away!' said she, bitterly—'away! T[he thread] once woven the Fates only can untie.

'Come, dearest!' said Glaucus, impa[tiently] 'Thinkest thou that the gods above [or those] below hear the impotent ravings of [...] Come!'

Long and loud rang the echoes of the [cave] with the dread laugh of the Sa[ga; she] deigned no further reply.

The lovers breathed more freely wh[en they] gained the open air: yet the scene t[hey had] witnessed, the words and the laughte[r of the] witch, still fearfully dwelt with Ion[e; and] even Glaucus could not thoroughly s[hake off] the impression they bequeathed. [The storm] had subsided—save, now and then[...]

Figure 7.24. Eve Kosofsky Sedgwick, *The Last Days of Pompeii/Cavafy collage book* (c. 2007), pp. 52–53. Photo: Kevin Ryan, Collection H.A. Sedgwick, © H.A. Sedgwick.

the most common or originary features.[69] But if Sedgwick's rear view is not anomalous, accounts of the statue's paradigmatically 'taut and loose', 'active and passive', and 'straight and bent' elements suggest there should be a more dialectical relationship between the statue's archaeological status, within the straight *Kopienkritik* tradition, and its reception as a gay icon — the latter claim made by Andrew Stewart[70] — with Sedgwick's citation adding to the statue's queer possibilities.

Sedgwick employs a particular, fragmented, rear view, and only a part of that, once again cropping an icon of world art history, as she had done in the case of Manet's *Déjeuner,* as we saw in Chapter One. If the postcard crops the figure at the lower back, just above the buttocks, and at the mid-point of the thighs, between the knees and ass, Sedgwick in turn crops the postcard, reducing it down to the figure's silhouette and decontextualizing it from its neutral-grey background, cutting carefully along the contour of the figure's left thigh and lower back, up its more curvaceous right thigh, around its right buttock, and down its right lower arm, just visible in the top right of the image. The postcard itself, meanwhile, represents an already cropped surviving version of the statue, emphasizing the buttocks, given the museum's weathered and fragmentary marble copy of Polykleitos' statue, which is decapitated, truncated below both knees, has lost the thumb and fingers of its right hand, and almost all of its left arm from just above the elbow, as well as its cock and balls.

Sedgwick has added, meanwhile, another quotation from Cavafy, on a piece of more or less translucent, waxed, green paper at a suggestively erectile, 45-degree angle, just above the figure's left buttock, echoing the left-to-right ascending angle formed by the buttocks themselves. This contains the concluding erotic lines from 'Sculptor of Tyrana', with all their talk of heat, erection, and coming: 'This one — it was a summer day,

69 For examples of rear views in this tradition, see Moon, ed., *Polykleitos,* figs. 1.11, 4.10, 6.57, 6.58, 6.62, 6.64, 6.65, 6.66, 6.70, 13.21, and 13.22.
70 Stewart, cited in Moon in *Polykleitos,* ed. Moon, 247.

very hot, / and my mind rose to ideal things - / this one came to me in a vision, this young Hermes'.

In addition, Sedgwick has wrapped tightly around the spear-bearer's hips a piece of corrugated, gold fabric, and, in so doing, identifies the figure not only with Cavafy's 'very hot' Hermes, but with the subtitle of Lytton's novelistic text to the left: 'The Lord of the Burning Belt and His Minion', which is underlined by the extended golden fabric. In so doing, and whilst scholars have tended to identify Polykleitos' figure as Achilles, older lover of Patroklus,[71] whose dead body we have already mourned, Sedgwick provocatively identifies her torso with Arbaces, the novel's Egyptian anti-hero, who is the 'Hermes of the Burning Girdle' and the 'Master of the Flaming Belt', and who wears a 'cincture seemingly of fire, that burned around his waist'. As in the case of Gary Fisher that we explored in Chapter Two, black lives again here matter. The statue also calls to mind the novel's earlier description of the priests of Isis, 'naked save by a cincture round the middle'.[72] Sedgwick thus suggests that her Doryphoros is an Egyptian Greek-diasporic, thus Cavafian, figure, rather than an Athenian or Roman one;[73] although, later, readers also encounter gladiators, those much enjoyed by Clodius, 'naked save by a cincture round the waist' and 'completely naked, save by a cincture round the loins'.[74]

In sending her queer, Polykleitan postcard to Lytton's Pompeii, Sedgwick challenges, as the most representative illustration of the text, his heteronormative and Eurocentric sculptural preference for Glaucus and Ione, in favor of the queer Clodius and Egyptian Arbaces, as well as the canonical status, in nineteenth-century culture and our own art historiographical moment, of Rogers's equally normative *Nydia* (see Figure 7.25).

71 For more on the likely Achilles identification, see ibid., 248.

72 Lytton, *MC*, 14, 53–54.

73 For more on the Afro-Asiatic origins of Greco-Roman culture, see Martin Bernal, *Black Athena* (London: Free Association, 1987). For more on Cavafy's relationship with Orientalism, see Jeffreys, *Eastern Questions*.

74 Lytton, *MC*, 87, 91.

Figure 7.25. Randolph Rodgers, *Nydia, the Blind Flower Girl of Pompeii*, 1853–54, carved 1859, marble, 137.2 × 64.1 × 94 cm, Metropolitan Museum of Art, New York: 99.7.2: Gift of James Douglas, 1899, public domain.

First carved in 1854, Rogers claimed to have produced more than 150 versions of the sculpture during his lifetime, at least fifty of which survive today. As a result, the statue has, according to Jon L. Seydl, attained an 'omnipresence' in American museums, thanks to its successful address to presumptively straight male viewers. The blind marble *Nydia*, after all, cannot return our gaze, enabling us to objectify her straightforwardly, whilst her 'clinging drapery', in Seydl's words, hang in obviously 'labial folds'.[75]

Interdisciplinary studies of Pompeii, meanwhile, focus on a second, emphatically heterosexual sculpture of a woman; the now lost plaster-cast made from the imprint of a female breast discovered, in the Pompeian ruins, in December 1763, and put quickly on display, first at the Portico Museum and then the National Archaeological Museum in Naples. This now-lost breast inspired Théophile Gautier's much discussed *Arria Marcella: Souvenir de Pompeii* (1852), but was almost certainly too poignant to contemplate, and undesirable to fetishize, for an artist who had lost her right breast.[76] I therefore don't reproduce it here.

But Sedgwick's use of Polykleitos' *Doryphorus* to illustrate The *Last Days* resonates, in other, perhaps more normative, ways, in the larger context of interdisciplinary studies of Pompeii and Herculaneum. As Andrew Wallace-Hadrill has noted, Herculaneum was initially famous for the 'unrivalled collection of marbles and bronzes' unearthed particularly at the Villa of the Papyri, statues that 'Pompeii was never to match' (see Figure 7.26).[77]

The most famous of these was, undoubtedly, the marble *Pan and Goat,* now in the so-called permanent 'Secret Museum' exhibition at the National Archaeological Museum of Naples; an exhibition space to which, as of April 2000, no unaccompanied

[75] For more on Nydia, see Hales and Paul, eds., *Pompeii in the Public Imagination,* 217–20.

[76] See ibid., 109–17, 133.

[77] For more on the Herculean bronzes, see Hales and Paul, eds., *Pompeii in the Public Imagination,* 369.

Figure 7.26. Anonymous, *Pan with Goat,* marble, 1st century CE, 44 × 49 × 47cm, Gabineto Segreto, Museo Archaeologico Nazionale di Napoli, public domain.

spectators under 14 could gain access. This depicted the ancient god fucking a nanny goat.

Now, the claims regarding the censorship of the so-called 'Secret Cabinet' have recently come under pressure, by Kate Fisher, Rebecca Langlands, and Sarah Levin-Richardson, as a myth privileging a fantasy of uninhibited ancients, repressed Victorians, and enlightened contemporaries. In addition, Sedgwick's inclusion of the *Doryphoros* cannot rival the sheer perversity of a statue emblematizing a still-taboo bestiality that remains on the fringes of queer theory and critical animal studies.[78] But, as

78 For more on the secret museum, see ibid., 201–30. For example, there Richardson contentiously, but perhaps representatively, notes that the statue's 'graphic depiction of bestial sex' still 'defies attempts at neutralization', and 'cannot easily be laughed away', since the sculpture does not 'form part of a continuous narrative of sexuality from antiquity to today' (ibid., 320–22, 329).

Lytton's text reveals, and Richardson has documented, there has been a sustained 'privileging of hetero-erotic sexuality' in accounts of Pompeian eroticism, in terms of what is on display in the secret cabinet and what is officially offered to tourists visiting the brothel in Pompeii, which the heterosexual *Pan and Goat* does little to contest.[79]

For example, as Richardson argues, the erotic frescoes on display at the brothel, widely believed to represent the 'Greco-Roman Kama Sutra' or a 'sex menu for the clients', and the 'be all and end all' of Pompeian sexuality, depicts only a 'narrow range' of 'male–female genital sex', even though 'other sexual acts — including oral and anal sex, and involving same sex pairs and groups — were part of the Pompeians' sexual repertoire'. These are acts depicted at Pompeii's much less publicized, and visited, Suburban Baths. Indeed, Richardson suggests, there is a semi-official conspiracy of silence around Pompeian queer sexualities, since although the brothel's graffiti 'mention a variety of sexual practices not represented in the frescoes', including 'oral sex performed on men and women (fellatio, *irrumatio,* and cunnilingus), anal sex, and male-male couplings', the graffiti is 'easy to miss in the shadow of the well-lit and evocative frescoes'. The graffiti also remains unavailable to those tourists without Latin since it is not translated and is referred to in neither the *Brief Guide,* nor by tour guides, at least in March 2007, the moment Sedgwick was working on *Last Days.* In fact, 'none of the site's didactic material', according to Richardson, raises the possibility of non-genital sexual activities or homoerotic activity, whilst the audio-guides focus on 'complaints about venereal disease' supposedly found in the graffiti, but, to Richardson's knowledge, not appearing there; whilst only around 1% of the tour guides she observed 'mentioned anything about homoeroticism or male prostitutes'.[80]

From this heteronormative perspective, Sedgwick's use of the Doryphoros might be understood to be even queerer than

79 Ibid., 317.
80 Ibid., 320–23.

the *Pan and Goat*. In addition, the *Doryphorus* resonates, perhaps surprisingly, with our final example from the text, and her other most significant art historical addition to it, the image by Duncan Grant. Whilst Bloomsbury might seem remote from the various literary and art historical contexts I have explored so far, Grant had Pompeian credentials. As Johanna Paul documented, influential inter-war art critic, in 1941 Kenneth Clark encouraged Grant to paint St Paul's Cathedral in London, in the midst of the Blitz, having discovered that it had never 'looked more beautiful' than 'rising out of this sort of Pompeii in the foreground', which had 'all the elements of color' which Clark thought Grant would 'enjoy painting'. Indeed, Paul described how, in the subsequent work, a ruined church on the right recalled 'typical views of Pompeian ruins', whilst the overall composition assumed a 'vantage point low down in the basement area of another bombed building', reflecting the 'view of deep excavations in an archaeological site', such as Pompeii.[81]

But it is not Grant's Pompeian images of St Paul's that preoccupied Sedgwick (see Figure 7.27).

It was his 1925 watercolor nativity; one of two versions, inscribed by Grant with a message and sent as Christmas cards to friends that year. Sedgwick's reproduction was of the version Grant sent to Lady Ottoline Morrell, now in a private collection, and last seen as part of the 1959 Grant retrospective at Tate, as exhibit 101. Resisting the idea of the straight, white Christmas Sedgwick satirized in *Tendencies*,[82] she adds the image, in a characteristically raggedy-edged, torn version, to the right-side of a double page spread, on pages 22–23. This is the moment where readers first learn about the ancients' queer same-sex public bathing habits, those so carefully edited from official tours of Pompeii. Grant's image is joined and overlapped by a red stamped image of a primitive-looking mask. The entire page is also obscured by eight, rectangular, grey sponge patches. These

81 Joanna Paul, 'Pompeii, The Holocaust, and the Second World War', in *Pompeii in the Public Imagination*, eds. Hales and Paul, 345–46.

82 Sedgwick, *Tendencies*, 5–9.

recall Sedgwick's earlier photo-collage arrangements, in the case of *Listening to Dionne (1)*, that we discussed in Chapter Two; the layered, colored, rectangular paper patterning of Grant's 1914 *Abstract Kinetic Collage Painting with Sound*; and, most obviously in this context, the marks of the 'sponges' that the delicate Pompeiians preferred to 'strigils' during their baths.[83]

Again resisting the homophobic logic of the needless closure of gay New York bathhouses in 1985, in the midst of the AIDS crisis, Sedgwick places Grant, imaginatively, in Lytton's text, in a 'favorite place' for a 'gay and thoughtless people', in which Glaucus is asked 'How are you? Gay as ever?' Here, Grant could find a 'voluptuous', 'artificial warmth' and a 'luxurious air', accompanied by 'an exhalation of spicy perfumes.' He could also meet 'habituated bathers', some of whom visited 'seven times a day', and who reclined in a 'state of enervated and speechless lassitude' except when they 'turned their listless eyes' on 'newcomers', like him, 'recognizing their friends with a nod'. And here, Grant, like his fellow bathers, 'with closed eyes and scarce perceptible breath', could undergo 'all the mystic operations'.[84]

Sedgwick also adds to the page a final passage from Cavafy's 'Anna Dalassina', which, in this context, might read as the words of a cruisily open sauna queen, uninterested in monogamy, speaking of Grant himself:

> Much is said in praise of her.
> Here let me offer one phrase only,
> a phrase that is beautiful, sublime:
> 'She never uttered those cold words 'mine' or 'yours'.'[85]

As in the case of the *Doryphoros* and Cavafy quotations throughout, Sedgwick's use of Grant's image queers Lytton's text. If the painting depicts a relatively straightforward naked Christ child

83 Lytton, MC, 4. For more on the scrolls and Grant's collage technique with 'cut and pasted painted paper', see Simon Watney, *The Art of Duncan Grant* (London: Murray, 1990), 39.
84 Lytton, MC, 20–22.
85 Sedgwick also discusses the poem in *The Weather in Proust*, 65.

QUEER AND BOOKISH

'A poor place this, compared with the Roman thermæ,' said Lepidus, disdainfully.

'Yet is there some taste in the ceiling,' said Glaucus, who was in a mood to be pleased with everything; pointing to the stars which studded the roof.

Lepidus shrugged his shoulders, but was too languid to reply.

They now entered a somewhat spacious chamber, which served for the purpose of the apodyterium (that is, a place where the bathers prepared themselves for their luxurious ablutions).

In this apartment Fulvius seated himself with a magisterial air, and his audience gathering round him, encouraged him to commence his recital.

The poet did not require much pressing. He drew forth from his vest a roll of papyrus, and after hemming three times, as much to command silence as to clear his voice, he began that wonderful ode, of which, to the great mortification of the author of this history, no single verse can be discovered.

By the plaudits he received, it was doubtless worthy of his fame; and Glaucus was the only listener who did not find therein the best odes of Horace.

The poem concluded, those who took only the cold bath began to undress; they suspended their garments on hooks fastened to the wall, and receiving, according to their condition, either from their own slaves or those of the thermæ, loose robes in exchange, withdrew into that graceful circular building which yet exists, to shame the curiosity posterity of the south.

The more luxurious departed by another door to the tepidarium, a place which was heated to a voluptuous warmth, partly by a movable fireplace, principally by a suspended pavement, beneath which was conducted the caloric of the laconicum.

Here this portion of the intended bathers, after unrobing themselves, remained for some time enjoying the artificial warmth of its luxurious air. And this room, as befitted its important rank in the long process of ablution, was more richly and elaborately decorated than the rest; the arched roof was beautifully carved and painted; the windows above, of ground glass, admitted but wandering and uncertain rays; below the massive cornices were rows of figures in massive and bold relief; the walls glowed with crimson, the pavement was skilfully tessellated in white mosaics. Here the 'habituated bathers, men who bathed seven times a day, would remain in a state of enervate and speechless lassitude, either before or (mostly) after the water-bath; and many of these victims of the pursuit of health turned their listless eyes on the new-comers, recognising their friends with a nod, but dreading the fatigue of conversation.

From this place the party again diverged, according to their several fancies, some to the sudatorium, which answered the purpose of our vapour-baths, and thence to the warm-bath itself; those more accustomed to exercise, and capable of dispensing with so cheap a purchase of fatigue, resorted at once to the calidarium, or water-bath.

STRIGILS AND OIL FLASK

In order to complete this sketch, and give to the reader an adequate notion of this, the main luxury of the ancients, we will accompany Lepidus, who regularly underwent the whole process, save only the cold-bath, which had gone lately out of fashion. Being then gradually warmed in the tepidarium, which has just been described, the delicate steps of the Pompeian *élégant* were conducted to the sudatorium, where let the reader depict to himself the gradual process of the vapour-bath, accompanied by an exhalation of spicy perfumes. After our bather had undergone this operation, he was seized by his slaves, who always awaited him at the baths, and the dews of heat were removed by a kind of scraper. Thence, somewhat cooled, he passed into the water-bath, over which fresh perfumes were profusely scattered, and on emerging from the opposite part of the room, a cooling shower played over his head and form. Then wrapping himself in a light robe, he returned once more to the tepidarium, where he found Glaucus, who had not encountered the sudatorium; and now, the last main delight and extravagance of the bath commenced. Their slaves anointed the bathers from vials of gold, of alabaster, or of crystal, studded with profusest gems, and contain the rarest unguents gathered from all quar of the world.

'But tell me,' said a corpulent citizen, was groaning and wheezing under the op ation of being rubbed down, 'tell me, Glaucus!—evil chance to thy hands, O sla why so rough?—tell me—ugh—ugh!— the baths at Rome really so magnificen Glaucus turned, and recognised Dion though not without some difficulty, so and so inflamed were the good man's ch by the scraping he had so lately underge 'I fancy they must be a great deal finer t these. Eh?' Suppressing a smile, Glau replied,—

'Imagine all Pompeii converted into ba and you will then form a notion of the siz the imperial thermæ of Rome. But a not of the *size* only. Imagine every entertainme for mind and body—enumerate all gymnastic games our fathers invente repeat all the books Italy and Greece h produced—suppose places for all these gam admirers for all these works—add to baths of the vastest size, the most complica construction—intersperse the whole w gardens, with theatres, with porticoes, schools—suppose, in one word, a city of gods, composed but of palaces and pu edifices; and you may form some faint id the glories of the great baths of Rome.

While Glaucus was thus conversi Lepidus, with closed eyes and scarce p ceptible breath, was undergoing off on me operations, not one of which he ever ord his attendants to omit. After the perfumes the unguents, they scattered over him luxurious powder which preserved further accession of heat; this this is rubbed away by the smooth surface of pumice, he began to indue, not the garm he had put off, but those more festive o termed 'the synthesis,' with which Romans marked their respect for the conv ceremony of supper, if rather, from its ho (three o'clock in our measurement of tin it might not be more fitly denominated dinn This done, he at length opened his eyes gave signs of returning life.

At the same time, too, Sallust betook by a long yawn the evidence of existence.

'It is supper time,' said the epicure; ' Glaucus and Lepidus, come and sup with n

'Recollect you are all three engaged to house next week,' cried Diomed, who mightily proud of the acquaintance of exce fashion.

'Ah, ah! we recollect,' said Sallust, seat of memory, my Diomed, is certainly the stomach.'

Passing now once again into the cooler and so into the street, our gallants of that concluded the ceremony of a Pompeian b

Figure 7.27. Eve Kosofsky Sedgwick, *The Last Days of Pompeii/Cavafy collage book* (c. 2007), pp. 22–23. Photo: Kevin Ryan, Collection H.A. Sedgwick, © H.A. Sedgwick.

and smiling virgin, in Marian blue, perhaps initially suggesting the epitome of Christian family values to Republican spectators, the theological Christ's is a queer family, in that his mum is a virgin, and he either has no dad, or two. In Grant's picture, Christ and Mary are also joined by two pagan musicians: an angel dressed in pink, with blond hair, to the right, playing a lute, to whom Jesus is waving; whilst a more or less nude figure, with just enough pink drapery to cover his modesty, is seated bottom right, playing a wind instrument.

This extended aesthetic family evokes Grant's queer Bloomsbury circle, where, following earlier affairs with Lytton Strachey, John Maynard Keynes, and Arthur Hobhouse, Grant formed a lifelong open relationship with the already married Vanessa Bell, another person who tried hard never to utter 'those cold words 'mine' or 'yours''. The pair ultimately had a daughter, Angelica, in 1918, who subsequently married Grant's earlier male lover David Garnett. Bloomsbury is, therefore, a grouping about as far from the endlessly heterosexual coupling and straight triangulation of Bulwer-Lytton's novel as you can get.[86]

Sedgwick's queer affiliation with Grant and Bell extended well beyond the pages of *The Last Days*. Like Sedgwick's artist's book, Bell's juvenilia included a *Last-Days*-like 'bound album' with 'drawings of ships, copies from Christmas cards, and vignettes from everyday life' including a 'kitchen cupboard with its doors open to disclose pots and plates, a canary in a wooden cage, and still lifes'. And again like Sedgwick, especially in the second half of the 1990s, as we saw in Chapters Three and Five, Grant was similarly interested in projects of 'joint authorship',

[86] For more on Grant and Bell, see Francis Spalding, *Duncan Grant: A Biography* (London: Pimlico, 1998) and *Vanessa Bell* (London: Papermac, 1984), as well as Richard Shone, *Bloomsbury Portraits: Vanessa Bell, Duncan Grant, and Their Circle* (Oxford: Phaidon, 1976); *Duncan Grant and Vanessa Bell: Design and Decoration, 1910–1960* (London: Spink, 1997); and *The Art of Bloomsbury: Roger Fry, Vanessa Bell, and Duncan Grant* (London: Tate, 1999). For their daughter's account, see Angelica Garnett, *Deceived with Kindness: A Bloomsbury Childhood* (London: Pimlico, 1995). I am grateful to Jonathan King for numerous productive conversations about Bloomsbury's queer domesticity.

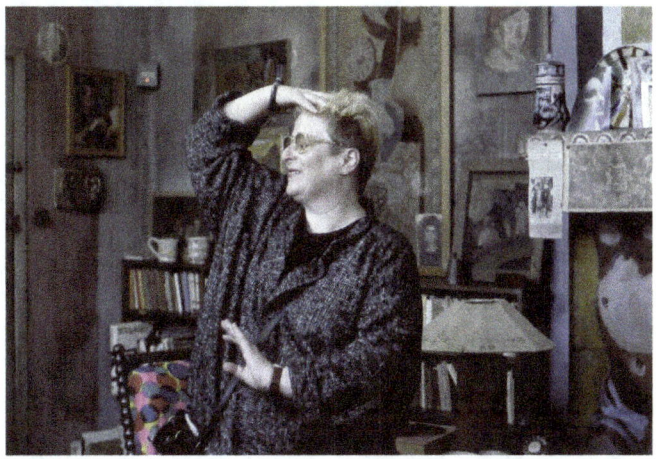

Figure 7.28. Simon Watney, colour photographic portrait of Eve Kosofsky Sedgwick at Charleston, October 1996. © Simon Watney, with permission of the artist.

for example across all the available surfaces of his and Bell's Charleston home, on which they worked jointly.[87]

On a rare visit to the UK, in October 1996, Sedgwick visited Charleston, with her husband Hal and friend Simon Watney: Grant scholar, art historian, AIDS activist, and the house's then-curator (see Figure 7.28).[88]

There, he photographed Sedgwick in an ecstatic pose, with her eyes closed, mouth smilingly open, right hand caressing her hair, and left extended out as if to say she could bear no more

87 Watney, *The Art of Duncan Grant*, 17, 53.

88 For more on Charleston, and the 1925–1932 studio and its decorations by Grant, in which Sedgwick was photographed, see Quentin Bell and Virginia Nicholson, *Charleston: A Bloomsbury House and Garden* (London: Francis Lincoln, 1997), especially 66, 70, 72; Christopher Reed, *Bloomsbury Rooms: Modernism, Subculture, and Domesticity* (New Haven: Yale University Press 2004), 182–99, 231–51, especially 244–45; and Nuala Hancock, *Charleston and Monk's House: The Intimate House Museums of Virginia Woolf and Vanessa Bell* (Edinburgh: Edinburgh University Press, 2012).

of the joyous artwork around her. Her pose precisely echoes the right-hand variant of the two more-or-less nude, difficult-to-gender, Michelangelesque dancing figures Grant painted on plywood on the fireplace immediately behind her, emphasizing further the depth of her gay, visceral identification with Grant's queer Charleston life and circle well beyond her *Last Days*.

Bibliography

Abelove, Henry. 'The Bar and the Board'. GLQ 17, no. 4 (2011): 48–86. DOI: 10.1215/10642684-1302325.

Adams, William Howard. *Atget's Gardens*. New York: Doubleday, 1979.

Alsdorf, Bridget. *Fellow Men: Fantin-Latour and the Problem of the Group in Nineteenth-Century French Painting*. Princeton: Princeton University Press, 2013.

Anderson, Benedict. *Mythology and the Tolerance of the Javanese* (1965). Jakarta: Equinox, 2009.

Anker, Elizabeth S., and Rita Felski, eds. *Critique and Postcritique*. Durham: Duke University Press, 2017.

Anton, John P. *The Poetry and Poetics of Constantine P. Cavafy: Aesthetic Visions of Sensual Beauty*. Chur: Harwood Academic Press, 1995.

Apter, Emily, and Elaine Freedgood. 'Afterword'. *Representations* 108, no. 1 (Fall 2009): 139–46. DOI: 10.1525/rep.2009.108.1.139.

Apollinaire, Guillaume. *Selected Poems*. Edited and translated by Martin Sorrell. Oxford: Oxford University Press, 2015.

Arnar, Anna Sigridur. *The Book as Instrument: Stephane Mallarme, The Artist's Book and the Transformation of Print Culture*. Chicago: University of Chicago Press, 2011.

Arts Council of Great Britain. *Hockney's Photographs*. London: Balding and Mansell, 1983.

Atterbury, Paul, and Maureen Batkin. *The Parian Phenomenon: A Survey of Victorian Parian Porcelain Statues and Busts.* Somerset: Richard Dennis, 1989.

Bachelor, Stephen, trans. *Tao Te Ching* (1988). San Francisco: Harper, 1992.

Barber, Stephen. 'Lip-Reading: Woolf's Secret Encounters'. In *Novel Gazing: Queer Readings in Fiction,* edited by Eve Kosofsky Sedgwick, 401–43. Durham: Duke University Press, 1997.

———. 'Review of Eve Kosofsky Sedgwick's *The Weather in Proust* (2011)'. *Psychoanalysis, Culture and Society* 18, no. 4 (2013): 431–33. DOI: 10.1057/pcs.2013.15.

Barber, Stephen, and David Clark, eds. *Regarding Sedgwick: Essays on Queer Culture and Critical Theory.* London: Routledge, 2002.

———. 'This Piercing Bouquet: An Interview with Eve Kosofsky Sedgwick'. In *Regarding Sedgwick: Essays on Queer Culture and Critical Theory,* edited by Stephen Barber and David L. Clark, 243–62. London: Routledge, 2002.

Barker, Dennis. *Parianware.* Aylesbury: Shire, 1985.

Barthes, Roland. *Camera Lucida* (1981). Translated by Richard Howard. London: Vintage, 2000.

Bartolovich, Crystal. 'Humanities of Scale: Milton, Marxism, Surface Reading, and Milton'. PMLA 127, no. 1 (January 2012): 115–21. DOI: 10.1632/pmla.2012.127.1.115.

Baudelaire, Charles. *Les Fleurs du Mal* (1857). Oxford: Oxford University Press, 2008.

Bell, Quentin, and Virginia Nicholson. *Charleston: A Bloomsbury House and Garden.* London: Francis Lincoln, 1997.

Belton, Don. 'Gary at the Table: An Introduction'. In *Gary in Your Pocket: Stories and Notebooks of Gary Fisher,* edited by Eve Kosofsky Sedgwick, vii–xii. Durham: Duke University Press, 1996.

Bennett, Paula. *Emily Dickinson: Woman Poet.* Iowa City: University of Iowa Press, 1990.

———. *My Life A Loaded Gun: Female Creativity and Feminist Poetics.* Boston: Beacon, 1986.

Berlant, Lauren. 'Eve Sedgwick, Once More'. *Critical Inquiry* 35, no. 4 (2009): 1089–91. DOI: DOI: 10.1086/605402.

———. 'Live Sex Acts (Parental Advisory: Explicit Material)'. In *Curiouser: On the Queerness of Children,* eds. Steven Bruhm and Natasha Hurley, 57–81. Minneapolis: Minnesota University Press, 2004.

———, ed. *Reading Sedgwick.* Durham: Duke University Press, 2019.

———. 'Reading Sedgwick, Then and Now'. In *Reading Sedgwick,* edited by Lauren Berlant, 1–5. Durham: Duke University Press, 2019.

———. 'The Pedagogies of "Pedagogy of Buddhism"'. *Supervalent Thought,* March 18, 2010. https://supervalentthought.com/2010/03/18/after-eve-in-honor-of-eve-kosofsky-sedgwick.

———. 'Two Girls, Fat and Thin'. In *Regarding Sedgwick: Essays on Queer Culture and Critical Theory,* eds. Stephen Barber and David Clark, 71–108. New York: Routledge, 2002.

Berlant, Lauren, and Lee Edelman. *Sex, or, The Unbearable.* Durham: Duke University Press, 2013.

———. 'What Survives'. In *Reading Sedgwick,* edited by Lauren Berlant, 37–63. Durham: Duke University Press, 2019.

Bernal, Martin. *Black Athena.* London: Free Association, 1987.

Best, Stephen, and Sharon Marcus. 'Surface Reading: An Introduction'. *Representations* 108, no. 1 (Fall 2009): 1–21. DOI: 10.1525/rep.2009.108.1.1.

Bewes, Timothy. 'Reading with the Grain: A New World in Literary Criticism'. *differences* 21, no. 3 (2010): 1–33. DOI: 10.1215/10407391-2010-007.

Bhattacharya, Subhas. 'The Indigo Revolt of Bengal'. *Social Scientist* 5, no. 12 (July 1977): 13–23.

Black, Anthea, and Nicole Burisch. 'Craft Hard, Die Free: Radical Curatorial Strategies for Craftivism in Unruly

Contexts'. In *The Craft Reader,* edited by Glenn Adamson, 609–19. Oxford: Berg, 2010.

Bohm, David. *Wholeness and the Implicate Order.* London: Routledge, 1980.

Bois, Yve-Alain, and Christian Hubert, 'El Lissitzky: Reading Lessons'. *October* 11 (Winter 1979): 113–28. DOI: 10.2307/778238.

Boletsi, Maria. 'How to Do Things with Poems: Performativity in the Poetry of C.P. Cavafy'. *Arcadia Band* 41 (2006): 396–418. DOI: 10.1515/ARCA.2006.025.

Boone, Joseph Allan. *The Homoerotics of Orientalism.* New York: Columbia University Press, 2014.

Bora, Renu. 'Outing Texture'. In *Novel Gazing: Queer Readings in Fiction,* edited by Eve Kosofsky Sedgwick, 94–127. Durham: Duke University Press, 1997.

Boulton, Meg. 'Waiting in the Dark: Musing on Sedgwick's Performative(s)'. In *Bathroom Songs: Eve Kosofsky Sedgwick as a Poet,* edited by Jason Edwards, 169–77. Earth: punctum books, 2017.

Bradway, Tyler. '"Permeable We!": Affect and the Ethics of Intersubjectivity in Eve Kosofsky Sedgwick's *A Dialogue on Love*'. *GLQ* 19, no. 1 (2013): 79–110. DOI: 10.1215/10642684-1729554.

Britzman, Deborah P. 'Theory Kindergarten'. In *Regarding Sedgwick: Essays on Queer Culture and Critical Theory,* edited by. Stephen Barber and David L. Clark, 121–24. London: Routledge, 2002.

Brown, Angus Connell. 'Look with Your Hands'. In *Bathroom Songs: Eve Kosofsky Sedgwick as a Poet,* edited by Jason Edwards, 17–75. Earth: punctum books, 2017.

Brown, Gavin, and Kath Browne, ed. 'Sedgwick's Geographies: Touching Space'. *Progress in Human Geography* 35, no. 1 (2011): 121–31. DOI: 10.1177/0309132510386253.

Bruhm, Steven. '*All Is True (Henry VIII)*: The Unbearable Sex of Henry VIII'. In *Shakesqueer,* edited by Madhavi Menon, 28–38. Durham: Duke University Press, 2011.

Bruhm, Steven, and Natasha Hurley, eds. *Curiouser: On the Queerness of Children.* Minneapolis: Minnesota University Press, 2004.

Bryan-Wilson, Julia. *Fray: Art and Textile Politics.* Chicago and London: University of Chicago Press, 2017.

———. 'Queerly Made: Harmony Hammond's Floorpieces'. *The Journal of Modern Craft* 2, no. 1 (March 2009): 59–80. DOI: 10.2752/174967809X416279.

Bullejos, Maria José Belbel, trans. *Tocar la fibra.* Madrid: Estudios de Género, 2018.

Bulwer Lytton, Edward. *The Last Days of Pompeii* (1834). London: Dent, 1962.

———. *The Last Days of Pompeii* (1834). With illustrations and annotations by Felix Gluck Press. London: Marshall Cavendish, 1976.

Burke, Edmund. *A Philosophical Enquiry into the Origin of Our Ideas of the Sublime and Beautiful.* Edited by Adam Phillips (1757). Oxford: Oxford University Press, 1990.

Buszek, Maria Elena, ed. *Extra/Ordinary: Craft and Contemporary Art.* Durham: Duke University Press, 2011.

Butler, Judith. *Bodies That Matter: On the Discursive Limits of 'Sex'.* Oxford: Routledge, 1993.

———. 'Capacity'. In *Regarding Sedgwick: Essays on Queer Culture and Critical Theory,* edited by Stephen M. Barber and David L. Clark, 109–20. London: Routledge, 2002.

———. *Gender Trouble: Feminism and the Subversion of Identity.* New York: Routledge, 1990.

———. 'Proust at the End'. In *Reading Sedgwick,* edited by Lauren Berlant, 63–71. Durham: Duke University Press, 2019.

Campbell, Mary Baine. '"Shyly / as a big sister I would yearn / to trace its avocations", or Who's the Muse'. In *Bathroom Songs,* edited by Jason Edwards, 139–51. Earth: punctum books: 2017.

Carter, Holland. 'Silence Wrapped in Eloquent Cocoons': Judith Scott's Enigmatic Sculptures at the Brooklyn Museum'. *The New York Times,* December 4, 2014. https://

www.nytimes.com/2014/12/05/arts/design/judith-scotts-enigmatic-sculptures-at-the-brooklyn-museum.html.

Castronova, Russ, and David Glimp. 'Introduction: After Critique?'. *English Language Notes* 51, no. 2 (Fall–Winter 2013): 1–5. DOI: 10.1215/00138282-51.2.1.

Catton, Chris. *Pandas*. London: Christopher Helm, 1990.

Cavafy, C.P. *Selected Poems*. Translated by Avi Sharon. London: Penguin, 2008.

———. *Selected Prose Works*. Edited and translated by Peter Jeffreys. Ann Arbor: University of Michigan Press, 2010.

———. *The Collected Poems*. Translated by Evangelos Sachperoglou. Oxford: Oxford University Press, 2007.

———. *The Collected Poems of C.P. Cavafy: A New Translation*. Translated by Aliki Barnstone. New York: Norton, 2006.

Chambers, Anne. *Suminagashi: The Japanese Art of Marbling — A Practical Guide*. London: Thames and Hudson, 1991.

Chaich, John, ed. *Queering the BibliObject*. New York: The Centre for Book Arts, 2016.

Chen, Mel Y. *Animacies: Biopolitics, Racial Mattering, and Queer Effect*. Durham: Duke University Press, 2012.

Chen, Mel Y., and Dana Luciano, eds. *Queer Inhumanisms*. Special issue of GLQ 21, nos. 2–3 (June 2015).

Cleary, Thomas. *The Essential Tao* (1991). San Francisco: Harper, 1993.

Clinton, Paul. 'A Queer Image: Eve Kosofsky Sedgwick Photographed by Terry Richardson'. *Frieze,* September 21, 2016. https://www.frieze.com/article/queer-image.

Cohen, Ed. 'The Courage of Curiosity, or The Heart of Truth'. *Criticism* 52, no. 2 (2010): 201–7. DOI: 10.1353/crt.2010.0030.

Cohen, Jeffrey Jerome. 'Queer Crip Sex and Critical Mattering'. GLQ 21, no. 1 (2015): 151–62. DOI: 10.1215/10642684-2818552.

Copeland, Robert. *Parian: Copeland's Statuary Porcelain*. Woodridge: Antique Collectors' Club, 2006.

Corby, James. 'Critical Distance'. *Journal for Cultural Research* 21, no. 4 (2017): 293–94. DOI: 10.1080/14797585.2017.1370492.

Cotter, Holland. 'Silence Wrapped in Eloquent Cocoons: Judith Scott's Enigmatic Sculptures at the Brooklyn Museum'. *The New York Times*, December 4, 2014. https://www.nytimes.com/2014/12/05/arts/design/judith-scotts-enigmatic-sculptures-at-the-brooklyn-museum.html.

Coulson, Victoria. 'Redemption and Representation in Goblin Market: Christina Rossetti and the Salvific Signifier'. *Victorian Poetry* 55, no. 4 (Winter 2018): 423–50. DOI: 10.1353/vp.2017.0027.

Court, Louise Allison. 'The Changing Fortunes of Three Archaic Japanese Textiles'. In *Cloth and Human Experience*, edited by Annette B. Weiner and Jane Schneider, 377–415. Washington, DC: Smithsonian, 1989.

Crawford, Lucas. 'Slender Trouble: From Berlant's Cruel Figuring to Sedgwick's Fat Presence'. GLQ 23, no. 4 (2017): 447–72. DOI: 10.1215/10642684-4157474.

Crimp, Douglas. 'Mario Montez, For Shame'. In *Regarding Sedgwick: Essays on Queer Culture and Critical Theory*, edited by Stephen M. Barber and David L. Clark, 57–70. London: Routledge, 2002.

———. *Melancholia and Moralism: Essays on AIDS and Queer Politics*. Cambridge: MIT Press, 2002.

———. 'Mourning and Militancy'. *October* 51 (Winter 1989): 3–18. DOI: 10.2307/778889.

Crompton, Andrew. 'How to Look at a Reading Font'. *Word and Image* 30, no. 2 (2014): 79–89. DOI: 10.1080/02666286.2013.817132.

Cvetkovich, Ann. 'The Utopia of Ordinary Habit: Crafting, Creativity, and Spiritual Practice'. In *Depression: A Public Feeling*, 154–203. Durham: Duke University Press, 2012.

Daly, Ann. *Done into Dance: Isadora Duncan in America*. Middletown: Wesleyan University Press, 2002.

Daly, Nicholas. 'The Volcanic Disaster Narrative: From Pleasure Garden to Canvas, Page, and Stage'. *Victorian Studies* 53, no. 2 (Winter 2011): 255–85. DOI: 10.2979/victorianstudies.53.2.fm.

Davis, Whitney. 'Triple Cross: Binarisms and Binds in *Epistemology of the Closet*'. *Representations* 149, no. 1 (Winter 2020): 134–58. DOI: 10.1525/rep.2020.149.1.134.

Dean, Tim. *Unlimited Intimacy: Reflections on the Subculture of Barebacking*. Chicago: University of Chicago Press, 2009.

Delaney, Samuel R. *Times Square Red, Times Square Blue*. New York: New York University Press, 1999.

Deleuze, Gilles. *The Fold: Leibniz and the Baroque*. Translated by Tom Conley. London: Athlone, 1993.

Dever, Carolyn. 'Strategic Aestheticism'. *Victorian Studies* 49, no. 1 (Autumn 2006): 94–99. https://www.jstor.org/stable/4618953.

Dickinson, Emily. *The Collected Poems of Emily Dickinson*. London: Faber and Faber, 2016.

Dinshaw, Carolyn. *Getting Medieval: Sexualities and Communities, Pre- and Post-Modern*. Durham: Duke University Press, 1999.

Dinshaw, Carolyn, et al. 'Theorising Queer Temporalities: A Roundtable Discussion'. GLQ 13, nos. 2–3 (2007): 177–95. DOI: 10.1215/10642684-2006-030.

Dinshaw, Carolyn, Karma Lochrie, and Madhavi Menon. 'Queering History'. PMLA 121, no. 3 (May 2006): 837–39.

Dodier, Virginia. *Clementina, Lady Hawarden: Studies from Life, 1857–1864*. Denville: Aperture, 1999.

Downes, Lawrence. 'An Artist Who Wrapped and Bound Her Work, and Then Broke Free'. *The New York Times*, December 2, 2014. https://www.nytimes.com/2014/12/02/opinion/an-artist-who-wrapped-and-bound-her-work-and-then-broke-free.html.

Doyle, Jennifer, and David J. Getsy, 'Queer Formalisms: Jennifer Doyle and David Getsy in Conversation'. *Art Journal Open* 72, no. 4 (Winter 2013). http://artjournal.collegeart.org/?p=4468.

Drucker, Johanna. *Figuring the Word: Essays on Books, Writing, and Visual Poetics*. New York: Granary, 1998.

———. *The Alphabetic Labyrinth: The Letters in History and Imagination*. London: Thames and Hudson, 1995.

———. *The Century of Artists' Books* (1994). New York: Granary, 2004.

Duggan, Lisa. *The Twilight of Equality: Neoliberalism, Cultural Politics, and the Attack on Democracy*. London: Penguin, 2004.

Duncan-Jones, Katherine, ed. *Shakespeare's Sonnets*. London: Bloomsbury, 2010.

Edelman, Lee. *No Future: Queer Theory and the Death Drive*. Durham: Duke University Press, 2004.

———. 'Tearooms and Sympathy or The Epistemology of the Water Closet'. In *The Lesbian and Gay Studies Reader*, edited by Henry Abelove, Michele Aina Barale, and David M. Halperin, 553–76. London: Routledge.

———. 'Unnamed: Eve's Epistemology'. *Criticism* 52, no. 2 (Spring 2010): 185–90. DOI: 10.1353/crt.2010.0023.

Edwards, Jason, ed. *Anxious Flirtations: Homoeroticism, Art, and Aestheticism in Victorian Britain*. Special issue of *Visual Culture in Britain* 8, no. 1 (Spring 2007).

———, ed. *Bathroom Songs: Eve Kosofsky Sedgwick as a Poet*. Earth: punctum books, 2017.

———. *Eve Kosofsky Sedgwick*. London: Routledge, 2009.

———. 'For Beauty Is a Series of Hypotheses? Sedgwick as Fiber Artist'. In *Reading Sedgwick*, edited by Lauren Berlant, 72–91. Durham: Duke University Press, 2019.

———. *Queer Craft: Eve Kosofsky Sedgwick as Fiber Artist*. Durham: Duke University Press, forthcoming.

Ellis, Jim. 'Conjuring the Tempest: Derek Jarman and the Spectacle of Redemption'. GLQ 7, no. 2 (2001): 265–84. DOI: 10.1215/10642684-7-2-265.

Ellmann, Richard. *Oscar Wilde*. New York: Random, 1988.

Faderman, Lillian. *Surpassing the Love of Men: Romantic Friendship and Love Between Women from the Renaissance to the Present* (1981). London: Virago, 1985.

Felski, Rita. *The Limits of Critique*. Chicago: University of Chicago Press, 2015.

Ferenczi, Sandor. *Thalassa: A Theory of Genitality* (1938). London: Karnac, 1989.

Fisher, Kate. 'The Censorship Myth and the Secret Museum'. In *Pompeii in the Public Imagination from Its Rediscovery to Today,* edited by Shelley Hales and Joanna Paul, 301–30. Oxford: Oxford University Press, 2011.

Flatley, Jonathan. 'Like: Collecting and Collectivity'. *October* 132 (Spring 2010): 71–98. DOI: 10.1162/octo.2010.132.1.71.

———. *Liking Andy Warhol.* Chicago: University of Chicago Press, 2018.

———. 'Unlike Eve Sedgwick'. *Criticism* 52, no. 2 (Spring 2010): 225–34. DOI: 10.1353/crt.2010.0041.

Foucault, Michel. *Discipline and Punish: The Birth of the Prison.* Translated by Alan Sheridan. London: Allen Lane, 1977.

Frank, Adam, and Elizabeth A. Wilson. *A Silvan Tomkins Handbook: Foundations for Affect Theory.* Minneapolis: University of Minnesota Press, 2020.

———. 'Like Minded'. *Critical Inquiry* 38, no. 4 (Summer 2012): 870–77. DOI: 10.1086/667428.

Frank, Arthur W. 'Bodies, Sex and Death'. *Theory, Culture, and Society* 15, nos. 3–4 (1998): 417–25. DOI: 10.1177/0263276498015003021.

Frecerro, Carla. *Queer/Early/Modern.* Durham: Duke University Press, 2006.

Freeman, Elizabeth. *Time Binds: Queer Temporalities, Queer Histories.* Durham: Duke University Press, 2010.

Fried, Michael. *Absorption and Theatricality: Painting and Beholder in the Age of Diderot.* Berkeley: University of California Press, 1980.

———. *Manet's Modernism, or The Face of Painting in the 1860s.* Chicago: University of Chicago Press, 1996.

———. 'Realism, Writing, and Disfiguration in Thomas Eakins's *Gross Clinic,* with a Postscript on Stephen Crane's *Upturned Faces*'. *Representations* 9 (Winter 1985): 33–104. DOI: 10.2307/3043766.

———. *Realism, Writing, and Disfiguration: On Thomas Eakins and Stephen Crane.* Chicago: Chicago University Press, 1987.

Fury, Gran, and Michael Cohen, eds. *Gran Fury: Read My Lips.* New York: 80WSE, 2011.

Gabriele Grunebaum. *How to Marbleize Paper: Step-by-Step Instructions for 12 Traditional Patterns.* New York: Dover, 1984.

Gallop, Jane. 'Early and Earlier Sedgwick'. In *Reading Sedgwick,* edited by Lauren Berlant, 13–120. Durham: Duke University Press, 2019.

———. 'Sedgwick's Twisted Temporalities, "or even just reading and writing"'. In *Queer Times, Queer Becomings,* edited by E.L. McCallum and Mikko Tuhkanen, 47–75. Albany: State University of New York Press, 2011.

———. *The Deaths of the Author: Reading and Writing in Time.* Durham: Duke University Press, 2011.

———. 'The Ethics of Reading: Close Encounters'. *Journal of Curriculum Theorising* 16, no. 3 (Fall 2000): 7–17.

Garland-Thomson, Rosemarie. 'Seeing the Disabled: Visual Rhetorics of Disability in Popular Photography'. In *Disability Studies: Enabling the Humanities,* edited by Sharon L. Snyder, Brenda Jo Bureggemann, and Rosemarie Garland-Thomson, 56–75. New York: MLA, 2002.

Garnett, Angelica. *Deceived with Kindness: A Bloomsbury Childhood.* London: Pimlico, 1995.

Gibbs, Anna. 'At the Time of Writing: Sedgwick's Queer Temporalities'. *Australian Humanities Review* 48 (May 2010): 41–53. http://australianhumanitiesreview.org/2010/05/01/at-the-time-of-writing-sedgwicks-queer-temporalities/.

Giffney, Noreen, and Myra J. Hird, eds. *Queering the Non/Human.* Aldershot: Ashgate, 2008.

Goldberg, Jonathan. *Come As You Are, After Eve Kosofsky Sedgwick.* Earth: punctum books, 2021.

———. 'Editor's Introduction'. In Eve Kosofsky Sedgwick, *The Weather in Proust,* xiii–xvi. Durham: Duke University Press.

———. 'Eve's Future Figures'. In *Reading Sedgwick,* edited by Lauren Berlant, 121–31. Durham: Duke University Press, 2019.

———. 'On the Eve of the Future'. *Criticism* 52, no. 2 (Spring 2010): 283–92.

———. 'On the Eve of the Future'. *PMLA* 125, no. 2 (March 2010): 374–77. DOI: 10.1632/pmla.2010.125.2.374.

———. *Reclaiming Sodom.* New York: Routledge, 1994.

———. *Sodometries: Renaissance Texts, Modern Sexualities.* Stanford: Stanford University Press, 1992.

Goldhill, Simon. 'A Writer's Things: Edward Bulwer Lytton and the Archaeological Gaze; or, What's in a Skull?'. *Representations* 119, no. 1 (Summer 2012): 92–118. DOI: 10.1525/rep.2012.119.1.92.

Gordon, Bob. *1000 Fonts from Albertus to Zupra Sans.* Lewes: Ivy, 2009.

Grunebaum, Gabriele. *How to Marbleize Paper: Step-by-Step Instructions for 12 Traditional Patterns.* New York: Dover, 1984.

Gunn, Thom. *The Man with Night Sweats.* London: Faber, 1992.

Halberstam, J. Jack. *In A Queer Time and Place.* New York: New York University Press, 2005.

———. 'Oh Bondage Up Yours! Female Masculinity and the Tomboy'. In *Curiouser: On the Queerness of Children,* edited by Steven Bruhm and Natasha Hurley, 191–214. Minneapolis: Minnesota University Press, 2004.

Hale, C. Jacob. 'Leatherdyke Boys and Their Daddies: How to Have Sex Without Women or Men'. *Social Text* 52–53 (Autumn–Winter 1997): 223–36. DOI: 10.2307/466741.

Hales, Shelley, and Joanna Paul, eds. *Pompeii in the Public Imagination from Its Rediscovery to Today.* Oxford: Oxford University Press, 2011.

Halley, Janet, ed. *A Tribute from Legal Studies to Eve Kosofsky Sedgwick.* Special issue of *Harvard Journal of Law and Gender* 33, no. 1 (Winter 2010): 309–56.

Hancock, Nuala. *Charleston and Monk's House: The Intimate House Museums of Virginia Woolf and Vanessa Bell*. Edinburgh: Edinburgh University Press, 2012.

Hanson, Ellis. 'Knowing Children: Desire and Interpretation in *The Exorcist*'. In *Curiouser: On the Queerness of Children*, edited by Steven Bruhm and Natasha Hurley, 107–39. Minneapolis: Minnesota University Press, 2004.

———. 'The Future's Eve: Reparative Readings After Sedgwick'. *South Atlantic Quarterly* 110, no. 1 (2011): 101–19. DOI: 10.1215/00382876-2010-025.

———. 'The Languorous Critic'. *New Literary History* 43, no. 3 (Summer 2012): 547–64.

Haag, Michael. *Vintage Alexandria, 1860–1960*. Cairo: American University in Cairo Press, 2008.

Hardt, Michael. 'The Militancy of Theory'. *The South Atlantic Quarterly* 110, no. 1 (Winter 2011): 19–35. DOI: 10.1215/00382876-2010-020.

Hawkins, G. Ray, and Alexandra Anderson-Spivy. *Of Passions and Tenderness: Portraits of Olga By Baron De Meyer*. Marina Del Rey: Graystone, 1992.

Hawkins, Katherine. 'Re-Creating Eve: Sedgwick's Art and the Practice of Renewal'. *Criticism* 52, no. 2 (Spring 2010): 271–82. DOI: 10.1353/crt.2010.0036.

———. 'Woven Spaces: Eve Kosofsky Sedgwick's *Dialogue on Love*'. *Women and Performance: A Journal of Feminist Theory* 16, no. 2 (July 2006): 251–67. DOI: 10.1080/07407700600744568.

Hawkins, Peter S. 'Naming Names: The Art of Memory and the NAMES Project AIDS Quilt'. In *Thinking About Exhibitions*, edited by Reesa Greenberg, Bruce W. Ferguson, and Sandy Nairne, 133–56. London: Routledge, 1995.

Haye, Christian, and Eve Kosofsky Sedgwick. 'All About Eve'. *Frieze* (May 6 1997): 1–6. https://www.frieze.com/article/all-about-eve.

Hayward, Eva. 'Lessons from a Starfish'. In *The Transgender Studies Reader 2*, edited by Susan Stryker and Aren Z. Aizura, 178–88. London: Routledge, 2013.

———. 'More Lessons from a Starfish: Prefixial Flesh and Transspeciated Selves'. *Women's Studies Quarterly* 36, no. 4 (Fall-Winter 2008): 64–84. DOI: 10.1353/wsq.0.0099.

Hensley, Nathan K. 'Curatorial Reading and Endless War'. *Victorian Studies* 56, no. 1 (Autumn 2013): 59–83. DOI: 10.1353/vic.2013.0159.

Herbrechter, Stefan. 'Critical Proximity'. *Journal for Cultural Research* 21, no. 4 (2017): 323–36. DOI 10.1080/14797585.2017.1370485.

Herring, Scott. 'Contraband Marginalia'. In *Queering the BIbliObject,* edited by John Chaichm n.p. New York: The Centre for Book Arts, 2016.

———. 'Eve Sedgwick's "Other Materials"'. *Angelaki* 21, no. 1 (2018): 5–18. DOI: 10.1080/0969725X.2018.1435365.

Hertz, Neil. 'Attention'. *GLQ* 17, no. 4 (2011): 511–16. DOI 10.1215/10642684-1302352.

———. *The End of the Line* (1985). Aurora: The Davies Group, 2009.

Hewitt, Barbara. *Blueprints on Fabric: Innovative Uses for Cyanotype.* Colorado: Interweave, 1995.

Highmore, Ben, ed., *The Design Culture Reader.* New York: Routledge, 2009.

Hill, Marylu. 'Shadowing Sense at War with Soul: Julia Margaret Cameron's Photographic Illustrations of Tennyson's *Idylls of the King*'. *Victorian Poetry* 40, no. 4 (2002): 445–62. DOI 10.1353/vp.2003.0004.

Hilton, Brian, ed. *Illustrations by Julia Margaret Cameron of Alfred Lord Tennyson's Idylls of the King and Other Poems.* Freshwater Bay: Julia Margaret Cameron Trust, 2004.

Hirsch, Faye. 'Judith Scott'. *Art in America,* February 3 2015. https://www.artnews.com/art-in-america/aia-reviews/judith-scott-2-61864/.

Hitchens, Robert. *The Green Carnation.* London: William Heinemann, 1894.

Hoang, Nguyen Tan. *A View From the Bottom: Asian-American Masculinity and Sexual Representation.* Durham: Duke University Press, 2014.

Hoffmann, Yoel, ed. *Japanese Death Poems Written by Zen Monks and Haiku Poets on the Verge of Death.* Boston: Tuttle, 1986.

Holmes, Jessica. 'Boundless: Judith Scott at the Brooklyn Museum'. *Art Critical,* March 2015. https://artcritical.com/2015/03/20/jessica-holmes-on-judith-scott/.

Hoskins, Janet. 'Why Do Ladies Sing the Blues? Indigo Dyeing, Cloth Production, and Gender Symbolism in Kodi'. In *Cloth and Human Experience,* edited by Annette B. Weiner and Jane Schneider, 141–76. Washington, DC: Smithsonian, 1989.

Huysmans, J.K. *Against Nature* (1891). Oxford: Oxford University Press, 2009.

Jagose, Annamarie. 'Thinkiest'. *Australian Humanities Review* 48 (May 2010): 11–15. http://australianhumanitiesreview.org/2010/05/01/thinkiest/.

Jain, S. Lochlann. 'Cancer Butch'. *Cultural Anthropology* 22, no. 4 (2007): 501–38. DOI: 10.1525/can.2007.22.4.501.

James, Henry. *Notebooks of Henry James.* Edited by F.O. Matthiessen and Kenneth B. Murdock. New York: Oxford University Press, 1947.

Janes, Dominic. *Picturing the Closet: Male Secrecy and Homosexual Visibility in Britain.* Oxford: Oxford University Press, 2015.

Jay, Peter, ed. *The Greek Anthology and Other Ancient Epigrams.* London: Penguin, 1981.

Jeffreys, Peter. *Eastern Questions: Hellenism and Orientalism in the Writings of E.M. Forster and C.P. Cavafy.* Greensboro: University of North Carolina Press, 2005.

Jing, Zhu, and Li Yangwen. *The Giant Panda.* Beijing: Van Nostrand Reinhold, 1980.

Johnson, Barbara. 'Bringing Out D.A. Miller'. *Narrative* 10, no. 1 (January 2002): 3–8. DOI: 10.1353/nar.2002.0002.

———. 'Speech Therapy'. In *Shakesqueer: A Queer Companion to the Complete Works of William Shakespeare,* edited by Madhavi Menon, 328–32. Durham: Duke University Press, 2011.

Jones, Edgar Yoxall. *Father of Art Photography: O.G. Rejlander, 1813–1875.* Newton Abbot: David and Charles, 1973.

Jusdanis, Gregory. T*he Poetics of Cavafy: Textuality, Eroticism, History.* Princeton: Princeton University Press, 1987.

Kafer, Alison. *Feminist, Queer, Crip.* Bloomington: Indiana University Press, 2013.

Katz, Jonathan David et al. *Art AIDS America.* Seattle: Tacoma Art Museum/University of Washington Press, 2016.

Keeley, Edmund. *Cavafy's Alexandria: Study of a Myth in Progress.* Cambridge: Harvard University Press, 1976.

Kent, Kathryn R. 'Eve's Muse'. In *Bathroom Songs,* edited by Jason Edwards, 111–39. Earth: punctum books, 2017.

———. *Making Girls into Women: American Women's Writing and the Rise of Lesbian Identity.* Durham: Duke University Press, 2003.

———. '"No Trespassing": Girl Scout Camp and the Limits of the Counterpublic Sphere'. In *Curiouser: On the Queerness of Children,* edited by Steven Bruhm and Natasha Hurley, 173–90. Minneapolis: Minnesota University Press, 2004.

———. '"Surprising Recognition": Genre, Poetic Form, and Erotics from Sedgwick's "1001 Seances" to *A Dialogue on Love*'. GLQ 17, no. 4 (2011): 497–510. DOI 10.1215/10642684-1302343.

Kincaid, James. 'Producing Erotic Children'. In *Curiouser: On the Queerness of Children,* edited by Steven Bruhm and Natasha Hurley, 3–16. Minneapolis: Minnesota University Press, 2004.

———. 'When Whippoorwills Call'. In *Regarding Sedgwick: Essays on Queer Culture and Critical Theory,* edited by Stephen M. Barber and David Clark, 229–43. London: Routledge, 2002.

Koestenbaum, Wayne. 'A Manual Approach to Mourning'. PMLA 125, no. 2 (March 2010): 382–84. DOI: 10.1632/pmla.2010.125.2.382. Reprinted in Wayne Kostenbaum, *My 1980s and Other Essays,* 65–70. New York: Farrar, Strauss, and Giroux, 2013.

———. *Cleavage: Essays on Sex, Stars, and Aesthetics*. New York: Ballantine, 2000.

———. 'Preface'. In Eve Kosofsky Sedgwick, *Between Men: English Literature and Male Homosocial Desire*, ix–xvi. New York: Columbia University Press, 2015.

Kosofsky, L.J., and Farouk El-Baz, eds. *The Moon as Viewed by Lunar Orbiter*. Washington, DC: NASA, 1970.

Kozlof, Max. 'Poetics of Softness'. In *Renderings: Critical Essays on a Century of Modern Art*, 223–35. London: Studio Vista, 1970.

Lagoudis, Jane. *Alexandria Still: Forster: Durrell, and Cavafy*. Princeton: Princeton University Press, 1977.

Latimer, Tirza True. 'Balletomania: A Sexual Disorder?'. GLQ 5, no. 22 (1999): 173–97. DOI: 10.1215/10642684-5-2-173.

Latour, Bruno. *Reassembling the Social: An Introduction to Actor-Network-Theory*. Oxford: Clarendon, 2005.

———. 'Why Has Critique Run Out of Steam?'. *Critical Inquiry* 30, no. 2 (Winter 2004): 225–48. DOI: 10.1086/421123.

Lawrence, Tim. 'AIDS, The Problem of Representation and Plurality in Derek Jarman's *Blue*'. *Social Text* 52–53 (Autumn–Winter 1997): 241–64. DOI: 10.2307/466743.

Lesjack, Carolyn. 'Reading Dialectically'. *Criticism* 55, no. 2 (Spring 2013): 233–77. DOI: 10.1353/crt.2013.0012.

Levine, Caroline. 'Scaled Up, Writ Small: A Response to Carolyn Dever and Herbert F. Tucker'. *Victorian Studies* 49, no. 1 (Autumn 2006): 100–5. https://www.jstor.org/stable/4618954.

———. 'Strategic Formalism: Toward a New Method in Cultural Studies'. *Victorian Studies* 48, no. 4 (Summer 2006): 625–57. https://www.jstor.org/stable/4618909.

Levinson, Marjorie. 'What Is New Formalism?'. PMLA 122, no. 2 (March 2007): 558–69. https://www.jstor.org/stable/25501722.

Lewis, Gail. 'Not By Criticality Alone'. *Feminist Theory* 15, no. 1 (2014): 31–38. DOI: 10.1177/1464700113513084.

Liddell, Robert. *Cavafy: A Critical Biography*. London: Duckworth, 1974.

Lin, Lana. *Freud's Jaw and Other Lost Objects: Fractured Subjectivity in the Face of Cancer*. New York: Fordham, 2017.

Lissitzky, El. 'The Book'. In *El Lissitzky: Life, Letters, Texts,* edited by Sophie Lissitzky-Küppers, 359–65. London: Thames and Hudson, 1992.

Loomis, Chauncey. 'The Arctic Sublime'. In *Nature and the Victorian Imagination,* edited by U.C. Knoepflmacher and G.B. Tennyson, 95–112. Berkeley: University of California Press, 1977.

Lorde, Audre. *A Burst of Light: Essays*. Ithaca: Firebrand, 1988.

———. *The Cancer Journals*. San Francisco: Spinsters Ink, 1988.

Love, Heather. 'Bookish'. In *Queering the BIbliObject,* edited by John Chaich, n.p. New York: The Centre for Book Arts, 2016.

———. 'Close But Not Deep: Literary Ethics and the Descriptive Turn'. *New Literary History* 41, no. 2 (2010): 371–91. https://www.jstor.org/stable/40983827.

———. 'Close Reading and Thin Description'. *Public Culture* 25, no. 3 (2013): 401–34. DOI: 10.1215/08992363-2144688.

———. *Feeling Backward: Loss and the Politics of Queer History*. Cambridge: Harvard University Press, 2009.

———. 'Truth and Consequences: On Paranoid Reading and Reparative Reading'. *Criticism* 52, no. 2 (Spring 2010): 235–42. DOI: 10.1353/crt.2010.0022.

Luna, Paul. *A Very Short Introduction to Typography*. Oxford: Oxford University Press, 2018.

Lynch, Michael. 'Terrors of Resurrection "By Eve Kosofsky Sedgwick"'. In *Confronting AIDS through Literature,* edited by Judith Laurence Pastore, 79–83. Chicago: University of Chicago Press, 1993.

———. *These Waves of Dying Friends: Poems by Michael Lynch*. New York: Contact, 1989.

Mallarmé, Stéphane. *Collected Poems and Other Verse.* Translated with notes by E.H. and A.M. Blackmore. Oxford: Oxford University Press, 2008.

McDonald, Ronan. 'Critique and Anti-Critique'. *Textual Practice* 32, no. 3 (2018): 365–74. DOI: 10.1080/0950236X.1442400.

MacGregor, John M. *Metamorphosis: The Fiber Art of Judith Scott.* Berkeley: Creative Growth Art Center, 1999.

Malamud, Margaret. 'On the Edge of the Volcano: The Last Days of Pompeii in the Early American Republic'. In *Pompeii in the Public Imagination from Its Rediscovery to Today,* edited by Shelley Hales and Joanna Paul, 199–220. Oxford: Oxford University Press, 2011.

Maltz, Diana. 'Baffling Arrangements: Vernon Lee and John Singer Sargent in Queer Tangier'. In *Rethinking the Interior: Aestheticism and Arts and Crafts, 1867–1896,* edited by Jason Edwards and Imogen Hart, 201–226. Aldershot: Ashgate, 2012.

Marcus, Sharon. *Between Women: Friendship, Desire, and Marriage in Victorian England.* Princeton: Princeton University Press, 2007.

Marcus, Sharon, and Stephen Best. 'Surface Reading: An Introduction'. *Representations* 108, no. 1 (Fall 2009): 1–21. DOI: 10.1525/rep.2009.108.1.1.

Marcus, Sharon, Heather Love, and Stephen Best. 'Building a Better Description'. *Representations* 135, no. 1 (Summer 2016): 1–21. DOI: 10.1525/rep.2016.135.1.1.

Mark, Ira S. 'The Lure of Philosophy: Craft and Higher Learning in Greece'. In P*olykleitos, the Doryphoros, and Tradition,* edited by Warren G. Moon (Madison: University of Wisconsin Press, 1995), 25–29.

Mavor, Carol. *Becoming: The Photographs of Clementina, Viscountess Hawarden.* Durham: Duke University Press, 1999.

———. *Black and Blue: The Bruising Passion of Camera Lucida, La Jetee, Sans soleil, and Hiroshima mon amour.* Durham: Duke University Press, 2012.

———. *Blue Mythologies: Reflections on a Colour.* London: Reaktion, 2013.

———. *Pleasures Taken: The Performance of Sexuality and Loss in Victorian Photography.* Durham: Duke University Press, 1995.

McCruer, Robert. 'As Good As It Gets: Queer Theory and Critical Disability'. GLQ 9, nos. 1–2 (2003): 79–105. DOI: 10.1215/10642684-9-1-2-79.

———. *Crip Theory: Cultural Signs of Queerness and Disability.* New York: New York University Press, 2006.

———. 'Disabling Sex: Notes for a Crip Theory of Sexuality'. GLQ 17, no. 1 (2010): 107–17. DOI: 10.1215/10642684-2010-021.

———. '*Richard III*: Fuck The Disabled: The Prequel'. In *Shakesqueer: A Queer Companion to the Complete Works of Shakespeare,* edited by Madhavi Menon, 294–301. Durham: Duke University Press, 2011.

McCruer, Robert, and Anna Mollow, eds. *Sex and Disability.* Durham: Duke University Press, 2012.

McCruer, Robert, and Abby L. Wilkerson. 'Introduction'. GLQ 9, nos. 1–2 (2003): 1–23. DOI: 10.1215/10642684-9-1-2-1.

McMahon, Elizabeth. 'The Proximate Pleasure of Sedgwick: A Legacy of Intimate Reading'. *Australian Humanities Review* 48 (May 2010): 17–29. http://australianhumanitiesreview.org/2010/05/01/the-proximate-pleasure-of-eve-sedgwick-a-legacy-of-intimate-reading/.

McWilliam, Neil, and Veronica Sekules, eds. *Life and Landscape: P.H. Emerson – Art and Photography in East Anglia 1885–1900.* Norwich: Sainsbury Centre, 1986.

Menon, Madhavi. *Indifference to Difference: On Queer Universalism.* Minnesota: University of Minnesota Press, 2015.

———, ed. *Shakesqueer: A Queer Companion to the Complete Works of William Shakespeare.* Durham: Duke University Press, 2011.

Merrill, James. *A Different Person: A Memoir* (1993). In *James Merrill: The Collected Prose,* edited by J.D. McClatchy and Stephen Yenser, 457–685. New York: Alfred A. Knopf, 2004.

———. *Collected Poems.* New York: Knopf, 2002.
———. *The Changing Light at Sandover.* New York: Athenaeum, 1984.
Milhout, Terry Satsuki. *Kimono: A Modern History.* London: Reaktion, 2014.
Miller, D.A. *Bringing Out Roland Barthes.* Berkeley: University of California Press, 1992.
———. *Hidden Hitchcock.* Chicago: University of Chicago Press, 2016.
Mitchell, George, ed. *Vijayanagara: Splendour in Ruins.* New York: Alkazi, 2008.
Mitchell, Stephen. *Tao Te Ching: A New English Version.* New York: Harper, 1988.
Mitchell, W.J.T. 'The Commitment to Form; or, Still Crazy After All These Years'. MLA 118, no. 2 (2003): 321–25. DOI: 10.1632/003081203X67703.
Mohr, Richard. D. 'The Pedophilia of Everyday Life'. In *Curiouser: On the Queerness of Children,* edited by Steven Bruhm and Natasha Hurley, 17–30. Minneapolis: Minnesota University Press, 2004.
Moon, Michael. *Darger's Resources.* Durham: Duke University Press, 2012.
———. *Disseminating Whitman: Revision and Corporeality in Leaves of Grass.* Harvard: Cambridge University Press, 1991.
———. 'Memorial Rags'. In *Professions of Desire,* edited by George E. Haggerty and Bonnie Zimmerman, 233–40. New York: MLA, 1995.
———. 'On the Eve of the Future'. In *Reading Sedgwick,* edited by Lauren Berlant, 141–51. Durham: Duke University Press, 2019.
———. 'Psychosomatic? Mental and Physical Pain in Eve Sedgwick's Writing'. *Criticism* 52, no. 2 (Spring 2010): 209–14. DOI: 10.1353/crt.2010.0033.
———. 'The Black Swan: Poetry, Punishment, and the Sadomasochism of Everyday Life; or, Tradition and the Individual Talent'. *GLQ* 17, no. 4 (2011): 487–96. DOI: 10.1215/10642684-1302334.

Moon, Warren G. *Polykleitos, the Doryphoros, and Tradition.* Madison: University of Wisconsin Press, 1995.

Moorman, Eric. M. 'Christians and Jews at Pompeii in Late Nineteenth-Century Fiction'. In *Pompeii in the Public Imagination from Its Rediscovery to Today,* edited by Shelley Hales and Joanna Paul, 171–84. Oxford: Oxford University Press, 2011.

Moretti, Franco. *Distant Reading.* London: Verso, 2013.

Morris, Catherine, and Matthew Higgs, eds. *Judith Scott: Bound and Unbound.* New York: Delmonico Books/Brooklyn Museum, 2015.

Morris, Ramona, and Desmond Morris. *Men and Pandas.* New York: McGraw-Hill, 1966.

Muñoz, Jose Esteban. *Cruising Utopia: The Then and There of Queer Futurity.* New York: New York University Press, 2009.

———. 'Race, Sex and the Incommensurate: Gary Fisher with Eve Kosofsky Sedgwick'. In *Reading Sedgwick,* edited by Lauren Berlant, 152–65. Durham: Duke University Press, 2019.

Murphy, Erin, and J. Keith Vincent, eds. *Honoring Eve.* Special issue of *Criticism* 52, no. 2 (Spring 2010).

Naremore, James. *North by Northwest: Alfred Hitchcock, Director.* Rutgers: Rutgers University Press, 1993.

Nelson, Maggie. *Bluets.* London: Penguin, 2009.

———. 'In the Bardo with Eve Sedgwick: A Buddhist "Art of Dyeing" (And Dyeing)'. CUNY *Matters,* Summer 2000, 9.

———. *The Argonauts.* New York: Melville House, 2016.

Newhall, Nancy. *P.H. Emerson: The Fight for Photography as a Fine Art.* New York: Aperture, 1975.

Ngai, Sianne. *Ugly Feelings.* Boston: Harvard University Press, 2005.

Nichols, Ben. 'Queer Footing: Pedestrian Politics and the Problem of Queer Difference in *The Princess Casamassima*'. *Henry James Review* 34, no. 1 (2013): 98–111. DOI: 10.1353/hjr.2013.0004.

———. 'Reductive: John Rechy, Queer Theory, and the Idea of Limitation'. GLQ 22, no. 3 (2016): 409–35. DOI: 10.1215/10642684-3479318.

———. *Same/Old: Queer Theory, Literature, and the Politics of Sameness*. Manchester: Manchester University Press, 2020.

Nicholls, Henry. *The Way of the Panda*. London: Profile, 2010.

Noys, Benjamin. 'Skimming the Surface: Critiquing Anti-Critique'. *Journal for Cultural Research* 21, no. 4 (2017): 295–308. DOI: 10.1080/14797585.2017.1370483.

Ohi, Kevin. 'Narrating the Child's Queerness in *What Maisie Knew*'. In *Curiouser: On the Queerness of Children*, edited by Steven Bruhm and Natasha Hurley, 83–103. Minneapolis: Minnesota University Press, 2004.

Ovendon, Graham, ed. *Clementina Lady Howarden*. London: Academy, 1974.

Palmer, Martin, and Jam Ramsay, with Man-Ho Kwok. *The Kuan Yin Chronicles: The Myths and Prophecies of the Chinese Goddess of Compassion* (1995). Charlottesville: Hampton Roads, 2009.

Parker, Andrew. 'Eve At Amherst'. PMLA 125, no. 2 (May 2010): 385–86. DOI: 10.1632/pmla.2010.125.2.385.

———. 'The Age of Frankenstein'. In *Reading Sedgwick*, edited by Lauren Berlant, 178–88. Durham: Duke University Press, 2019.

Pater, Walter. *The Renaissance: Studies in Art and Poetry*. London: Macmillan, 1873.

Paterson, Elaine Cheasley, and Susan Surette, eds. *Sloppy Craft: Postdisciplinarity and the Crafts*. London: Bloomsbury, 2015.

Patton, Cindy. 'Love Without the Obligation to Love'. *Criticism* 52, no. 2 (Winter 2010): 215–24. DOI: 10.1353/crt.2010.0037.

Paul, Joanna. 'Pompeii, the Holocaust, and the Second World War'. In *Pompeii in the Public Imagination from Its Rediscovery to Today*, edited by Shelley Hales and Joanna Paul, 341–55. Oxford: Oxford University Press, 2011.

Pearl, Monica. 'American Grief: The AIDS Quilt and Texts of Witness'. *Gramma* 16 (2008): 251–272. DOI: 10.26262/gramma.v16i0.6438.

———. 'Conversation and Queer Filiation'. In *AIDS Literature and Gay Identity*, 143–65. London: Routledge, 2013.

———. 'Eve [Kosofsky] Sedgwick's Melancholic "White Glasses"', *Textual Practice* 17, no. 1 (2003): 61–80. DOI: 10.1080/0950236032000050744.

———. 'Queer Therapy: On the Couch with Eve Kosofsky Sedgwick'. In *Bathroom Songs: Eve Kosofsky Sedgwick as a Poet*, edited by Jason Edwards, 151–68. Earth: punctum, 2017.

Peiry, Lucienne. 'Judith Scott'. *Notes d'Art Brut*, May 29, 2013. https://www.notesartbrut.ch/judith-scott/.

Pinchin, Jane Lagoudis. *Alexandria Still: Forster, Durrell, and Cavafy*. Princeton: Princeton University Press, 1977.

Poggi, Christine. *In Defence of Painting: Cubism, Futurism, and the Invention of Collage*. New Haven: Yale University Press, 1993.

Porter, Jenelle. *Fiber: Sculpture 1960–Present*. Munich: Prestel/Del Monico, n.d.

Potts, Jason, ed. 'Dossier: Surface Reading'. *Mediations: Journal of the Marxist Literary Group* 28, no. 2 (Spring 2015): 1–108. https://mediationsjournal.org/toc/dossier-surface-reading-preview.

Prettejohn, Elizabeth. *The Modernity of Ancient Sculpture*. London: I.B. Taurus, 2012.

Prodger, Philip. *Victorian Giants: The Birth of Art Photography*. London: National Portrait Gallery, 2018.

Prosser, Jay. *Second Skins: The Body Narratives of Transexuality*. New York: Columbia University Press, 1998.

Proust, Marcel. *In Search of Lost Time; Vol. 2: Within a Budding Grove*. Translated by Terence Kilmartin and C.K. Scott Moncrieff, revised by D.J. Enright (1919). London: Vintage, 1996.

———. *In Search of Lost Time; Vol. 3: The Guermantes Way*. Translated by Terence Kilmartin and C.K. Scott Moncrieff, revised by D.J. Enright (1920–21). London: Vintage, 2000.

———. *In Search of Lost Time; Vol. 5: The Captive and The Fugitive*. Translated by Terence Kilmartin and C.K. Scott

Moncrieff, revised by D.J. Enright (1923 and 1925). London: Vintage, 2000.

Puar, Jasbir K. *Terrorist Assemblages: Homonationalism in Queer Times.* Durham: Duke University Press, 2007.

Rambuss, Richard. 'A Midsummer Night's Dream: Shakespeare's Ass Play'. In *Shakesqueer: A Queer Companion to the Complete Works of Shakespeare,* edited by Madhavi Menon, 234–44. Durham: Duke University Press, 2011.

Reid-Pharr, Robert F. 'Clean: Death and Desire in Samuel Delaney's *Stars in My Pocket Like Grains of Sand*'. *American Literature* 83, no. 2 (2011): 289–411. DOI: 10.1215/00029831-1266099.

———. 'The Shock of Gary Fisher'. In *Black Gay Men: Essays,* 135–49. New York: New York University Press, 2001.

Reed, Christopher. *Bloomsbury Rooms: Modernism, Subculture, and Domesticity.* New Haven: Yale University Press for the Bard Graduate Center for Studies in Decorative Arts, Design and Culture, 2004.

Roach, Joseph. 'Culture and Performance in the Circum-Atlantic World'. In *Performativity and Performance,* edited by Eve Kosofsky Sedgwick and Andrew Parker, 45–63. London: Routledge, 1995.

Rogers, Millard F. *Randolph Rogers: American Sculptor in Rome.* Boston: University of Massachusetts Press, 1971.

Rohy, Valerie. *Anachronism and Its Others.* New York: SUNY Press, 2009.

———. *Lost Causes: Narrative, Etiology, and Queer Theory.* Oxford: Oxford University, 2015.

Rooney, Ellen. 'Live Free or Describe: The Reading Effect and the Persistence of Form'. *differences* 21.3 (2010): 112–39. DOI: 10.1215/10407391-2010-012.

Ruskin, John. *The Elements of Drawing* (1857). New York: Dover, 1971.

Sandahl, Carrie. 'Queering the Crip or Cripping the Queer: Intersections of Queer and Crip Identities in Solo Autobiographical Performance'. *GLQ* 9, nos. 1–2 (2003): 25–56. DOI: 10.1215/10642684-9-1-2-25.

Sayag, Alain, ed. *David Hockney Photographs*. London: Petersburg, 1982.

Schaaf, Larry J. *Sun Gardens: Victorian Photograms by Anna Atkins*. New York: Hans P. Kraus, Jr., 1985.

Scott, Joyce. *Entwined: Sisters and Secrets in the Silent World of Artist Judith Scott*. Boston: Beacon, 2016.

Schmitt, Cannon. 'Tidal Conrad (Literally)'. *Victorian Studies* 55, no. 1 (Autumn 2012): 7–29. DOI: 10.2979/victorianstudies.55.1.7

Schneider, Jane. 'Rumpelstiltskin's Bargain: Folklore and the Merchant Capitalist Intensification of Linen Manufacture in Early Modern Europe'. In *Cloth and Human Experience*, edited by Annette B. Weiner and Jane Schneider, 177–214. Washington, DC: Smithsonian, 1989.

Schulman, Sarah. *The Gentrification of the Mind: Witness to a Lost Imagination*. Berkeley: University of California Press, 2012.

Sedgwick, Eve Kosofsky. *A Dialogue on Love*. Boston: Beacon, 1999.

———. 'Against Epistemology'. In *Questions of Evidence: Proof, Practice, and Persuasion Across the Disciplines,* edited by J. Chandler, A.I. Davidson, and H. Harootunian, 132–36. Chicago: University of Chicago Press, 1994.

———. *Between Men: English Literature and Male Homosocial Desire*. New York: Columbia University Press, 1985.

———. *Between Men: English Literature and Male Homosocial Desire*. 2nd edn. (1985). New York: Columbia University Press, 1993.

———. *Censorship and Homophobia*. Edited by Sarah McCary. New York: Guillotine, 2013.

———. 'Come As You Are' (1999). In Jonathan Goldberg, *Come As You Are, After Eve Kosofsky Sedgwick,* 86–109. Earth: punctum books, 2021.

———. *Epistemology of the Closet* (1990). 2nd edn. Berkeley: University of California Press, 2008.

———. 'Eulogy'. *Women and Performance: A Journal of Feminist Theory* 25 (1996): 233–35. DOI: 10.1080/07407700208571414

———. *Fat Art, Thin Art*. Durham: Duke University Press, 1994.

———, ed. *Gary in Your Pocket: Stories and Notebooks of Gary Fisher*. Durham: Duke University Press, 1996.

———, ed. *Novel Gazing: Queer Readings in Fiction*. Durham: Duke University Press, 1997.

———. 'Pandas in Trees'. *Women and Performance* 8, no. 2 (1996): 175–83. DOI: 10.1080/07407709608571238.

———. Response to C. Jacob Hale's 'Leatherdyke Boys and Their Daddies: How to Have Sex Without Women or Men', *Social Text* 52–53 (Autumn–Winter 1997): 237–39. DOI: 10.2307/466742.

———. Review of *No Man's Land: The Place of the Woman Writer in the Twentieth Century, Vol. 1; The War of the Words* by Sandra M. Gilbert and Susan Gubar (New Haven: Yale University Press, 1988). *English Language Notes* 28 (September 1990): 73–77.

———. 'Sabrina Doesn't Live Here Anymore'. *Amherst* 37, no. 3 (Winter 1985): 12–17, 21.

———. 'Shame and Performativity: Henry James's New York Edition Prefaces'. In *Henry James's New York Edition: The Construction of Authorship*, edited by David McWhirter, 206–39. Stanford: Stanford University Press, 1995.

———. *Tendencies*. Durham: Duke University Press, 1993.

———. 'The 1001 Seances'. *GLQ* 17, no. 4 (2011): 457–83. DOI: 10.1215/10642684-1302316.

———. *The Coherence of Gothic Conventions* (1980). New York: Methuen, 1986.

———. *The Last Days of Pompeii* (c. 2007). Original artist's book.

———. 'The L Word: Novelty in Normalcy'. *The Chronicle of Higher Education* 50, no. 19, January 16, 2004, B10–B11.

———. *The Weather in Proust*. Edited by Jonathan Goldberg. Durham: Duke University Press, 2011.

———. 'Tide and Trust'. *Critical Inquiry* (Summer 1989): 745–57. DOI: 10.1086/448513.

———. *Touching Feeling: Affect, Pedagogy, Performativity.* Durham: Duke University Press, 2003.

———. 'Writing the History of Homophobia'. In *Theory Aside*, edited by Jason Potts and Daniel Stout, 29–34. Durham: Duke University Press, 2014.

Sedgwick, Eve Kosofsky, et al. *Assembling: Memory Palace* (May 2008). Original artists' book, edition of 60.

Sedgwick, Eve Kosofsky, and Adam Frank, eds. *Shame and Its Sisters: A Silvan Tomkins Reader.* Durham: Duke University Press, 1995.

———. 'Shame in the Cybernetic Fold: Reading Silvan Tomkins'. *Critical Inquiry* 21, no. 2 (Winter 1995): 496–522. https://www.jstor.org/stable/1343932.

Sedgwick, Eve Kosofsky, and Michael Moon. 'Confusion of Tongues'. In *Breaking Bounds: Whitman and American Cultural Studies,* edited by Betsy Erkkila and Jay Grossman, 23–29. New York: Oxford University Press, 1996.

Sedgwick, Eve Kosofsky, Michael Moon, Benjamin Gianni, and Scott Weir. 'Queers in (Single Family) Space'. *Assemblage* 24 (August 1994): 30–37. DOI: 10.2307/3171189. Reprinted in *The Design Culture Reader,* edited by Ben Highmore, 40–49. New York: Routledge, 2009.

Sedgwick, Eve Kosofsky, and Andrew Parker, eds. *Performativity and Performance.* London: Routledge, 1995.

Sedgwick, Eve Kosofsky, and Michael D. Snediker. 'Queer Little Gods: A Conversation with Michael D. Snediker'. *Massachusetts Review* 49, nos. 1–2 (2008): 194–218.

Sedgwick, Hal A. 'A Note on "The 1001 Seances'. *GLQ* 17, no. 4 (2011): 451–56. DOI 10.1215/10642684-1302307.

———. 'Relating Direct and Indirect Perception of Spatial Layout'. In *Looking into Pictures: An Interdisciplinary Approach to Pictorial Space,* edited by Heiko Hecht, Robert Schwarz, and Margaret Atherton, 61–75. Cambridge: MIT Press, 2003.

Sharpe, Chloe. *Multiple Bodies: Looking at Spanish Cemetery Sculpture, 1875–1931.* PhD thesis, University of York, 2018. DOI 10.1215/10642684-1302307.

Sherman, William H. 'Toward a History of the Manicule'. http.www.livesandletters.ac.uk/papers/FOR_2005_04_001.pdf.

Shone, Richard, ed. *Bloomsbury Portraits: Vanessa Bell, Duncan Grant, and Their Circle.* Oxford: Phaidon, 1976.

———. *Duncan Grant and Vanessa Bell: Design and Decoration, 1910–1960.* London: Spink, 1997.

———. *The Art of Bloomsbury: Roger Fry, Vanessa Bell, and Duncan Grant.* London: Tate, 1999.

Siegel, Elizabeth, et al. *Playing with Pictures: The Art of Victorian Photocollage.* New Haven: Yale University Press, 2009.

Simmons, James C. 'Bulwer and Vesuvius: The Topicality of The Last Days of Pompeii'. *Nineteenth-Century Fiction* 24, no. 1 (June 1969): 360–89. DOI: 10.2307/2932356.

Smith, Keith A. *Structure of the Visual Book* (1984). 3rd edn. Rochester: Keith A. Smith Books, 1996.

———. *Text in the Book Format* (1989). Book Number 120. Rochester: Keith Smith, 2004.

Snediker, Michael. 'Weaver's Handshake: The Aesthetics of Chronic Objects (Sedgwick, Emerson, James)'. In *Reading Sedgwick,* edited by Lauren Berlant, 203–35. Durham: Duke University Press, 2019.

Solomon, Melissa. 'Eighteen Things I Love About You'. In *Reading Sedgwick,* edited by Lauren Berlant, 236–41. Durham: Duke University Press, 2019.

———. 'Flaming Iguanas, Dalai Pandas, and Other Lesbian Bardos'. In *Regarding Sedgwick: Essays on Queer Culture and Critical Theory,* edited by Stephen M. Barber and David L. Clark, 201–16. London: Routledge, 2002.

Somerville, Siobhan B. 'Feminism, Queer, Theory, and the Racial Closet'. *Criticism* 52, no. 2 (Spring 2010): 191–200. DOI: 10.1353/crt.2010.0027.

Spalding, Francis. *Duncan Grant: A Biography.* London: Pimlico, 1998.

———. *Vanessa Bell*. London: Papermac, 1984.
Spencer, Herbert. *Pioneers of Modern Typography* (1969). London: Lund Humphries, 1982.
Spencer, Stephanie. *O.G. Rejlander: Photography as Art*. Ann Arbor: UMI Research Press, 1985.
Stacey, Jackie. 'Wishing Away Ambivalence'. *Feminist Theory* 15, no. 1 (2014): 39–49. DOI: 10.1177/1464700113513083.
Stevens, Rebecca A.T., and Yoshiko Iwamoto Wada. *The Kimono Inspiration*. San Francisco: Pomegranate, 1996.
Stewart, Garrett. *Bookwork: Medium to Object to Concept to Art*. Chicago: University of Chicago Press, 2011.
Stockton, Kathryn Bond. 'Afterword'. In *Reading Sedgwick*, edited by Lauren Berlant, 274–78. Durham: Duke University Press, 2019.
———. *Beautiful Bottom, Beautiful Shame: Where 'Black' Meets 'Queer'*. Durham: Duke University Press, 2006.
———. 'Eve's Queer Child'. In *Regarding Sedgwick: Essays on Queer Culture and Critical Theory*, edited by Stephen Barber and David L. Clark, 181–200. London: Routledge, 2002.
———. *Making Out*. New York: New York University Press, 2019.
———. 'Prophylactics and Brains: *Beloved* in the Cybernetic Age of AIDS'. In *Novel Gazing: Queer Readings in Fiction*, edited by Eve Kosofsky Sedgwick, 41–70. Durham: Duke University Press, 1997.
———. 'Reading as Kissing, Sex with Ideas: "Lesbian" Barebacking'. *LA Review of Books,* March 15, 2015. https://lareviewofbooks.org/article/reading-kissing-sex-ideas-lesbian-barebacking/.
———. *The Queer Child, or Growing Sideways in the Twentieth Century*. Durham: Duke University Press, 2009.
Szarkowski, John, Willais Hartshorn, and Anne Ehrenkranz. *A Singular Elegance: The Photographs of Baron Adolph de Meyer*. San Francisco: Chronicle/ International Centre of Photography New York, 1995.
Taylor, John. *The Old Order and the New: P.H. Emerson and Photography, 1885–1895*. Munich: Prestel, 2006.

Taussig, Michael. 'Redeeming Indigo'. *Theory, Culture and Society* 25, no. 3 (2008): 1–15. DOI: 10.1177/0263276408090655.

Thomson, Mark, ed. *Leatherfolk: Radical Sex, People, and Practice* (1991). Los Angeles: Daedalus, 2004.

Trollope, Anthony. *An Autobiography* (1883). New York: Dodd, Mead and Co., 1905.

Tuchman, Maurice, and Esti Dunow, eds. *Chaim Soutine (1893–1943): Catalogue Raisonné*. Cologne: Taschen Verlag, 1993.

Tucker, Herbert F. 'Tactical Formalism'. *Victorian Studies* 49, no. 1 (Autumn 2006): 85–93. https://www.jstor.org/stable/4618952.

Turner, Peter Richard Wood. *P.H. Emerson: Photographer of Norfolk*. London: Gordon Fraser, 1974.

Urbach, Henry. 'Closets, Clothes, Disclosure'. In *Gender, Space, Architecture: An Interdisciplinary Introduction,* edited by Jane Rendell, Barbara Penner, and Ian Borden, 342–52. London and New York: Routledge, 2003.

Van Leer, David. 'The Beast of the Closet: Homosociality and the Pathology of Manhood'. *Critical Inquiry* 15, no. 3 (Spring 1989): 587–605. DOI: 10.1086/448502.

Wada, Yoshiko Iwamoto, Mary Kellogg Rice, and Jane Barton. *Shibori: The Inventive Art of Japanese Shaped Resist Dyeing* (1983). Tokyo: Kodansha, 1999.

Wada, Yoshiko Iwamoto. *Memory on Cloth: Shibori Now*. Tokyo: Kodansha, 2002.

Warner, Michael. *The Trouble With Normal: Sex, Politics, and the Ethics of Queer Life*. Cambridge: Harvard University Press, 1999.

Watney, Simon. *Practices of Freedom: Selected Writings on HIV/AIDS*.

———. *The Art of Duncan Grant*. London: Murray, 1990.
Durham: Duke University Press, 1994.

Weed, Elizabeth. 'The Way We Read Now'. *History of the Present* 2, no. 1 (Spring 2012): 95–106. DOI: 10.5406/historypresent.2.1.0095.

Weinberg, Jonathan. 'Urination and Its Discontents'. *Journal of Homosexuality* 27, no. 1 (1994): 225–44. DOI: 10.1300/J082v27n01_10.

Werner, Marta, and Jen Bervin. *Emily Dickinson: The Gorgeous Nothings*. New York: The Christine Burgen Gallery/Granary, 2013.

Westwood, Benjamin. 'The Abject Animal Poetics of The Warm Decembers'. In *Bathroom Songs: Eve Kosofsky Sedgwick as a Poet,* edited by Jason Edwards, 85–110. Earth: punctum books, 2017.

———. 'The Queer Art of Ardent Reading: Poems and Partiality'. *Raritan* 61, no. 1 (Summer 2021): 50–71.

Wiegman, Robin. 'Eve, At a Distance'. *Trans-Scripts* 2 (2012): 157–75.

———. 'Eve's Triangles: Queer Studies Beside Itself'. In *Reading Sedgwick,* edited by Lauren Berlant, 242–73. Durham: Duke University Press, 2011).

———. 'The Times We're In: Feminist Criticism and the Reparative 'Turn''. *Feminist Theory* 15, no. 1 (2014): 4–25. DOI: 10.1177/1464700113513081a.

Williams, Carolyn. 'The Boston Years: Eve's Humor and Her Anger'. *Criticism* 52, no. 2 (Spring 2010): 179–84. DOI: 10.1353/crt.2010.0019.

———. 'The Gutter Effect in Eve Kosofsky Sedgwick's *A Dialogue On Love*'. In *Graphic Subjects: Critical Essays on Autobiography and Graphic Novels,* edited by Michael A. Chaney, 195–99. Madison: University of Wisconsin Press, 2011.

Wolfson, Susan J. 'Reading for Form'. MLQ 61, no. 1 (March 2000): 1–16. DOI: 10.1215/00267929-61-1-1.

Yamashiro, J.P. 'Idylls in Conflict: Victorian Representations of Gender in Julia Margaret Cameron's Illustrations of Tennyson's *Idylls of the King*'. *The Library Chronicle of the University of Texas at Austin* 26, no. 4 (1996): 89–116.

Yeats, W.B. *The Variorum Edition of the Poems*. Edited by Peter Ault and Russell K. Alspach. New York: Macmillan, 1957.

www.ingramcontent.com/pod-product-compliance
Lightning Source LLC
Chambersburg PA
CBHW060821220526
45466CB00003B/929